BORN OF RESISTANCE

Born of Resistance

Cara a Cara *Encounters* *with Chicana/o* *Visual Culture*

Edited by
SCOTT L. BAUGH and
VÍCTOR A. SORELL

THE UNIVERSITY OF
ARIZONA PRESS

TUCSON

The University of Arizona Press
www.uapress.arizona.edu

Printed in the United States of America
20 19 18 17 16 15 6 5 4 3 2 1

ISBN-13: 978-0-8165-2582-9 (paper)

Cover design by Leigh McDonald
Cover art by Delilah Montoya, 1992/1993: [*top*] *El Cielo* (Heaven); [*bottom*] *El Infierno*
(Hell). Juxtaposed here for dramatic effect, Montoya's dichotomous images are emblematic
of the push-pull dynamics of resistance between opposing poles and within the liminal
encounters between those poles.

Publication of this book is made possible in part by the proceeds of a permanent
endowment created with the assistance of a Challenge Grant from the National
Endowment for the Humanities, a federal agency.

Library of Congress Cataloging-in-Publication Data
Born of resistance : *cara a cara* encounters with Chicana/o visual culture / edited by
Scott L. Baugh and Víctor A. Sorell.
 pages cm
 Includes bibliographical references and index.
 ISBN 978-0-8165-2582-9 (pbk. : alk. paper)
 1. Mexican American art—Political aspects. I. Baugh, Scott L., editor. II. Sorell, V. A.
(Víctor A.), editor.
 N6538.M4B67 2015
 700.89'6872073—dc23
 2015006095

♾ This paper meets the requirements of ANSI/NISO Z39.48-1992 (Permanence of Paper).

Contents

Part VIII

Part IX

Acknowledgments

"Ars longa, vita brevis, occasio praeceps, experimentum periculosum, iudicium difficile." We are reminded as editors and readers that art endures: the craft is long, even as lives seem short, opportunities are fleeting, and judgments are rarely easy. Yet we should revel in the peril of the experiments. Our hopes go to readers encountering these experiments and seeking their opportunities. Our dedications go to the lives touching, and perhaps touched by, this volume. Special tribute to Luis Jiménez, Mel Casas, Héctor Torres, Larry Baugh, and Eero Alexander Sorell.

For the two editors, this book is the culmination of an arduous, vigorous, and rewarding journey. Together we've shared the responsibilities large and minute as well as the rich benefits of collaborations. For any collection to succeed, it depends upon the input of and interaction among its contributors; for this collection, with its *cara a cara* encounters and multi-faceted and provocative conversations, collaborations are paramount. The craft is indeed long, and the art endures. As editors, we foremost want to express our appreciation to all of the contributors—artists, curators, scholars, critics. We are indebted to each of them for their creative and critical insights, their stories, and their generosity. They are also our colleagues, compatriots, and friends, and we thank them all.

The University of Arizona Press has demonstrated steady support for and unparalleled professionalism with this project. We would like to formally thank the administration and director of the press for standing behind this project. We extend our gratitude especially to our former editor, Patti Hartmann, for launching us into this project and to our current editor,

Kristen Buckles, for the dedication to keep it flying and then landing it safely. Thanks to the entire editorial and production staff at the University of Arizona Press for delivering this volume and supporting these topics. Special thanks go to Leigh McDonald for her assistance with the illustrations and, particularly, for her splendid and expert design of the cover, to Amanda Krause for her production oversight, and to our manuscript editor, Diana Rico, for her meticulous and careful attention to the manuscript. We would be hard pressed to find a better team with which to work. *c/s*

For *Víctor*. Initially, I want to recognize my coeditor, Scott Baugh, a person I've come to admire and appreciate as a kindred spirit. I'm proud to have labored so hard and so long with this *carnal*, an individual I regard as my intellectual brother and *amigo querido* (dear friend). Scott is an exemplary editor in the broadest sense of that word. Time and again, he's demonstrated his keen analytical and critical eye. Let there be no doubt: he's the proverbial "editor's editor"! A product of the techie era, Scott has been our project's "wired" guru, resolving all manner of taxing technical issues that we encountered as this book evolved. I'm particularly grateful for his youthful enthusiasm and perseverance. The irony is not lost on us that while our collection of essays is premised on a face-to-face dialogue, ours was a distant collaboration between Chicago, Illinois, and Lubbock, Texas. The finished publication affirmed and overcame that geographic divide.

Retiring five years ago after a career that spanned some forty-two years inside and outside academia, I wish to acknowledge many people. Long-time colleagues at Chicago State University deserve first mention for their ongoing interest and past (when deceased) support of my investigative work in Chicana/o, Latina/o, and Latin American cultural studies: the late Fred Blum and Chernoh Sesay, Scott Bennett, Marc Bouman, Leticia Carrillo, Phil Cronce, Fernando Díaz, Rachel Lindsey, Genevieve Lopardo, Pancho McFarland, Paul Musial, Howie Silver, Mark Smith, Gabrielle Toth, and Laurie Walter. Special thanks to Mati Maldre, Bernard Rowan, Virginia Shen, Robert Weitz, and the late John Hobgood for their unwavering collaboration, friendship, and support throughout much of my career. Colleagues and friends from other agencies and institutions are also most deserving of my acknowledgment: the late Rudy Padilla (Hourglass Prison Gallery, Albuquerque, New Mexico); Ana Caravelli, James Early, Cheryl McClenney, Marty Sullivan, and Shirley Sun (the National Endowment for the Humanities); Albert Boime, Cecelia Klein, Holly Barnet-Sánchez, and Marcos Sánchez-Tranquilino (University of California, Los Angeles); Miguel Gandert, Enrique Lamadrid, José Rivera, and Vangie Samora

(Southwest Hispanic Research Institute at the University of New Mexico, Albuquerque); Allen Isaacman and Gabriel Weisberg (University of Minnesota); Francisco Lomelí (University of California, Santa Barbara); and Diana Rivera (Michigan State University). Among those at other agencies and institutions, eleven individuals stand out as steadfast friends and/or mentors: Jesús Macarena-Ávila (Columbia College), Gilberto Cárdenas (University of Notre Dame), José González (el Movimiento Artístico Chicano/the Chicano Art Movement), Gary Keller (Arizona State University), Tom Mitchell (University of Chicago), Santos Rivera (Northeastern Illinois University), Marc Rogovin (Public Art Workshop and the Peace Museum), David Sokol (University of Illinois at Chicago), John Weber (Chicago Public Art Group), Tomás Ybarra-Frausto (Stanford University and the Rockefeller Foundation), and Marc Zimmerman (University of Illinois at Chicago and University of Houston). Independent visual artists Marcos Raya and the late Carlos Cortéz Koyokuikatl and Bill Walker also hold a very special place in my life's professional work. To my brother Tom Sorell (University of Warwick, United Kingdom), I owe a debt of inspiration through his many philosophical tomes.

My many students, during the course of some four decades, are too numerous to mention. However, a few do demand acknowledgment: Felicia Beckett, Ana Guajardo, Lysette Haro, Raymond Patlán, and Shan Wong (Chicago State University); Constance Cortéz (University of California, Los Angeles); Andrew Hershberger and Carmen Ramos (University of Chicago); and Dread Scott Tyler (School of the Art Institute of Chicago).

Four of my teachers had a profound influence on me: Francis Dowley, John Hirshfield, Earl Rosenthal, and, most singularly, Joshua Charles Taylor.

My family—wife Ida, daughter Nicole, son Alexander, and grandson Eero—keep me tethered through their love and companionship. Our dog Milagrito (Little Miracle) is another constant companion, especially when I'm tethered to a computer for hours on end.

Apologies are due to those whom I've inadvertently overlooked because of lapses in memory.

For Scott. I wish to begin by thanking my coeditor, Víctor Sorell, for all he has shared with me over a dozen years and more. I feel lucky beyond words that our paths crossed as they did. Through both smooth sailing and choppiest of waters, the many pushes and pulls this project has ingenerated, he has proven himself a very dear friend, model mentor, trusted colleague, and real mensch. Thanks especially for loyalty, wisdom, compassion, and humor.

I am grateful for my students at Texas Tech University, particularly those from graduate and senior seminars in Latina/o cinema and cultural studies. Many colleagues deserve my gratitude, and I want to express particular appreciation to Sara Spurgeon, Cordy Barrera, Priscilla Solis Ybarra (University of North Texas), Monica Montelongo, Javier Ramírez, Justin Schumaker, Mike Schoenecke, Sam Dragga, Wendell Aycock, Brian McFadden, and Bruno Clarke for their insights, friendship, and support. Curtis Bauer and Marco Dominguez deserve special thanks for their advice on translations.

I must acknowledge institutional support over the years. Portions of the project benefited from a faculty development leave and research enhancement programs from Texas Tech University (2004, 2006, 2009) and its libraries (2003). Primary and archival research for this project was supported in part by grants from the Popular Culture Association (2008) and the Centro de Estudios Americanos at the Universidad Autónoma de Coahuila (2005). Additionally, I offer my personal and professional appreciation to the staffs at the Special Collections at Stanford University, the Centro de Estudios Americanos at the Universidad Autónoma de Coahuila, the Video Data Bank in the School of the Art Institute of Chicago, the Chicano Studies Research Center at the University of California, Los Angeles, the Special Collections at the University of Texas at El Paso, and Texas Tech University. Special thanks to Mike Stone (University of California, Los Angeles) for technical support with illustrations.

This project arose amid a set of ideas and through many conversations, and so I wish to extend thanks to the participants in the Chicana/o cultural studies sessions with whom I have exchanged ideas at the meetings of the Congreso Internacional de las Américas/International Congress of the Americas (2001–4), the Popular Culture Association/American Culture Association (PCA/ACA) (2004–11), and the Southwest/Texas PCA/ACA (2001–6). I wish to acknowledge Tey Diana Rebolledo (professor emerita, University of New Mexico), John Bratzel (Michigan State University), Luisela Amelia Alvaray (DePaul University), Theresa Delgadillo (Ohio State University), and Henry Puente (California State University, Fullerton), among others, for their insights, inspiration, and advice from conference meetings and exchanges. In addition to thanks to each of the contributors to this volume, I particularly want to thank Willie Varela for his friendship and humor.

Finally, personally, I wish to give my deepest thanks to my family: to them, Tammy Moriearty, and Washington Street, I dedicate my best efforts and owe my greatest hope and joy.

BORN OF RESISTANCE

Introduction

Resisting Definitions
of Chicana/o Visual Culture

Scott L. Baugh and Víctor A. Sorell

Arriba ya del caballo, hay que aguantar los reparos.
(Once up on the horse, one must bear when it rears.)
 —Mexican American proverb

Resistance remains the most contested social, political, and aesthetic con-
cept and issue in Chicana and Chicano cultural studies. Certainly since
the 1960s, Chicana/o culture rightly has claimed resistant qualities, nego-
tiating restive stances, demanding tact, suppling command, and nerving
the ride; and yet, any singular definition of *resistance* denies some rogue
characteristics, limits its resourcefulness, dispirits its artistry and beauty,
and overlooks its balance and diversity as social mechanism and cultural
expression. More to the point, how have resistant qualities changed over
the last half century? Owing to the complexity inherent to and dimensions
of resistance in Chicana/o culture then, this collection's contents and con-
formation are extensive and multilayered. Rather than a single listing of
collinear chapters on distinct topics, readers will find that the contents'
thirty-eight chapters are organized into nine parts, each featuring and fo-
cusing upon a single piece of artwork, a significant pairing, or a series wor-
thy of attention for visual-cultural expressions; moreover, within each part,
several chapter-length discussions give voice to the featured artwork's art-
ist, its curator or distributor, and its critical and scholarly audiences. Read-
ers will discover that, as such, chapters interact, correlate, and function in
a number of ways—as artistic statements and interview conversations with
the artists, as curatorial reflections, as scholarly appreciations and histori-
cal contextualizations, and as critical analyses and interpretive readings.

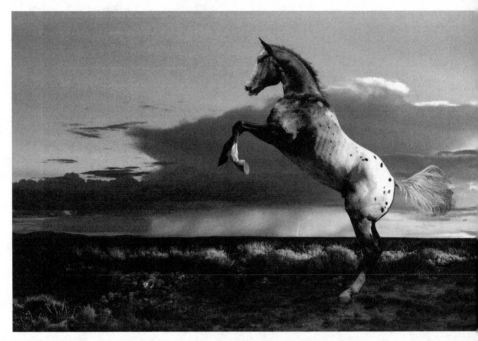

Figure I.1. Delilah Montoya, *Appaloosa Stallion in Eastern New Mexico* (2010/2012, photographic digital collage, archival inkjet print, 20 x 29.75 in.). The Appaloosa stallion is a metaphor for Chicana/o syncretism, the blending of the indigenous and Iberian to create a new breed for a new global order. (Photograph courtesy of the artist.)

Across the collection, the varied richness of resistance, actual and potential, practical and theoretical, reveals itself. While each component of this discussion is presented specifically, given a name and a face, the overlaps and overall polyphonic combination provide for a richer appreciation of the artwork, its creation and completion, and its characterization as an expression of Chicana and Chicano visual culture, *born* of resistance and evolving into the twenty-first century.

This collection, then, offers encounters *cara a cara*, face to face, among constituents across the origination and reception of the artwork, delivering what art historian Lisa Bloom recognizes as absent from existing scholarship, "greater attention to the complex discursive and rhetorical dimensions of visual culture," particularly surrounding tensions inherent in racial, ethnic, gendered and sexualized, class-based, and national identification (1999, 5). The collection recapitulates, as sociologist Edward J. McCaughan describes it, the personal-political nexus in art and social movements around "struggles to resolve long-standing tensions . . .

about politics, art, and desire" (2012, xii). Essays in the collection answer a call advanced by cultural studies scholars Arturo J. Aldama and Naomi H. Quiñonez to "recover subjugated histories" in "new dimensions of perception, focus, and analysis [that] have emerged since the social and cultural gatherings of the 1960s and 1970s" (2002, 1–2), particularly surrounding violence inherent to our "millennial anxieties," as Aldama claims (2002, 24–25), and recognizing the importance of spirituality, as Laura E. Pérez urges (2007). Across borders and within interstitial spaces, among a range of methods and objectives, Chicana/o visual culture can extend the full force of what Emma Pérez conceptualizes as the "decolonial imaginary" (1999). Put even more directly, the component chapters and their combination as parts address salient aspects, hinge points, of resistance in visual art and cultural expression. Rather than settle on singular readings, isolated approaches, or even a distinct definition of resistance, this collection provides readers a chance to reimagine the conversations over the artwork and art's many instances of resistance, enter the negotiations on Chicana/o visual cultural expression, and possibly enact their own forms of resistance.

The work or works of art focused upon within each part have been selected carefully and deliberately as special case studies of art's network of resistance but also as exemplary of the many facets of Chicana/o cultural expression and categories of visual art. A relatively very diverse array of media includes illustration, painting, sculpture, printmaking, photography, film, video, and television. These media encumber even greater complexity as they encroach upon issues of nonprofit and commercial status, found art, public art, performance, installation, and serialization. Artwork ranges from documentary to avant-garde genres and sometimes commingles these approaches; some artwork seems primarily drawn toward entertainment, while some stems from propaganda, but these currents and undercurrents more likely stream in a confluent manner rather than flow in different directions. Distinctions over formal training and self-taught techniques and issues of authorship and collaboration surface across several chapters. These works of art spur controversy and bear it in significant ways. While this collection takes as a point of departure works of the late 1960s and early 1970s, an era of social and civil rights movements, an era marked by protest and defiant stance for Chicana/o culture, it looks back further as well as quickly moves ahead into the following decades of update and change. It may be most useful to suggest that Chicana/o visual culture was *born* of resistance and what it has since grown into is open to interpretation and negotiation, as affirmed in the conversations that appear in this collection.

The Riddle of Resistance

We perceive the version of reality that our culture communicates. Like others having or living in more than one culture, we get multiple, often opposing messages. The coming together of two self-consistent but habitually incompatible frames of reference causes un choque, *a cultural collision. . . . A counterstance locks one into a duel of oppressor and oppressed. . . . All reaction is limited by, and dependent on, what it is reacting against. . . . The possibilities are numerous once we decide to act and not react.*
<div align="right">—Gloria Anzaldúa (1987, 78–79)</div>

Through violence you may murder a murderer, but you can't murder murder. Through violence you may murder a liar, but you can't establish truth. Through violence you may murder a hater, but you can't murder hate.
<div align="right">—Martin Luther King Jr. ([1967] 1990, 249)</div>

The reason we're so dangerous is because we're totally harmless.
<div align="right">—Cheech and Chong[1]</div>

All art enacts resistance. While the reaches of creativity may drive in multiple directions and with varying magnitude, inevitable and often underlying clashes of push-pull forces perform the drama and dance of art's resistance. In what is a fairly abstract conceptualization, forces of freedom, liberation, consciousness, autonomy, and creativity *resist* coterminous forces of oppression, repression, restriction, constriction, convention, and domination. Motivation for resistance surely arises from the confrontation and contest with named and unnamed limits on freedom and agency, and yet concomitant motivations may grow in resistant counterpoise.[2] None of these forces or their motivations could exist without the others: none can be appreciated fully without the others being appreciated. And so resistance, in this abstract conceptualization, ultimately breeds a multiplicity of complementary resistances.[3] A multidirectional network of power, perforce, results from any act of resistance.

The application of resistance in discursive or symbolic circumstances, as in artistic mediations and performances, emboldens key aspects of these abstract ideas.[4] Put another way, art, artist, and audiences arbitrate and mediate their interlocutionary resistances. Amid the plurality of sites of art's resistance, multiperspectivalism—the examination, consideration, and negotiation of an artwork's complex dimensions from different approaches through origination and reception—affords us access to the complex play of power dynamics. Art's resistance may be isolated and considered

specifically but must be considered also amid its divergences from and convergences and intersections with, its *encounters* among, neighboring forces. Art's resistance immanently accords itself with material and mundane networks of power.

Ironically, for resistance to exist, there must be freedom. Because the pushes and pulls of resistance are not binary, linear, nor absolute, resistance can live and breathe only where freedom draws some currents of air. Art's resistance may stand for freedom against domination; if so, though, reactionary varieties of resistance may stand for what may at first glance only seem like or may actually prove to be competing causes. In the act of this universal struggle, the participants—the art, the artist, and the audiences—likely encumber precisely the dominant power dynamics and terms of engagement that might lend them some disadvantage. In praxis, the audiences, the artist, maybe even the artwork itself assume some degree of complicity and privilege in the network of power. Acknowledgment of this privilege may likely take the form of artistic inspiration, the infusion of individual talent amid traditions,[5] and the acceptance of artistic forms, genres, and conventions, as well as the consolidation of categories of knowledge and language. Amid social pressures, some art's resistance may rise to the surface of visibility, while others may mask themselves or plunge to hidden depths.[6] The emancipatory and affirmative functions of art—by artists as well as for and within their audiences—may best be calculated only by considering in tandem the occasions of resistance. Across a spectrum of functions, art may espouse various types and forms of resistance at the same time as it may continue to bear, accommodate, undermine, transform, or try to overcome them.

Resistance requires freedom in order to beget freedom; resistance requires consciousness in order to beget consciousness; art's variety of resistance requires creativity to provide for creativity. Art's resistance requires resistance. Herein lies our riddle.

A Story of Chicana and Chicano Cultural Expression

We cannot understand all that history simply in terms of victimization. . . . Raza resistance, which took the form of organized armed struggle in the Southwest during the last century, continues today in many forms. . . . If liberatory terminology becomes an end in itself and our only end, it ceases to be a tool of liberation. Terms can be useful, even vital tools, but the house of La Raza that is waiting to be built needs many kinds.

—Elizabeth "Beta" Martínez (1998, 3)

Chicano speech is like the mestizo body and the borderlands home: it simultaneously reflects multiple forces and asserts its hybridity.
—Alfred Arteaga (1997, 16)

The technologies of semiotic reading, deconstruction of signs, meta-ideologizing, and moral commitment-to-equality are its vectors, its expressions of influence. These vectors meet in the differential mode of consciousness, carrying it through to the level of the "real" where it can guide and impress dominant powers. Differential consciousness is itself a force which rhyzomatically and parasitically inhabits each of these five vectors, linking them in movement, while the pull of each of the vectors creates ongoing tension and re-formation. Differential consciousness can be thus thought of as a constant reapportionment of space, [of] boundaries, of horizontal and vertical realignments of oppositional powers.
—Chela Sandoval (2000, 384)

Sometimes in the face of my own/our own limitations, in the face of such world-wide suffering, I doubt even the significance of books. Surely this is the same predicament so many people who have tried to use words as weapons have found themselves in—¿Cara a cara con el enemigo de qué valen mis palabras? [Face to face with the enemy, what good are my words?] . . . But we continue to write. To the literate of our people and the people they touch. We even write to those classes of people for whom books have been as common to their lives as bread. For finally, we write to anyone who will listen with their ears open (even if only a crack) to the currents of change around them.
—Cherríe Moraga (1983, iii)

Containment only happens when you stop creating and keep producing. I think most of our artists are still creating. . . . They still have too many stories to tell.
—Tomás Ybarra-Frausto[7]

The riddle of resistance is surely not limited to abstract statements and universal principles. The traditions of Chicana and Chicano cultural expression and their reflection in the visual arts over generations foreground these paradoxical facets and teasing issues of resistance.

Much of the story of Chicana/o cultural expression has been written around the political instability and social revolutions of the 1960s and early 1970s. The story is longer, as Armando B. Rendón suggests in his dating of the political instabilities as far back as Father Miguel Hidalgo's efforts at rallying Mexicans to rebel against a repressive Mexican government in the early nineteenth century via El Grito de Dolores, the cry for

independence (1971, 2, 105); as far back as Joaquín Carrillo Murrieta, "the Robin Hood of El Dorado," and his "horse gang" avenging Mexicanos driven off their claims in the 1850s California gold rush; as far back as "the Red Robber of the Rio Grande," Juan Nepomuceno Cortina Goseacochea, and his Cortinistas battling the U.S. army, the Texas Rangers, and even the Brownsville Tigers over the eviction of Tejanos in South Texas in 1875. Rodolfo Acuña's pivotal history, first published in 1972 as *Occupied America: The Chicano's Struggle Toward Liberation*,[8] advances the "internal colonial" model, which evidences centuries of European conquest and colonization across the Americas as the basis of civil rights–era protest. Much remains the same, though, as an underclass engages a dominant power structure, protest marks social injustice, and future generations will negotiate the legend, song, corrido, and drama of the "story," one that nevertheless demanded to be told.

Noteworthy scholarship on Chicana/o cultural expression rightly places special importance on countercultural events of the late 1960s and early 1970s—the meeting of the organizing committee of the National Farm Workers Association (which would become the United Farm Workers, or UFW) in 1962, led by César Chávez and Dolores Huerta; the founding of the Crusade for Justice in 1966 under the leadership of Corky Gonzales; the Rio Arriba County Courthouse raid in northern New Mexico in 1967 in the name of the Alianza Federal de Pueblos Libres and by the charge of Reies López Tijerina; the initiation of the political party La Raza Unida in 1967 and its full formation by 1970; student-led walkouts in East Los Angeles in 1968; rallies, protests, marches, and riots in the name of student rights, worker rights, antiwar sentiment, immigration policy, human rights, and social justice over this entire period and beyond.[9] The 1965 Delano, California, grape pickers' strike, supported by the arm of the UFW, was a galvanizing moment in Chicana/o cultural expression, especially as it inspired related enterprises with social protests, widely publicized marches, and demonstrations to follow. The first Chicano Moratorium, held in McAllen, Texas, in 1969, inspired similar, larger events, highlighted perhaps by the 1970 March in the Rain in Southern California's Laguna Park, which attracted national attention. News of violent confrontations between protesters and Los Angeles County Sheriff's officers over police brutality reached a national stage as well, and such events announced in no uncertain terms that Chicana/o cultural expression is not always pacific or civil.

The social protest activities of the civil rights movement in the late 1960s and early 1970s made an indelible mark on the whole of American culture, and perhaps nowhere was this more evident than in the artistic

affirmation of Chicana/o culture following El Movimiento, the Chicano civil rights movement. Throughout the 1970s and into the 1980s, expressions of Chicana/o culture effectively proclaimed militant nationalism and a general spirit of defiance and protest, carrying forward the agenda of El Movimiento in an attempt to resist the hegemony of "white America" and affirm a distinctly Chicana/o cultural space. The landmark art exhibit *Chicano Art: Resistance and Affirmation, 1965–1985* (CARA), perhaps the prime example of such expressions, speaks to and embodies this link between Chicana/o visual arts and a popular and strident nationalism. Nationalism defines the trajectory of Chicana/o arts as encapsulated in *El Plan Espiritual de Aztlán* (The Spiritual Plan of Aztlán), a pivotal document and manifesto of El Movimiento Chicano issued in March 1969 as a resolution document on the occasion of the Chicano Youth Liberation Conference in Denver, Colorado.[10] Accounting for specific points of intersection among social movements, Mexican and Chicana/o cultural politics, and visual arts, Edward J. McCaughan argues that "artists helped to attribute new meaning to social phenomena as varied as class, race, gender, sexuality, citizenship, and power," constituting, not simply reflecting, social-political changes across American culture and in Mexican and Chicana/o communities (2012, 1, 6). El Movimiento, McCaughan clarifies, may be better understood in hindsight as a "loose network of many movements" (2012, 9), and, as María Teresa Marrero insightfully indicates, "then necessary nationalism" of the late 1960s and 1970s afforded oppositionality to mainstream hegemony while it concurrently invited exclusions and fictional homogeneity within Chicano and Chicana identification (2000, 132–33). Kymberly Pinder suggests that racial-cultural hybridities in contemporary artistic and popular cultural production may be a key to understanding our problematic histories of race relations and social conflict alongside our "desire for harmony, past and present" (2000, 44–46).[11] Art's resistance delivers affirmation in shorthand, and yet its complex legacies require a breadth of approaches.

Initially, the *movida* (or strategy) of resistance, considered in its most linear form as oppositional to a dominant force of oppression in the name of freedom, led to better-informed and more sensitive critical analyses of issues related to American studies, which has promoted widespread acceptance of cultural diversity throughout the Americas. Forms of resistance, more broadly conceived, also clearly have fed generations of artists and those involved in the production, exhibition, distribution, and collection of Chicana/o visual arts. Despite this progress, however, Chicana/o cultural expressions continue in an overwhelming way to be critically defined and

oversimplified according to their "resistant" politics without acknowledgment of their significant influence on mainstream American and global markets, social politics, and ideological values, without the complex interplay of forces of resistance among dynamics of power, and without their own interpolations and mediations involved. In her groundbreaking study of the CARA exhibit, Alicia Gaspar de Alba offers a remarkable insight that—after seeing the exhibit multiple times in different venues; after talking with curators, museum staff, and arts administrators in addition to artists, art historians, scholars, critics, and viewers of the exhibit; after recognizing consent, dissent, and sharing—"this dialogue was part of CARA's intention" (1998, xv). Chicana/o visual culture represents and expresses a vast array of cultural values and social and political stances, individual, familial, and communal histories, religious and spiritual inspirations, and more than any singular "story" of Chicana/o cultural expression has heretofore offered. The present volume reincarnates these many-voiced dialogues and recovers significant stories.

Born of Resistance enters into the conversations a number of movidas, social and artistic strategies, too frequently overlooked—experiential knowledge and insider codes, *testimonio* and self-determinant claims; recognition of underdeterminacy and uncertainty; forms of solidarity and collectivism, audience participation, and civil disobedience; site specificity and communal "space," mobility and border crossing; hybridization, revisionism, and recovery; sustainability and resourcefulness; *rasquachismo*, subversive humor and satire, parody, simulacrum, and transformation; differential consciousness; *las ofrendas*, or offerings; call-and-response devices; multilingualism, multidiscursivity, cross-disciplinarity, multimedia experimentation, and more. Several of the art pieces discussed in this collection classify technically as "public art," planned and executed with a public-accessible stage in design; all, however, access and engage their audiences across a number of contexts, commercial and nonprofit included, inviting comparisons across these functions of art. The diversity of Chicana/o visual arts provides opportunities for identifying with varying audiences and inculcating some progressively wider markets and venues. What of the rest of these stories of Chicana/o cultural expression and visual arts? They have yet to be told.

The essays in this collection revisit and update the discussion on resistance, the most contested political, social, and aesthetic concept and issue in Chicana/o arts and cultural studies.

Resisting a singular definition of *resistance* and instead drawing on dynamic interplay and complex power relations of resistance, the essays

consider how Chicana/o visual culture in the late 1960s was "born of resistance" against the dominant forces and authoritative elements of the mainstream and how, in the intervening five decades and more, its subversive nature has, in practice, reconfigured the mainstream, potentially and actually engendering multiculturalism and transnationalism. Traditionally accompanying the nationalistic paradigm are aesthetic, socioeconomic, political, gender, and spiritual issues that this study lays bare precisely through its own multiple-voiced diversity. Unlike previous compilations addressing Chicana/o cultural studies, this collection includes contributors who are artists, filmmakers, curators, and others involved in the origination, the production, and the exhibition of the physical cultural expressions and texts, alongside distinguished scholars and critics who enhance our appreciation of the creative and cultural output. Artwork, artists, and audiences negotiate the network of relations that they constitute. This collection, then, will attempt to draw a detailed portrait of Chicana and Chicano visual culture, considering the role of nationalism in its foundation, while also examining its evolving syncretic and complex character.

Social histories and cultural studies of the United States by John Higham (2001), David Hollinger (2006), Werner Sollors (1987), Edward Said (1993; 2003), and others have acknowledged the role of multiculturalism and synthesis in American society. Within the field of Chicana/o literary studies, scholarship over the last two decades or so has initiated the move away from Chicano nationalism to integrational pluralism; book-length studies by Rafael Pérez-Torres (1995), Ramón Saldívar (1990), José David Saldívar (1997), Héctor Calderón (2004), and Emily Hicks (1991) argue that Chicana/o literature transcends the singular and exclusionary social politics of nationalism to address diverse national and international issues of concern to all citizens throughout the Americas and the world. Pioneering work by Marshall McLuhan (1951; 1964) and W. J. T. Mitchell (1986; 1994), among others, heralds recent revolutions in media studies and provides tools with which to read visual cultural expressions and ideological formulations. However, the few book-length studies of Chicana/o visual culture have not yet adequately or effectively moved in these directions, and as a result they do not fairly reflect the subsequent impact of these changes on Chicana and Chicano visual culture. Moreover, no other book-length study to date attempts to give voice to such a diverse range of related perspectives in a sensitive and thorough exploration of Chicana/o visual culture.

The last two decades of the twentieth century witnessed a complex shift from a bifurcation of American culture based on racial separatism

to pluralist synthesis. The paradoxical tensions between racial inequality and American democracy have a history as long as or longer than does the United States itself; however, the advent of the twenty-first century marks a significant moment when American cultural expressions syncretize divergent influences. How complete are these shifts, though? Do such shifts truly reflect American values and beliefs or merely marketing trends and political polling data? Can such shifts facilitate real social change as we stand in the twenty-first century? And in the cultural climates of the post-9/11 era, an age marked by terrorism and global and domestic violence, will Americans continue to consolidate achievements that reinforce diversity, or will they backslide into xenophobic paranoia, as they did following the bombing of Pearl Harbor, within the red scare of the Cold War, or during the neoconservative push in the 1980s? Chicana/o culture's diversity and inherently multicultural makeup exemplify cultural synthesis prevailing today in the United States, throughout the Americas, and across the rest of the world. The essays in this collection disclose a range of perspectives and amplify voices that shed some light on and speak to these complex questions by focusing on the diversity and multiculturalism grounding the aesthetics of Chicana/o visual arts and cultural expressions. The collection equally places these voices and perspectives in dialogue with one another, showcasing the cara a cara encounters, quite possibly the hinge points of art's resistance. Moreover, readers are invited into the conversations, to help finish telling our story.

Overview of Parts and Chapters

The chapters in part I feature discussions of two of the most iconic, significant, and recognizable pieces of Chicana/o artwork from the 1970s, Ester Hernández's *Libertad* (1976, drypoint etching, 17.25 x 11.25 in.) and Yolanda López's *Who's the Illegal Alien, Pilgrim?* (1978, offset lithograph, 30 x 22 in.). *Libertad*, which appeared in the 1985 CARA exhibit, tells a story of a Latina artist chiseling away parts of the Statue of Liberty's torso to reveal an indigenous artifact, at the base labeled "Aztlán," flaming torch now held high in left hand instead of right. And the poster *Who's the Illegal Alien, Pilgrim?* directly and angrily addresses the audience through the face of an ancient warrior, obverse to the familiar Uncle Sam recruitment propaganda. As significant as these two pieces are, they are almost equally as overlooked in cultural studies scholarship and art history, particularly as they arise from then-current political and cultural climates and, crucially,

have helped keep several key formulations of resistance alive for generations that have followed.

In her artistic statement "(Re)Forming America's *Libertad*," Ester Hernández offers an update to her making of this print, remembering inspiration from the U.S. Bicentennial as well as the vibrancy of student and worker activism of the time. *Libertad*, as Hernández explains her artistic aims, redraws our conception of American patriotism and freedoms, particularly by directing attention to resistant *movidas*, strategies, that expand knowledge bases, that enact subversive humor, that complicate the dualistic notion of freedom-oppression hinted at in the print, and that reveal themselves through the art's and artist's own processes and creative energy.

In her essay "Freedom and Gender in Ester Hernández's *Libertad*," Laura E. Pérez's curatorial expertise informs her readings of *Libertad* and Hernández's artistic processes. Pérez argues that while *Libertad*'s exhibition since the 1970s embodies that era's political and cultural climate, especially around civil rights struggles, its iconicity resignifies the symbolism of Mayan history and the national monument of the Statue of Liberty. The simultaneous coexistence and hybridization of ostensibly competing traditions initiates a decolonizing force and results in the formulation of solidarity, one especially flavored by politics centered on indigenous and U.S. women, as Pérez claims.

Yolanda López, in an interview with Víctor A. Sorell, retraces her making of the poster *Who's the Illegal Alien, Pilgrim?*, with special attention to the social activist charge of the 1970s in the Chicano Moratorium and antiwar protests that were necessarily "intertwined" with larger human rights issues and questions over immigration policy. *Who's the Illegal Alien, Pilgrim?* overlays the authority of official military propaganda and the familiarity of popular culture reference, as López discusses, with indignation and anger through parodic humor and biting mimicry.

In his reflective statement "Thoughts on Who's the Illegal Pilgrim," curator and peer artist René Yañez recasts his experiences of first seeing the poster print exhibited and of later conveying it to gallery visitors over generations. Yañez argues that exaggeration in the artwork offers a challenge to viewers, as initial laughter over the poster frequently converts to sober contemplation. Perhaps as important as its exhibition are its moments of censure; the artwork's exhibition and growth toward familiarity entail a degree of courage and acts of resistance.

Concluding part I, Yvonne Yarbro-Bejarano's chapter, "Remapping America in Ester Hernández's *Libertad* and Yolanda López's *Who's the Illegal Alien, Pilgrim?*," resituates each piece in its respective artist's oeuvre

as well as aligning both pieces within the purview of Chicana/o art history and cultural studies. Of paramount importance, these two pieces of art for Yarbro-Bejarano at once operate within and permeate traditions of Chicano visual arts and cultural expression while at the same time they marry activism and theory of a specifically feminist Chicana tradition. From acerbic to playfully humorous tones and through sacred to mundane themes and messages, *Who's the Illegal Alien, Pilgrim?* and *Libertad* exemplify a special offering of Chicana/o nationalism by enacting transformations in the art and for its artists and audiences across personal, communal, and global levels. Of particular importance, Yarbro-Bejarano points to the forces of resistance in explicit and implicit self-portraiture and its explorations of identity; the reconfiguration of popular and "monumental" icons; and the "remapping" of time and space parameters. For artist, artwork, and audience, the notion of "homeland" is redrawn, and questions buried in nationalism, patriotism, and immigration are awakened as simply "What is America?" and "Who is American?"

The chapters in part II focus upon two multimedia installation/performance art pieces, *San Diego Donkey Cart* (1986, mixed media, acrylic on wood, fence, barbed wire, 60 x 96 x 90 in.) by David Avalos and *The Border Door* (1988, door, frame, keys, mixed media, 7 x 3 x 5 ft.) by Richard A. Lou. Designed as public art, *San Diego Donkey Cart* was to be installed and exhibited in an open space outside of the downtown San Diego, California, federal courthouse and the offices of the Immigration and Naturalization Service (INS), an adjacent neighbor. From the *Donkey Cart Altar*, an intermediate-scale version in 1985 that appeared in the CARA exhibit, to *San Diego Donkey Cart*, our chapters discuss its evolution and emphasize the controversies in the piece's installation. The work itself appeared shocking—a repurposed tourist attraction garishly marked by symbolic reminders of racist stereotypes, unjust immigration policies, and cultural hegemony—but its removal from the site and its accompanying censure were even more provocative. Controversy and debates over censorship of the *San Diego Donkey Cart* proved a boon to publicity, if not for the work's actual visibility, for the artist and for the artwork's ideas. Traversing the same border region and arts scene, *The Border Door* also exists in several forms: an actual doorway erected in a striated borderland field as a performance; its installation as found art and mixed media; a photograph (1988, 10.5 x 14 in.) by Jim Elliott documenting the execution; and the door's replication within a museum-installed sequel, *Border Door Tunnel* (1988, photograph, mixed media, 36 in. x 36 in. x 30 ft.). Like *San Diego Donkey Cart's* public art initiative, *The Border Door* largely stands outside of the

sanctions of art institutions and draws significance from its in situ place-ment. If, as David Avalos says of his own work, *San Diego Donkey Cart's* use of the border acts "as a bridge," then, as Richard Lou says of his own work, *The Border Door* engages a "border phenomenon."

In his artistic statement *"San Diego Donkey Cart* Reconsidered," David Avalos stresses the role that public art might play among art, business, and federal bureaucracies. *San Diego Donkey Cart* disrupts the expectations that publicly accessible art should be primarily decorative, that it should avoid political agenda, and that it should uphold popular opinion; instead, its accessibility to wide and nonart audiences privileges the opportunity to incite meaningful conversations like those expected from social and political activist groups. Avalos's experience with student and community activism and arts organizations is, as he describes it, rich and varied, in-cluding notable positions on the Committee on Chicano Rights (CCR) and the *Voz Fronteriza/Border Voice* newspaper and with the San Diego–based Centro Cultural de la Raza and the Border Arts Workshop/Taller de Arte Fronterizo (BAW/TAF). Avalos's political and cultural viewpoints, in-formed especially by his familial and communal connections, inspirit *San Diego Donkey Cart* and its revelations of the contradictory impulses in American identity and citizenship. Avalos draws on similarities among the actual U.S.-Mexico national border, immigration policy, and art indus-tries as "gatekeepers," and his multimedia installation addresses significant shifts in their gatekeeping functions in mid-1980s America.

In her essay "A Remembered Dismemberment: David Avalos's *San Diego Donkey Cart*," Lynn Schuette writes from her perspective as cu-rator of the *Streetworks* project, which sponsored the *San Diego Donkey Cart's* installation at the San Diego federal courthouse. Schuette not only explains the finer points of curating this exhibit—even to the details of funding and obtaining permits—but claims, reflecting back almost three decades, that in the mid-1980s it marked a profound shift in American society and for American arts. Speaking from her curatorial experience, Schuette provides an overview of the role of regional galleries and alterna-tive spaces in the mid-1980s, where artwork could seek a more diverse au-dience, could address a broader range or more controversial spectrum of topics, and could figure social and political activism more tightly in its aes-thetics than traditional outlets allowed. Public funding, regional programs, alternative spaces, and public arts more generally shared certain goals and obstacles. As much as *San Diego Donkey Cart*, its artist, its curator, and its audiences all participated in this move toward egalitarianism through the arts, its experience of censorship and political intimidation renders it a

victim of the culture wars. We now know that public funding for the arts, even on as grand a scale as the National Endowment for the Arts (NEA), and regional programs would diminish or die outright over the intervening decades. As Schuette argues, *San Diego Donkey Cart* forecasted this shift.

In his visceral essay "*The Border Door*: Complicating a Binary Space," Richard A. Lou demystifies the very idea of an artist's statement; somewhere in between his own artistic "self-determination" and collaborative influences, Lou acknowledges that the artwork takes on a "life of its own." *The Border Door* invites a kind of life study, a passage back—like flipping through the pages of Lou's family photo album—and extends past his "rebirth" amid the community of artists at the Centro Cultural de la Raza, the awakening of his multiracial identity as Mexican, Chinese, and Chicano. From personal backstories and through the site-specific installation and performance, *The Border Door* extends into the museum space as the *Border Door Tunnel*. If crossing the border can be a transformative experience, then injustice at the hands of immigration officers yields a destabilized sense of self. If hope can act as transgression, then dissonance may reinforce humanistic values and basic human rights. If anger speaks as relentless intellectual muse, then it also betrays a bond in Chicana/o cultural expression hidden beneath social manners. *The Border Door* and Richard Lou, artwork and artist, complicate the binary spaces and offer thresholds for understanding.

Patricio Chávez, in his curatorial essay "Through *The Border Door*," examines the sites of *The Border Door* from performance act through installation to photographed and recontextualized imagery. Chávez argues that the simulations of *The Border Door* ideas subscribe to a procession of simulacra, and through this thoroughly deconstructive move, the artwork reveals "deeper human truths" and a "hyperreal" experience. In a much more grounded way, as well, *The Border Door* places the artist's personal and communal experiences within a larger communal consciousness, perhaps a doubled consciousness, and one that answers to specific issues related to empire—immigration, nationalism, war, racism, violence, and capital. Chávez's assessments of the performance piece and installation suggest its demonstration of tenets of the 1988 *Border Realities IV* exhibit at the Centro Cultural de la Raza in San Diego, of which it was a part through the BAW/TAF, and its historical significance to mid-1980s art culture and border arts more broadly.

Concluding part II, Guisela Latorre's critical readings in "Public Interventions and Social Disruptions: David Avalos's *San Diego Donkey Cart* and Richard Lou's *The Border Door*" recognize the sweep of public art

and site-specific work in the 1980s and their stimulation of political consciousness. If the traditional purpose of publicly accessible arts was to offer something benignly decorative and either apolitical or reflective of mainstream affairs, arts in the 1980s experimented with different topics and spatial issues within and outside of museum and gallery exhibitions; Avalos and Lou compound these experiments by instigating conversations in the public square specifically about immigration policy, border violence, and transnational politics. As assertive as their two sculptural pieces are, they effectively echo the growing militarization of the border, sanctioned through state apparatuses, thus segmenting those points of resistance held together and taken for granted. In the evolution from the *Donkey Cart Altar* (1985) to *San Diego Donkey Cart* (1986), the absurdity of the tourist attraction, generated around tourism and consumerism, is amplified by self-parody and heightened to a sense of secular worship. That *The Border Door* opens from Mexico to the United States in the middle of a borderland field replaces the notion of illegal crossings with open access, secured by material keys. Public access to these issues, self-consciously mediated as hyperrealities, discloses the communal experiences of the border and offers viewers participatory involvement. The greater the visibility is, the greater the potential significance of the artwork, even as the status quo may be offended or challenged. Latorre's careful critical analyses are bolstered by a scholarly history of the BAW/TAF and Avalos's and Lou's contributions to that group.

Part III features a pairing of bultos (three-dimensional spiritual imagery), *Dos Pedros sin Llaves* (Two Peters Without Keys) (1994, pine, acrylic, gesso, mixed media, 25 x 11.5 x 7.25 in.) by Luis Tapia and *St. Peter Is Imprisoned* (1998, mixed media, 15 x 17 x 11 in.) by Nicholas Herrera. These two artists and their tableaux sculptures at once both honor and update traditions of *santeros* (artists working with saint imagery) and Spanish, Spanish American, Hispanic/Hispano, and Nuevomexicano (New Mexican) religious folk art, reaching from the present back some four centuries. In their updates, especially around their incorporation of local resources and contemporary cultural expressions, *Dos Pedros sin Llaves* and *St. Peter Is Imprisoned* disclose several telling sites of resistance in and around the art and their artists. Notably, both Tapia and Herrera witnessed and engaged in late 1960s and early 1970s countercultural revolutions; they both found some commercial success in Santa Fe's Spanish Market; and both relieved themselves of certain traditional demands by leaving that market and steering into more inclusive conceptions of Chicana/o visual art in the 1990s.

In his testimonial essay "Thoughts on *Dos Pedros sin Llaves*," Luis Tapia formulates in an artist's statement, coauthored with trusted partner Carmella Padilla, one of the often overlooked "stories" commenting upon the "evolution of Chicano culture" and its reflection in treatments of Catholicism and community and family values in sculptural liturgical arts. Tapia admits that his art mirrors the "journey" of his life and creativity, but his aim through his sculptures is to share his perspective as artist with his audience. *Dos Pedros* emulates his struggle over identity and faith, but it forecloses upon the larger social struggles—for him and his audience—over the tensions of remaining involved, being denied involvement, and the forces in between.

In "Thoughts on *St. Peter Is Imprisoned*," artist Nicholas Herrera and coauthor and longtime friend Sallie Gallegos blend first-person testimonial and third-person reportage into a candid, even confessional, artistic statement. For Herrera, like Tapia, religion and spirituality inform both his life and his work. Documenting his past and present personal struggles, encountered in the faces of racist institutions, substance abuse, near-death vision, and more, Herrera instead sublimates familial and spiritual inspirations that feed his artistic endeavors. Amid all of these forces, though, Herrera points to the resistant elements of "controversy," its push and pull reminding us we are alive.

Tey Marianna Nunn injects curatorial expertise into her critical examination and historical placement of these two pieces in her chapter, "Pedro in the *Pinta*, Have You Seen My Keys?: Inside the Art of Luis Tapia and Nicholas Herrera." For Nunn, *Dos Pedros sin Llaves* and *St. Peter Is Imprisoned* stand as testament to a "vital cultural critique" of traditional art forms, especially as they update religious folk art. In their reinvention of santos, *Dos Pedros sin Llaves* and *St. Peter Is Imprisoned* honor the past while exonerating their artists' personal expressions and contemporary communal values. Humor, even biting satire, hinges the new to the old. These two sculptures afford profound transformations for both artists and their audiences according to Nunn's readings. Finding the keys to power serves as a trope in these two pieces, and although the answers are admittedly conjectural and their resolutions are professedly open-ended, the points of debate gain some accessibility.

Concluding part III, art historian Víctor A. Sorell's essay "The Persistence of Chicana/o Art: Contemporary *Santeros* Reinterpret a Traditional Santo" historically and culturally situates the two sculptures. *Dos Pedros sin Llaves* and *St. Peter Is Imprisoned*, Sorell proves, invite conversation with traditions on at least four planes—a santero tradition, the worldwide

and centuries-long making of saint imagery; Nuevomexicano and specifically American inclusions to santero traditions; Tapia's and Herrera's engagement with Chicano civil and social rights movements of the 1960s and 1970s; and the two artists' engagement in more recent issues since the mid-1970s. For Sorell, Tapia's and Herrera's works of art enact the offering, la ofrenda, of spiritual inspiration and invite participation through call-and-response devices for their audiences. Perhaps most telling, the incorporation of tattoo imagery inverses profane-sacred dichotomies as points of resistance and, thus, is emblematic of guardianship and transcendence. Finally, through an epigraphic statement by the late Chicano artist José Montoya, readers are reminded that the origins of Chicana/o art owe something to the santero tradition and to *pinto* (prisoner) art itself.

Part IV pays tribute and due respect to artist Luis Jiménez and focuses particular attention on his last sculpture, posthumously completed after his tragic death in 2006 and installed as *Mesteño/Mustang* (2008, steel, fiberglass, paint, 32 ft.) on the grounds of Denver International Airport in Colorado. The mustang sculpture rears on hind legs, its blue coat and glowing eyes proving particularly attractive and detractive, given the contentious background on this piece. No small controversy has swirled around Jiménez and his artwork in the years leading up to and following his death, several key aspects of which highlight precisely the pressure points of resistance in Chicana/o cultural expression, debates over the role of public art, and notions of authorship and artistic integrity. As a starting point, part IV reprints a brief excerpt from the 1994 *Man on Fire* exhibition catalog in which Jiménez explains his hopes to devise a project that reflects his "agenda" while garnering community favor as public art. Jiménez had hoped to pay special tribute to the Appaloosa mustang, for him a symbol of America's multicultural lineage and the unbridled power of nature. An editorial note follows, acknowledging that the sculpture is not visually represented as illustration in part IV, a striking reminder of the controversial—and arguably political—nature of public art agendas. Nevertheless, a vibrant portrait by Jiménez's friend and fellow artist Gaspar Enríquez offers one presence of the artist.

In "*Rearing Mustang*, Razing *Mesteño*," Delilah Montoya, peer artist and Luis Jiménez's compañera, provides rare and sensitive insight as well as a careful delineation of the events surrounding the creation of Jiménez's artwork and his efforts on this last sculpture. With no small grain of testimonio, Montoya argues that the drive of Jiménez's creativity may be seen metaphorically as the crossing of borders. The sculptures Jiménez is best known for embrace paradoxical elements of public and private issues,

history, and family background. Communal politics butt against private affairs; and his aesthetics and style remain uniquely daring and evocative, even as they often encroach on commercial aims and a community-based public scene. His artwork travels the frontiers and crosses the boundaries separating seemingly oppositional terms. For Jiménez collectivism, especially drawn around a philosophical notion of a community-based collective unconscious, as Montoya explains, informs several of the kinds of resistance that Chicana/o visual arts and cultural expression proffer in the twenty-first century, related to but departing from the notions of resistance endemic to late 1960s counterculture.

As the title of her essay, "Kindred Spirits: On the Art and Life of Luis Jiménez," reveals, Ellen Landis shares her perceptions on Luis Jiménez's life and art as a curator as well as a longtime friend and confidante of the artist. As a friend Landis helped Jiménez celebrate his many successes, and her curatorial guidance and consolation met Jiménez's distress over several controversies; her chapter reflects this privileged insight into his artistic processes and the aesthetic decisions that supported his public arts program. Landis delivers readers through a tour of select sculptures among Jiménez's most significant and highlights several key aspects worthy of critical examination in *Mesteño/Mustang*.

In his chapter "Occupying a Space Between Myth and Reality: The Sculpture of Luis Jiménez," Charles R. Loving, curator, art historian, and scholar, continues the virtual tour of the artist's work. Loving's readings signal elements of "protest" in the sculptures that Jiménez as artist, as well as his varying audiences, attune to and react against. The signature elements across the body of Jiménez's artwork specify precisely points of resistance amid debates and appraisals of *Mesteño/Mustang* and over the course of Jiménez's career.

Part V features Mel Casas and his *Humanscapes* series of paintings. Casas discusses his paintings, the importance of his teaching experiences, his inspiration, and his artistic processes in an interview compiled from 2008 telephone conversations with Chicano art historian Rubén C. Cordova, and he specifically examines the social and political thrusts of the series. The *Humanscapes* consist of 153 paintings that were made from 1965 to 1989 (typically acrylic or oil on larger-than-life-sized canvases), and the series possesses a holistic quality that not only reflects the artist's progressions and shifting inclinations but more crucially marks an evolution in politically inspired visual arts and Chicana/o cultural expression over these decades. Casas notes that while several parts of the series speak directly to civil rights and social movements, the *Humanscapes* organically

grew out of this and into larger contexts. Somewhat surprisingly, Casas claims that his series does not articulate specifically Chicano politics but rather is "totally confrontational." That the series represents confrontation probably as much as it enacts similar forms of confrontation draws on larger questions about and differing strategies of resistance in Chicana/o visual arts and cultural expression. Cinematic qualities—including references to film aspect ratio, large-screen scale, montage theory, even the use of subtitles—as well as the barrage of pop-culture references, mainstream-commercial markers, and thematic treatment of competing histories and myths address a wide audience, even as each individual painting's acrylic-on-canvas materiality is never ignored. Casas confesses to the ambiguities, deliberately conflating audiences and the ways that viewers may look at, look through, and look from within the paintings that make up the series to complicate the social and political functions of his art.

Following the 2008 interview, part V includes reprints of two of Casas's writings, "Brown Paper Report" and "A Contingency Factor." "Brown Paper Report," originally "born" in 1971 and published in 1975 in *La Movida Con Safo*, an extension of the artist collective to which Casas contributed, reads initially as a displaced glossary, defining terms relevant to Chicana/o politics. "A Contingency Factor" first appeared in a Con Safo exhibit brochure in 1972 and was reproduced in *La Movida Con Safo* in 1975, and it too brings attention to its own language and form as pronouncements. For Casas and his collaborators, both documents likely served in some fashion as aphoristic artistic statements and manifestos in the early 1970s; now, they encase those terms of debate as in a time capsule and invite comparisons with later conversations on the *Humanscapes* series and Chicana/o visual arts.

Concluding part V is Rubén C. Cordova's own essay "Getting the Big Picture: Political Themes in the *Humanscapes* of Mel Casas." Cordova's chapter merges curatorial and critical perspectives on the *Humanscapes* series; moreover, it invents a "virtual exhibition" of key paintings, demonstrating and analyzing social and political themes alongside their predominant formal devices and aesthetics. Through eight groupings of paintings he surveys key movements within Casas's aesthetics and across the earliest period of his *Humanscapes* series, 1968 to 1977, inviting readers into an imaginary gallery space and the activities of curating and reading. Cordova's particularly close attention to cinematic aspects of several *Humanscape* paintings discloses the relationship a spectator may have to a visual art text, revealing how Casas as artist and *Humanscapes* as artwork dismantle configurations of spectatorship. Cordova's readings of references—to

Nixon-era politics, Chicano Moratorium protests, farm worker strikes, and similar 1960s and 1970s social and civil rights movements—show how Casas over time has lifted these historically placed events out of their original contexts and resituated them for an expanded political program. Cordova's reading of *Humanscape 62 (Brownies of the Southwest)* (1970, acrylic on canvas, 72 x 96 in.), for example, addresses the social politics of stereotypes, where the term "brownies" alludes simultaneously to popular junk food, junior Girl Scouts, indigenous American representations, Mesoamerican myth, modern Mexican culture, and the Frito-Lay advertisements with the Frito Bandito character. Cordova recognizes that Casas's references—while admittedly cryptic or ambiguous at times, and at times simultaneously scathing and playful—redress the role of political themes in Chicana/o visual arts and cultural expression and beyond. Cordova's essay allows readers to access some of these resistant processes. In the "virtual exhibition," *Humanscape 62* and its myriad uses of "brownies" fit alongside *Humanscape 63 (Show of Hands)* (1970, acrylic on canvas, 72 x 96 in.) and *Humanscape 68 (Kitchen Spanish)* (1973, acrylic on canvas, 72 x 96 in.), among others in the *Humanscapes* series with their corresponding multiple allusions, and this combination reminds readers that engaging them in juxtaposition—through critical and curatorial perspectives—replaces the more specific referential contexts with "totally confrontational" political arguments, even if admittedly conjectural and ambiguous in interpretation.

Part VI centers on two photographic narrative series, *My Alamo* (1995, series of 12 images: 6 pairs of hand-colored silver gelatin prints and mixed media, each photograph 20 x 16 in.) by Kathy Vargas and *El Corrido de Happy Trails (Starring Pancho y Tonto)* (1995, 8 silver gelatin prints, each photograph 16 x 20 in.) by Robert C. Buitrón. Both series first appeared in the *From the West: Chicano Narrative Photography* exhibition in 1995, curated by Chon Noriega, and in the catalog, coedited by Jennifer A. González. As photographic narratives, these two series place "real" and "ideal" sources of information in conversation and contest with one another, a particularly provocative approach, as they incorporate popular material culture and commercial cinema references into imagery that redresses myths of American identity and conceptions of the West. Both series interject subversive humor and satire as part of this address and their aesthetic-political strategy.

In her artistic statement "Revisiting *My Alamo*," Kathy Vargas discusses the pressures on and opportunities for her creative process that came with her producing the *My Alamo* series as a commissioned piece; she

admits to balancing the aims of the external assignment with her own internal motivations. Vargas also compares a previous commission with *My Alamo*, disclosing in some respects her evolving character as an artist. For Vargas, the Alamo serves as an icon and legend that she may revisit as one may reminisce over family photos. Inspiration from her mother, other family members, friends, and their family members align with her treatment of popular-culture references; the results combine documentary impulses with reanimated and staged events and blend sacred and secular themes. Kathy Vargas enters "her" Alamo as part of a generational statement, but she likewise invites her audiences to extend the generational conversations.

Robert C. Buitrón, in his artistic statement "*Malinche y Pocahontas, Breaking out of the Picture*," discusses his photographic series *El Corrido de Happy Trails (Starring Pancho y Tonto)* and places special emphasis on his intent in one image from the series, *Malinche y Pocahontas contando la historia de Pancho y Tonto*. The artist remembers that popular culture, especially Hollywood movies and mainstream television shows, influenced his childhood views and earliest formations of an American cultural identity. TV Westerns' "old frontier" matched up with President John F. Kennedy's espousal of a "New Frontier," both reaching back to Manifest Destiny and a frontier ethos. As an artist, Buitrón uses image-based narratives to update those formative histories and myths. Humorous, staged retellings not only contest the tried-and-true narratives but place distance between the memory, the media, and the messages, allowing viewers to consider those as points of resistance along the way to interpretation and entertainment. In *Malinche y Pocahontas contando la historia de Pancho y Tonto*, modern-day Latinas enact the scandal of their iconic counterparts, deflating it to a coffeehouse chat session.

Chon A. Noriega enters into this conversation an excerpt from his curatorial statement from the exhibition *From the West*, which commissioned both Vargas's and Buitrón's photographic series. In the "From 'Many Wests'" passage, Noriega deposes the typical binary-oppositional values of the West (especially around histories of the place) and the Western (genre) and calls attention instead to uses of "geopolitical space" to help us better understand the operations of both. Considering "the West" and its bordered, nation-state aspects allows a new view of American communities and cultural systems as well as the discourse and character types that have tried to reflect them. Noriega's argument demands attention on its own, but crucially it also frames the curating process of the *From the West* exhibit and, particularly, Vargas's and Buitrón's photographic series.

In her essay "Topographies of the Imaginary: Kathy Vargas's *My Alamo* and Robert C. Buitrón's *El Corrido de Happy Trails*," Jennifer A. González informs her critical readings of these two photographic series with scholarly expertise on curation that considers the use of exhibition space, public-private spaces, and virtual space. If memory offers a psychic construct of a past event marked in time and place, Vargas and Buitrón utilize a "photographic memory," González argues, that collapses time and space; the temporal arrest and the landscape imagined provide a remarkable presence for viewers of these two photographic narratives. Viewers identify not just with "countermemories" but with the interrelationships among acts of remembering and real, personal, and artificial sources of information as they are bound into the media of narrative photographic art. Vargas, largely more autobiographical in approach, and Buitrón, drawn to popular-culture references, both level American icons, from the Alamo to Malinche and Pocahontas. These two series, as a result, map social and ideological associations of mainstream, commercial, and popular culture with American myths and history.

Asta Kuusinen's meditative essay "Where *Carnales* Were, There Shall Unprodigal Daughters Be: Kathy Vargas's *My Alamo* and Robert C. Buitrón's *Malinche y Pocahontas*" concludes part VI. Beyond complicating the representations possible for American nationhood and a grand American historical narrative, these two photographic narrative series, in Kuusinen's critical estimation, also treat the more intimate, less readily available, but equally crucial elements of *la familia*, the idealized Mexican American family, and its definitive associations. Subversive humor and satire reinforce the manner in which gender trouble, class clashes, and the dynamics of family echo the larger narrative revisions for Buitrón and Vargas. And *My Alamo* and *El Corrido de Happy Trails* reflect the manner in which Chicana/o visual arts participate in the grand narrative revisions, investigating multiple directions of resistance while avoiding dialectical models of explanation and counterstance.

Part VII revolves around Willie Varela's *This Burning World* (2002, 2-channel, color and black-and-white video and sound installation, 30 min.), which first appeared as part of his larger exhibition, *Crossing Over*, along with three video sculpture pieces and a series of photographs. Although Varela's film and video work has been screened in several of the most prestigious venues in the United States, including the Whitney Museum of American Art and the Museum of Modern Art, his work remains frequently overlooked in both experimental cinema scholarship and Chicana/o cultural studies, and he had yet to see the opportunity to create

a video art installation before *This Burning World*. With Carter McBeath's soundtrack, Varela's *This Burning World* presents to viewers a dizzying array of images, some shot by the artist and others either included as found footage or reshot from an eclectic array of source material. Like practically all of Varela's artwork, *This Burning World* speaks to Chicana/o cultural expression but denies adherence to it; it references the avant-garde aesthetic of personalism but refuses to be restricted by it; it borrows techniques from formalist experimental cinemas, but it travels more widely than that. The personal and political connections exist in *This Burning World* but rarely in ways that conform to viewers' expectations or industry prescriptions.

"A Conversation with Willie Varela and Scott L. Baugh" combines interview material between Varela and Baugh from 2003 conversations in El Paso, Texas, with follow-ups roughly five years later by telephone and e-mail. Varela provides insight to his design of the piece as a video art installation, and he claims that the artwork and its meanings reflect the venue, particularly with respect to scale of the image and spatial arrangement of the pieces. This mutability proves a benefit rather than a detriment to the piece or threat to the artist. Moreover, Varela explains that his use of two channels, two cinematic streams of information appearing side-by-side within a single frame, increases the options he may have in combining imagery; and yet, rather than adhere to principles of narrative or continuity, *This Burning World*'s imagery frequently provides its viewers dissonance, a storm of information, and multiple viable readings. Its double-channel montage places perhaps even greater pressure on questions of synthesis than commercial fictive-narrative cinema typically imparts. Resistance is endemic to his art, Varela proclaims, but whether it is fed with anger or a motivation that comes from "something deeper" determines the power of the work.

As curator of videos for the *Crossing Over* exhibit, Kate Bonansinga offers in her essay "In *This Burning World*, Willie Varela Resists" an extension of several key issues detailing its status as video art installation. In describing the spatial arrangement of the exhibit in El Paso, Bonansinga admits that photography and video sculptures filled one room, but in the room with *This Burning World* playing on a large screen as a looped text, "another world entirely" existed. *This Burning World* absorbed its exhibition space and proved daunting to many of its viewers, mostly as it defied their mainstream-inscribed expectations of what cinema can do or be. Varela resists categorization as an artist, and his work rejects any easy inclusions or descriptions. Although Varela's most productive years coincided with a predominance of nationalism in Chicana/o arts, as suggested by

Bonansinga, Varela instead forecasted by certainly a decade postnationalist interests in global issues and the widest possible range of aesthetics. Varela's personal and political affiliations with the border, particularly with the El Paso-Ciudad Juárez metropolis, carries into his visual arts; in *This Burning World* and other videos, films, and photographs, viewers may recognize a paradoxical ubiquity and erasure of the frontier space and border-crossing acts. *This Burning World* as video art installation conveys connections and disconnections, understandings and misunderstandings, but its relentless chaos is not meaningless or insignificant by a far cry.

In his critical appreciation "Sense and Sensibilities: Discontinuing Conventions in/for Willie Varela's *Burning World*," Scott L. Baugh places particular emphasis on the nonlinear montage and disrupted narrative that *This Burning World* presents its viewers. A close reading of an exemplary sequence of the text and technical description of its shots over this period lend readers some ideas about the eclecticism and graphic nature of the imagery in this video art piece, overviews its dis-continuity and cryptic code, and resolves in ambiguity and assured conjecture over its possible meanings. Viewers may be left with questions about its meanings rather than definitive interpretations, but *This Burning World* succeeds as it leaves its viewers with a sense of awakening, a heightened awareness of its images as images, its media as media.

The chapters in part VIII feature *Señorita Extraviada* (2001, in Spanish and English with English subtitles, color Super 16mm film and digital video, 74 min.), an experimental documentary, produced and directed by Lourdes Portillo and distributed by Women Make Movies, that treats the issues of femicide along the Mexican-U.S. border. The title may be translated as "a missing young woman" or "a young woman disappeared." In the years between 1993 and 2001, when the film was made, hundreds of women and teenaged girls were victims of horrific violent crimes — they were abducted, raped, and murdered, their mutilated bodies with just scraps of clothing strewn in the desert borderlands outside El Paso, Texas, and Ciudad Juárez in Chihuahua, Mexico. As the documentary title suggests, these missing young women were lost, made "disappeared," from their families and friends and discarded by society. What is at stake in these cases is the very presence of personhood, the worth of a human life against competing forces of cultural and corporate globalization. Portillo's documentary techniques problematize the traditional notions of objective and subjective information as they may be mediated in cinema. In the subsequent decade the number of victims, tragically, has steadily increased, and the criminal investigations have yielded no resounding solutions. The

film is a paradigmatic example of visual sociology, a documentary work embedded within a sociological context. The activist charge of *Señorita Extraviada* offered a powerful intervention at the turn of the century, and its impact continues to be felt.

Lourdes Portillo, in her artistic statement "Tracking the Monster: Thoughts on *Señorita Extraviada*," describes her experience with the experimental documentary as a "journey." This journey was initiated by the sorrow of seeing murders starting in the early 1990s go largely unnoticed; one that took four years of meeting with family and friends of the murdered young women and two years to record; and a journey that continued as the documentary traveled throughout festivals and international screenings in years to follow. The film received numerous accolades, including a Special Jury Prize at the Sundance Film Festival, but Portillo focuses upon the documentary's ability to bear "witness to effect change" and its dialogue with organized human rights and women's rights activism. Portillo points to the collaborations in making the film and to the participatory action in the meanings of the film, recognizing that "journalistic objectivity" traditionally associated with the documentary genre could not combat adequately the "fetish for power" at the root of the disappearances. Before *Señorita Extraviada*, the public mostly had been silent about the murders and possibly silenced by fear, threats, or bribery; the media sensationalized coverage of the murders and treated the story as a mystery for macabre entertainment value; government and law officials on both sides of the border frequently chose to look the other way or reside in ineffectiveness; corrupt institutions may have been complicit or may even have gained from the horrific events and their cover-up. Portillo explains her artistic strategies to restage the surviving family members' testimony alongside visual reminders of the young women when they were alive, to put "a face" to their suffering.

In her analysis of Portillo's documentary film, "Between Anger and Love: The Presence of *Señorita Extraviada*," Bienvenida Matías, informed by her own experiences as a filmmaker and her service to numerous boards, including the National Association of Latino Independent Producers (NALIP) and Women Make Movies, offers keen insight to funding pressures, distribution mechanisms, and the inherent challenges facing women-of-color filmmakers more broadly and Lourdes Portillo more specifically. Matías recounts how a filmmaker finds her voice in making a film in order to lend it to the voiceless, and this was exemplified during one speaking engagement by Portillo for the release of *Señorita Extraviada*, in which her audience, made up of peer artists and younger

students, was incited by an activist charge. Matías carries this argument into her careful critical remarks on the documentary, observing that the film gives voice to "women invisible in society." Matías's readings specify key issues for the film's young women subjects and their families—working-class issues, sex crimes, and the deeply felt suffering. In between the love and anger, however, in between these points of resistance, *Señorita Extraviada* replaces their disappearance with a renewed presence of the young women and affords renewed dignity for their survivors and the documentary's audiences.

In "The Eye of Pain/*El Ojo del Dolor*," poet and peer artist–activist Claire Joysmith emulates key movidas in *Señorita Extraviada*'s Spanish-English bilingualism and generic experimentation. Joysmith's essay, offering its own bilingual and concurrent transcultural dialogue, ruminates on the film's venture into neighboring literary arts—as an "ode to vulnerability" with referential esteem for the Virgin Mary, as a cinematic poem of solidarity, and as a testimonio with its "act of witnessing." If a reinvigorated presence survives in between love and anger for Beni Matías, then for Claire Joysmith it is created between the heart and the camera. Joysmith sensitively ascribes to Lourdes Portillo a "Chicana sensibility"—born of the borderlands, endlessly crossing boundaries, and bearing witness to suffering—out of which a piece of artwork like *Señorita Extraviada* may arise. As spectators, Joysmith concludes, we find ourselves face to face, cara a cara, with the multiple wounds, *las multiples heridas*, of this sensibility and are spurred to act.

Concluding part VIII, Mónica F. Torres argues in her essay "Resisting the Violence of Values: Lourdes Portillo's *Señorita Extraviada* as Performative Utterance" that the documentary's cinematic discourse "re-presents" the young women disappeared by the murderous acts. With careful comparisons to Portillo's *The Devil Never Sleeps* (1996), her critically close reading of several key shots from *Señorita Extraviada* reveals how several aspects of the documentary transcend conventional application; particularly the reanimation of still photographs as documents and interview as testimonial narration, considered within postmodern contexts, incur tensions over the instability/stability of speech and the photographic image. The presence of the young women in *Señorita Extraviada* certainly urges the viewer to see that the dismissed women cannot be dismissed again; moreover, it privileges particular types of knowledge that, too, have been dismissed and reprioritizes these. Torres's readings accentuate and counteract the prevailing acceptance of the "disposability" of a human life, especially a Mexicana life in American society.

Our last chapters, which make up part IX, give attention to the television series *Resurrection Blvd.*, a family drama that ran on Showtime for fifty-three episodes over three seasons (2000–2002), and consider it at one end of a timeline with the television documentary *Yo Soy Chicano* (1972, Spanish with English subtitles, 16mm color and black-and-white film, 60 min.) at the other. Spanning this timeline is the film and television work of Jesús Salvador Treviño, which can be described as nothing less than revolutionary. Treviño wrote and produced *Yo Soy Chicano*, composed of 16mm footage, animation, and rare archival material and funded by Southern California public television station KCET; airing in 1972, it became the first nationally broadcast documentary about Mexican Americans. Almost three decades later, *Resurrection Blvd.* aired on premium cable television as the first nationally broadcast drama series about a Latino family in English, and over its three seasons it stands as the longest running series written, directed, and produced by Latinos. Produced through Patagonia House and by show runner Dennis Leoni, *Resurrection Blvd.* surely helped pave a way and prove there was a market for subsequent Latino-themed family television series, namely, *The Garcia Brothers* (2000) and the highly acclaimed *American Family* (2002, 2004). The ties of *Resurrection Blvd.* to the television industry, the Directors Guild of America (DGA), the Writers Guild of America (WGA), and NALIP cannot be overlooked. Hollywood mavericks, Leoni and Treviño cocreated a two-hour *Resurrection Blvd.* TV movie that served as the show's pilot; they got a green light to go to series; Leoni served as executive producer throughout the series and wrote many episodes, and Treviño directed and served as a producer over many episodes. Rather than exclusively reading themes and formal devices of the show, however, the chapters in part IX acknowledge the historical dimensions across these two shows, their production, as landmarks for Chicana/o visual arts and cultural expression, the beginnings of an ongoing story of resistance.

In his incisive essay, "From *Yo Soy Chicano* to *Resurrection Blvd.*, Thirty Years of Struggle," Jesús Salvador Treviño offers a unique perspective on and insider's view of representation issues in mainstream U.S. film and television industries. Treviño begins by outlining the dismal numbers of Latino writers, directors, and producers working in Hollywood over decades and discusses how the underrepresentation behind the screen accounts for traditions of misrepresentation and stereotypes on the screen. A generation of activists in the late 1960s and early 1970s began bringing about change—admittedly slow change but gradual progress, which Treviño describes as a "struggle." Inroads were found through grants and

public-television funding and distribution, but commercial cinema and mainstream television offered greater parameters of change, wider audiences, and fuller potential. A marked shift from nonfiction and news programming to fictive narrative equally opened doors. Treviño not only chronicles this decades-long revolution, a revolution in arts as well as in cultural expression and society at large, but also enacts that progressive change as an activist and one of the most prolific Chicano media artists. In recounting the details of making *Yo Soy Chicano*, Treviño glimpses back to where Chicana/o media arts came from; and in describing the accomplishments of *Resurrection Blvd.*, he peers into the future.

"A Conversation with Dennis Leoni and Christine List" draws on 2007 telephone conversations between *Resurrection Blvd.* cocreator and executive producer Dennis Leoni and film scholar Christine List. Leoni claims that there is an activist agenda to the show, but it is one less infused with a strident Chicana/o nationalism or defiant posture and more inclined toward a "sensibility of tolerance" and expressions of American multiculturalism. Ultimately, for Leoni, collectivism provides the greatest strength. For example, decisions on the casting of the protagonists, the members of the Santiago family, emphasized Latino representation and speak to the unity among all Latinos and the larger patterns of American society. The Santiago family frequently suggests a kind of microcosm of American society, each member voicing an extreme political and cultural expression. Eclectic music and style choices for the soundtrack also mirror the diverse options throughout American culture. Leoni did not want to set the story in contemporary East Los Angeles, but, as he points out, that was a lost battle and one he remains somewhat conflicted over, as some other setting might have short-circuited some stereotypical associations. Bilingual dialogue, too, spurred debates. Among the many glowing victories of the franchise, Leoni proclaims, was the addition of writers and directors to the industry guilds, including Chicana documentary pioneer Sylvia Morales, who directed episodes of *Resurrection Blvd.* and whose success reflects aspects of Treviño's three-decade struggle. Leoni provides candid remarks about the importance of demographics, marketing and promotion, and the business decisions involved in making commercial art out of Latina/o cultural expression.

"De-Essentializing Chicanismo: Interethnic Cooperation in the Work of Jesús Salvador Treviño" by Juan J. Alonzo concludes part IX. Alonzo carefully blends scholarly and production-history approaches as his chapter retraces several steps of the path from *Yo Soy Chicano* to *Resurrection Blvd.* Treviño's earliest success in cinema met contextual demands during

the emergence of Chicana and Chicano cultural movements. *Yo Soy Chicano*'s politically conscious aesthetic energized in the early 1970s and continues to energize even decades later its audiences' notions of resistance toward affirmation. By the middle of the 1980s, however, Treviño found himself limited in or removed entirely from film and television opportunities. Alonzo rightly points out that this too is emblematic of obstacles facing Chicana/o media artists employed in entertainment industries. Treviño's overwhelming success in directing and producing commercial fare proves all the more remarkable as he manages to retain much of the activist charge of his earliest work. The constant aim is for greater, fairer representation behind the camera and on the big and small screens, and the consistent message delivered across these thirty years and more of cinema work is for justice and authenticity. Alonzo's reading highlights the hinge points of resistance that may be located in Treviño's career up through *Resurrection Blvd.* The span of Treviño's career, from the landmark *Yo Soy Chicano* through the notable accomplishments of *Resurrection Blvd.*, reveals the potential for moving beyond essentialist considerations of Chicana/o visual-cultural expression.

Notes

1. Attributed variously to Cheech Marin and to Tommy Chong, referring to their own comedy team, Cheech and Chong. See, for example, the production notes for *Nice Dreams* (1981), which was scripted by the team and directed by Chong.

2. Nietzsche's conception of "the will to power" in some respects establishes this multiply directed view of resistance (1968). Foucault, too, claims that resistant power may derive from the very power it opposes ([1975] 1979). Foucault, following Nietzsche, notably initiates reconsiderations of power both theoretically and socially applied.

3. Foucault famously describes these sites of resistance and counterresistance as "a multiplicity of points of resistance"; they are all dependent upon a "strictly relational character of power relationships" within a "sphere of force relations" ([1976] 1978, 95–97).

4. Following Foucault's conception of resistances, in some key respects, Judith Butler (1997) suggests that while resistances exist in material ways through the language one may use or the form and performance of an expression, the complex plays of resistances exist precisely as a result of the instability of the meanings of those texts. That is, resistances may arise in discursive forms as the creator and receiver of a message negotiate the meaning and content of that message. Also owing to Foucault, Roger Bartra distinguishes between "real" networks of power, such as those that guide social circumstances, and the "imaginary" sites of power, which may be masked but all the more influential. A process of mediation, for Bartra, can "bridge" these two spheres of

power dynamics at the same time it "blurs" all-important "antagonistic contradictions" among them (1992, 9–13).

5. T. S. Eliot's famous essay on poets and literary tradition, "Tradition and the Individual Talent," offers an analogy. Eliot refutes the romantic notion that literature—or art—favors indiscriminate change; rather, literature and art succeed precisely as their innovations honor and implement accepted traditions. The profound results of this view of change in arts complicate how the old and the new combine and compete with one another in arts ([1919] 1975).

6. James C. Scott's thorough explanation of masks and private against public transcripts in what he calls the "arts of resistance" proves especially useful on these points (1990).

7. From Tomás Ybarra-Frausto's remark during an interview with Alicia Gaspar de Alba on March 5, 1993. Please see Gaspar de Alba's *Chicano Art Inside/Outside the Master's House* (1998, 218).

8. Acuña's history undergoes significant revision following the first edition and through numerous subsequent editions, the title reflecting this change as *Occupied America: A History of Chicanos*, displacing a key resistant term of "struggle."

9. Readers may consult particularly noteworthy scholarship by Juan Gómez-Quiñones (1990), Rosaura Sánchez (1995), Miguel Montiel (1970; 2009), Octavio Romano-V (1969), and Ignacio García (1997), among others. Among recent scholarship on diversity in education, readers may consult "resistance theory" (Talavera-Bustillos and Solórzano 2012).

10. *El Plan Espiritual de Aztlán* was originally published in the New Mexican activist newspaper *El Grito del Norte* in 1969 but is more widely available as reprinted in the 1972 *Aztlán* anthology edited by Luis Valdez and Stan Steiner. Occasionally attributed to Chicano writer Alberto "Alurista" Urista—author of the plan's preamble—the more frequently accepted and cited author is Rodolfo "Corky" Gonzales. Additionally, Colorado-based Chicano visual artist Emanuel Martínez contributed to subpoint 6 (subsumed under *El Plan*'s point II, "Organizational Goals"), which addresses cultural values and urges La Raza to "insure that our writers, poets, musicians, and artists produce literature and art that is appealing to our people and relates to our revolutionary culture"; see Sorell (1995) for further discussion.

11. Stephen F. Eisenman reminds readers that, despite disciplinary avoidances of the subject in the past, art history's historical approaches to race—along with "a whole confluence of social, cultural, and economic inequalities" typically justified by racism—in visual arts and cultural expression yield "the potential to make signal contributions to our emerging understanding of the form and meaning of racism" (1996, 603–4). Readers may consult provocative scholarship on this intersection of topics by Jacqueline Francis on "racial art" (2012) and by Ella Shohat and Robert Stam on Eurocentrism in multimedia arts (2001).

Bibliography

Acuña, Rodolofo. 1972. *Occupied America: The Chicano's Struggle Toward Liberation.* San Francisco: Canfield.

——. 2010. Occupied America: A History of Chicanos. 7th ed. New York: Pearson.

Aldama, Arturo J. 2002. "Millennial Anxieties: Borders, Violence, and the Struggle for Chicana and Chicano Subjectivity." In Decolonial Voices: Chicana and Chicano Cultural Studies in the 21st Century, edited by Arturo J. Aldama and Naomi H. Quiñonez, 11–29. Bloomington: Indiana University Press.

Aldama, Arturo J., and Naomi H. Quiñonez. 2002. "¡Peligro! Subversive Subjects: Chicana and Chicano Subjects in the 21st Century." In Decolonial Voices: Chicana and Chicano Cultural Studies in the 21st Century, edited by Arturo J. Aldama and Naomi H. Quiñonez, 1–7. Bloomington: Indiana University Press.

Anzaldúa, Gloria. 1987. Borderlands/La Frontera: The New Mestiza. San Francisco: Aunt Lute Books.

Arteaga, Alfred. 1997. Chicano Poetics: Heterotexts and Hybridities. New York: Cambridge University Press.

Bartra, Roger. 1992. The Imaginary Networks of Political Power. Translated by Claire Joysmith. New Brunswick, NJ: Rutgers University Press.

Bloom, Lisa. 1999. "Introducing With Other Eyes: Looking at Race and Gender in Visual Culture." In With Other Eyes: Looking at Race and Gender in Visual Culture, edited by Lisa Bloom, 1–16. Minneapolis: University of Minnesota Press.

Butler, Judith. 1997. Excitable Speech: A Politics of the Performative. New York: Routledge.

Calderón, Héctor. 2004. Narratives of Greater Mexico: Essays on Chicano Literary History, Genre, and Borders. Austin: University of Texas Press.

Calderón, Héctor, and José David Calderón, eds. 1991. Criticism in the Borderlands: Studies in Chicano Literature, Culture, and Ideology. Durham, NC: Duke University Press.

Eisenman, Stephen F. 1996. "Triangulating Racism." Art Bulletin 78, no. 4: 603–9.

Eliot, T. S. [1919] 1975. "Tradition and the Individual Talent." In Selected Prose of T. S. Eliot, edited by Frank Kermode, 37–44. New York: Harcourt Brace Jovanovich.

Foucault, Michel. [1975] 1979. Discipline and Punish: The Birth of the Prison. Translated by Alan Sheridan. Harmondsworth, UK: Penguin.

——. [1976] 1978. The History of Sexuality. Vol. 1, An Introduction. Translated by Robert Hurley. New York: Pantheon.

Francis, Jacqueline. 2012. Making Race: Modernism and "Racial Art" in America. Seattle: University of Washington Press.

García, Ignacio. 1997. Chicanismo: The Forging of a Militant Ethos. Tucson: University of Arizona Press.

Gaspar de Alba, Alicia. 1998. Chicano Art Inside/Outside the Master's House: Cultural Politics and the CARA Exhibition. Austin: University of Texas Press.

Gómez-Quiñones, Juan. 1990. Chicano Politics: Reality and Promise. Albuquerque: University of New Mexico Press.

Hicks, Emily. 1991. Border Writing: The Multidimensional Text. Minneapolis: University of Minnesota Press.

Higham, John. 2001. Hanging Together: Unity and Diversity in American Culture. New Haven, CT: Yale University Press.

Hollinger, David. 2006. Postethnic America: Beyond Multiculturalism. 6th rev. ed. New York: Basic Books.

King, Martin Luther, Jr. [1967] 1990. "Where Do We Go from Here?" In *A Testament of Hope: The Essential Writings and Speeches of Martin Luther King Jr.*, edited by James M. Washington, 245–53. New York: Harper.

Marrero, María Teresa. 2000. "Out of the Fringe? Out of the Closet: Latina/Latino Theatre and Performance in the 1990s." *Drama Review* 44, no. 3: 131–53.

Martínez, Elizabeth. 1998. *De Colores Means All of Us: Latina Views for a Multi-Colored Century*. Cambridge, MA: South End.

McCaughan, Edward J. 2012. *Art and Social Movements: Cultural Politics in Mexico and Aztlán*. Durham, NC: Duke University Press.

McLuhan, Marshall. 1951. *The Mechanical Bride: Folklore of Industrial Man*. New York: Vanguard.

———. 1964. *Understanding Media: The Extensions of Man*. New York: McGraw-Hill.

Mitchell, William J. Thomas. 1986. *Iconology: Image, Text, Ideology*. Chicago: University of Chicago Press.

———. 1994. *Picture Theory: Essays on Visual and Verbal Representation*. Chicago: University of Chicago Press.

Montiel, Miguel. 1970. "The Chicano Family: A Review of Research." *Social Work* 18, no. 2: 22–31.

Montiel, Miguel, et al. 2009. *Resolana: Emerging Chicano Dialogues on Community and Globalization*. Tucson: University of Arizona Press.

Moraga, Cherríe. 1983. Foreword to *This Bridge Called My Back: Writings by Radical Women of Color*, edited by Cherríe Moraga and Gloria Anzaldúa. 2nd ed. New York: Kitchen Table.

Nice Dreams. 1981. Directed by Tommy Chong. Columbia Pictures. Production notes. Accessed April 10, 2010. http://www.sonymoviechannel.com/movies/cheech-chongs-nice-dreams/details.

Nietzsche, Friedrich. 1968. *The Will to Power*. Translated by Walter Kaufmann and R. J. Hollingdale. New York: Viking.

Pérez, Emma. 1999. *The Decolonial Imaginary: Writing Chicanas into History*. Bloomington: Indiana University Press.

Pérez, Laura E. 2007. *Chicana Art: The Politics of Spiritual and Aesthetic Altarities*. Durham, NC: Duke University Press.

Pérez-Torres, Rafael. 1995. *Movement in Chicano Poetry: Against Myths, Against Margins*. New York: Cambridge University Press.

Pinder, Kymberly N. 2000. "Biraciality and Nationhood in Contemporary American Art." *Third Text* 14, no. 53: 43–54.

El Plan Espiritual de Aztlán. [1969] 1972. Reprint. In *Aztlán: An Anthology of Mexican American Literature*, edited by Luis Valdez and Stan Steiner, 402–6. New York: Knopf. Originally published in *El Grito del Norte* 2, no. 9 (July 6, 1969): 5.

Rendón, Armando B. 1971. *Chicano Manifesto*. New York: Macmillan.

Romano-V., Octavio Ignacio. 1969. *The Historical and Intellectual Presence of Mexican-Americans*. Berkeley, CA: Quinto Sol.

Said, Edward W. 1993. *Culture and Imperialism*. New York: Knopf.

———. 2003. *Culture and Resistance: Conversations with Edward Said*. With David Barsamian. Cambridge, MA: South End.

Saldívar, José David. 1997. *Border Matters: Remapping American Cultural Studies*. Berkeley: University of California Press.

Saldívar, Ramón. 1990. *Chicano Narrative: The Dialectics of Difference*. Madison: University of Wisconsin Press.

Sánchez, Rosaura. 1995. *Telling Identities: The Californio Testimonios*. Minneapolis: University of Minnesota Press.

Sandoval, Chela. 2000. "New Sciences: Cyborg Feminism and the Methodology of the Oppressed." In *The Cybercultures Reader*, edited by David Bell and Barbara M. Kennedy, 374–87. New York: Routledge.

Scott, James C. 1990. *Domination and the Arts of Resistance: Hidden Transcripts*. New Haven, CT: Yale University Press.

Shohat, Ella, and Robert Stam. 2001. *Unthinking Eurocentrism: Multiculturalism and the Media*. London: Routledge.

Sollors, Werner. 1987. *Beyond Ethnicity: Consent and Descent in American Culture*. New York: Oxford University Press.

Sorell, Víctor A. 1995. "The Persuasion of Art—The Art of Persuasion: Emanuel Martínez Creates a Pulpit for *El Movimiento*." In *Emanuel Martínez: A Retrospective*, edited by Teddy Dewalt, 26–28. Denver: Museo de Las Américas.

Talavera-Bustillos, Valerie, and Daniel G. Solórzano. 2012. "Resistance Theory." In *Encyclopedia of Diversity in Education*, edited by James A. Banks, 1856–59. Thousand Oaks, CA: Sage.

(Re)Forming America's Libertad

Ester Hernández

Libertad is what I consider a humorous drypoint etching that I created while a student at the University of California, Berkeley. It was 1976, and the United States was celebrating the American Bicentennial. Being such a good citizen, I felt I had to contribute something from my perspective. It was just a little reminder that we must not forget the Americas were/are inhabited by mestizo/Native peoples. Beneath the surface of this modern-day icon, the ancient Mayan stele reminds us of the rather recent arrival of a European culture. Yes, that's me taking action and chipping away and unmasking the truth. (Thank God bell-bottoms are in again!) At this time of immigrant bashing, this image continues to illustrate the fact that many original descendants find themselves in the ironic situation of being foreigners/criminals in their own original land. But we are still here.

After years spent living and working in various rural farming areas of Central and Northern California, I moved into the San Francisco Bay area in the early 1970s and returned to school, eventually attending and studying Chicano/a studies and art at the University of California, Berkeley. This was at the height of every movement you can imagine: hippie heaven, free speech, free love, Black Panthers, Gray Panthers, the American Indian Movement, the Chicano movement, the feminist movement, the gay movement, the Third World movement, "sex, drugs and rock 'n' roll," et cetera. Needless to say, this country girl was never the same . . . I loved it! So the combination of my family's United Farm Worker activist background and the politically charged world of Berkeley helped develop my sociopolitical artistic identity, my commitment to political activism, and, most importantly, a sense of humor.

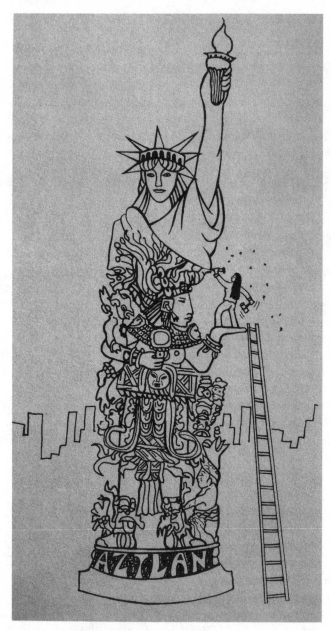

Figure 1.1. Ester Hernández, *Libertad* (Liberty) (1976, drypoint etching, 17.25 x 11.25 in.). Deconstructing a revered and iconic symbol of U.S. patriotism and righteousness, the artist reveals the complex makeup of the Americas. A Mayan stele and the mythic indigenous land of Aztlán emerge to underscore the mestiza artist's pride in her own ancient heritage. (Photograph courtesy of the artist.)

During this time, I began to meet and interact with a group of women from different ethnic backgrounds—and, very importantly to me, Afro-Latina and Pan-Amerindian groups. Some were compiling a book called *Third World Women*[1] and had come together to share stories of our struggles, hopes, dreams, and aspirations. The book project encapsulated a bigger movement. Borrowing from the words of Chicana theorist/critic Chela Sandoval, I say that one of its primary goals was to unmask gender, sexual, racial, and social inequalities within the USA and abroad.[2] We were living and creating a beautiful sisterhood, which I, coming from a very rural and race- and class-segregated background, could never have dreamed. It was a borderless, creative interaction woven together by words, visual art, song, and dance. We observed, absorbed, made sense, transformed, healed, and disrupted in order to find fresh ways of living, seeing, and creating new relationships with each other, the world, and the universe.

Through my meeting with these women from all over the Americas, I began to see the Americas in a different way. Through their stories the borders began to melt away. It's interesting what brought them here: repression in Haiti; a dictatorship in Chile that Mapuche women were fleeing; poverty in California and other states that Native people were trying to escape; the isolation and racism of the rancherias/reservations. We were all invisible, not respected, exploited. We found we were running from common demons.

At that time, I was studying art, anthropology, and Mexican history. The only way I could cope with the weight of all I was learning was by giving visual form to my thoughts and feelings through my art. So all of this manifested itself in this image—*Libertad*—and it was my "little" contribution to the American Bicentennial. It is a combination of the Statue of Liberty and a Mayan stele, which I transformed from a traditionally male Mayan warrior into a woman warrior with prominent breasts. She symbolically became an agent of change and an activist in the Chicano civil rights movement. Also, at the time I was learning about printmaking and was not aware that when printed, the image reversed. So instead of the torch being held in the right hand, my *Liberty* holds it in the left. I chose to leave it this way.

People always ask about Aztlán. What is Aztlán? To me, this refers to the myth that this is and always will be our ancient homeland and, thus, we have as much right (if not more) as anyone to be here. As it is said along the *frontera*, "We didn't cross the border—the border crossed us."

The Statue of Liberty is the iconic image of the United States as an immigrant nation. During the Bicentennial celebrations, the emphasis was

on the American Revolution, and I felt compelled to talk about the deeper roots of the Americas. I did this to remind people (Latinos, too) that the roots of this place go back into ancient times. Although this image was created more than thirty years ago, it still speaks to the truth and sheds light on the fact that we are still here. These roots have not only shaped America but have changed and formed America, the Americas, and us.

Notes

1. This book was sponsored by the journal *Heresies*, which proclaimed itself to be a "Feminist Publication on Art & Politics." The book was a collaborative project made possible by the collective efforts of Lula Mae Blocton, Yvonne Flowers, Valerie Harris, Zarina Hashrni, Virginia Jaramillo, Dawn Russell, Naeernah Shabazz, Su Friedrich, Lucy Lippard, Harmony Hammond, and more. Joan Braderman offered a one-page introduction to the collection, referring to the "editorial collective" that made the book possible (Braderman et al. 1979, 1).

2. See, for example, Chela Sandoval's essay "Mestizaje as Method" in Carla Mari Trujillo's *Living Chicana Theory* reader.

Bibliography

Braderman, Joan, et al., eds. 1979. *Third World Women: The Politics of Being Other.* New York: Heresies Collective.

Sandoval, Chela. 1998. "Mestizaje as Method: Feminists-of-Color Challenge the Canon." In *Living Chicana Theory*, ed. Carla Mari Trujillo, 352–70. Berkeley, CA: Third Woman.

Freedom and Gender in
Ester Hernández's Libertad

Laura E. Pérez

Based on pencil and ink versions and a drawing sold some two years before its definitive production as an etching in 1976 and, subsequently, as a silk-screen print, *Libertad* is today one of Chicana/o and U.S. feminist art's most familiar images.[1] It embodies that era's racial, gender, and sexual civil rights struggles and pioneers a culturally decolonizing melding of Euro-American and Native American visual cultures and a U.S. woman-of-color-centered politics of solidarity across cultural differences.[2]

In *Libertad*, Ester Hernández pictures herself carving a regal Mayan female figure from the Statue of Liberty, one of the most recognizable symbols of the United States and of freedom. The monument was given to the United States by France in 1886, on the occasion of the centennial of the signing of the Declaration of Independence. Standing on Liberty Island in New York Harbor, the massive 151-foot icon, installed upon a 305-foot pedestal and foundation, has been reproduced as a public statue hundreds of times throughout the world, as an image of freedom's certain step against oppression. The words of "The New Colossus," an 1883 sonnet by Emma Lazarus, engraved in 1903 on a plaque within the interior of the "Mother of Exiles," have given voice to the democratic ideals identified with the copper and steel figure: "ancient lands / . . . / With silent lips, 'Give me your tired, your poor, / Your huddled masses yearning to breathe free."[3]

The symbolism of the national public monument harkens back to Europe's ancient religious and visual cultural roots, to Libertas, Roman goddess of freedom from slavery, oppression, and tyranny. Officially named *Liberty Enlightening the World (La liberté éclairant le monde)*, the statue

holds high a torch in her right hand and a tablet of knowledge in her left, and she tramples upon shackles at her feet as she steps forward. The figure's flowing tunic and seven-spiked crown, representing the Greek and Roman sun gods, bestows ancient pedigree and dignity to the struggle of the former colony against political oppression and domination and to those seeking refuge in the new nation.

It is to this cultural and political legacy that Ester Hernández laid claim in 1976, in her visual reworking of the national icon during the U.S. Bicentennial. In Hernández's version, Libertad/Liberty smiles contentedly as an image of the artist chisels away at her, revealing a visually continuous and harmonious Mayan female figure. The legs of the Mayan carving, roughly in proportion to Libertad's figure, serve them both, as does the right arm, thus identifying the two figures as one. Three-quarters of the statue's body (excluding the upraised arm) is composed of the Native American figure, yet Hernández's print does not efface either the recognizable visage of the national monument nor the upraised arm and torch. Hernández allows for the visual coexistence and hybridization, the mingling and melding, of the two figures drawn from different cultures, art histories, religions, and philosophical world views. In art historical and feminist "sisterhood," they stand together (on the same legs!) for the struggle for greater social and political freedoms.

Given their juxtaposition, Hernandez's drawing/print illuminates and resignifies the received symbolism of these historic images. Both are images of power, represented through females, and both would seem to suggest female empowerment in ancient Greco-Roman and Mayan cultures, among divine and, at least, elite social orders. Within the context of the civil rights social movements against racism, sexism, and homophobia of the 1950s through the 1970s in the United States, the invocation of these ancient figures in Libertad, however, brings into focus the ongoing legacy of patriarchy and heteronormativity within Freedom's so-called birthplace.

The Mayan figure, selectively copied and altered from the ancient carved depictions of "royals," is rendered by her a strong and beautiful, gender-bending warrior figure with baby. The Mayan "royal" is atypically clothed and adorned in Libertad, "wearing the clothing of a Classic Maya elite male. The belt and loincloth worn with bare torso is a distinctly male practice. The shoulder wrap could have been worn by either sex, but women wearing them at Yaxchilan wore them over a full-length Huipil. The sandals and wristbands were worn by both sexes."[4]

The artist has explained that she wanted to decorate her figure lavishly and that she gave herself the liberty to adorn her as she found attractive

from the imagery available to her at the time as a student of pre-Columbian art, anthropology, and feminism.[5] So Hernández bared the breasts of the commanding figure and replaced traditional accoutrements, such as the presence of a "vision serpent," with an image of the artist herself at work. While a relationship between the two figures is made manifest visually, it is not clear that the substitution of a vision serpent as such by the artist was conscious. If it was, it would suggest that the contemporary artist is the ancient figure's future. The continuity of the figures, in any case, is arrived at in other ways, as we shall see momentarily. In the crook of the other arm, the artist transformed what in the archaeological lintels might have appeared as a deity image, representing social status, into a baby. The artist explained that the baby came out of her memories of the empowering religiosity of the strong women of her childhood rural community, centered around the Virgin of Guadalupe, which she also drew upon for her other well-known print of that period, *La Virgen de Guadalupe Defendiendo los Derechos de los Xicanos* (The Virgin of Guadalupe Defending the Rights of Xicanos).[6]

Ester Hernández's image enacts, on the visual level, the "U.S. women of color" thesis of the imbrication and simultaneity of gender, "race," class, and sexuality oppressions, born in the sixties and seventies and continuously elaborated through the present. That is, that there is no universal experience of gender because women experience gender differently, according to class, racial, heteronormative, and other forms of social privilege—or its lack—that allow them different degrees of freedom.[7] And while gender cannot be understood without the effects of racialization, neither can racialization, sexuality, or class be understood in isolation from each other or apart from gender privilege or its lack.[8] Chicana feminists of the late 1960s and the 1970s were fascinated by accounts of pre-Columbian female social life not only as a decolonizing antidote to the cultural Darwinism of Eurocentrism, which propagated the self-serving idea that European cultures, particularly those of English and Germanic extraction, were superior, but also, as importantly, because they offered alternative models of gender and sexuality brought by the Europeans and imposed, by the colonization of the Americas, onto people native to the continent.

From this perspective, the Statue of Liberty, a gift from one patriarchal republic to another, is ironic in its seemingly simultaneous celebration of liberty and "the female." But it is also ironic that the female monarchs of Spain and England led the colonization of the Americas, where patriarchal social, economic, and political privileges were extended beyond aristocratic nobles to European men and their male descendants, which

would not have been possible in their own highly and rigidly stratified "mother"lands. And while "liberty for all," for the "founding fathers" of the United States, actually meant property-owning men, descending preferably from English "stock," by the nineteenth century, the gendered racialization of "white" men was a "democratic" privilege of even the most criminal of "white" men.

In contrast, the seemingly more empowered and fluid gender roles for women of pre-European indigenous American cultures represented to Chicana feminist and queer artists and intellectuals models of greater social democracy. And indeed, queer studies scholars from the eighties to the present believe gender roles and sexual practices prior to colonization among many of the different peoples of the American continent to have been less binary and more fluid than in Europe, with such phenomena as cross-dressing and androgynous people being socially recognized, rather than repressed.[9]

Thus, Hernández's *Libertad* hybridizes different visual cultures and thereby the social imaginaries out of which they emerge and within which images, symbols, color, media, materials, and other tools acquire culturally and historically particular meanings. In simultaneously staging female gender as free and creative (i.e., the artist as female), as androgynous and institutionally recognized (i.e., the cross-dressing Mayan elite female), and as a deity representing human freedom (e.g., the goddess-based Statue of Liberty), Hernández lays claim to multiple visual imaginaries in order to broaden the social imaginary, that is, our national culture's general assumptions about freedom, democracy, justice, gender, sexuality, and racialization.

The image could be said to enact a postmodern aesthetic that anticipates the architectural and art manifestos of the eighties, in its cutting and pasting of historically disparate styles. But *Libertad*'s visual bilingualism more precisely and meaningfully represents that era as the beginning of a growingly respectful engagement between different cultures, an engagement that emerges from direct experience with each other and knowledge about those historically silenced from their own perspective, as democratically necessary correctives to the tales told by the socially dominant. Hernández does not obliterate the European goddess, nor does she collaborate with a colonizing effacement of an equally magnificent Native American womanhood. The two ancient female figures and the contemporary woman are shown as simultaneously different and yet also one with each other in their stand for freedom for all, regardless of gender, sexuality, and racialization.

At the heart of *Libertad,* American and European ancestors are shown as visually continuous with their "racially" and culturally mixed progeny, the Chicana feminist artist, who dynamically stands upon the outstretched palm of the one and, chisel in hand, within the crook of the outstretched arm of the other. Hernández pictures herself as she creates her version of the ancients and as they cocreate with her a liberated notion of being for the present.

Notes

1. From my interview with Ester Hernández at her home in San Francisco on June 26, 2009. My thanks to Sara Ramírez for accompanying me and for adding her own questions.

2. *Libertad* today circulates internationally in the form of silk-screen prints, reproductions in exhibition catalogs, art books, journal and newspaper articles, book covers, postcards and greeting cards, websites, and even T-shirts.

3. Details regarding Emma Lazarus's poem and its placement at the Statue of Liberty can be found in Bette Roth Young's biography *Emma Lazarus in Her World.*

4. My thanks to Professor Gerardo Aldana for his kind collegiality in providing an interpretation of the Mayan iconography in Hernández's *Libertad,* identifying these elements as most resembling the sculptural reliefs of Yaxchilan, particularly those in lintels 13 and 14, while noting the recurrence in various lintels of elements reproduced by the Chicana artist. All details regarding Mayan iconography here are indebted to his expertise.

5. Assertions regarding the artist's methodology, intentions, and biography are from my interview with the artist in 2009.

6. See Hernández's own writing about *Libertad* in this volume, where she explains that in her image the hand holding the torch aloft was unintentionally reversed. Nonetheless, upon discovering this, she chose to keep the image as it was.

7. Consider Audre Lourde's *Sister Outsider* and Alma M. García's *Chicana Feminist Thought,* collected essays from the 1960s and 1970s on "double" or "triple" oppression."

8. For further discussion of the history of Chicana feminist and queer thought and art articulating the theory of the simultaneity of oppression, see my previous publications, *Chicana Art: The Politics of Spiritual and Aesthetic Altarities* and "*El desorden,* Nationalism, and Chicana/o Aesthetics" in *Between Women and Nation.*

9. On the berdache and other "two-spirit" figures across North America, see Will Roscoe's *Changing Ones.* For an overview on gender and sexual role complexity and the pitfalls of colonizing mistranslation, omission, and of ahistorical projection of current queer studies concepts in the study of the "Aztecs," see Pete Sigal's "Queer Nahuatl: Sahagún's Faggots and Sodomites, Lesbians and Hermaphrodites." Also see Michael J. Horswell's *Decolonizing the Sodomite.*

Bibliography

García, Alma M., ed. 1997. *Chicana Feminist Thought: The Basic Historical Writings.* New York: Routledge.

Hernández, Ester. 2009. Interview with Laura Pérez. San Francisco, CA, June 26.

Horswell, Michael J. 2005. *Decolonizing the Sodomite: Queer Tropes of Sexuality in Colonial Andean Culture.* Austin: University of Texas Press.

Lorde, Audre. 1984. *Sister Outsider: Essays and Speeches.* Freedom, CA: Crossing Press.

Pérez, Laura Elisa. 1999. "*El desorden*, Nationalism, and Chicana/o Aesthetics." In *Between Women and Nation: Nationalisms, Transnational Feminisms, and the State,* edited by Caren Kaplan, Norma Alarcón, and Minoo Moallem, 19–46. Durham, NC: Duke University Press.

———. 2007. *Chicana Art: The Politics of Spiritual and Aesthetic Altarities.* Durham, NC: Duke University Press.

Roscoe, Will. 1998. *Changing Ones: Third and Fourth Genders in Native North America.* New York: St. Martin's Press.

Sigal, Pete. 2007. "Queer Nahuatl: Sahagún's Faggots and Sodomites, Lesbians and Hermaphrodites." *Ethnohistory* 54, no. 1 (Winter): 9–34.

Young, Bette Roth. 1995. *Emma Lazarus in Her World: Life and Letters.* Philadelphia: Jewish Publication Society.

A Conversation with Yolanda López and Víctor A. Sorell

Víctor A. Sorell (VS): Yolanda, you prevail as one of the most trenchant image makers among contemporary Chicana visual artists. You've created indelible, iconic images that continue to resonate long after you created them. Their acerbic edge has not been dulled by the passage of time. One totemic drawing you satirically entitled *Who's the Illegal Alien, Pilgrim?*— created in San Diego and rendered in India ink on paper—dates from 1978, but still retains its strident voice several decades later. Its advocacy of Mexicans assailed in the United States by an unabated xenophobia is no less topical now than it was then. Please share with our readers the genesis of this powerful icon.

Yolanda López (YL): Context has a great deal to do with it. In 1978, San Diego, California, was a very frightening place on the U.S.-Mexico border. Emotion has always been the odor, the indiscernible perfume, on the border, sometimes alluring and "festive" for the American Tourist, and most often also alluring for Mexicans or Mexican Americans, but fraught with tension and anxiety. Few issues they've had to negotiate have been more fraught with tension and anxiety than immigration. I had become acquainted with the Committee on Chicano Rights (CCR), led and run by Herman Baca in National City, the second-oldest city in San Diego [County], located 5 minutes from the international border.

I joined this small group of between two hundred and three hundred people. Baca's activism dated back to the Chicano Moratorium of August 29, 1970, against the Vietnam War. The Vietnam War, enhanced technology, and immigration are all intertwined for me in the evolution of this image. In fact, I did a mixed media collage on paper in 1978 as a prefatory

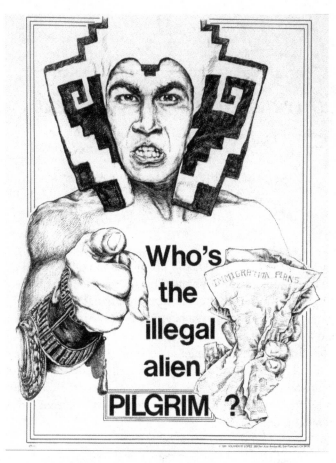

Figure 3.1. Yolanda López, *Who's the Illegal Alien, Pilgrim?*
(1978, offset lithograph, 30 x 22 in.). Confronting viewers to
engage in a frank dialogue addressing immigration, the artist is
visibly passionate concerning the palpable tension and anxiety on
the U.S.-Mexico border, which evokes for her a pungent odor, an
"indiscernible perfume." (Photograph courtesy of the artist.)

study for *Who's the Illegal Alien, Pilgrim?* I pointedly entitled it *Stop the
Vietnamization of San Diego/Say No! to Carter's Plan.* This image was
a not thinly veiled condemnation of heightened and militarized surveil-
lance tactics used to discourage Mexican immigrants from crossing the
border. I included a hovering helicopter like the kind so commonplace in
the war and manufactured in San Diego's economically important aircraft
industry.

Nativist groups in Southern California mounted various campaigns to pressure President Jimmy Carter to stop the flood of Mexicans coming over the border, allegedly to "steal" American jobs and "contaminate" America's racial composition. Carter was urged to allocate 22 million dollars—an appreciable sum at the time—to build a wall and secure the border between Tijuana and San Diego.

VS: One infers a deeply conservative political climate in San Diego of the late seventies. Would you agree?

YL: Definitely. I grew up in San Diego. The city was a very conservative and patriotic area going back in time to my days in elementary school during the Korean War. We were so steeped in patriotism that I recall a time long before I read Rudy Acuña's book, *Occupied America*, when I didn't question the stereotype I was fed in school that my Pilgrim forefathers and foremothers came across on the *Mayflower*. I still consider myself patriotic.

VS: What would lead you to question your earlier assumptions?

YL: My involvement in the Chicana/o movement, the emergent feminist movement, and reading books like Acuña's would prompt me to question my own upbringing—in a sense, to indict it. Pilgrims no longer appeared quite so benign, the Border Patrol assumed sinister guises, and from a conceptual and intellectual perspective, I began to ask myself how images could influence people.

VS: Evidently, you had become angry and confrontational, arguably projecting combative emotions onto the fabric of *Who's the Illegal Alien, Pilgrim?*

YL: Yes. The prominent male figure is very angry, and yet hardly anyone commented on this aspect.

VS: Yolanda, let's return to the military connection. Interestingly, your indigenous figure can trace his visual patrimony to Amerindian and other sources, namely James Flagg's World War One *I Want You* recruitment poster, which, in turn, owes something iconographically to a British poster of 1915 entitled *Who's absent? Is it you?*, featuring an imperious John Bull pointing a finger at the would-be recruit. The gestural, rhetorical language speaks directly to us.

YL: With the accusing finger of his right hand and defiantly crumpling immigration plans in the grip of his left, the pre-Columbian *guerrillero* is modeled from a Madison Avenue–type Aztec advertising a brand of beer in a magazine. I modified some of the elements with a Mexican dancer's image I saw in *National Geographic* magazine. He, as a man with living and ancient roots in this land, stands resolute, knowing that significant parts of the Midwest and the great Southwest expanse to the Pacific were literally stolen in the shameful U.S.-Mexican War. The war culminated in the disingenuous Treaty of Guadalupe Hidalgo (1848), granting citizenship and equal rights to Mexicans living in what became United States land: Texas, California, Arizona, New Mexico, Colorado, and part of Oklahoma. U.S. immigration policy has always revealed America's brutish protection of its Anglo-European racial identity and our country's political amoral stance on profit and power.

VS: Your barbed message of historical reclamation is eloquent in its economy of means, right down to your decision to limit its palette to black and white for ease of reproduction.

YL: My artwork is how I share my thoughts. Artists are intellectuals. In my pictures I hope to contribute to our discourse on immigration and to also share a wicked snort, laugh, giggle that acknowledges our smarts and our deep well of courage. Art making is one way I practice my citizenship.

Thoughts on Who's the Illegal Pilgrim

René Yañez

The first time I saw Yolanda López's *Who's the Illegal Alien, Pilgrim?* print, it made me stop and think about the content of its message. It came to the point of why it was relevant to the Chicano movement. It confronted the racism that permeated the attitude of mainstream America in its media education and cultural outlook.

As African Americans and Chicanos integrated into American institutions during the civil rights struggle, cries of "Go back to where you came from" echoed throughout the country. Yolanda's poster became a counterpoint to those cries and made Anglo-Americans reflect upon their own origins. It also empowered many artists to think of images and words as powerful tools they could use to engage their own communities on the subject of identity.

Lengthy discussions took place that addressed the question "What am I? Mexican, Hispanic, Mexican American, Latin American, Latino, or Chicano?" Geography also played an important role in this discussion. In Los Angeles great numbers of people debated this issue. In Sacramento, José Montoya started the artist collective the Royal Chicano Air Force (RCAF). In Oakland, Malaquias Montoya, Esteban Villa, Manuel Hernandez, and I started the Mexican American Art Liberation Front. It was during this time that we were confronted with the word *Chicano* as the proper label with which to identify ourselves. In conjunction with this, Yolanda's piece did a lot to widen the discussion of identity and force us to look at our indigenous past. This was a generation whose education system and popular entertainment painted our indigenous history as that of savages and colonized servants. *Who's the Illegal Alien, Pilgrim?* made

us question that history and those who wrote it. It also helped expose how ludicrous the portrayals of Native Americans and people of color were by white actors.

Throughout our history I have seen Yolanda's poster at immigration rallies to remind the Minute Men that "we didn't cross the border, the border crossed us" and of the vast bounty that was stolen from Mexico under the banner of Manifest Destiny. The poster holds up a mirror to white supremacy and shows that it's not destiny to bring injustice to a nation of people who welcomed European immigrants to settle in Texas. In the same vein, immigrants who declared independence proceeded to discriminate against the citizens who already populated the land. In California, the gold rush brought chaos to Anglo landowners and Native Americans alike, again bringing up the questions of immigration and identity that yet remain unresolved to this day. During prosperity or hard economic times, day laborers become an easy target for the Ku Klux Klan in the South and the U.S. Immigration and Customs Enforcement in the West. Yet in cities where laws are passed against immigrants, businesses move to where they can afford to operate, leaving behind closed factories and an aging population without care.

Looking back at a time when I worked at Galería de la Raza in San Francisco and we first began to sell Yolanda's poster, I remember Chicanos and Latinos would first react to it with laughter but then ponder the larger issues that it spoke to. When white Americans saw it, they would bring up the label of reverse racism and spark a debate on the subject. Cultural centers were necessary in the community because mainstream museums and galleries would not sell posters like Yolanda's, which would remind them of the history of segregation and of the fact that the original Pilgrims who came to this country had Puritan values they imposed on the populations they encountered. This issue of history and values became apparent in U.S. history lessons and then later in college art history classes that only validated a Eurocentric context. I bring up these points because this poster may have been made years ago, but the issues remain in today's world.

Millions rally across this country for dignity and justice against a sea of discrimination. The poster *Who's the Illegal Alien, Pilgrim?* is a reminder that in this country, aside from the Native Americans, we are all immigrants and that groups like the Irish and Italians once faced discrimination here as well. So in today's America, my only hope is that every American will get its message.

Remapping America in Ester Hernández's Libertad and Yolanda López's Who's the Illegal Alien, Pilgrim?

Yvonne Yarbro-Bejarano

From our vantage point in the early twenty-first century, Ester Hernández and Yolanda López appear as two towering figures of the Chicano art movement, and many of their images serve as paradigmatic distillations of that movement's ideology and aesthetic strategies. The two images featured in this volume, Hernández's etching *Libertad* (1976) and López's poster *Who's the Illegal Alien, Pilgrim?* (1978), have attained iconic status, surrounded by an aura designating them as unique individual images. But recontextualizing them in the Chicano art movement reminds us that they are but two drops in the river of striking images produced by myriad artists working in the mid- to late 1970s within the reigning paradigm of resistance and affirmation.[1] Inspired by the principles of the movement to put their art at the service of the community, Chicana and Chicano artists in diverse regions of the United States created murals, posters, painting, sculpture, installations, performances, prints, videos, and films contesting the oppression of the dominant society and validating aspects of Chican@ identity and culture. Some other images of the period, featured in the 1990 retrospective exhibition *Chicano Art: Resistance and Affirmation*, preceding the creation of these two images or circulating concurrently in the 1970s, include Salvador Roberto Torres's vivid *Viva la Raza* (1969), combining the title text and the UFW eagle; tributes to important cultural and political precursors, such as Frida Kahlo in Alfredo Arreguín's *Images of*

Frida (1978) and Yreina Cervántez's *Homenaje a Frida Kahlo* (1978) and the pachuco in José Montoya's *Pachuco: A Historical Update* and Richard Duardo's *Zoot Suit* (1978); depictions of barrio realities in Amado Peña's *Chicano Gothic* (1974), Cecilia Alvarez's *Las Cuatas Diego* (1978), Leo Limón's *No Vale, Homes*, and Wayne Alaniz Healy's *Ghosts of the Barrio* (1974); the work of influential collectives, such as the RCAF, Los Four, Asco, and Mujeres Muralistas; representations of immigrant and farm-worker existence in Rupert García's *¡Cesen Deportación!* (1973), Emanuel Martínez's *Farm Workers' Altar* (1967), and Daniel DeSiga's *Campesino* (1976); and murals celebrating Chican@s' pre-Columbian heritage, such as José Gamaliel González's *La Raza de Oro* (1975), Zarco Guerrero's *Culture, Brotherhood, and Pride* (1976), and Emanuel Martínez's *La Alma* (1977), with Judith Baca's *The Great Wall of Los Angeles*, begun in 1967, redressing the gaps in official histories of Los Angeles.[2] Three years following *Libertad*, Malaquias Montoya created the print *Abajo con la Migra* (1979), showing a menacing Statue of Liberty with a meat cleaver in her raised hand and a migrant impaled on the spikes of her crown. While the strategy of revisioning a dominant icon to critique U.S. nationalism and anti-immigration policy is the same, the tone of the print is very different from Hernández's piece. Hernández and López are seasoned veterans of this art movement who for more than thirty years have been producing images that incite political passions. Fully engaged with El Movimiento Chicano, as women in a male-dominated movement they also confronted gender issues. In their representations of the multiple particularities of Latinas' lives, their work is positioned squarely within the tradition of Chicana feminist thought, not just as examples of feminist images, but as active contributions to the development of Chicana feminism itself as activism and theory. Their images help theorize Chicana identity and experience, stimulating dialogue with Chicana studies scholars, such as Laura E. Pérez, Karen Mary Davalos, and Angie Chabram-Dernersesian. As Chicana feminist artists, López and Hernández fiercely engage histories of colonialism and their legacies in the Americas and center women in their frames who speak to the viewer of how these histories intimately inform who they are *as women*. Striving to make sense of the world, they have given us the visual equivalent of Gloria Anzaldúa's "borderlands" and Chela Sandoval's "oppositional consciousness," teaching us about race/sex/gender and socioeconomic position in the lived experience of Latinas. The political desire that infuses Hernández and López's work is for transformation on all levels, the personal, communal, societal, and global. Their images of Chicana, Latina, and Latin American women capture a moment in time yet gain in relevancy over time. Drawing on imagination,

memory, political attitude, and the raw materials of their medium and their lives, they fashion unforgettable images of diverse Chicana bodies not represented in relation to a man in the heteronormative confinement of la familia.

Together Hernández's and López's artistic practices encompass a wide array of media, including painting, drawing, printmaking (subsuming the poster), muralism, video, photography, and mixed-media installation. Their themes are equally broad. Both artists depict the hardships and dignity of labor, as in Hernández's *La Virgen de las Calles* (2001). Through the reference to the Virgin Mary in the title and the decorative elements of the shawl and the roses at her feet, the piece honors an immigrant woman who out of necessity is reinventing herself as a street vendor. The artist renders the stance and eyes of the figure to convey dignity and strength. The image is a tribute to the perseverance and resourcefulness of immigrant women in a time of globalized economic adversity and U.S. xenophobia. In a print from López's series of the same name, *Women's Work Is Never Done* (1995), female farmworkers wear bulky protective clothing and bandanas over their mouths and noses, in a futile attempt to defend themselves from pesticides, and baseball caps adorned with the UFW eagle, demonstrating their political agency. In the left background a youthful Dolores Huerta brandishes a *huelga* (strike) sign. The temporal designations "California Broccoli Harvest: 1995" along the right margin of the frame and "Dolores Huerta: 1965" along the left point to the continuity of farmworker adversity and struggle over more than thirty years. Hernández's starkly ingenious *Sun Mad* deploys the aesthetic of the double take to represent the dangers of pesticides, reversing the image on the Sun-Maid raisin box from healthy abundance to a specter of destruction. Unlike Hernández's portraits, this figure is turned against itself to comment on the corporate use of the female body to sell commodities, revealing in one bold stroke the death-dealing lie and the harm done to farmworkers and consumers alike through the use of pesticides. In López's 1994 installation *The Nanny*, the domestic's uniform hangs in the center, surrounded by objects and media representations that lay bare the social and racial hierarchies of power between women.[3] Immigration features largely in their work—as in López's *Cactus Hearts, Barbed Wire Dreams*, in the two pieces under consideration, and in Hernández's *La Virgen de las Calles* as well as her diaphanous installation *Immigrant Woman's Dress* (1998), relating in visual form her grandmother's trek across the border.

Though not always titled as such, both artists create self-portraits, as in Hernández's *Libertad, La Virgen de Guadalupe Defendiendo los Derechos de los Xicanos* (1975), and the lovely *California Special* (1987), the latter

portraying the artist as a child wearing a dress made out of the material of the flour sacks upon which she sits, a testament to beauty in poverty. Besides López's famous *Portrait of the Artist as La Virgen de Guadalupe* (1978), she presents self-portraits in her runner series and in the black-and-white *Taking It Off*, which shows a woman removing a mask. The pattern of bombs on the right balancing the lacy floral pattern to the left of the figure informs the implications of identity exploration; flowers and rifles alternate in the border. This reference to violence in women's lives recalls Hernández's *Tejido de los Desaparecidos*, which also requires a second look to allow the elements bespeaking genocide to float to the surface of the weaving. The piece bears witness to the forced displacements, disappearances, and massacres during Guatemala's civil war in the 1980s. The fetuses visible among the skulls and helicopters suggest the gendered nature of violence against women. In *Luna Llena/Full Moon* (1990) Hernández depicts a Central American campesina's armed revolutionary response to such violence, as she carries both hoe and rifle by the light of an enormous moon bearing the design of the Mesoamerican deity Coyolxauhqui. These examples of the two artists' thematic concerns reveal their common artistic vision: an unflinching gaze at inequality and suffering and an uncompromising commitment to art's power to trace a path to truth and justice.

Along with the similarities, there are salient differences with respect to subject matter and their approaches to it. Hernández is more interested in exploring love and sexuality in her work, as in, for example, the sexy drawing *Renée la Troquera* (1993) and the sensuous print *La Ofrenda* (1988), with the image of the Virgin of Guadalupe on a woman's back. López has six beautiful paintings featuring self-portraits as a runner dating from 1976 and 1977, which evoke meditations on urban solitude and physical endurance; this is the origin of the athletic female body in López's *Virgen* work. Over the years, López has dedicated herself to the deconstruction of ruinous stereotypes about Mexicans, as in her video *When You Think of Mexico: Commercial Images of Mexicans* (1986), the installation *Things I Never Told My Son About Being Mexican* (1988), and the *Cactus Hearts, Barbed Wire Dreams* exhibition she cocurated in 1988. The witty *Mexican Chair* (1986) consists of a chair with nails coming out of the seat, with a representation of a Mexican sleeping against a cactus on the back. The piece seems to ask, If you think Mexicans enjoy sleeping against a cactus, why don't you try sitting in this chair?

Both artists are perhaps most famous for their important images revisioning the Virgin of Guadalupe, images that caused scandal, controversy, and

dismay alongside delight, satisfaction, and appreciation. López's approach to the Virgin in her Guadalupe series (1978–88) is more deconstructive than Hernández's. As Laura Pérez notes, "Her concern with Virgin of Guadalupe iconography was more an experiment of speaking through the familiar to a population visually and not simply religiously shaped through culturally omnipresent images" (2007, 273). López is more critical with respect to the use of the icon as a socializing tool and instrument of social control. In one piece, an image of the Virgin of Guadalupe stands behind a Latin American dictator being waited on by a black servant. López's deconstructive approach is especially visible in *Eclipse* (1981), beautifully analyzed by Angie Chabram-Dernersesian, in which all three elements (the doubled self-portrait as jogger, the doubled traditional icon of the Guadalupe, and the single image of the indigenous mother nursing her baby taken from *Madre Mestiza* [1978]) are falling out of the frame within the frame. Besides her well-known and heavily commentated triptych from 1978 comprising portraits of herself, her mother, and her grandmother as the Virgin of Guadalupe, López produced *Guadalupe Out for a Walk* (1978) and the less familiar *Tableau Vivant* of the same year, a live installation/performance piece documented by photographs, in which a radiant López strikes various poses, in running clothes and with paintbrushes in hand, as she emerges from the Virgin's mandorla.[4] López's work with la Virgen is characterized by bringing the icon down from her pedestal to sanctify Chicanas' everyday lives and their bodies. An exception to this approach is found in the large painting *Nuestra Madre* (1981–88), which remains on the mythic plane, replacing the icon of the Virgin of Guadalupe with a hieratic rendering of the formidable Coatlicue, Mesoamerican "Lady of the Serpent Skirt."

Hernández, on the other hand, comes to the recasting of la Virgen from a place of devotion. In these images she practices not so much a taking apart as a layering of traditional and innovative meanings. Hernández's renowned piece *La Virgen de Guadalupe Defendiendo los Derechos de los Xicanos* is one of the first to revision the traditional icon, and she is the first Chicana artist to remake the Virgen de Guadalupe on paper, drawing power from the centuries-old syncretic icon already layered with multiple meanings.[5] The karate kick that breaks through the rays of light and mandorla traditionally containing the sacred image foregrounds new meanings relevant to the artist's needs and experiences. This image has become iconic in its own right, synonymous with Chicanas' militant energy and refusal of restrictive gender and social roles. The screen print *La Ofrenda* retains the traditional form of the Virgin of Guadalupe, but in positioning

it as a tattoo on a Chicana's back, with a feminine hand in the foreground offering a thorny rose to both the religious icon and the tattooed Chicana, it sacralizes the pain and passion of love between women. With these pieces Hernández simultaneously respects the communal significance of the Virgin and claims her right as a working-class mestiza to see her as uniquely her own, combining her spiritual roots in family and community with a call for social and personal transformation.

Hernández's work exhibits remarkable coherence as a mestiza-centered art practice. With few exceptions, her images represent working-class women of color, including cultural and political heroes like healer Doña Maria, performers Lydia Mendoza and Astrid Hadad, and street vendors and drag queens. Hernández's eye discerns a kernel of truth in the women she draws: agency, dignity, defiance, and inner strength. Her aesthetic blends an abiding humor, ranging from the acerbic to the playful, with a pervasive spirituality rooted in an indigenous world view not entirely visible from a Western optic that tends to separate the sacred and the profane.

In her book on López, Karen Mary Davalos stresses the often-overlooked deconstructive and conceptual aspects of her aesthetic. López has a particularly sharp eye for the harmful images of Mexicans in mass media. Her work deconstructing stereotypes models the process by which Chican@s can develop what she calls "visual literacy" as a survival skill (Lippard 1990, 42). Social psychologist Claude Steele's recent book on "stereotype threat," in which exposing subjects to stereotypes impairs their performance in the area affected by the stereotype, demonstrates the enduring value and importance of López's work. López's 1997 print *Your Vote Has Power*, part of the *Women's Work Is Never Done* series, continues her interventions into the empowerment of women. Most recently she is at work on a new series called *Mexican Bag*, questioning "notions of authenticity, identity, and tourism in Mexican culture."[6]

Within the overarching Chicano art movement project of resistance and affirmation, the two images under consideration work with a cultural nationalist repertory for contesting U.S. national narratives of belonging by reinventing Chican@s' indigenous heritage. Signifiers of the pre-Columbian become the vehicle for claiming the right of Mexican-origin people to be in the United States in social contexts of nativist reaffirmation of European-oriented definitions of nationhood and citizenship (the U.S. Bicentennial in the case of *Libertad*), and xenophobic, racist anti-immigration sentiment (immigration reform during the Carter years in the case of *Who's the Illegal Alien, Pilgrim?*). The images directly engage Chican@s' bogus status as outsiders, "strangers in their own land,"[7] and

implicitly remind the viewer of the centuries-old migration and trace routes crisscrossing the Americas.[8] Pre-Columbian iconography permits a hemispheric spatial reorientation, expanding the map of the U.S. nation-state to all of the Americas. Through the indigenous, the artists contest the homogeneous U.S. "imagined community,"[9] targeting its body politic and ideal citizen by putting other, indigenous bodies into circulation with a claim to belonging *here*. The artists reach into their cultural national-ist toolbox for indigenous elements that signify a decolonizing process. This alternative mapping jumps the geopolitical border and establishes a prior claim to the land—the land before European settlement. In this aesthetic strategy mixing the mythical and the historical, common in Chi-cano movement art, the pre-Columbian functions as a way to index the theft of land in 1848 and subsequent settler colonialism. It sets the stage for complex identifications and reimaginings of Chican@ "homeland."

In addition to indigenous signifiers contesting U.S. narratives of na-tional identity, the two images deploy another technique common to Chicano movement art and especially Chicana feminist art, that of "turn-ing around" mainstream popular cultural icons, the Statue of Liberty in Hernández's case and the Uncle Sam recruiting poster and the 1962 film *The Man Who Shot Liberty Valance* in López's case.[10] Both artists have an uncanny knack for putting indigenous signifiers to new uses and turning the very icons of U.S. national identity against themselves. In doing so, they offer another face and space for America.

In *Who's the Illegal Alien, Pilgrim?*, the title question appears over the body of an indigenous figure, angrily pointing with one hand at the viewer and crumpling in the other some papers marked "immigration plans."[11] In a departure from her feminist art work, in this image López genders as male the agency of resistance and the anger that accompanies it, as well as the ideal body of Chicano nation, as was common in much cultural nationalist production. This may be conditioned by the source, the Uncle Sam recruiting poster, on a subliminal level, since López says she didn't have it in mind when she made the poster (Raab 2003, 4, n. 1). A mural from the same year, *We Are Not a Minority!* by the Congreso de Artistas Chicanos en Aztlán, features a Che Guevara figure with the same fore-shortened finger pointing at the viewer, suggesting the presence of the re-cruiting poster in all Americans' social imaginary. The poster matches the authoritative white patriarch with an indigenous one. Together the indig-enous figure and the question posed address the issue of who has the right to be in the United States.[12] Combating the "dehumanizing phrase" (Lip-sitz 2001, 76) used to marginalize Mexican migrants, the image converts

"illegal aliens" into the original inhabitants of the land. As René Yañez points out in his commentary in this volume, the image stimulated debate on identity in relation to Chican@s' indigenous past.

Though consistently referred to as an "Aztec," "Mexican," or "Toltec" warrior by commentators, the figure wears a headdress and bracelet that function less as accurate reproductions of specific Mesoamerican dress than as signifiers of the indigenous, which López has selected and combined for contemporary meanings, suggested by the anachronistic juxtaposition of "pre-Columbian warrior" and "immigration plans." Similarly, the drawing of the body is quite different from the monumental corporeal perfection of muscular yet static pre-Columbian bodies found in many murals, such as *La Alma*. The figure in the poster, though wiry, has a perfectly ordinary body. López's drawing of the twisted lips, clenched teeth, piercing eyes, and glowering eyebrows individualizes the figure and intensifies its dynamism and confrontational aspect; the figure's "facial expression and his de-centered position in the picture convey his rage, as does the fact that on three sides his figure ruptures the picture's three-lined frame" (Raab 2003, 4), adding to the tension of the image. The corporeal individuation and gestural force of the poster contrast with the hieratic style of drawing indigenous bodies found in other artwork of the time, such as *La Raza de Oro*, a mural panel directed by José Gamaliel González on Chicago's celebrated Hubbard Street mural-graced corridor. Part of the power and the humor of the poster derive precisely from its ordinariness—it is as if the figure has come off the wall or down from the pedestal to get in the faces of those who would tell Chican@s to "go back where they came from." The strong anger is directed at the viewer, supposedly someone who holds the view that migrants are illegal. The implied Chican@ viewer, in effect standing to one side of the intended viewer, gets the joke.[13]

López's choice of medium conditions the form and reception of the piece. Along with murals, posters were the privileged form in the Chicano art movement, as "multiples designed for quick, inexpensive production and mass distribution" (Lipsitz 2001, 72). According to cultural critic George Lipsitz, "Posters functioned as crucial components of a Chicano public sphere created by community-based artists and activists at the grass roots. . . . Within the Chicano Movement, poster production emerged as one of the important sites where insurgent consciousness could be created, nurtured, and sustained" (2001, 72, 74). Like other posters, *Who's the Illegal Alien, Pilgrim?* owes its effect in part to "the practical imperatives of the poster form: to attract attention, communicate clearly, and encapsulate a complex message in a compressed form" (Lipsitz 2001, 72). Easily and

quickly read, *Who's the Illegal Alien, Pilgrim?* nevertheless unfolds and keeps unfolding layers of historical, cultural, and political meanings about "America."

Goaded by the nativist hype surrounding the Bicentennial and the trumpeting of the usual version of "American" history (thirteen colonies, independence, western expansion), Hernández created *Libertad* to explore the questions of what is America and who is American. Like López's image, the portrayal of a long-haired woman sculpting the Statue of Liberty into a Mayan stele delivers a history lesson about the Americas and the original and enduring presence of indigenous peoples. The Spanish of the title contrasts with the English word *liberty* in the statue's name, the very word in Spanish conjuring other histories of struggles for independence and freedom from tyranny, even as it stands as a reminder of another imperial language. As in the López image, the cultural nationalist recourse to the pre-Columbian for claims to land allows for the unmasking of U.S. settler colonialism while glossing over the Spanish and Mexican colonialisms that preceded it.

As I have pointed out elsewhere, *Libertad* captures a state of flux in which both statue and stele are visible, theorizing mestiza identity and consciousness as inhabiting the in-between.[14] In this way this remarkable image condenses a politics, a hermeneutic, and an aesthetic. In her image Hernández juxtaposes two visual styles: the spare neoclassical lines of the European monument and the intricate scrolls and baroque detail of the Mayan stele. The ornate style of the monument also contrasts with the delicacy and elegance of the line used to depict the New York skyline and the fragility of the ladder.

While López's poster, in its bid to grab the attention of the viewer, reworks a familiar image that features a single body, reproduces conventional gender notions, and is outwardly directed in its emotional interaction with the intended and the implied viewers, Hernández's etching doubles the female body, deviates from conventional gender norms, and turns inward, focusing on the interaction between the sculptor and the Mayan figure. Besides rewriting U.S. national narratives, the self-reflexive image mirrors Hernández's own act of creating the etching *Libertad*, extending both agency and critical consciousness to the woman sculptor and representing the very process by which Chicanas participate in arts activism.

The doubling juxtaposes two levels or registers: the "everyday" and the mythical monumental, the contemporary moment and the pre-Columbian past, active and static, small and large. The image represents the power of the Mayan figure but also that of the sculptor, with her interpretive

authority, artistic talent, technological know-how, and daring. The Chicana sculptor high on a ladder above the New York skyline hyperbolically renders Chicana muralists' bravery in painting on scaffolding high above the city street (three stories high, in the case of the *Maestra Peace* mural in San Francisco). Here, the sculptor is depicted more than halfway up the 151-foot statue.

Sooner or later, the viewer notices that, unlike the real Statue of Liberty, Hernández's version is holding the torch aloft in her left hand. In her statement in this volume the artist explains that she was learning the medium when she made this image and was unaware that the image would be reversed when printed. This is fine as far as anecdotal explanations go, but what remains is the image, in which we see a left-handed Statue of Liberty. What does it mean if we reverse the "right-handed," or official, understanding of freedom and liberty, which is what Hernández's image accomplishes in its doubled transformation of the national icon? Perhaps we twenty-first-century viewers see this "different" Statue of Liberty, left-handed and part European/part indigenous, with the word *Aztlán* emblazoned on the base, as a manifestation of *el mundo zurdo*, or left-handed world, that Gloria Anzaldúa began to theorize in *This Bridge Called My Back* (1981). In a move similar to Hernández's own, Anzaldúa turns around the concept of being "left-handed" to imagine community building and social movement based on commonality that does not demonize difference. As Ana Louise Keating sees it, the commonality shared by the "inhabitants of *El Mundo Zurdo*" rests on "their rejection of the status quo and their so-called deviation from the dominant culture" (2009, 86). *Libertad* converts the ultimate icon of sameness (acceptance of immigrants as long as they assimilate) to a sign of difference.[15] The hybrid monument, in its very difference from itself (left-handed, part indigenous), imagines a community that acknowledges difference but unites around social transformation.

In her statement in this volume, Hernández reveals that she feminized the traditional Mayan male warrior, adding breasts. The eye is drawn to the place where the two female figures interact. They face each other, the hand of the Mayan figure forming a platform for the sculptor. We could imagine that she sculpted it that way for herself, but the finished effect is as if the figure is offering her hand to facilitate the work. While the Statue of Liberty faces the viewer frontally, staring out with her blank eyes, neither of the other figures directs the gaze outward. The sculptor concentrates energetically on the task at hand; small lines mark the movements of the arm and the hammer and the chips flying off the chisel in her hand. The

viewer gazes at the process depicted and grasps the meaning. This interaction between the two female figures introduces a note of intimacy into the piece, of conspiracy and collaboration, in spite of the monumental scale. The doubling involves a familiarizing of the monumental and a monumentalizing of the everyday, in the hyperbolic rendering of the physical challenges faced by women muralists on scaffolds.

Besides the breasts that mark the Mayan figure as female, the baby she holds and the child at her knee also mark the reproductive body, but as was the case with López, the Chicano *familia* romance is not the hermeneutic or aesthetic tool Hernández wants here.[16] The baby has a strange face, with a birdlike beak, which refers the viewer to a Mayan world view. At the same time, this nonrealist representation of mother and child is significant in the context of national belonging, since the "offspring" of Chican@s' indigenous ancestors, however different, have the right to be in the United States. The female reproductive body is used symbolically, to map out a genealogy of precedence for the nation rather than to represent la familia as Chicano nation. *Libertad* puts the indigenous female reproductive body into circulation as an alternative to the ideal body of the U.S. nation represented by the Statue of Liberty, not in the context of la familia, but reoriented to the woman artist. By emphasizing the female body, Hernández genders the pre-Columbian as female and, by extension, underscores resistance and affirmation embodied by the artist actively at work.[17]

These images came into being as aesthetic and political responses to nativism and anti-immigrant sentiment in the 1970s and have remained effective and timely until today. Nativism has been on the rise since 9/11 (Raab 2003, 4), and the militarization of the border and criminalization of migrants that increased throughout the 1980s culminated in California Proposition 187 and in the federal Operation Gatekeeper, both in 1994, and in Arizona's SB 1070 in 2010. The rapid dissemination of images by Chican@ artists online in response to the developments in Arizona shows that the arts activism represented by *Libertad* and *Who's the Illegal Alien, Pilgrim?*, and by the sculptor in *Libertad*, is still a reality today, with artists marshaling their impressive skills and imaginations for social justice. Targeting the ubiquitous wanted poster in the American social imaginary, Hernández's humorous yet pointed 2010 print *Wanted* features a mug shot of *La Virgen*, hunted for terrorism and for accompanying "countless men, women and children illegally into the U.S.A." The lasting impact of *Libertad* and *Who's the Illegal Alien, Pilgrim?* and the continued efficacy of this kind of arts activism suggest that the "post" in "post-Chicano" is yet

another modality of art making that coexists alongside one that galvanizes images around identity, race, and ethnicity at a time when antimigrant hate looms large.[18]

Notes

1. See Teresa McKenna, Richard Griswold del Castillo, and Yvonne Yarbro-Bejarano, eds., *Chicano Art: Resistance and Affirmation*; Alicia Gaspar de Alba's *Chicano Art Inside/Outside the Master's House*; and Karen Mary Davalos's *Exhibiting Mestizaje*.

2. For reproductions of these images, see McKenna, Griswold del Castillo, and Yarbro-Bejarano's *Chicano Art: Resistance and Affirmation*.

3. See Laura E. Pérez's wonderful analysis of this piece (and others by both Hernández and López) in *Chicana Art* (2007, 52–57).

4. Laura Pérez notes that this piece was the "first to explicitly link the comic book superhero tradition, through a 'Wonder Woman' comic book, to Virgin of Guadalupe iconographical elements" (2007, 340, n. 31).

5. Quoting Amalia Mesa-Bains, Laura Pérez notes that the honor of being the first to revise the icon goes to Patssi Valdez and Asco in their *Walking Mural* of 1972 (2007, 267), three years prior to Hernández's image.

6. Information taken from the presenters' bios in the program of the "Sex y Corazón" symposium at UCLA in February 2010, sponsored by the César E. Chávez Department of Chicana/o Studies.

7. Such is the title of Albert Prago's history of Mexican Americans, published in 1974. See also David J. Weber's edited volume *Foreigners in Their Native Land: Historical Roots of the Mexican Americans*, published in 1973.

8. See Laura Pérez (2007, 147–48). In an interview with Theresa Harlan, Hernández remarks, "Borders did not always exist but migrations have always occurred" (quoted in Gaspar de Alba 1998, 142).

9. The famous phrase is Benedict Anderson's (1991).

10. The phrase "turning around" is Lucy R. Lippard's (1990); on López's revisioning of the Uncle Sam poster and the film, see George Lipsitz (2001).

11. Historian Vicki Ruiz (2008 [1998]) explains how political debate in the United States resulted in the passage of the Immigration and Nationality Act Amendments of 1978, which limited immigration from a single country to 20,000 people per year, with a total cap of 290,000.

12. Rafael Pérez-Torres considers López's image under the sign of "critical mestizaje," interpreting the "defiance" of the poster as "a response to the idea of dislocation and displacement in relation to the land that Chicanos occupy," and "reminding the viewer that it was the European as invader/immigrant who unlawfully occupied the Americas" (2006, 128).

13. That the message is unwelcome to some of the intended viewers is seen in a website denouncing the poster: "Divisive Aztlan Art by Yolanda M. Lopez. This 'work of art' is an intimidating rendition of an Aztec God and bears the admonition 'Who's

the illegal alien, Pilgrim.' . . . Many of the Raza groups feature this taunting image as one more symbol of their hatred of the United States."

14. See my brief 1993 essay "Turning It Around" in *Crossroads*.

15. For Alicia Arrizón, in her article "Mythical Performativity," the partly "disembodied" Statue of Liberty of Hernández's etching "invokes transculturation and its potentially counterhegemonic function" (2000, 42).

16. For critiques of the heteronormative representation of the "Chicano familia romance," see Rosa-Linda Fregoso (2003) and Richard T. Rodríguez (2009).

17. Alicia Arrizón sees the female body in *Libertad* as "essentially the creator and instigator of freedom" (2000, 42).

18. On "art after the Chicano movement," see Chon Noriega (2008).

Bibliography

Anderson, Benedict. 1991. *Imagined Communities: Reflections on the Origin and Spread of Nationalism*. New York: Verso.

Anzaldúa, Gloria, and Cherríe Moraga, eds. 1981. *This Bridge Called My Back: Writings by Radical Women of Color*. Watertown, MA: Persephone Press.

Arrizón, Alicia. 2000. "Mythical Performativity: Relocating Aztlán in Chicana Feminist Cultural Productions." *Theatre Journal* 52, no. 1: 23–49.

Chabram-Dernersesian, Angie. 1992. "'I Throw Punches for My Race, but I Don't Want to Be a Man': Writing Us—Chica-nos (Girl)/(Us) Chicanas—into the Movement Script." In *Cultural Studies*, edited by Lawrence Grossberg et al., 81–95. New York: Routledge.

Davalos, Karen Mary. 2001. *Exhibiting Mestizaje: Mexican (American) Museums in the Diaspora*. Albuquerque: University of New Mexico Press.

——. *Yolanda López*. 2008. Minneapolis: University of Minnesota Press.

"Divisive Aztlan Art by Yolanda M. Lopez." N.d. *Hal Netkin's MayorNo* website. http://www.mayorno.com/Pilgrim.html.

Fregoso, Rosa-Linda. 2003. *MeXicana Encounters: The Making of Social Identities on the Borderlands*. Berkeley: University of California Press.

Gaspar de Alba, Alicia. 1998. *Chicano Art Inside/Outside the Master's House: Cultural Politics and the CARA Exhibition*. Austin: University of Texas Press.

Keating, Ana Louise. 2009. "From Intersections to Interconnections: Lessons for Transformation from *This Bridge Called My Back: Writings by Radical Women of Color*." In *The Intersectional Approach: Transforming the Academy Through Race, Class, and Gender*, ed. Michele Tracy Berger and Kathleen Guidroz, 81–99. Chapel Hill: University of North Carolina Press.

Lippard, Lucy R. 1990. *Mixed Blessings: New Art in a Multicultural America*. New York: Pantheon Books.

Lipsitz, George. 2001. "Not Just Another Social Movement: Poster Art and the Movimiento Chicano." In *Just Another Poster? Chicano Graphic Arts in California*, edited by Chon A. Noriega, 72–89. Santa Barbara: University Art Museum, University of California, Santa Barbara.

McKenna, Teresa, Richard Griswold del Castillo, and Yvonne Yarbro-Bejarano, eds. 1991. *Chicano Art: Resistance and Affirmation*. Los Angeles: Wight Art Gallery, University of California, Los Angeles. Exhibition catalog.

Noriega, Chon A. 2008. "The Orphans of Modernism." In *Phantom Sightings: Art After the Chicano Movement* by Rita González, Howard N. Fox, and Chon A. Noriega, 16–45. Los Angeles: Los Angeles County Museum of Art, University of California Press.

Pérez, Laura E. 2007. *Chicana Art: The Politics of Spiritual and Aesthetic Altarities*. Durham, NC: Duke University Press.

Pérez-Torres, Rafael. 2006. *Mestizaje: Critical Uses of Race in Chicano Culture*. Minneapolis: University of Minnesota Press.

Prago, Albert. 1974. *Strangers in Their Own Land: A History of Mexican-Americans*. New York: Four Winds Press.

Raab, Josef. 2003. "The Changing Face of the U.S.A." *ZiF-Mitteilungen* 2: 1–10.

Rodríguez, Richard T. 2009. *Next of Kin: The Family in Chicano/a Cultural Politics*. Durham, NC: Duke University Press.

Ruiz, Vicki. 2008 [1998]. *From Out of the Shadows: Mexican Women in Twentieth-Century America*. New York: Oxford University Press.

Sandoval, Chela. 2000. *Methodology of the Oppressed*. Minneapolis: University of Minnesota Press.

Steele, Claude. 2010. *Whistling Vivaldi: And Other Clues to How Stereotypes Affect Us*. New York: Norton.

Weber, David J., ed. 1973. *Foreigners in Their Native Land: Historical Roots of the Mexican Americans*. Albuquerque: University of New Mexico Press.

Yarbro-Bejarano, Yvonne. 1993. "Turning It Around." *Crossroads* 31 (May): 15, 17.

San Diego Donkey Cart
Reconsidered

David Avalos

Somewhere Between Disneyland
and the U.S. Constitution

I conceived of the *San Diego Donkey Cart* as a Chicano public art object
that would be located at the center of federal immigration bureaucracies
instead of the usual marginalized Chicana/o spaces. It was intended to
be an invitation to strangers to engage me in public conversations. I also
hoped that it might function as a media provocation. Even though the *San
Diego Donkey Cart* Project benefited as much from dumb luck as from
good intentions,[1] it is significant because it contributed to the develop-
ment of the San Diego/Tijuana region's border art by rallying the support
of a network of Chicano and non-Chicano individuals and organizations
committed to freedom of political and artistic expression.[2]

The *Cart's* brief appearance in downtown San Diego in 1986 man-
ifested my cultural and political point of view derived from my family
history and from my working relationships within various student, com-
munity, and arts organizations. That perspective focused my insights about
art and immigration issues in the border region. I grew up in (Old Town)
National City, California, in the 1950s, and I regularly visited relatives in
Tijuana. I became accustomed to crossing the street to play with some of
my cousins and crossing the border to play with others. In 1975, as a com-
munications major at the University of California, San Diego, I joined a
group of Chicanos and Chicanas who started a student newspaper. When
Arnulfo Casillas, the Vietnam veteran who guided our efforts, urged us to
name the paper *Voz Fronteriza* (Border Voice) because of our location in
a border neighborhood, it made sense to me.

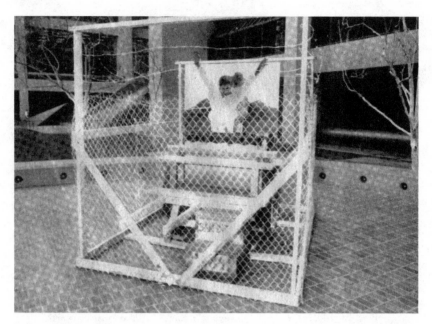

Figure 6.1. David Avalos, *San Diego Donkey Cart* (1986, mixed media, acrylic on wood, fence, barbed wire, 60 x 96 x 90 in.). Photographed in situ on the plaza facing the U.S. courthouse in downtown San Diego — then site of the U.S. Immigration and Naturalization Services (INS) offices and, the artist points out, the "epicenter of judicial decisions affecting the daily lives of immigrants throughout the region" — the installation sought to "provoke a response from INS bureaucrats." Published in *La Prensa San Diego*, vol. 10, no. 2 (January 10, 1986). (Photograph courtesy of the artist.)

The first story I covered for *Voz* took me back to my hometown to interview Herman Baca, organizer of a group of activists protesting the police killing of a Latino teenager. Soon, I would join Baca and others to found the Committee on Chicano Rights (CCR), a non-government-funded organization committed to the civil, constitutional, and human rights of Chicana/os.[3] Discussions with Baca and his mentor, labor organizer Bert Corona, contributed to my understanding that U.S. immigration policy was more about maintaining a cheap and easily exploitable labor pool than about controlling immigration. In the 1970s, Corona was the first to criticize César Chávez's tactic of reporting undocumented strikebreakers to the U.S. Border Patrol. Through Corona's influence, Chávez was finally convinced to unionize, not criminalize, undocumented farmworkers. In the CCR, I also met and learned from Peter Schey, a lawyer who in 1981 had successfully argued the Plyler v. Doe case before the U.S. Supreme

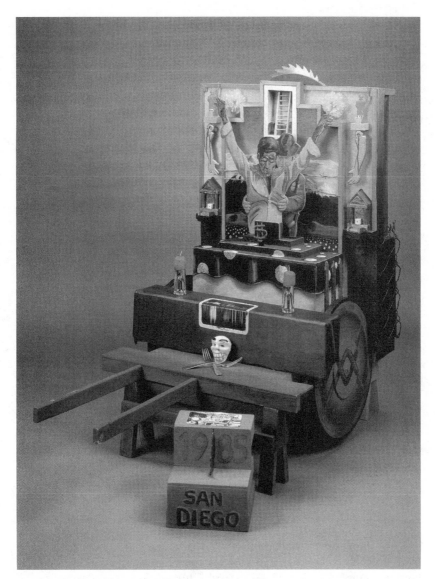

Figure 6.2. David Avalos, *Donkey Cart Altar* (1985, mixed media and acrylic on wood, 42 x 28 x 45 in.). An earlier iteration of *San Diego Donkey Cart*, this version (included in the CARA traveling exhibition of the 1990s) not only depicts an immigrant being frisked by a border patrolman (depicted on the altar's front) but—and arguably more significantly in a twenty-first-century context—the rarely seen back side incorporates a portrait of Francisco Sánchez, a man killed by the U.S. Border Patrol in December 1980. (Photograph courtesy of the artist.)

Court, resulting in a decision that prevented public schools from denying undocumented children access to education.

In 1978 I began working at the Centro Cultural de la Raza in San Diego's Balboa Park. In the late 1970s and early 1980s, mainstream cultural gatekeepers viewed the border as a bridge between the nationally recognized arts of the United States and Mexico. The Centro, dedicated to the creation, promotion, and preservation of Indian, Mexican, and Chicano art and culture, focused on what was happening in the cultural arena under the bridge. Border awareness was inculcated in Centro artists like Victor Ochoa, who had attended the grand opening of Disneyland in 1955 and later that year experienced Operation Wetback, the Eisenhower administration's official name for the Immigration and Naturalization Service's (INS) grandiose closing of the U.S.-Mexico border. Though a U.S. citizen born in Los Angeles, Ochoa was deported with his parents to Tijuana.

He and I, together with other Chicana/o artists at the Centro, first under the direction of Josie Talamantez and then Veronica Enrique, reflected on our individual border realities and began to articulate an artistic border consciousness. The realization that as artists we had something unique and urgent to say about our border home has influenced my work for more than twenty-five years. We surveyed the confluence of San Diego and Tijuana and embraced the idea that these border towns shared the same cultural hotbed. The Centro envisioned a cultural arena not dissimilar to that of Kumeyaay Native Americans, the region's first people, who have dwelled in an area embracing portions of what is now Southern California and northern Baja California for more than ten thousand years. In 1984 this border consciousness led to the Centro's sponsorship of the Border Arts Workshop/Taller de Arte Fronterizo (BAW/TAF), a multidisciplinary collaborative of Chicano, non-Chicano, and Mexican artists.[4]

Independently, I also sought ways to maintain my commitment to immigrant rights with socially and politically engaged art projects informed by my involvement with the CCR. As a self-taught artist, I absorbed the border region's familiar Mexican and Chicano folk, popular, religious, and tourist arts. At the Centro in the late 1970s, I began assembling border artworks influenced by everything from José Guadalupe Posada's pulque-chugging *calacas* (skeletons) to photographs of border protest marches to vintage automobile hubcaps. For inspiration, I shuffled a stacked deck of Catholic holy cards, *lotería* (bingo) cards, and border postcards depicting giddy tourists photographed atop Tijuana donkey carts.

Putting the Cart Before the Donkey

Tijuana donkey carts evolved from functional, animal-drawn work vehicles into platforms on wheels designed exclusively to be used to photo document tourist visits to "Old Mexico." On the bed of each cart sits a bench in front of a painted backdrop of a stereotypical Mexican scene. Festooned with painted sombreros and rainbow-bright serapes, the cart's undercarriage rests on wooden horses that lift garishly polychromed wooden wheels off the street, thus providing a stable, immovable stage for mounting and dismounting tourists. The immobilized cart is hitched, nevertheless, to a live donkey painted to resemble a zebra. As a child in the 1950s, I fell in love at first sight with this cultural absurdity.

In 1985, when Lynn Schuette, director of Sushi Performance and Visual Art Gallery, invited me to create a public artwork to be sited somewhere in San Diego, I imagined what a Chicano version of a Tijuana donkey cart would look like on a San Diego street. Looking beyond a donkey cart's preposterous splendor, I considered its possibilities as a border metaphor. Could a donkey cart, incapable of hauling anything anywhere, be reconfigured to convey social and political meaning? Perhaps, instead of dissembling border region tensions with comforting Mexican stereotypes, a cart could be assembled to reveal something about U.S. cultural and economic contradictions. Could a tourist cart get at the disjunction between U.S. citizens' pride in our so-called nation of immigrants and U.S. citizens' collusion with government and business in the exploitation of undocumented immigrant labor?

To find answers to my questions, I chose to place *San Diego Donkey Cart* on the plaza in front of the Edward J. Schwartz United States Courthouse and Federal Building complex in downtown San Diego. The courthouse is the epicenter of judicial decisions affecting the daily lives of immigrants throughout the region. Housed in the same building were the offices of the INS. In 1985, the CCR organized a picket at the plaza to protest the INS imprisonment of undocumented children as young as ten years old. The familiar site seemed a fitting venue to test the impact of a transplanted donkey cart. Because the INS offices overlooked the plaza, I figured that the *Cart*'s presence could provoke a response from INS bureaucrats spying the "¡Raza Sí—Migra No!" (The People Yes—The INS No!) slogan painted on its frame. I looked forward to the opportunity to parlay any overreaction into at least one newspaper article publicizing and documenting the *Cart*'s political intent.

As a Chicano artist, I further wanted a public work that would communicate beyond the physical limits of barrio walls and serve as a backdrop for a wider public dialogue. To better understand the nature of modern urban centers, I read Richard Sennett's *The Fall of Public Man* (1977). There he describes how human interaction in the public realm has degenerated, over centuries, to the point that we respond to strangers in public with silence and suspicion. As part of the *San Diego Donkey Cart* Project, I planned to station myself next to the artwork and invite passersby to talk about public issues. I wanted to discover if a donkey cart, reimagined as a public artwork, could transform public space into a forum for public discourse where strangers would converse with me about art, politics, and immigration.

Here Comes the Judge

On Monday morning, January 6, 1986, Chief Judge of the U.S. District Court Gordon Thompson Jr. arrived at work in downtown San Diego and came face-to-face with a donkey cart and its backdrop depicting a Border Patrol agent arresting an undocumented worker. Within hours, he issued a memorandum to the building manager stating that for "security reasons you are hereby directed forthwith to cause the removal of the structure standing in front of the United States Courthouse." The structure in question was the *San Diego Donkey Cart*, my public art transmutation of a Tijuana donkey cart. Instead of a stereotypical scene, such as an Aztec warrior cradling a Mesoamerican princess, I had painted the U.S. government's criminalization of migrant labor. Opinions ranged widely:[5]

> We didn't know if some kook would get into this . . . in the middle of the night and plant some bomb. (Gordon Thompson Jr., quoted in Jahn 1986)

> A classic First Amendment case. We think this is censorship based on political content. (Linda Hills, quoted in Harper 1986)

Thompson's order resulted in the *Cart*'s disassembly and confinement in the courthouse basement. This occurred despite a permit obtained from the building manager to place it on the courthouse plaza for two weeks as part of *Streetworks*, an exhibition sponsored by Sushi. Represented by

American Civil Liberties Union attorney Gregory Marshall, Sushi and I took legal action against the judge. For the remainder of the decade, the case plodded through various federal district courts and the U.S. Court of Appeals for the Ninth Circuit. Eventually, the U.S. Supreme Court refused to address our claim that Judge Thompson had violated my First Amendment rights. But the judge would find no such shelter in the court of public opinion.

After the *Cart's* "arrest," I hastily organized a news conference using the savvy I had developed in the CCR and at the Centro. Matching wits with Baca as we brainstormed media tactics for various CCR public events gave me confidence to engage the print and electronic media with respect to my constitutional rights as well as immigrant issues. I had also developed art media contacts while publicizing Centro art events. I contacted news journalists and art writers alike.

The *San Diego Donkey Cart* achieved its greatest public visibility through the mass media, not despite but *because of its removal* from public view on the street. The cart may have been missing in action, but the judge's proscription could not prevent me from talking to strangers at the courthouse plaza. On January 7, 1986, the strangers with whom I conversed were all members of the print and electronic media. In response to their questions, I spoke into cameras and tape recorders and watched my words transcribed into journalists' notebooks. The next day I read my quotes in the *San Diego Union-Tribune* while sitting at home, just like tens of thousands of the newspaper's other readers. And, while I was not involved in the public exchange I had planned—for virtually all forms of mass media are privately owned and privately consumed—I appreciated the media's diligence in highlighting the judge's repressive action and his bogus security alibi. The response continued for weeks and far exceeded my original expectations. Fair conclusions were drawn:

> Since when should anybody's First Amendment right be taken away just because of what some kook might do? . . . Should you be prevented from criticizing the government for your own good . . . for "security reasons"? (Michael Tuck 1986)

> Summary action was unjustified and unjudicial. We discount the security aspect and believe no great damage would have been done by allowing the assemblage to remain in place for two weeks, when it would have been removed without controversy. ("*San Diego Donkey Cart* Outrage" 1986)

Consuelo Santos Killens, a member of the California Arts Council, said calling the sculpture "a security risk is just a ruse." She said she would present to the arts council a resolution calling Judge Thompson's order "anti-art, anti-artist and unconstitutional." ("Sculpture Prompts Censorship Suit" 1986)

Outlaws in the Promised Land

The *San Diego Donkey Cart* significantly contributed to the development of border art. A Tijuana tourist icon supplied its artistic form, and the Chicano community's public activism in defense of immigrants' rights provided its subject matter and political stance. Judge Thompson's memo officially affirmed the *Cart*'s political and social content. Its disappearance revealed the contradiction of a federal court system functioning to deprive me of the U.S. Constitution's First Amendment protections. And, though removed from physical space, the ricocheting reactions it provoked in the contentious space of the law and the informational space of the mass media gave it real meaning.

While undocumented and unauthorized Mexican and Central American immigrants seem to exist in a public realm as media "celebrities," few physical spaces allow for meaningful social interaction and dialogue with them. Branded on society's consciousness as "illegal aliens," they are outside of the law yet constantly under public scrutiny via mass media and the Internet. Their reality parallels in certain ways the reality of slaves in the antebellum U.S. South. Though an integral part of plantation society, slaves were kept outside of social and political institutions through legal means. Similarly, undocumented laborers, no doubt including some janitors and gardeners working in and around downtown buildings like the courthouse, are indispensible to the economic life of the United States while they are kept outside of social and political institutions by U.S. immigration laws.

Though not in the ways I intended, the *San Diego Donkey Cart* Project taught me much about art's place in public life. Despite my failure to engage strangers in public conversation in physical space, I came to relish all of the unruliness and uncertainty the *Cart* unleashed. I lost artistic control and, in the process, found a network of mutually supportive individuals from diverse communities throughout the city. Artists, arts administrators, Chicana/o activists, educators, attorneys, journalists, editorial writers, and other engaged citizens and residents together viewed Judge

Thompson's travesty of justice as an opportunity for all of us to take our roles in an improvised civic performance. In various public arenas of power, we contested the insults to our reason and the limits placed on our creativity. The *Cart* carried us to places I could have never planned. Ultimately, I value the *San Diego Donkey Cart* for reaffirming the idea that new forms of socially and politically expressive art could find a place in border consciousness.

Notes

1. Throughout this essay I will refer to the art object as the *San Diego Donkey Cart* or *Cart*. By "Project" I mean the *Cart* and the planned and improvised actions surrounding its installation, forced removal, community organizing, media response, and legal actions.

2. The Project occurred within the context of an already existing regional border culture. The Border Arts Workshop/Taller de Arte Fronterizo (BAW/TAF) had taken its *Border Realities* exhibition to the Galería de la Raza in San Francisco in 1985. At the same time Louis Hock and Elizabeth Sisco were documenting the lives of undocumented workers in San Diego's north county with photographs and videos. In 1982 I chaired the Steering Committee for what we called the Border Culture Seminar at the Third International Conference of the United States–Mexico Border Governors. As a consequence, the conference formally recognized the border region as possessing a well-defined and distinct cultural identity. In 1979 artists had performed *Incarnated Silhouettes*, a multimedia choral poem about the border conceived by Manuel "Zopilote" Mancillas, sponsored by San Diego's Intercultural Council of the Arts/Community Arts and presented at five venues throughout the county.

3. In 1977, when the Ku Klux Klan announced its plan to patrol the border and apprehend undocumented immigrants, the CCR organized a march and rally at the border, denouncing the Klan and federal immigration policy and demanding that the Carter administration stop its building of a border fence in San Diego.

4. In 1984 Victor Ochoa and I had been invited by René Yañez to cocurate an exhibition at the Galería de la Raza in San Francisco. The five artists we invited to work with us on a border-themed installation became the cofounders of the BAW/TAF. Michael Schnorr was a non-Chicano visual artist who had painted murals in Chicano Park. Tijuana native Isaac Artenstein had recently directed the award-winning video documentary on Pedro J. González, a Spanish-language radio pioneer in Los Angeles and Tijuana in the 1920s and 1930s. Jude Eberhard was a filmmaker/producer and Artenstein's partner in the film production company Cinewest. Guillermo Gómez-Peña, from Mexico City, was a poet, essayist, and performance artist. He and Sara-Jo Berman, a dancer and performance artist, codirected the performance art group Poyesis Genetica.

5. More than a dozen references demonstrate the widespread media coverage of the Project, including two televised editorials and articles in the *New York Times*, the *San Jose Mercury News*, and various news services such as UPI. For more information,

readers may see 1986 articles by Victoria Dalkey, David Beck Brown, Margarita Bazo, Bob Dorn, Conrado Gerardo, Daniel Muñoz, and more. My own 1986 article in *Community Murals Magazine* outlines some of the controversies surrounding the Project.

Bibliography

Avalos, David. 1986. "The Donkey Cart Caper: Some Thoughts on Socially Conscious Art in Anti-Social Public Space." *Community Murals Magazine* (Fall): 14.

Bazo, Margarita. 1986. "*San Diego Donkey Cart*: Expression vs. Oppression." *Southwestern Sun* (Southwestern College, Chula Vista, CA), Feb. 12, n.p.

Brown, David Beck. 1986. "Political Art Stirs up Controversy." *Daily Californian* (La Mesa, CA), Jan. 14, 5A.

Dalkey, Victoria. 1986. "Riding on the 'Donkey Cart' Is Issue of Artistic Freedom." *Sacramento Bee* May 15, n.p.

Dorn, Bob. 1986. "Court Banishes 'Inappropriate' Artwork." *San Jose Mercury News*, Jan. 9, n.p.

Gerardo, Conrado. 1986. "The Donkey Cart Incident." *Voz Fronterizo* 11, no. 4: n.p.

Harper, Hilliard. 1986. "ACLU Files Against Judge Who Killed Donkey Cart Art." *Los Angeles Times*, San Diego County ed., Jan. 11, M1.

Jahn, Ed. 1986. "Judge Orders Removal of Artwork." *San Diego Union-Tribune*, Jan. 8, B1.

"*San Diego Donkey Cart* Outrage." 1986. *San Diego Union-Tribune*, Jan. 9, 10.

Muñoz, Daniel L. 1986. "Censorship on Local Artist by U.S. Federal Judge." *La Prensa San Diego*, Jan. 10, 1.

"Sculpture Prompts Censorship Suit." 1986. *New York Times*, national edition, Jan. 21, A21.

Sennett, Richard. 1977. *The Fall of Public Man*. New York: Knopf.

Tuck, Michael. 1986. "Perspective" (televised editorial). KGTV News–San Diego, Jan. 8.

A Remembered Dismemberment

David Avalos's *San Diego Donkey Cart*

Lynn Schuette

On a cool California morning, Tuesday, January 6, 1986, I walked from my organization, Sushi Performance and Visual Art, to the federal building and plaza through quiet downtown San Diego. I was meeting David Avalos to view his installation of *San Diego Donkey Cart*, which Sushi had commissioned as part of our first annual *Streetworks* project.[1] We had heard that the piece had caused some controversy, but I was not emotionally prepared for what I was to see — an empty plaza. The preemptive removal of the piece, after only two days of its scheduled two weeks, struck me as a violent dismemberment of a living artwork and an unnecessary and foreboding act of censorship. I now look back and recognize that its removal and the aftermath serve as a landmark in the political shifts that so dramatically altered public arts in Southern California and throughout the United States.

In the design of the *Streetworks* project and the selection of artists and artworks, our goal was to invigorate public spaces and engage a nonart audience, inducing people to question their beliefs and starting conversations about social and political issues as well as aesthetics. Commissioning four new works, the project also forced artists to think and create work for a public context and paid for its creation, not relying on a potential sale of the work in order to compensate the artist.[2] As the executive director of Sushi and the curator of the project, I chose the Avalos work for its innovation, content, and value as a temporary public artwork. The installation consisted of a multimedia replica of the donkey carts of Tijuana, which

provide an odd tourist photo opportunity. The folk-inspired carts are pulled by donkeys painted as zebras, and tourists are encouraged to wear sombreros and have their portraits taken. The Avalos work used a cart that was painted with an immigrant/undocumented worker being frisked by a Border Patrol agent and was surrounded by barbed wire. In the context of the San Diego/Tijuana region, this juxtaposition of imagery provided a startling and effective way to generate dialogue on many levels. It was provocative. I had hoped for a thoughtful and energetic discourse. What ensued went far beyond this anticipation.

The *Streetworks* project had received specific funding from the Visual Arts Program of the National Endowment for the Arts (NEA). Artist Mario Lara, the site coordinator, and I had worked with staff at the General Services Administration and received all necessary permits for the public installation. But a federal judge overruled this formal process and deemed the installation a security risk. The ensuing media coverage of the situation and the American Civil Liberties Union case, on behalf of the artist and Sushi, which alleged the judge's action were unconstitutional and a violation of First Amendment rights, brought a series of issues into focus. After three years, the U.S. Supreme Court refused to hear an appeal, letting stand a Ninth Circuit Court of Appeals ruling to dismiss the case, after a U.S. District Court found that the judge had a legal right to take action on perceived security threats.

It is important to note that David Avalos had carefully organized a community "tour" for his artwork. *San Diego Donkey Cart* opened with a Saturday evening performance/ritual by Guillermo Rosette and Poyesis Genetica (Guillermo Gómez-Peña and Sara-Jo Berman) on the sidewalk in front of Sushi, and it was shown at Centro Cultural de la Raza in San Diego's Balboa Park on January 19 to 25 and at Southwestern College in Chula Vista, California, on January 26 to February 4. A panel discussion with political activist Herman Baca was also part of the activities. After only two days of the two-week stay, scheduled January 5 through 18, at the federal complex, the work was partially dismantled and retained in the building basement. There in the basement, Robert Pincus, the *San Diego Union-Tribune* art critic, and other media representatives were allowed to view the installation in exile.[3] While the rest of the public viewings took place as scheduled, the preemptive removal of the installation from the federal building plaza was a clear act of censorship and marked a turning point in American public arts over the course of the last two decades.

* * *

Sushi Performance and Visual Art, which I founded in 1980, was part of the national movement of artists' spaces also known as "alternative spaces." As envisioned, these spaces were dedicated to presenting and supporting a new breed of contemporary artists who no longer fit into the limited opportunities provided by museums and the commercial gallery system. Many of these artists were socially motivated, having grown up with the civil rights, Chicano, and women's movements. They no longer felt constrained by formal aesthetics and its specialized audiences, and they felt a responsibility to incorporate social issues into their artworks, seeking to engage a broader audience. The basis of Sushi's programming was the belief that art must reflect its culture.[4] As a visual artist from a working-class midwestern family, I believe that this alternative art movement and its egalitarian value system perfectly fit my own need to actively participate in contemporary culture, where art has played a new and vital role.

My professional background also included work as the assistant director of Community Arts in San Diego, a multicultural and multidisciplinary arts program that was among the many important arts and culture organizations critical to the regional arts scene. In addition to Sushi and Community Arts, the San Diego border region had an active group of programs presenting visual art and performance, including the Border Arts Workshop/Taller de Arte Fronterizo, the Centro Cultural de la Raza, Installation, and the Multicultural Arts Institute. Also, two service organizations emerged that supported this new art: the National Association of Artists' Organizations (NAAO) in the early 1980s and the National Performance Network (NPN), founded in 1985.[5] The National Association of Latino Arts and Culture (NALAC) followed in 1989.

The *Streetworks* project relied on the provocative group of practicing artists who had settled in the region, many having graduated from the University of California, San Diego, and San Diego State University. Artists from Tijuana were also involved, including Felipe Almeida and Carmela Castrejon. During its seven years, the artists from whom the project commissioned works included James Luna, Walter Cotten and James Skalman, Michael Schnorr, Deborah Small, Roberto Salas, Mario Lara, Elizabeth Sisco and Louis Hock, Cynthia Zimmerman, and Robert Sánchez. In addition, Sushi was presenting performance art by Guillermo Gómez-Peña, Karen Finley, Paul McCarthy, Tim Miller, Holly Hughes, and Rachel Rosenthal. All of these artists were supported by and working in both artists' spaces and community organizations, expanding the boundaries of art making with social, political, sexual, racial, and personal

content—content that was appropriately complex, provocative, and potentially uncomfortable, but crucially topical.

The artwork of David Avalos and Sushi's *Streetworks* project also grew out of the politically charged cultural milieu of the San Diego/Tijuana border region, which included many social activist and human rights groups examining immigration and other current issues. Local media were writing about this new art and these public issues. Both the *San Diego Union* and the *Los Angeles Times*, which then had a local bureau, were actively covering this emerging and exciting art scene. And the publicity generated by the Avalos controversy was covered by the national press, including articles in the *New York Times*, taking the issues to a larger than anticipated audience.

<p style="text-align:center">* * *</p>

In spite of the acts of censorship that hindered their efforts, exemplified namely by the removal of Avalos's *San Diego Donkey Cart* from the federal building complex in 1986, artists in Southern California and throughout the United States continued to redraw the boundaries of artistic expression. During this time frame, the confluence of new engaged artists, art spaces, community and social service organizations, funding agencies, and an active media provided an important crucible for artistic freedom. Artists working with nontraditional subject matter and a multicultural, multidisciplinary perspective provided a new and vital art. The national network of spaces and programs dedicated to supporting, presenting, and promoting these artists and their art provided an invaluable mechanism for public interaction. National and local funding sources, led by the NEA, actively supported the new work. And an engaged press brought the dialogue to an extended mainstream audience.

Sadly, by 1992, the end of the seventh year of Sushi's street projects, the National Endowment for the Arts and other public funding agencies were being attacked regularly by the Heritage Foundation.[6] The overturning of grant awards to the "NEA Four"—Karen Finley, Tim Miller, John Fleck, and Holly Hughes—had been added to a growing list of notorious art censorship cases that included Andres Serrano and Robert Mapplethorpe.[7] It's not surprising that these instances—marked by political intimidation, censorship, and the denial of earned livelihood and artistic freedom—were compared fairly with the witch hunts and the red scare of the 1950s.[8] These so-called culture wars were instrumental in bringing an end to public funding for individual artists and diminished the National Endowment for the Arts, demolished the California Arts Council, and instilled numerous and lasting effects on other public funding sources.[9] The

dismantling of funding opportunities particularly hurt both artists' spaces and community organizations, which had previously flourished.[10]

As I think back on that morning in January 1986, I recognize that the *San Diego Donkey Cart* was a significant artwork, introducing a provocative new art to San Diego and generating a critical and lively debate about the nature of public art. I can now see the Avalos work as an exciting sign of art's ability to generate public dialogue about important social issues and its censorship as a harbinger of the end of the artistic freedoms that I cherish. Provocative public art no longer seems to exist, and opinions have become so polarized that the notion of a healthy discussion among differing viewpoints is almost inconceivable; as a result, most art is again safely limited to a specialized audience. During those heady years, I experienced a profound sense of the power of art and its potential as part of American democracy.

Notes

1. Sushi's emphases in the *Streetworks* project included presenting original artists' work that had been created specifically for this project and that used the "street" as imagery, metaphor, inspiration, and social forum.

2. In addition to David Avalos's *San Diego Donkey Cart*, the first *Streetworks* project included Frank Grow's *Cruci-fiction #3*, Mario Lara's *Topophobia*, and Marjorie Nodelman's *Roadscapes*.

3. Robert Pincus reported on the removal of *San Diego Donkey Cart* in 1986 and revisited the incident almost two decades later, in 2007, noting its historical importance.

4. In an interview with William Peterson, David Avalos expounds on this point: "Sushi is important to San Diego in that it's a model of an art organization that reflects contemporary society in terms of the artists it represents. . . . Lynn sees her art as connected with society and the face of society here in Southern California is not a white male dominated society. [There's] a wild mix of cultural diversity and a very overwhelming need to maintain some sense of history and tradition while feeling that one is empowered. . . . If you look at Sushi's programming over the years in terms of the racial and ethnic backgrounds of various artists you'll find a lot of diversity. . . . In terms of content of the work by a variety of artists including 'white' artists you'll find that the issues that concern people are equally diverse" (quoted in Peterson 1988, 70, 78).

5. Both David Avalos and I served on the NAAO board.

6. The Heritage Foundation report from 1989 misrepresented my role on an NEA panel and stated that I gave Sushi a grant. In reality, I was on an Inter-Arts preselection panel for artists' projects, and in accordance with the NEA conflict-of-interest policy, I did not participate in the discussion of a grant for Guillermo Gómez-Peña that used Sushi as its fiscal sponsor. Gómez-Peña was awarded the grant by the final selection panel.

7. All of the "NEA Four" had presented their work at Sushi prior to the scandal, and I wrote a letter of recommendation for Karen Finley's grant proposal.

8. Members of the arts community and media described the circumstances surrounding the *Streetworks* project as a "witch hunt." See Divina Infusino's timely article (1990).

9. In 1989, I wrote an article about art and censorship titled "Our Cultural Civil War."

10. At this time, Sushi was receiving support from three programs at the NEA—Visual Arts, Inter-Arts, and Dance—as well as the Inter-Arts program of the California Arts Council (CAC). In the early 1990s both the NEA and CAC ended their Inter-Arts programs, which were vital to both interdisciplinary artists and artists' spaces.

Bibliography

Infusino, Divina. 1990. "Strangling the Arts." *San Diego Union-Tribune*, Aug. 5.

Peterson, William Dwight. 1988. "The Contributions of the Sushi Gallery to Performance Art in San Diego." Master's thesis, San Diego State University.

Pincus, Robert. 1986. "An Ironic Focus for Street Art." *San Diego Union-Tribune*, Jan. 19.

——. 2007. "The Hidden Heart." *San Diego Union-Tribune*, May 6.

Schuette, Lynn. 1989. "Our Cultural Civil War" (working paper). In *Off the Back Burner: An Opinion Show*, Sushi Performance and Visual Art. Sushi Performance and Visual Art archive, 1980–2009, Mandeville Special Collections, University of California, San Diego.

The Border Door

Complicating a Binary Space

Richard A. Lou

I.

There has never been a free people, a free country, a real democracy on the face of this Earth. In a city of some 300,000 slaves and 90,000 so called free men, Plato sat down and praised freedom in exquisitely elegant phrases.

—Lerone Bennett Jr. (1966; 1967)[1]

It has become more and more difficult for me to take credit for *The Border Door* as it has expanded its sphere of operation and taken on a life of its own. As I carefully reexamined my motives, with the purchase of time, distance, and experience, I recognize how the people around me were formative in the realization of this piece. *The Border Door* is as much theirs as it is mine. So in order to attempt to move beyond the formal and ideological description of *The Border Door*, I needed to stop and listen as I began to gather the unrefined emotional impetus for this work. Lifting the many layers of my compartmentalized memories caused me to reexperience the great pain from which I have been disconnected. Pulling at veils of old and foggy impressions and without the comforting intellectual framing of ideology, history, humor, and my training as a visual artist, I found some of those places where my raw and roiling anger resided—anger slightly hidden and alone. I have often joked about the love affair that I have with my anger: my intellectual muse imbued with an insidious relentlessness. What I have learned is that it is also a bond among Chicana/os that simmers below our outward affections.

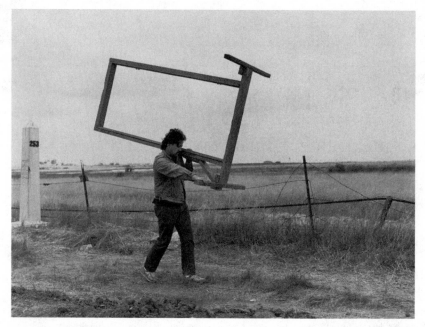

Figure 8.1. Richard A. Lou shown carrying the frame for *The Border Door* (1988). The collaboratively conceived and executed performative tableau is meant to eliminate all borders, a legacy the artist bequeaths to his family, past, present, and future. (Photograph courtesy of collaborating photographer Jim Elliott.)

As a Chicano artist, I find the recurrent themes of my work have been and continue to be the subjugation of my community by the dominant culture and white privilege. The artworks manifest themselves in the creation of counterimages and counterdefinitions made in an evolving, self-determinant manner. As a contemporary image maker, I am interested in collecting dissonant ideas and narratives, allowing them to bump into one another, to coax new meanings and possibilities that dismantle the hierarchy of power through images. The work serves as an ideological, social, political, and cultural matrix through which I understand my place in this world and through which I map my cultural shifts as a transitive member of my multiple communities. The artwork examines how the dominant community uses visual images and verbal language to dehumanize the "Other" in order to ignore the "Other's" basic human rights. *The Border Door* lies within this system of ideological creative production, fueled by emotional and psychological remnants that are embedded in my memories/experiences.

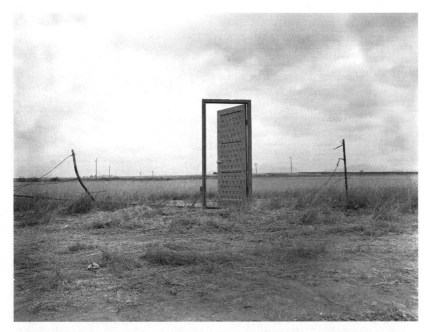

Figure 8.2. Richard A. Lou et al., *The Border Door* (1988, mixed-media [door, frame, and keys] installation/performance tableau, 7 x 3 x 5 ft.). A site-specific installation, *The Border Door* is conceptual — a freestanding framed door erected along a fence line in a barren field in the U.S.-Mexico borderlands. (Photograph courtesy of collaborating photographer Jim Elliott.)

"A Border Phenomenon"

My father, Lou Yet Ming, was a "paper son" from Canton Province, China, and he rightfully claimed that he was from the Delta in Coahoma, Mississippi. He was educated in both the United States and in China, traveling on trains and steamships as a young boy. A month after the bombing of Pearl Harbor, he enlisted in the U.S. Marine Corps and served for the duration of World War Two. He was honorably discharged from the Marines as a technical sergeant in San Diego, California. At thirteen, my mother immigrated alone to Tijuana with only a second-grade education and the gritty wisdom of a survivor. She was from Pánuco, a small silver-mining town in the mountains of southeastern Sinaloa, Mexico, some twelve hundred miles away. My parents met in Tijuana at a coffee shop where my mother worked as a waitress. The circumstance of their meeting highlights

their courage as an interracial couple in the 1950s brought together by a world war, the racist aftermath of the Chinese Exclusion Act, sexism, and poverty. I remember explaining all of this when I met David Avalos in 1987 at the Centro Cultural de la Raza in San Diego. David had called me for a meeting to talk about my photographic work *Inner City Portraits/ Self Portraits*. Astonished with my family's story, David would call my hybridity "A Border Phenomenon."

"Chino-Chino-Japones, Come Caca y No Me Des."[2]

My father worked as a butcher for Mayfair Market in San Diego and would ferry my oldest sister, Linda, and me across the border daily to go to Harborside Elementary School in Chula Vista. The *migra* (U.S. Border Patrol) would question our legitimacy and identity on a daily basis as we crossed the border into a destabilized sense of self. Then, in the afternoon, my godfather and neighbor, Jorge, would pick us up at the house of Jean Hom, my Chinese cousin, to return back to Tijuana. Once we entered Mexico, my godfather would drive to el Panteón Jardin (the Garden Pantheon), the cemetery, so he could pray for the soul of his dead infant son, and then to our colonia (neighborhood). Our young feet would caress the familiar terrain. The daily crossings, and their idiosyncratic meanderings, were informative and formative in the construction of my world view. In Tijuana we were part of the middle class, supported by my father's working-class union wages in the United States. As biracial children in La Colonia Roma, we were for the most part considered Mexican and accepted into a largely homogenous community; we were a novelty and a quiet curiosity. We were also subjected to lilting rhyming slurs, petitions circulated by our neighbors to have us removed from the neighborhood, and some of our "friends" telling us, "No puedo jugar contigo porque se me va a pegar lo chino" (I can't play with you because the Chinese will stick on me).

I remember playing baseball with my friends. I remember dodging the overloaded blue and white city buses while shagging flies. I remember roaming around the colonias with rocks in our pockets, smoking stolen cigarettes, playing with *las aguas negras* (open sewage, described as "the black waters"). I remember learning about the end of the world from my friend Chuy's father, Don Amador Ramírez. And I will always remember the secret fights about our race. What my parents endured will remain mostly a mystery.

"Go Back to Mexico!"

Our principal tried to have us removed from the U.S. school for living in Mexico, for living "outside of the district." My father showed up to a meeting with the school administrator in his Marine's blues, his stripes, and his Purple Heart, and that ended that. When I was about nine, we moved from our beautiful two-story home that my father built in Tijuana to a trailer park in Chula Vista, California. "Go back to Mexico" became a haunting and common refrain. Cultural conflicts and misunderstandings were a constant part of our family life as we navigated through our new surroundings. At Harborside Elementary School I was taught that my mother's hero Pancho Villa was a bandit. At Chula Vista Junior High, in metal shop, we had to learn how to weld a log holder for the fireplaces that none of us had in our homes.

At California State University, Fullerton, the only people on campus who looked like me were the janitors and two other Mexican American students, both named Art. By mistake one day I said, "¡Orale, Arturo! Qué honda?" (Hey, Arthur! What's happening?) Art Number One said, "My name is Art, and I don't do that Mexican thing!" Art Number Two's wife had to call off the security guards at the Sears in the Fullerton Mall when she overheard on the store radio that they were hunting for two suspicious-looking Mexicans. I was shopping for shoes for my graduation. During my history of photography class, a white male student turned around and leered at me. "Mexicans make the best car thieves," he said. Every filthy word and phrase in Spanish, English, and Spanglish would clatter against my clenched and grinding teeth, to be smothered against my fucking useless catatonic tongue. But it was too late; as class began, the lights were switched off, the white boy smiled and turned around in his seat, and Professor Johnson started the lecture with images of Minor White.

Back Stories for The Border Door: Antonio Sánchez y Petra Arredondo Lizarrága Sánchez

My grandmother, Petra, and grandfather, Antonio, would travel from their home in Culiacán, Sinaloa, to come visit us every summer after my grandfather's retirement from the Mexican Department of Transportation. They both had shocking white hair, small, rounded bodies, humble smiles, and a shuffle with a slight bend from the weight of years of manual labor. I would always ride to the airport in Tijuana with my mother to receive my

abuelos (grandparents) and help them with their bags. The routine was to seek an extended visitor/tourist visa at the port of entry in San Ysidro. My grandparents always had their papers in order, but that was not the point. I would sit in the stiff plastic chairs enduring the vulgar treatment my beloved abuelos received from being rudely questioned by the migra, the U.S. officials ignoring our cultures' deference to our elders. My abuelos' *pena* (shame), bewilderment, and uncertainty were agonizing to watch as I held my useless head in my useless hands. As a young adolescent I could not conceive what potential threat my grandparents posed to the United States other than going to Disneyland or the San Diego Zoo. My mother and father would answer all of the belligerent border agent's questions directly and courteously as my grandparents painfully wondered, quietly out loud, if their request would be denied. As a young boy I would seethe watching the *pinche* migra (damned Border Patrol) display their power. My mother would whisper to my grandparents, using her dark eyes to gesture toward la migra, "Malcriados y maleducados" (ill raised and ill educated). My abuela Petrita would say to her young proto-Chicano artist grandson, "Que pena" (What shame). Little did my grandmother know how costly each of those penas (shameful humiliations) were to me and how I would absorb them into my bloodstream: my blood would become thick with those burdens.

Maricela Rodríguez Ayala: A Braver Person I Have Yet to Meet

Maricela struggled, as an undocumented laborer working at a drugstore in San Ysidro, in order to support her mother, Gregoria, who was dying of cancer, and her younger brothers and sisters, who had been abandoned by their father years before. This strikingly beautiful, young brown woman with green eyes and crazy curly hair that overwhelmed her young, slender body took on the role of caregiver, protector, leader, and provider of hope. The fourth child out of ten, she did not hesitate or consider the possibility of an alternative in shouldering what would, for most, be an overwhelming task and responsibility. A year after her mother died, the Border Patrol physically removed her from her place of employment and returned her to Mexico. She called me from her house in Tijuana sobbing in humiliation and grief, repeating to me what the migra had said to her: "Go back to Mexico!" My girlfriend of three months was just deported. Ours was not your typical courtship narrative. Five years later, as my wife and mother to

our first child, she would help me paint *The Border Door* a bright gold, for *Gumshan* ("Gold Mountain," the Chinese concept of the United States), and count the 134 keys on the Mexican side of the door.

II.

The Chicana/o/Mexicana/o Movement is too important to be left solely to the grass roots organizations and the Chicana/o/Mexicana/o Art Movement is too important to be left solely to the artists.
— Marco Antonio Anguiano (1999)[3]

I would often wonder, as a young child, why my father and mother would not stop and let us ride the other colorful carousel on our family outings to Balboa Park. We would drive by the Centro Cultural de la Raza after a whole day at the zoo, and I would careen my head all the way around to mistakenly read the colorful murals as a carousel in motion. The Centro Cultural de la Raza was the place of my Chicano *nacimiento* (birth). Veronica Enrique, David Avalos, Marco Anguiano, Josie Talamantez, Guillermo Gómez-Peña, Robert J. Sánchez, Amalia Mesa-Bains, Patricio Chávez, James Luna, and all of the others I would bump into at the Centro and all of the other centros that were the collective *parteras* (midwives). The beautifully cavernous Centro provided the terminology and ideological framework to help me understand my pain growing up as a Mexican/ Chinese in a racist society. (Guillermo would later anoint me a "Chicanese.") The Centro taught me that when I assert who I am as a Chicano, I create counterimages and counterdefinitions, resulting in dissonance. The Centro facilitated the articulation of our Chicana/o identity, stating that we are standing in the midst of it, peering over our abundant sense of our selves, projecting out toward the world that we are. The Centro helped us recognize that our conflicted history resided in a landscape that is gorgeous and ripe, fruitful and punishing, dark, light, mythical, and saturated with the vibrant colors of our ancestral blood. I learned to embrace and transform my anger as I learned to embrace the dissonance.

The statement by my late and greatly cherished friend Marco Anguiano continues to be a tethering point for all the work that I do as a Chicano and as an artist. I was a Chicano before I knew that I was or what it meant or had known of its existence. His words reflect light upon my many shortcomings as I move forward, daily, toward breaking the distance between

his rarefied statement and my profane and humble deeds as an evolving being. I trust and hope that Marco continues to grace me with his guidance as he sits in Revolutionary Paradise.

III.

Entre el dicho y lo hecho . . . hay mucho trecho.
(Between what is said and what is done . . . lies a chasm.)
<div align="right">—*un dicho*/a saying[4]</div>

The Border Door Tunnel

The accompanying piece to *The Border Door* was the *Border Door Tunnel*, constructed for the *Casa de Cambio* installation in the *Border Realities IV* exhibition by the BAW/TAF, hosted at the Centro Cultural de la Raza in San Diego in 1988. The *Border Door Tunnel* consisted of a 30-foot-long by 36-inch-wide by 36-inch-tall tunnel, constructed out of wood. In the interior of the tunnel were three doors hung horizontally, with images and text documenting *The Border Door* performance. The first door was covered in a serape, with gold-painted keys covering the margins of the door. In the three kick panels, bordered by white lace, there was text describing the performance/installation. The second door was covered in canary gold Petition for Alien Relative I-130 forms; seven small 5-by-7-inch doors, lined up to divide the door in half lengthwise, would open to reveal black-and-white photographs of *The Border Door* performance/installation. The third and last door was painted a bright gold and completely covered in doorknobs. A cart with a light allowed the public to view the work. The cart was on a rope-and-pulley system so the audience could retrieve it. The tunnel also served as a ramp. The audience could choose how to interact with the tunnel/ramp—standing upright and walking on top of the ramp; crawling underneath the tunnel; or lying on the cart faceup and scooting their way through a dark and narrow tunnel with documentary "evidence" of *The Border Door* performance/installation to view inches from their faces. As people walked across the ramp, the more adventurous audience members would slowly inch their way in the tunnel directly below the feet of those "above ground," eventually arriving at the same place but with a different body of information. The *Border Door Tunnel* was constructed in a sanctioned art venue, unlike *The Border Door*. *The Border Door* was a public act of transgression informed by the borderland it briefly occupied,

to quote David Avalos, "outside of the law." Its defiant stance was not lost to me, but I also saw it as self-healing, transformative: it offered an opportunity to consider other models for hope.

We live in a highly conflicted land where it is seen as a contravention if we assert our desire for respect. Our hope is a transgression. And to seek dignity is an act of civil disobedience.

IV.

Art is one of the most sacred ways to communicate.
 —Consuelo Jiménez Underwood (1999)[5]

The Border Door *Is My* Don *(Gift)*—*It Was Given to Me*

The Border Door was authored by my grandparents, suffering the indignities of the pinche migra. *The Border Door* was authored by my father as he would recite out loud a language that he hated while holding a pebble on his tongue to grind away his beloved Chinese accent. *The Border Door* was authored by my mother, who fiercely defended her children against bigoted parents and taught us how to love being Mexican. It was authored by my oldest brother, Robert, who lived in two distinct worlds, a small farming village in Canton Province, before and after the Communist takeover, and the enormous suburban sprawl of San Diego. It was authored by my sister Linda, who as the eldest absorbed the brunt of the racist attacks while we were growing up in both Tijuana and San Diego. It was authored by my sister Mina, who, as a Jehovah's Witness trying to be a godly woman, attempts to bridge a multitiered relationship among her Catholic mother, who is independent and is respectful of her *don*; an older sister who questions her Catholic upbringing; an older brother who is a post-Nationalist agnostic leftist Chicano artist; and her younger gay brother, whom she loves and fears at the same time. It was authored by my gay brother, Francisco, and his partner, Jim, negotiating the love that they have for each other that is outside of an ill-defined and bigoted law in a bigoted nation. And it was authored by my niece, Michelle Muñoz, whose father died of a drug overdose when she was two and for whom I became a poor substitute father. *The Border Door* belongs to my dearly departed friend and mentor Marco Antonio Anguiano, who would often retell his story of his Chicano nacimiento as an important and formative point in his life. As a young boy he attended a Catholic school in San Ysidro and had the shit kicked out

of him by two racist classmates, to the point of sustaining a hernia. Ironically—and maybe not—one of his classmates was named John Adams. He would often thank them rhetorically for the beating and the lessons that beating brought to bear.

V.

The works I do are acts of love.

—Alma López (1999)[6]

Ultimately, the work that I create as a Chicano artist emanates from and is in response to the love I have for my family and my community. The work embraces the contradictions; the conflicts and triumphs; the quiet and raucous moments of a routine day; the flowering and the decaying; the markings and ceremonies that compose a lifetime, all within a society that subjugates its own people. At the core, all work I do is for them. And in that hopeful light, I am willing to take the chance that the power of the work will ultimately save my children and their children, who will become the inhabitants of a New *Nepantla* (a Nahuatl word meaning "the land in the middle") as they negotiate a home in this destabilized world. And, finally, *The Border Door* belongs to my wife, Maricela, who at the time of our meeting was an undocumented laborer supporting her younger brothers and sisters and living a half step from abject poverty in Tijuana. But most of all, *The Border Door* belongs to my children—Gloria Marisol, Maricela Alexandra, Magda Alexa, and Ming Alexander Yet. And it belongs to their bright future, I hope without unearned burdens, without humiliations, without anger, without borders, *¡sin fronteras!*

Notes

1. Lerone Bennett Jr. spoke at the Unitarian-Universalist Laymen's League in Boston, Massachusetts, on November 12, 1966, and made this statement. A recording of his speech is held in the Harvard University Divinity School's archives (Bennett 1966), and a transcript of the speech was published in the following year (Bennett 1967).

2. This subtitle references one of the childish slurs I remember from childhood. Translated into English it means, "Chinese-Chinese-Japanese, eat shit and don't give me any."

3. Commentary by Marco Antonio Anguiano from an interview during the *Hecho en Califas* art exhibit, which ran from 1999 to 2001.

4. My mother, Guillermina, would often use this saying.

5. Commentary by Consuelo Jiménez Underwood from an interview during the *Hecho en Califas* art exhibit, which ran from 1999 to 2001.

6. Commentary by Alma López from an interview during the *Hecho en Califas* art exhibit, which ran from 1999 to 2001.

Bibliography

Anguiano, Marco Antonio. 1999. Interview with Richard A. Lou. San Diego, CA.

Bennett, Lerone, Jr. 1966. "Freedom in Black and White." Convocation at "Future of Freedom" conference, Unitarian-Universalist Laymen's League meeting, Boston, Nov. 12.

———. 1967. "Freedom in Black and White." *Black World/Negro Digest* 16, no. 5: 4–8, 74–78.

Jiménez Underwood, Consuelo. 1999. Interview with Richard A. Lou. San Jose, CA.

López, Alma. 1999. Interview with Richard A. Lou. Los Angeles, CA.

Through The Border Door

Patricio Chávez

It is nevertheless the map that precedes the territory—precession of simulacra—that engenders the territory. . . . Today it is the territory whose shreds slowly rot across the extent of the map. It is the real, and not the map, whose vestiges persist here and there in the deserts that are no longer those of the Empire, but ours.

—Jean Baudrillard ([1981] 1994, 1)

Introduction

Sometimes an artist gives form to a work so eloquent in its simplicity that it transcends his or her personal experience even as it expresses it. The work then enters the realm of the most potent of symbols—it becomes a vessel open to the experiences of others and from which they too can extract meaning. *The Border Door*, executed in 1988 by artist Richard Lou, is an action, an installation, and an image that endures to this day.

The piece has become even more relevant as border issues and international conflicts escalate and old paradigms of nation-states, war, racism, violence, and greed play out. Even today, as the "war on terror" and "war on drugs" cast their long shadows of fear over the planet and are cultivated and used to manipulate people and nations alike, *The Border Door* offers an opening, a place for us to enter and walk through a veil of fear and deception. It is a revelation, this image that takes root when laid upon the map of the empire. Perhaps, as Baudrillard suggests, the territory no longer precedes the map. Abstraction is not of the map, the double, the mirror, or the concept; simulation is not of a territory, a referential being, or a substance; rather, "it is the generation by models of a real without origin

94

or reality: a hyperreal" (Baudrillard [1981] 1994, 1).[1] *The Border Door* allows us a brief but disquieting view, one that reveals deeper human truths and meaning, like Baudrillard states, "the desert of the real itself" ([1981] 1994, 1).

The Border Door was part of the *Border Realities IV* exhibition that took place in 1988 at the Centro Cultural de la Raza through the Border Arts Workshop/Taller de Arte Fronterizo. One of the Border Art Workshop's primary tenets was to identify this place, the San Diego/Tijuana border region, as its own place, a place of migration, and to recognize the movement of human beings as historical fact—something humans have always done. BAW/TAF challenged the prevailing rhetoric of the "immigration" paradigm that is inherently racist and xenophobic. *The Border Door* offers conceptual dignity and self-respect.

Defining the Work

The vocabulary and strategies of Richard Lou's work *The Border Door* are grounded in the Chicano movement precepts of community and collaboration. It incorporates postmodern strategies of deconstruction and critique through recontextualization, and it evolves the modernist notions of formal aesthetics into a poetic interpretation of the Lou family's personal experience living in the San Diego/Tijuana border region.

These layers of meaning reveal the rich fabric of the Lou family's personal-historical narrative interwoven with the greater social and political concerns of the complex realities of the U.S.-Mexico border region, the most traversed international border in the world.

The Act

In the act of placing *The Border Door*, Richard Lou takes the personal to the political. In creating *The Border Door*, he channels not only his own anger and frustration but the collective consciousness of communities with similar experiences.

As a child Richard Lou and his father would cross from Tijuana, Mexico, into the United States to go to school and to work. They would have their identity questioned daily, a profound experience for a child. Who am I? Who are my people? Where do I belong?

The piece was also influenced by the memory of crossing yearly with his grandmother from Mexico for her summer visits to San Diego and witnessing her treated with disrespect and suspicion—an especially disturbing act because of the almost saintlike esteem in which Mexicano children often hold their grandmothers.

And later, as a young adult, Richard witnessed the struggles of a young woman named Maricela, who would become his wife. Caught in an incomprehensible economic situation, she worked on the United States side of the border to support her brothers and sisters. The accumulation of experiences and a developing political consciousness inform Lou's critique of capricious U.S.-Mexican border policies and their blunt and direct effect on millions of lives. Depending on various factors, including the nature and mood of individual border agents and the mood of the nation, border policies are much more subjective than commonly acknowledged. *The Border Door* is not based upon a single incident or experience but on years of conflict, dissonance, resentments, angers, and frustrations, not to mention the collective and ancestral memories.

The Border Door and accompanying actions serve as a creative antidote to internalized colonization. The choice of movement over paralysis and stagnation, of self-affirmation over self-destruction, of life and creativity over death ultimately provides a political and spiritual action toward liberation.

The Border Door was an act. It was an act of articulating and giving voice rather than being silenced or mute in the face of daily contradictions of life in the border region. The reality of authoritarianism, racism, disrespect, and suspicion against a backdrop of the popular rhetoric of freedom, opportunity, and inclusion creates a cognitive dissonance that requires a dual consciousness. It enables one to navigate the so-called mainstream with all of its barriers, the subtle and not-so-subtle messages directed toward Mexicanos as being inferior and deserving contempt.

The act restores power to the charged moment of a child's powerlessness. The act loads the image with meaning and gives purpose to the installation. The act epitomizes something essential about the human spirit—that given the means, it can reach beyond limitations and claim that which is good and that which is truthful. It was not merely an act of defiance but also an act of human transcendence to place this doorway through a line of misunderstanding and misdirected power, a doorway through which others could pass. And to a child who witnessed authorized instances and attitudes of degradation directed at those he loved, it is an act of reconciliation.

The Installation

The Border Door evokes time and place. Its placement is clear—at the international border between two contemporary nations and, more specifically, at a certain location along that border between San Diego, California, and Tijuana, Mexico. It is a place that gathered meaning as a location between worlds and cultures and this side and that. But that meaning negated what had come before, an indigenous culture evolved over thousands of years, a colonial culture of five centuries, and some decades of no border of significance. People define and ground in "place"; it is where they derive from, gather sustenance, and belong. If the powers of place, or *genius loci*, are formed by events, *The Border Door* certainly made its mark in a timely way.

The Border Door follows Amalia Mesa-Baines's notion of "ceremony of memory" and serves as a site for pilgrimage and destination (1988). Offering no practical access or passage into the United States from Mexico, the piece rather functions as a spiritual location, an homage, and an altarpiece. The keys, those given out and to be taken to the altar through a pilgrimage and those left upon the door, act as objects upon the altar embodying the aspirations and dreams of those who came upon the piece. The door itself was painted gold, a direct reference to "Gold Mountain," which is what the Chinese immigrants called California during the California gold rush.[2] Another historical migration occurred at the very same time the U.S.-Mexico border was being established in 1848. The work, I think, was immediately understood by all of those who came upon it, even members of the U.S. Border Patrol.

As an image, it is stark, composed of a handful of elements: a framed doorway, a door, keys, fragments of a physically ineffectual fence, a portion of the greater landscape. Each component is loaded with meaning. Door-*ways* imply passage, entry, exit, connection, movement, and transition from one place to another. A door, on the other hand, allows passage or not. It can exclude; it can entrap. The doorframe frames air, the unseen. It is a construct and a construction, perhaps a social or political construct—but it's attempting to frame what ultimately cannot be limited or defined, which is an apt metaphor for the human spirit. Keys unlock; they open doors. They may honor and give privilege, like "The Keys to the City."[3] They may also unlock what is hidden and perhaps not understood. Holding the key to anything confers right of understanding and entry.

As an ephemeral piece, the work persists through the photographic image, through text, and through concept. The function of the

photography in *The Border Door* is important to bring up in the discussion of Richard Lou's work. Because it can be so easily overlooked or thought of as secondary to the installation itself, its importance is rarely recognized. Also, Richard Lou's artistic roots are in photography and were later expanded into performance art. The photograph acts as witness to an event and becomes an object that in and of itself is collected, viewed, and referenced. Much of the power of Chicano art has been in its ability to bear witness to a history and a people, a history that has been aggressively erased by others.

It is especially important to retain a visual history of this project and others like it, so its act and other actions like it continue to reaffirm the bearing of witness. The photograph also interprets and confers meaning and value to that which it images. The photograph, as used in *The Border Door*, goes well beyond description and narrative. It tells its story beyond a specific time and place. Each of the elements within the photograph speaks to the iconic nature of its elements—The Keys, The Door, The Landscape, and The Border.

When viewed as layers in some confused order of simulacrum, the photograph itself is not real, and the door is, then, not real. Instead, both reference other "realities." Some are painfully real (like the daily experience of crossing the border); others allude to maps drawn before there was territory, or, as Baudrillard suggests, a hyperreality.

The landscape is a discussion unto itself. The land is always imprinted with cultural values, and it keeps the long record of the actions of humans and all life, from a 10,000-year-old fire ring to a fence post to a footstep or to trails or to roads. Land is continuous, like the sky and the atmosphere and the ocean: it is one. That a group of men sat around as recently as 160 years ago and arbitrarily decided on a boundary some 3,000 miles away and then superimposed it onto a landscape reflects limited awareness and understanding and extreme arrogance. That this boundary would beget a future of fear, intimidation, and degradation was not considered.

Another one of the Border Art Workshop's primary tenets was to bring the margins to the center, so to speak, to recognize and bear witness to this place, the U.S.-Mexico border region. *The Border Door* is about the relationship a people have to their land, their place, and the recognition of the border as a region unto itself, its own place.

The Border Door reveals mundane symbolic representations of the pathways between the everyday internal familial spaces juxtaposed with the external greater world. The door offers a pathway through the protection of the inner familial sanctum. It also yields a passage between the sacred and

the profane; the placement of this mundane functional object addresses the larger global context of national borders, social-political mechanics, and controls. This recontextualizing strategy challenges the basic precepts of (family) home, (national) homeland, and our senses of place. It invokes the freedom to move physically, geographically, economically, socially, and spiritually.

The notions of access and equity are part of the conceptual framework and critique of *The Border Door* piece. Who is allowed into the United States by the gatekeepers, literally, is often based on what they look like and how they act. Race, ethnicity, and class are at the heart of the sifting process. Since 9/11 and the establishment of U.S. Department of Homeland Security policies, a new dimension entered the picture—not only economic migration but also the threat of terrorism.

As a child Richard Lou would cross the border with his father each day to go to school. At each crossing their identities would come into question by the border agents. The power flaunted to deny access, repeated day after day, is a potent psychological weapon used in the tactical control of the people crossing the border.

How appropriate is it that this complex personal and social history be manifested in the simple and profound act of placing a "golden door" on the border between the so-called developed and developing worlds? With their symbiotic history, the United States and Mexico have an undeniably intertwined *new world* future—one to be resolved together.

The passing out of keys juxtaposes the familiar and the profound. Ultimately, it is an act that has the effect of pulling back the veil and opening the door of the mind—to humanize a history perpetuated and framed in a very inhuman way by the gatekeepers, the so-called mainstream media and political establishment, not to mention the rhetoric and influence of the right wing.

Conclusion Riff

The Border Door is political action as performance art; it uses photography as memory and ritual, and it lends a ceremonial dimension to the process of community activism. Richard Lou is ultimately working in the liminal spaces of the international border region, the art world, and contemporary artistic media. He works with the internal liminal landscape of emotions, psychologies, and memory and expresses himself through his art. His art reflects the personal, political, and social realities of growing up on the

border with the layers of Chinese, Mexican, and American identities. His artwork foregrounds a postmodern Chicano experience.

Notes

1. Referencing a fable by Borges, Baudrillard elaborates: "The cartographers of the Empire draw up a map so detailed that it ends up covering the territory exactly (the decline of the Empire witnesses the fraying of this map, little by little, and its fall into ruins, though some shreds are still discernible in the deserts—the metaphysical beauty of this ruined abstraction testifying to a pride equal to the Empire and rotting like a carcass, returning to the substance of the soil, a bit as the double ends by being confused with the real through aging)—as the most beautiful allegory of simulation, this fable has now come full circle for us, and possesses nothing but the discrete charm of second-order simulacra" ([1981] 1994, 1).

2. "Gold Mountain" enacts a reference to Richard Lou's Chinese heritage; his father was Chinese and his mother was Mexican.

3. Being given the Keys to the City is an honor bestowed upon a resident or visitor, often for service given to the community. It is derived from the idea that the most esteemed persons are allowed "freedom of entry" to and from the city.

Bibliography

Baudrillard, Jean. [1981] 1994. *Simulacra and Simulations*. Translated by Sheila Faria Glaser. Ann Arbor: University of Michigan Press.

Mesa-Baines, Amalia, ed. 1988. *Ceremony of Memory: New Expressions in Spirituality Among Contemporary Hispanic Artists*. Santa Fe, NM: Center for Contemporary Arts.

Public Interventions and Social Disruptions

David Avalos's *San Diego Donkey Cart*
and Richard Lou's *The Border Door*

Guisela Latorre

Introduction

David Avalos and Richard Lou have emerged as pioneer installation and multimedia artists from the San Diego/Tijuana border region. As former members of the renowned artistic collective the Border Arts Workshop/ Taller de Arte Fronterizo and as highly visible solo artists, they have critically redefined the practice of public and site-specific art in the United States. Challenging the idea that public art ought to be primarily decorative, apolitical, and reflective of a hegemonic ideology, Avalos and Lou have made critical interventions into public space, often disrupting the business-as-usual model of corporate or state-sanctioned public monuments. These artists have situated their work, both physically and discursively, within the border region because they possess a heightened consciousness about the violent and contested history of this charged site. Their work questions the very existence of this border and the extreme inequities that it has ushered in, yet they also underscore and celebrate the cultural hybridity that emanates from it. Their site-specific and mixed-media installations reclaim the hypercolonized space of the border on behalf of its marginalized citizens: the undocumented immigrants who cross it every day, the residents of the nearby colonias and impoverished neighborhoods, the subordinated laborers of the maquiladora (assembly factory) industry, and the like. Even though their work spans more than

two decades and utilizes a multiplicity of artistic media, the focus of this essay will be two of their most critically acclaimed and publicly controversial pieces, namely, the *San Diego Donkey Cart* (1986) by Avalos and *The Border Door* (1988) by Lou. These two pieces responded directly to the growing militarization of the U.S.-Mexico border and the increasingly hostile attitudes and policies against immigrants during the 1980s. These installations were also produced at a time when the practice of border art was receiving a great deal of attention from the arts media, thus imbuing artists like Avalos, Lou, and others with a great deal of visibility.[1]

While this newfound popularity afforded Avalos, Lou, and other frontera artists greater resources, a broader audience, and wider dissemination of their politically engaged art than they had before, the media attention also presented a threat to the grassroots and community-oriented function of this engagé art. Border art was in danger of becoming commodified and co-opted by an arts media that did not fully comprehend the complex history of the U.S.-Mexico border. In spite of these concerns, Avalos also saw the benefits of this increased visibility within the arts community:

> We wanted our work to be seen and discussed in all available places including art spaces, both alternative and mainstream/gate keeping. We did not consider our work as less legitimate in galleries and museums, just different. If our work in museums attracted viewers that would otherwise not attend such spaces—all the better.[2]

Border Arts Workshop/Taller de Arte Fronterizo: A Brief History

The members of BAW/TAF, an artistic collective formed in the Tijuana/San Diego border region, are undoubtedly the pioneering and trailblazing figures in the history of border art. Founded in November 1984 by Avalos, Michael Schnorr, Isaac Artenstein, Jude Eberhard, Guillermo Gómez-Peña, and Sara-Jo Berman, BAW/TAF became the first artistic group to make border issues a central component of their mission. Even though the group gained much artistic success and recognition during the 1980s, their membership was in a constant state of flux, largely because of disagreements and conflicting artistic visions among its members. Avalos left the group in 1987, and Lou worked mostly as a solo artist, even while still affiliated with BAW/TAF. Even though Avalos's and Lou's connection to BAW/TAF was relatively short-lived, both artists were still working with

the group at the time their installations were created. These two pieces were thus deeply affected by the dialogue around border issues that was transpiring among the ranks of BAW/TAF during the 1980s.

The *San Diego Donkey Cart*:
Tradition Meets Subversion

"The border is not a line at the edge of a map," Avalos has commented, but, rather, "the border is a central component of U.S. cultural consciousness" (Nieto 1988). It is this conceptualization of the border that has driven much of his work since the 1980s. In 1985 Avalos created what would become one of his landmark mixed-media installations: the *Donkey Cart Altar*.[3] To construct this installation, Avalos utilized one of the carts in which tourists usually pose for photographs in Tijuana. As he would later recount: "I felt that I had found a way of working that enabled me to fall back on popular traditions of Mexico and invest them with contemporary political ideas. . . . What I focused on was a Tijuana donkey cart, which is really more tourist art than popular art" (Nieto 1988). Donkey carts like these epitomize a largely fictitious image of Mexico's agrarian past, which has been inscribed in the tourist imagination for many decades. Of course, here the irony resides in the very fact that these tourist curiosities about "simpler" rural times are found in the hyperurbanized environment of Tijuana. Furthermore, this irony became utterly absurd when Avalos noticed how the carts are usually set up for tourist consumption: "The amazing thing about these carts is that they're so dysfunctional now that they have to be propped up on wooden horses so the wheels don't even touch the ground. . . . Even though these carts are wonderfully colorful, the photographs they take are black and white. In order for the *burro* to stand out better, they paint him with black and white stripes. So you have this incredible absurdity" (Nieto 1988). These donkey carts revealed for Avalos the inherent absurdity of stereotypes themselves, thus allowing the artist to expose their artifice and deception easily. Like many other Chicana/o artists of his generation, Avalos understood that the process of representation was rigged with racist and colonialist ideologies, so the role of the socially committed artist was to overturn those representations or expose them for what they are: shams.

Avalos altered the donkey cart to resemble a Día de los Muertos (Day of the Dead) altar by including two votive candles and a skull. Art historian Víctor Sorell has indicated that the individual commemorated in

this cart/altar is Francisco Sánchez, a forty-year old man "shot to death by the Border Patrol on December 8, 1980" (1988, 128). Avalos placed a portrait of Sánchez on one side of the installation, while on the more visible side we see an anonymous border-crossing immigrant who is being detained and searched by a Border Patrol agent. Avalos included a number of poignant elements in this installation that deeply inform his audience's reading of the work. Directly below the body of the detained immigrant one sees a dollar sign, alluding to the dream of financial stability that motivates many immigrants to cross the border but also to the financial benefits reaped by the U.S. economy in having the cheap and unregulated labor of undocumented workers available. Several other objects that are critical to our reading of this installation flank the two central figures. Next to the upraised arms of the immigrant we see two *cempasúchil* (marigold) flowers adorning the altar. In cultural juxtaposition to the Mexican cempasúchil, Avalos placed two plastic figurines of the Statue of Liberty directly next to the flowers. As a nationalist symbol, the Statue of Liberty has come to epitomize freedom and the "American Dream," in particular to the European immigrants who came to the United States via Ellis Island in the early twentieth century. But here Liberty is literally and figuratively turning her back to this non-European immigrant who has access to neither freedom nor to the "American Dream."

The meaning of the *San Diego Donkey Cart* was further enhanced by its location in a publicly contested location, namely the federal courthouse in San Diego (Berelowitz 1997, 81). Even though Avalos had secured the proper permission to install the piece in this location for a two-week period, he found that his work was briskly removed after only one day in situ. Judge Gordon Thompson, who determined that the piece posed a security risk, carried out the removal order. "We didn't know," Thompson explained, "if some kook would get into this chicken-wire-and-box arrangement in the middle of the night and plant some bomb" (quoted in Joselit 1989, 126). The removal of the *San Diego Donkey Cart* signified for Avalos and his supporters an act of unmitigated censorship, for this location was critical to the audience's understanding of the piece. As public art scholar Erika Suderburg has explained, "'Site' in and of itself is part of the experience of the work of art" (2000, 4). Avalos in particular felt that this forced removal stripped the *San Diego Donkey Cart* of its power and potential for generating dialogue around the issue of immigration. He had planned to visit the location himself every lunch hour during the two weeks that the installation was meant to be in situ: "I could have had conversations with people about the public issue of immigration, [and] about

public art," Avalos said (Nieto 1988). The piece's hasty and unjustified removal from the courthouse thus denied the installation the full measure of its artistic and political potential.

The Border Door: A Portal into a Decolonized Space

Two years after Avalos's *San Diego Donkey Cart*, Richard Lou would make an equally radical intervention into public space with *The Border Door*. The artist had been invited by El Centro Cultural de la Raza (the People's Cultural Center), San Diego's premier Chicana/o/Latina/o/ indigenous exhibition space, to contribute a piece for their annual show. While the invitation was to create a work of art for the specific site of el Centro, Lou opted instead to take his work to the border itself. Lou placed a freestanding door hinged on a frame right on the border, just a few miles from the Tijuana International Airport. Attached to the surface of the door were 134 keys hung on nails (Berelowitz 2003, 164). The door could be opened from the Mexican side of the border, so it functioned as a symbolic invitation for would-be immigrants to cross the border with dignity. As Lou explained: "When Mexican migrant workers cross they are forced to do it in a humiliating manner. They have to crawl under the barbed wire or through the drainage pipes and then run in the darkness like frightened animals" (Border Arts Workshop 1988, 6). Lou was also prompted by his own family's experience with border crossing; the Immigration and Naturalization Services had raided his future wife's place of work and deported her while they were dating (Berelowitz 2005, 337). His personal connection with the border was further heightened by his own hybrid identity as the child of a Chinese father and a Mexican mother, one who grew up in the San Diego/Tijuana region.

While Lou was not necessarily seeking to make an aesthetic statement with this piece, *The Border Door* was a sight to behold in the barren landscape of the border region, often described as a no-man's land, a place where people pass by but never stay. Aside from providing a symbolic portal into a dignified existence in the United States, *The Border Door* also transformed the space of the border itself, thus disrupting the desolate and inhospitable environment of the region. Doors such as these are often associated with notions of home while also signaling the transition between public and private spaces. Lou was responding not only to the public denigration of undocumented immigrants but also to the vilification of the border itself as a space of vice, criminal activity, and alterity. For Lou, the

border was also a site of cultural citizenship, hybridity, and possibility, operating as the permanent home to entire populations. As such, the physical locality of the border deserved the same respect as state-sanctioned public spaces in Mexico and the United States. Like Avalos with the *San Diego Donkey Cart*, Lou found that the radical message behind his installation would quickly be suppressed. The Border Patrol took down the piece after only two days in situ. While *The Border Door* as site-specific public art was short-lived, the concepts and ideas that informed its creation far outlived its existence.

As a performative extension to this project, Lou visited local colonias and a shelter house for the poor called Casa de los Pobres (Home of the Poor) in Tijuana to hand out additional keys, thus encouraging people to cross through his door (Border Arts Workshop 1988, 46). Lou documented the reactions of the various individuals who received keys, encountering everything from confusion to knowing recognition of Lou's intentions as a community-driven artist. Children, the artist was surprised to find out, were most receptive to his project: "Children immediately surrounded me. As I described *The Border Door*, the kids became very excited and promised to distribute the rest of the keys. I watched these young emissaries run like new ideas, scattering to fill a void. I wished them well and walked back home crying because I knew in my heart and mind that what I was doing was right" (Border Arts Workshop 1988, 46). Like Avalos's desire to interact with the public, Lou's visit to the colonias signified the importance that dialogue played in his site-specific work. The artwork was not contained in the door itself, but rather in the intangible yet profound community interactions and alliances he forged in the process. The distribution of the keys was the means by which he built these community bonds, allowing him to spread information through the dissemination of everyday objects. Like Brazilian artist Cildo Meireles, who in the 1970s inscribed subversive messages against his country's political regime in Coke bottles and banknotes and then put them into circulation through the country's consumer-economic system, Lou's keys moved through social networks in Tijuana's colonias, disseminating decolonizing knowledge and subversive critiques of the social structures that maintain the border.

Conclusion

While much of the art world gravitated toward site-specific work for the sake of experimentation and to challenge the confines of the museum and gallery space, Chicana/o artists such as Lou and Avalos were fueled by a

desire to make art that was closer, and thus more relevant, to disenfranchised communities. The work of these two artists reclaims physical and discursive territories denied to people of color. Avalos and Lou have taken back the public and urban spaces denied to Latina/os and other marginalized populations of the United States. They also reclaimed an art practice that had been defined as the province of white European and North American artists by the arts media, namely, the practice of making conceptual, installation, and site-specific art. Latina/o visual culture is deeply steeped in public arts traditions. One need only look at elements of barrio decor, especially murals, *altares*, and lowriders, to understand how a heightened consciousness of space and site drives much of this cultural production. Thus, in uncompromising and fiercely unapologetic ways, David Avalos's *San Diego Donkey Cart* and Richard Lou's *The Border Door* have etched an indelible mark on the history of U.S. public art.

Notes

1. Critic Jo-Anne Berelowitz took notice of the art world's fascination with border art: "In the 1980s the art world, ever eager to highlight a new trend, announced that border art was it. Critics in New York, Chicago, Los Angeles, and other art world centers adjusted their myopic focus to accommodate distance, periphery, and margin. Suddenly art produced along the United States–Mexico borderspace became hot, and critical discourse abounded with terms such as cultural hybridity, liminality, and bicultural identity" (2003, 143).

2. David Avalos, e-mail exchange with the author, Nov. 20, 2008.

3. One year prior to the creation of the *San Diego Donkey Cart*, Avalos created the *Donkey Cart Altar*, which was on display in the landmark exhibition of Chicana/o art, *Chicano Art: Resistance and Affirmation*.

Bibliography

Berelowitz, Jo-Anne. 1997. "Conflict over 'Border Art': Whose Subject, Whose Border, Whose Show?" *Third Text* 40 (Autumn): 69–83.

———. 2003. "Border Art Since 1965." In *Postborder City: Cultural Spaces of Bajalta California*, edited by Michael Dear and Gustavo Leclerc, 143–82. New York: Routledge.

———. 2005. "The Spaces of Home in Chicano and Latino Representations of the San Diego–Tijuana Borderlands (1968–2002)." *Environment and Planning D: Society and Space* 23, no. 3 (2005): 323–50.

Border Arts Workshop/Taller de Arte Fronterizo. 1988. *The Border Arts Workshop (BAW/TAF) 1984–1989: A Documentation of 5 Years of Interdisciplinary Art Projects Dealing with U.S.-Mexico Border Issues*. San Diego, CA: BAW/TAW.

Joselit, David. 1989. "Living on the Border." *Art in America* 77, no. 12 (December): 120–30.

Nieto, Margarita. 1988. Interview with David Avalos, conducted at the Southern California Research Center, San Diego, CA, June 16 and July 5. Archives of American Art, Smithsonian Institution, Washington, DC.

Sorell, Víctor Alejandro. 1998. "'Telling Images Bracket the 'Broken-Promise(d) Land': The Culture of Immigration and the Immigration of Culture Across Borders." In *Culture Across Borders: Mexican Immigration and Popular Culture*, edited by David R. Maciel and María Herrera-Sobek, 99–148. Tucson: University of Arizona Press.

Suderburg, Erika. 2000. "Introduction: On Installation and Site Specificity." In *Space, Site, Intervention: Situating Installation Art*, edited by Erika Suderburg, 1–21. Minneapolis: University of Minnesota Press.

Thoughts on Dos Pedros sin Llaves

Luis Tapia with Carmella Padilla

Pedro and Pedro stand together on the same side of the towering prison door. Caged behind its massive frame, with no keys to make an escape, the men quietly consider their surroundings.

One Pedro turns his back to the steely gate. His arms firmly crossed, he stares blankly into the empty depths of his cell. He is resigned to his fate.

The other Pedro looks through the straight iron bars, his burly form confronting the obstacle before him. Though he shows no emotion, his stance belies his desire to believe that, perhaps, there is a future beyond the prison cell. Perhaps he is not powerless after all.

Dos Pedros sin Llaves (Two Peters Without Keys), which I sculpted in 1994, is a multilayered artwork that in many ways reflects the journey of my creative life. It is a piece about identity, failure, struggle, faith, and how each of us deals with the barriers that continually block our path. Are we destined to fail or determined to succeed? At the same time, the work tells a story about the evolution of my Hispano/Chicano culture. As a contemporary example of an art form developed in New Mexico over hundreds of years, the piece illustrates who we are today and where we've been.

Although I typically refuse to analyze my own work, I realize that by understanding the context in which *Dos Pedros sin Llaves* was created, the viewer might come to better appreciate the culture in which it was born. The discussion must begin with a brief history of religious folk art in Hispano New Mexico.

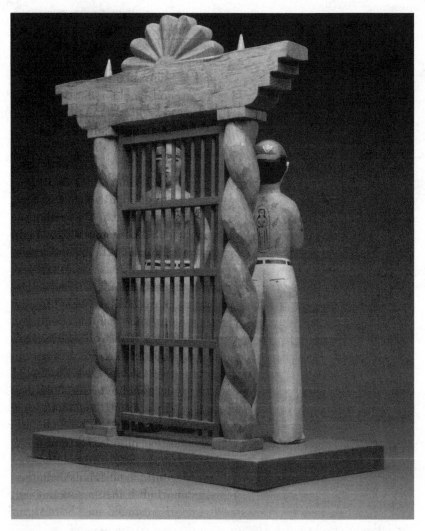

Figure 11.1. Luis Tapia, *Dos Pedros sin Llaves* (Two Peters Without Keys) (1994, contemporary bulto/carved tableau, pine, gesso, acrylic, 25 x 11.5 x 7.25 in.). Regarded in New Mexico as the saint to whom *pintos* (prisoners) petition to obtain their freedom, Saint Peter becomes humanized and familiar, perceived as a mere mortal Pedro. (Photograph courtesy of the artist and the Owings Gallery, Santa Fe, New Mexico.)

Saints and Struggle

Every culture through time has developed a distinctive way of using wood to tell a story. In New Mexico, religious wood carving, commonly called "santero art" in reference to early wood-carvers, developed shortly after the Spanish colonization of 1598, which established the area as the northern-most province of New Spain. Religious artworks from the Spanish empire and beyond were imported to New Mexico, including elaborate santos (images of saints) in the form of three-dimensional bultos (sculptures) and retablos (two-dimensional paintings and large-scale altarpieces). Created in wood or stone, and embellished with expensive imported paints and gold leaf, these images reflected the latest artistic styles in Spain, other European countries, and Mexico, which in 1821 won independence from Spain and claimed New Mexico as its own.

But imports were expensive and slow to arrive in the isolated northern frontier, leaving New Mexicans to create their own religious artworks for church and home. Using locally available woods, such as cottonwood, aspen, and pine, as well as local and imported paints, they carved and painted innovative reproductions of Spanish and Mexican saints. A distinctive regional expression of a sophisticated global art form took root, and it would come to be celebrated for its own unique artistry, character, and style.

Central to this artistic tradition was a zealous devotion to the Catholic Church, which these works were intended to inspire. As they took their places in churches and on home altars throughout the province, images of Jesus, the Virgin Mary, and the Catholic saints became main characters in the everyday lives of Hispanos, close members of the family to turn to in good times and bad. In this way, the artistic and spiritual tradition of santos was passed down through the generations.

I was born into this Catholic tradition in 1950 in the small village of Agua Fria, just outside of Santa Fe, New Mexico. Santos filled the house I grew up in, and my mother even placed plastic saints on the dashboard of her car. In Catholic schools, I learned about the lives of the saints, how these once-human figures struggled in their earthly lives until their belief in God inspired them to perform miracles and propelled them to eternal heaven.

At the time I was struggling, too. I didn't know it then, but I was dyslexic. School was overwhelmingly difficult, causing me to skip classes as early as third grade. Instead of traditional learning skills, I had an artistic

motivation. I loved to draw and use my hands. I spent hours combing through art books and the encyclopedia, looking at pictures of art. Art was everything to me.

My teachers didn't understand my learning problems, and their punishment for my erratic behavior was harsh. They took away my art and eventually suppressed my creative drive. I was forced to dig in and get through school. I stubbornly adapted my own way of learning to the subjects of reading, writing, science, and math. And I succeeded, graduating with honors from St. Michael's High School in 1968.

Nonetheless, I grew up frustrated and feeling incomplete. I was a rebel, in and out of trouble, yet I was determined to get to college. But once I made it to New Mexico State University, I struggled to keep up. It felt like going back to elementary school, except this time, I gave up and got thrown out. I returned to Santa Fe and joined the workforce. I married and had two kids. Sensing my continued frustration, my former wife, Star, wisely encouraged me to explore my creative side.

A Cry for Justice

It was a pivotal time, not only in my personal life, but also in the life of my culture. In New Mexico and nationwide in the late 1960s and early 1970s, the streets were teeming with social unrest. In the Hispano community, names like Reies López Tijerina and César Chávez gave voice to the previously unspoken subjects of stolen land grants, worker justice, and civil rights. I got involved in their cry for justice, demonstrating in the streets and using the politically charged term of *Chicano*, though I didn't fully understand what it all meant. I had grown up surrounded by the distinctive art, music, and traditions of my culture, but I had taken all of it for granted. Now I strived to comprehend just how these aspects had shaped my life and identity.

Questioning myself and my world, I began to develop my art. I sought out information at Santa Fe's renowned Museum of International Folk Art, which housed one of the world's largest collections of Spanish colonial New Mexican santos. The curator allowed me to study the centuries-old works of the master santeros; one by one, the santos gave me lessons in craftsmanship, Catholic iconography, and personal expression. They gave me new knowledge about my culture and myself.

I started to carve in my own very primitive, self-taught style. I copied the old pieces in faithful form and detail to create exact stylistic reproductions.

I traveled into the mountains to collect locally grown woods for carving and pigments from which to make traditional gessos and paints. I was meticulous in my imitation of the old ways, at first carving only for myself and giving my work away. As my work improved, I began charging for my santos. Finally, in the mid-1970s, I was accepted into Santa Fe's Traditional Spanish Market, the country's most prestigious venue for artists of New Mexico and southern Colorado working in Spanish colonial styles.

It was a great feeling of success as people began to admire and purchase my work. My research also had led me to develop skills as a traditional furniture maker, and I sold my colonial New Mexican furniture reproductions at the market as well. Mainly, I focused on refining my santos. Before long, however, I was bored. Making the same prescribed image of Saint Francis or Our Lady of Guadalupe time after time caused old feelings of stifled creativity to resurface. I desperately needed to feed my family, and selling exact reproductions produced steady cash to supplement wages from my full-time job. But I needed something new.

The preservationist standard-bearers who controlled the market dictated that santos should be exact copies made to look old and somewhat crude. But I believed that such static definitions were irrelevant in the modern world; I wanted my art to represent the world we live in today, just as the early santeros expressed the world and time in which they lived. I carved new subjects, such as Noah's ark and the Last Supper, not commonly found in the traditional santo repertoire. I made traditional santo iconography more spectacular, adding brilliant auroras, sun rays, or other touches that made old subjects look new. Finally, I brought it all together with a boldness of color that I believed was key to expressing the power and vibrancy of the saints.

Like wood, the use of color dates to ancient times and diverse cultures, when cave walls and, later, grand pyramids were embellished with bright color to document ritual and everyday life. Finding that homemade paints would not achieve the vivid expression I desired, I experimented with store-bought paints, ultimately using acrylics to produce the intensely bright palette of primary colors for which my work would become known. My use of color pushed me beyond the edge of acceptability for the conservative Spanish Market, and I was asked to leave. The rejection stung, though in hindsight, it delivered me closer to where I wanted to be.

Still strongly identified with the social movement of the late 1960s, I now integrated social commentary into the traditional santo form. The old santos were still important in Hispano life, but the culture was clearly changing. While I wanted to stay true to the craft and purity of carving

wood, I felt that my art should document that change. Thus my work became more nondenominational than Catholic. I began transforming such religious images as Joseph and Mary, who once searched for shelter, into contemporary figures of José and María who spend their days on the streets. For the establishment, it was a radical and somewhat controversial shift in perspective. Personally, it was a slow artistic transition, but my individual style began to gel.

From Saint Peter to *Dos Pedros*

In the midst of this transition, I created a particularly memorable work. While sculpting a figure of Saint Peter, the great gatekeeper who holds the keys to heaven, I struggled with questions of how to make him different, more meaningful, unique. Finally, the answer came: I would depict the gates of heaven as a Peñasco-style door, a style that originated in a small northern New Mexican village and is distinguished by layered patterns of laminated wood. The finished piece was simple enough: Saint Peter stands, keys in hand, outside of a Peñasco door. If you were New Mexican, you would recognize that door and perhaps see something of yourself in the piece as well.

Compared to my work today, this early work may seem inconsequential, but at that time in my development it was groundbreaking. For long after, the image stayed with me. More persistent than the image was the idea that one man, Saint Peter, holds the keys to heaven's gate, dictating who will or will not pass through. The idea led me to think about a more ordinary guy named Peter, the kind of man Saint Peter might have been before he was a saint, a man who faced the challenges of living in the world today. Perhaps he was that *vato* (guy), Pedro, who was doing time in the penitentiary. What if he was among the countless *pintos* (prisoners) who had no keys—no way of getting out, enjoying an unbound future, and making it to heaven?

And so *Dos Pedros sin Llaves*, like all of my work, was born from a stream-of-consciousness conversation with myself. I wanted to depict how easy it is to put ourselves in situations we can't control. I also wanted to address young Hispanos about how increased violence leads to larger prison populations, about how lack of education leaves people with fewer choices and, ultimately, less power.

The issue of perspective was critical to the viewer's involvement in the work. Using the inside-outside viewpoint, I allowed the viewer to be both

uninvolved and part of the action at once. Standing outside looking in, one is simply an observer. By shifting one's perspective to that of the prisoners, however, one shares their experience. It's not the most comfortable place for a viewer to be, but it is perhaps the most profound.

Dos Pedros sin Llaves is less colorful than most of my work. Indeed, life in prison is rather colorless; relationships are managed in shades of black and white, while the institution is a floor-to-ceiling study in cement and concrete. The piece makes an exception for a touch of local architectural color: the prison gate is capped by a traditional wooden corbel with a central rosette, a motif that dates back to early Christianity. Instead of color, tattoos embellish the figures, illustrating how religious images are no longer confined to church and home. In prison, as in everyday life, tattoos are used as a form of self-expression. More literally, they are used to shield prisoners from bodily harm. Finally, we see a bit of pinto fashion in the figures' clean, well-pressed khakis, which some prisoners have tailored to their own personal style.

Like in *Dos Pedros sin Llaves*, in other works I have continued to address the plight of young Chicanos. The 2006 work *Juan Diego* shifts the context to a more recent time. Here, Juan Diego is a poor Chicano street kid, as opposed to the venerated Mexican peasant from Tepeyac before whom the Virgin of Guadalupe miraculously appeared on a hillside in 1531. That early Juan Diego wore Our Lady's image on his crude peasant's cloak, but this Juan Diego sports her iconic figure on the front of his T-shirt. Like his predecessor, this Juan Diego also has a proud history. We see it in his shadow, which blooms beside him in the shape of a brilliant Aztec headdress.

While my work often addresses themes and issues that are relevant to Hispano culture, it shouldn't be characterized as purely Hispano. New Mexico today is part of a greater global culture, and the issues we contend with here are world issues that affect us all. For instance, in the 2005 work *Man Trapped in His Religion*, a naked man sits tangled inside a gilded glass box that is too small for his muscular form. I created the work to express my belief that organized religion of any denomination can be carried too far. Instead of setting us free, organized religion entraps. Is this really where God wants us to go?

Clearly, art is how I communicate my vision of the world. But in the end, I don't want my work to be simply about me. I don't wish to analyze my work. I put it out there for you, the viewer, to decide what it means in your heart. You are responsible for letting the piece pull the expression and the questions, and perhaps even the answers, from you. My role,

meanwhile, remains in the revolution, in the ongoing fight to step out of myself to express the world in which I live.

Today, my personal and artistic identities are clear. For all my criticism of the organized church, my faith remains my number one asset. Through faith, I've changed how people view our traditional art, and today more Hispano artists are taking the same path. It hasn't been easy trying to find places to exhibit and ways to survive financially. Like my two Pedros, I once faced a tightly shut door. I didn't get through on the first try, but eventually, I broke the door down. Of course, once you step through that door, it's all uphill.

Thoughts on St. Peter Is Imprisoned

Nicholas Herrera with Sallie Gallegos

In his youth, Nicholas Herrera was a wild Chicano child, living hard and burning his candle at both ends; he was his own worst enemy, hell-bent on self-destruction. Sober reflection on past actions was the catalyst for his 1998 carving *St. Peter Is Imprisoned*.

By age twenty-seven, Nicholas had himself been imprisoned on eight occasions in Española, New Mexico, for a variety of offenses, including drunk driving, kicking a police car, and accidentally shooting out the main electrical transformer in Chama, New Mexico, during annual Chama Days festivities.

On Christmas Eve 1991, Nicholas was in a head-on collision, which nearly ended his life. He had been drinking that snowy night when an oncoming vehicle (also manned by an intoxicated driver) traveling at high speed collided with his. Nicholas was thrown from his vehicle and remembers seeing his car continue to roll past him. The other driver was unharmed but fled the scene. Here follows Nicholas's account of the point when his life began to change:

> I saw sparks on the pavement while my car was still rolling. Then I went into another world. I wasn't here anymore. I was floating on a raft in the middle of a river. I was flat on my back but aware that people were standing on the banks of the river calling to me. There were men and women in robes. Some of them were good, and some were bad, but all of them were telling me to stay.
>
> Floating on the raft, I felt no pain. I felt great, and I remember thinking, "If this is heaven, it's nice."

117

Next I was in an emergency room at the Española hospital. The doctor used electroshock to bring me back. After that, there was intense pain everywhere in my body. I was back, but the doctor had told my mom I wasn't going to make it. Later, she told me that she always knew I would pull through.

I spent one week in the hospital. I was supposed to be there longer, but I walked out. I dragged myself out of bed with a broken back and went home.

Unfortunately, Nicholas's brush with death was not profound enough to compel him to change his ways immediately. He continued carousing, womanizing, using, and abusing alcohol every step of the way. However, the first art he produced after his accident is a 47.5-by-23-inch retablo (altar painting) titled *San Pedro*, which depicts Saint Peter fighting for Nicholas's soul. This was his first work paying homage to Saint Peter. In the retablo, Saint Peter is handing Nicholas a key, which represents the universal choice we all have to make, an image that proves Nicholas had acknowledged his behavior with regret. He recalls his motivations for the piece:

I felt that I had betrayed Jesus with my addictions and womanizing. But I found him the right way by almost dying. The inspiration for the retablo *San Pedro* came to me the way all my art comes, in a vision. I usually don't even have to make a sketch. Remembering all the shit I've been through comes out in my art. Saint Peter told me, "I'm going to save you, but the keys aren't yours yet; you've got to earn those keys, the keys to the kingdom."

Religion is my work. Religion is my life. I don't go to church much, but I feel that things happen for a reason, so you could say that God is my inspiration for my art. It's like the current piece I call *The Road to Heaven or Hell*. We all have choices. Some of us take the road to hell because we haven't suffered enough. There are some people who have already gone through hell on earth, but they still refuse to change. That's why so many end up in prison. That is their choice, because they decide to go with the system and make it their home.

In 1992, Nicholas Herrera was once again arrested, this time in Los Alamos, New Mexico, for evading arrest in his Datsun 280Z while driving without a license. Nick says he finally "let them" catch him, and he was sentenced to three months in jail. He was let go on leave once, but he

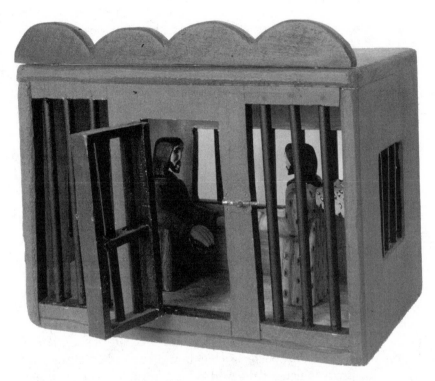

Figure 12.1. Nicholas Herrera, *St. Peter Is Imprisoned* (1998, contemporary bulto/carved tableau, mixed media, 15 x 17 x 11 in.). Christ's appointed gatekeeper to the kingdom of heaven was himself an inmate ordered imprisoned by King Herod Agrippa I. (Photo by Jean Vong, provided courtesy of Paul Rhetts, LPD Press, Albuquerque, New Mexico.)

returned to the jailhouse intoxicated and had to serve an additional two months with "no more leave."

Jail time gave Nick time to think, to ruminate on the downward spiral his life had taken. He thought about the future and what he wanted to do when he got out. Ironically, his first art show took place in Los Alamos a few months after his release, and it was the result of connections he made while serving his sentence. Nick relates the importance of that connection:

One of the jailers liked my work, so I gave him the drawing I was playing with. He liked it so much that he said he was going to show it to his wife, the curator at Fuller Lodge [Art Center], next door to the jail. Before I was released, he told me I needed to meet his wife to see what she had to say about my work. We met, and she thought my work was pretty cool,

so she gave me time to do some art, and I had my first show at Fuller Lodge in Los Alamos.

It was all meant to be. That's why I went to jail in Los Alamos—because that's how I met the curator whose enthusiasm about my work inspired me to keep producing art. Her recognition made me feel, maybe for the first time in my life, that I had worth. I always hated school and was even punished for doing artwork when I was supposed to be following lessons. It's hard to be a free spirit.

After the first show, I developed self-confidence and put my work through the jury for the Spanish Market in Santa Fe. My pieces were accepted, and I continued to show at the Spanish Market, where I became known to collectors. I kept up with the Spanish Market for years; that contact was an excellent stepping-stone to my full independence as a modern artist. I eventually quit showing at the market because they have too many rules. I was ready to move on independently, but I'll always be grateful to the people at Spanish Market.

As he reflected on his frightening past and what he learned in jail, it was fitting that in 1998 he produced a third tribute to Saint Peter, *St. Peter Is Imprisoned*. By this time, Nicholas Herrera had been sober for years and had made his way to fame in the world of art. In jail, he had become an avid reader and studied his favorite saints. He also took a close look at the people he encountered in jail.

A good day was when I saw people who were really fucked up. It made me think, "Man, I think I'm going to be OK." A bad day was when the jailer wouldn't let us smoke. Or we'd get a shitty jailer who was racist, and they'd try to provoke you to blow up, so you could really do time. I came close to blowing, but I learned that people with anger are going through what you're going through. That taught me that I can't go down to their level. In the past, I would have acted without thinking to get it done, but that attitude changed in jail.

I've always had the mentality to be a good criminal, because I know the only real secret is the one you keep to yourself. That's what worries me. Like I've always had the predisposition for addiction, my family has had a long history of being on the wrong side of the law, starting as far back as La Mano Negra [the Black Hand, a vigilante organization that fought against U.S. encroachment on Spanish land grants] in northern New Mexico. That concerns me, and that's what I fight every day of my life. The devil is always ready to get you back in his game. He works

24/7. Whiskey is the worst drug for me and it's legal; that's why it's so dangerous. Then with Indian, Spanish, and Irish blood, I'm susceptible to be pulled down again. But through my work, I've found a way to release all of those emotions, like love and hate. So having an outlet, my art, gives me a way to release stress and anger in the appropriate way.

I think what set me on the wrong path in the first place was seeing violence from my dad when I was young. Everyone in the family saw it, but some are in denial. My mom was an artist too, so she recognized that violence affected me worse, on a different level. After I started showing signs of abuse, she used to say, "If my Nicky lives to be twenty-five, he's going to make it."

My dad was doing what he had probably witnessed in his family. He was a tough man, not the type to say, "I love you." That's in me, too. When Mom was preparing for her own death, she had me take her to the mortuary to pick out what she wanted. She knew her time was coming, but she refused to be buried at the El Rito Cemetery. We buried her at home near my studio, like she wanted. She lived with me before her death. Sometimes she'd start talking about dying. So I'd take her outside in her wheelchair to watch me dig her grave. Then she'd say, "I'm not dead yet, Nicky. Take me in the house." So I'd take her in the house until the next time.

She did artwork before her death; it was therapy for her. She did work recounting her childhood in El Rito. She used nail polish or anything she could get a hold of. I have about a hundred drawings she made.

My inspiration for Saint Peter and the angel (*St. Peter Is Imprisoned*) came when my career was taking off. I was remembering all the shit I've been through, and my work is the way I document my life. I'm still earning the key into the kingdom. If I had not had a near-death experience, I would have ended up dead or in prison. The angel in *St. Peter Is Imprisoned* is the angel who assisted Saint Peter when he was imprisoned. The significance of Saint Peter handing me the key in the first *San Pedro* is that he is giving me the freedom to do what I was put here for, which is the same reason the angel assisted Saint Peter.

It's like my piece *Protect and Serve*, which is in the Smithsonian. Jesus is in the back seat of a cop car, because if he were here now they'd arrest him, thinking he's a crazy rainbow kind of guy. Many think the piece is sacrilegious because it is controversial. But that's life . . . controversy is life. I see myself doing God's work on earth, and if people don't like it [his art], they don't have to deal with it. But they usually have to deal with it because they have to look at it.

In Matthew [16:19], Jesus told Peter: "I will give you the keys to the kingdom of heaven. Whatever you bind on earth shall be bound in heaven; and whatever you loose on earth shall be loosed in heaven." When the risen Christ came before the disciples at [the sea of] Tiberias, he gave to Peter the famous commands to "feed my lambs," "tend my sheep, feed my sheep" [John 21:15–21:17].

Anyone with faith understands that Saint Peter is dutifully carrying out his promise through Nick's intervention. For those who disagree, perhaps they have neither studied nor suffered enough. For Nicholas, there is no doubt that Saint Peter came to his assistance, which not only saved his life but is also allowing him to fulfill his own mission. Nicholas Herrera might be misunderstood, but he is a messenger; God's messengers do come in many forms.

Pedro in the Pinta, Have You Seen My Keys?

Inside the Art of Luis Tapia and Nicholas Herrera

Tey Marianna Nunn

From a museum curator's perspective, the sculptural works *Dos Pedros sin Llaves* (Two Peters Without Keys) by Luis Tapia and *St. Peter Is Imprisoned* by Nicholas Herrera are powerful and poignant. Both examples visually testify to the ever increasing and vital cultural critique provided by artists who reframe and reimagine "traditional" art forms, in this case the New Mexican "Spanish colonial style" of carving santos, or saints. While both Luis Tapia and Nicholas Herrera are deeply rooted in the historicity and cultural legacy behind their art form, they are adamant in remaining true to whom they are as artists. Both have fought, and for the most part have won, the aesthetic battle against imposed colonial stereotypes of what New Mexican Hispanic art is or should be.[1] For their efforts, both have achieved recognition as contemporary artists inside and outside of New Mexico. Tapia and Herrera are also well-known for the wry wit and pointed humor, not to mention the twists and turns, they bring to their masterpieces. Their individual experiences in the art and culture wars have strengthened both artists' determination, allowing Tapia and Herrera to be fearless in their creativity. They are driven to visually translate the deeply embedded issues and often controversial realities faced by the Hispano/Chicano communities in New Mexico. Through their art these issues become even more symbolic and are embraced as universal issues (for example, poverty,

crime, drugs, and racism, to name a few) faced by many Latino communities throughout the United States and the Americas.

Tapia's title, *Dos Pedros sin Llaves* (Two Peters Without Keys), is powerful in and of itself. Tapia renders the everyday Pedro, or Peter, who does not have keys like his biblical namesake. Depending on their individual paths in life and the resulting outcome, these Pedros may or may not find access to heaven. Tapia depicts his Pedros in the *pinta* (jail). Each faces away from the other, pondering his situation and uncertain future. Questions jump into the mind of the viewer. Is there hope or no hope? Are they looking out or looking in? "*Sin llaves,*" without keys, do they or don't they have access? The title of the piece symbolically removes the keys from both figures and allows Tapia to make an important cultural critique about power and the powerless.

Dos Pedros sin Llaves is also somber in color, not enhanced by the bold palette Luis Tapia has built his career on. The gray of the jail cell door and platform immediately conveys the gravity of the situation. The Pedros in the pinta are solemn and serious, facing bleak prospects. Again, there are no pearly gates here. Fate and choice will play into the next chapter of this visual story. At the same time, interestingly, the tattooed vatos (guys), while standing inside the gates, are not necessarily spatially confined there by the artist. The space around the doorway and around the male figures is open, allowing for the possibility of either or both Pedros to access heaven at some other point in time. But will they move and grow into the future, or will they remain stuck where they are?

Inmates and prisoners have long figured in Chicano art and literature. Poetry and *paños* (handkerchiefs), to name only a couple of integral art forms, emerge out of incarceration experiences. These are experiences that unfortunately social and economic circumstances often enforce, yet the images and words produced in the pinta contribute to the artistic canon of Chicano culture. Herrera's *St. Peter Is Imprisoned* also places San Pedro in the pinta. The artist depicts the figure bound with shackles around his wrists. The cell, while warm in color, has no amenities whatsoever. Again, it is a harsh and hard backdrop. The scene references Saint Peter's imprisonment by Herod Agrippa I. This account in the life of Saint Peter indicates that while he was in Herod's prison, an angel appeared at night to open the gates and let Peter cast off his chains and escape. One of the intriguing aspects about this work is that while the title demonstrates that Peter "is imprisoned," and it certainly appears that way, the jail cell door is wide open. Is San Pedro free to go, or is he just beginning his prison term? Should he stay or should he leave?

The intentional placement by both artists of Peter against specific New Mexican architectural backdrops references their strong sense of geographical place as well as Tapia's and Herrera's individual, personal experiences. There is a distinct aesthetic to both works. Tapia's doorframe, which surrounds and holds in place the cell bars, incorporates a number of typical New Mexican architectural elements. The hand-carved rope columns illustrate the Moorish-influenced chip carving, a technique used to create rope patterning. This design is inspired by the braided rope belt worn by Franciscan friars. The corbeled lintel features a half rosette with finials on either side. In Herrera's work the scene plays out inside an adobe-style jail structure. The roof treatment includes a line of lunettes, or half-moons, typical design elements in New Mexican art and architectural design. Herrera has placed the figures of Saint Peter and the angel on the inside looking out. Rather than serving as gatekeeper, Saint Peter cannot control who enters the gates.

Religious iconography has been used throughout time to teach and visually translate church doctrine. Saint Peter is traditionally depicted as an older man with white hair and beard, dressed in flowing robes. His iconographical elements often include a set of keys to the gates of heaven. Instead of romanticizing this significant religious personage, the way he has been for centuries, both Tapia and Herrera critique and reframe the apostle. They approach San Pedro, not as a historical figure in the past, but rather as a contemporary man faced with contemporary social issues. As was often the case with much of the imagery in New Mexican santero tradition, the figures look very much like self-portraits of the artists, or at least like people they know. These Peters are younger men with dark hair. In the case of *St. Peter Is Imprisoned*, Saint Peter even has a beard and goatee. In Tapia's *Dos Pedros sin Llaves*, the two Pedros are vatos, with well-pressed and deeply creased pants. Tattoos with protective religious images adorn both figures. One wears a bandanna, while the other wears a sports-logo baseball cap backward.

The pearly gates, or gates to heaven, also serve a significant purpose in both sculptures. Gates and cell doors can be interpreted as portals; here the portals not only are New Mexican but are transparent and transformative. Gates and cell doors can be accessible or impenetrable. They can allow an individual to pursue a dream or prevent him from doing so. Gates can physically separate, placing people, things, or ideas inside or outside. Decision makers, gatekeepers, and even sometimes bouncers make the decisions at these points of entry and exit to let people in and out: people with keys are people with power. Interestingly, in their respective sculptures,

Tapia and Herrera have rendered San Pedro/Saint Peter simultaneously powerful and powerless, depending on how the viewer reads and positions himself or herself personally within the work.

Contemporizing saints to make them relevant to the times in which we live is nothing new. Luis Tapia and Nicholas Herrera are essentially following in a centuries-old tradition of artistic depictions of famous figures from religion. Challenging safe perspectives and reflecting on present-day social and cultural issues are effective components of being an artist. Artists often lead the way in critiquing their surroundings by drawing from their own experiences. Through their artworks *Dos Pedros sin Llaves* and *St. Peter Is Imprisoned*, Luis Tapia and Nicholas Herrera lament that not all Peters or Pedros get into heaven. Life circumstances, especially the experiences and challenges facing Hispanic youth in New Mexico, often ensure that many Peters and Pedros remain outside the gates, rarely entering heaven with permission.

Notes

1. Author's note: Curators have been known to categorize artworks and the artists who create them differently than the artists themselves may. I intentionally utilize and interchange the terms *Hispanic, Hispano, New Mexican, Nuevomexicano, Latino,* and *Chicano,* depending on the context, the topic, or the issue I am addressing. In doing so, I pay particular attention to individual artists and how they self-identify.

The Persistence of Chicana/o Art

Contemporary *Santeros* Reinterpret a Traditional *Santo*

Víctor A. Sorell

There is general agreement by Chicano artists that santos, *including* retablos *and* altares, *and the tattoo art produced by our* pinto *brothers in the prisons are considered the two original Chicano art forms.*

—José Montoya (1981, 27)

This chapter resists a myopic perception that bultos and retablos, the santero's religiously and spiritually inspired creations placed in situ within church altars (altares), are not, strictly speaking, expressions of Chicano art because they predate the Chicano political movement that from the 1960s onward nurtured a contextual, largely politicized and vibrant Chicano visual culture. Notably, Luis Tapia and Nicholas Herrera are two prominent contemporary santeros who witnessed and/or participated in El Movimiento (the Chicano civil rights movement) and are *herederos* (inheritors) of a centuries-old santero tradition in New Mexico. Tapia, in fact, also restores traditional santos in need of repair (Salvador 1995, 77).[1] Herrera and Tapia's santos dating from the 1990s are hardly anachronistic in their more contemporary contexts, calling as they do for a colloquial response from late twentieth- and early twenty-first-century New Mexicans. Fittingly, José Montoya, arguably one of the *pioneros* (pioneers) of politically engagé Chicano art, recognizes this unabated rhetorical call-and-response aesthetic, referring to santeros as "original" Chicano artists.[2]

Herrera and Tapia's two contemporary bulto tableaux—imbued with more of a *rasquache* spirit than with the solemnity or gravitas usually associated with santos of earlier centuries—invoke and reinterpret Saint Peter, a recurring subject in the venerable Nuevomexicano (New Mexican) santero tradition.[3] Regarded in New Mexico as the saint to whom prisoners petition to obtain their freedom (Griffith 2000, 54–55), Saint Peter becomes humanized and familiar, perceived as a mere Pedro (Peter) in the work of Nicholas and Luis.[4] Notwithstanding Saint Peter's biblical iconographic significance as one of the original twelve apostles, that feeling of familiarity may hinge in part on his own *in vincula* (in chains) imprisonment, ordered by King Herod Agrippa I in 41 to 44 AD. Traditionally depicted holding keys in his right hand, Peter was Christ's appointed gatekeeper to the kingdom of heaven. In the context of this essay, admission to paradise and release from prison are not mutually exclusive journeys. To argue that *Dos Pedros sin Llaves* (1994) might be considered a public ofrenda (offering) crafted in behalf of pintos (prisoners) is not to engage in idle hyperbole when this tableau is juxtaposed with a series of mural-sized photographic works (variously titled *El Guadalupano* and *La Guadalupana* [1998]) produced by another New Mexican artist, Delilah Montoya.[5] Votive candles and other altar staples have been placed before the photographic murals depicting a dorsal view of a handcuffed pinto (*El Guadalupano*), on whose back is emblazoned a large tattoo of Our Lady of Guadalupe (*La Guadalupana*).

Pinto tattoos, also foregrounded by José Montoya as novel Chicano art, figure prominently in Tapia's wonderfully dramatic and introspective in-the-round bulto. The two inmate "actors" with their tattoo-inscribed chests, arms, and backs anticipate Delilah Montoya's *El Guadalupano* by some four years. The Marian images empower these captives in a near-talismanic way, suggesting, perhaps, that in spite of the formidable cell door blocking their exit, they will obtain their freedom through sheer faith alone. Contrary to the artist's own introspective doubt that these Pedros or vatos (guys) doing time in the penitentiary may have a future beyond prison—their liberty compromised by their lack of keys, as invoked in the work's title—they already appear in La Virgen de Guadalupe's good graces and, moreover, seem likely to make it to heaven! Consider el testimonio (the testimony) of pinto Lawrence Honrada, a Chicano from East Los Angeles, incarcerated in the New Mexico State Penitentiary in Santa Fe: "In prison, I could understand better what Christ must have gone through as a victim and prisoner . . . without them [my tattoos], I could never have gotten out of the joint psychologically" (Sorell 2008, 15, 31).[6] Tattoos,

therefore, are not incidental body ornament but, rather, something more transcendent.[7]

Unlike Honrada, Nicholas Herrera does not betray any visible tattoos, despite having been imprisoned some eight times in Española, New Mexico, for various offenses. A jail stint in Los Alamos, New Mexico, was almost preordained because, by his own admission, it led Herrera to meet the curator whose enthusiasm for his work inspired him to keep producing art. It was also in jail that he became an avid reader and student of the lives of the saints. He regards God as the (ultimate) inspiration for his artistic output, and he says he's "still [in the process of] earning the key into the [heavenly] kingdom." This once "wild Chicano child" finds spiritual catharsis in turning to the subject of an imprisoned Saint Peter being visited by an angel. Herrera is seeking to be absolved of "all the shit he's been through."[8] His bulto, *St. Peter Is Imprisoned*, therefore, has autobiographical outlaw roots tempered by an emerging optimism about his own future. Saint Peter's prison door is ajar, implying that Herrera, now personified as an everyday Pedro through the leveling effect afforded by the dynamics of familiarity and Saint Peter's own humanity, will leave behind "the downward spiral his life was taking" and pursue a higher creative calling. As for Luis Tapia, spared doing actual time, the artist nevertheless types himself "a rebel, in and out of trouble."[9]

Both Tapia and Herrera are addressing in stark visual terms what the New Mexican Chicano writer and ex-pinto Jimmy Santiago Baca has expressed so eloquently in literary terms. All three believe in the human dignity of the pinto and document his struggle to find some kind of redemption on earth before encountering Saint Peter on a higher plane. The two works just examined have prompted the contemporary viewer's religious meditation, not unlike the effect centuries-old santos had on their then-contemporary faithful believers/viewers. The trajectory of Chicano art is thus shown to have come full circle, given the palpable religiosity endemic to Hispano Nuevomexico (Hispanic New Mexico).[10]

Notes

1. In their own essay contributed to this part of the current volume, Luis Tapia and Carmella Padilla acknowledge Luis's direct involvement in Movimiento activities. He was, after all, one of the founders of La Cofradía de Artes y Artesanos Hispanicos (the Fraternity of Hispanic Arts and Artisans/Craftsmen), a grassroots group that arranged opportunities for artists and encouraged the growth and validation of Hispanic art in New Mexico in the 1970s (Salvador 1995, 77). While Nicholas Herrera with Sallie

Gallegos makes no similar claims for himself in their respective essay, Barbe Awalt and Paul Rhetts, authors and avid santo collectors, write that Nicholas's pieces of social commentary were inspired by current events (2000, 3).

2. An inference drawn from the epigraph above. Montoya's affirmation of santero art resonates all the more loudly in the face of an anonymous criticism of the landmark CARA (*Chicano Art: Resistance and Affirmation, 1965–1985*) traveling exhibition as mounted in May 1992 at the National Museum of American Art, Smithsonian Institution, Washington, DC. Noting what he/she saw missing from the large and seemingly inclusive exhibit, the critical visitor asked, "What about the non-politicized Mexican-Americans, the traditional craftspeople of the Southwest?" (Gaspar de Alba 1998, 161, 266).

3. Iconic Chicano cultural critic Tomás Ybarra-Frausto characterizes rasquachismo as an "outsider viewpoint [stemming] from a funky, irreverent stance that debunks convention and spoofs protocol." He adds: "To be *rasquache* is to posit a bawdy, spunky consciousness, to seek to subvert and turn ruling paradigms upside down. It is a witty, irreverent, and impertinent posture that recodes and moves outside established boundaries" (1991, 155).

4. Jim Griffith, distinguished folklorist of the Southwest, points out: "It was to this very *human* person that Christ entrusted His church, making him in effect the first pope" (2000, 54). Italics for emphasis are mine.

5. No relation to José Montoya.

6. Tattoo scholar Alan Govenar (1988) first documented Honrada's statement.

7. Luis explains that he "started doing a lot of work with tattoos, the penitentiary type of deal with the sacred hearts and the crown of thorns, the head of Christ [because] that's what's going on today; *all this religious iconography is being put on bodies now*" (Salvador 1995, 79). Italics for emphasis are mine.

8. Refer to the chapter by Nicholas Herrera with Sallie Gallegos earlier in part III of this volume.

9. Refer to the chapter by Luis Tapia with Carmella Padilla earlier in part III.

10. No less distinguished a painter of the Southwest than Georgia O'Keeffe wrote about that very religious palpability when reflecting on her painting *Black Cross, New Mexico* (1929): "I saw the crosses so often—and often in unexpected places—like a dark veil of the Catholic Church spread over the New Mexico landscape. . . . For me, painting the crosses was a way of painting the country" (1976, n.p.). I am most grateful to Autumn L. Mather, reference librarian, Ryerson and Burnham Libraries of the Art Institute of Chicago, and Eumie Imm Stroukoff, Emily Fisher Landau Director of the Research Center, Georgia O'Keeffe Museum, Santa Fe, New Mexico, for their generosity and gracious assistance in identifying the source of this evocative and resonant reflection.

Bibliography

Awalt, Barbe, and Paul Rhetts. 2003. *Nicholas Herrera: Visiones de Mi Corazón/Visions of My Heart*. Albuquerque, NM: LPD.

Gaspar de Alba, Alicia. 1998. *Chicano Art Inside/Outside the Master's House: Cultural Politics and the CARA Exhibition.* Austin: University of Texas Press.

Govenar, Alan. 1988. "The Variable Context of Chicano Tattooing." In *Marks of Civilization: Artistic Transformations of the Human Body,* edited by Arnold Rubin, 209–17. Los Angeles: Museum of Cultural History, University of California, Los Angeles.

Griffith, Jim. 2000. *Saints of the Southwest.* Tucson, AZ: Rio Nuevo Publishers.

Montoya, José. 1981. "Chicano Art: Resistance in Isolation/*Aquí Estamos y No Nos Vamos.*" In *Missions in Conflict: Essays on U.S.-Mexican Relations and Chicano Culture,* edited by Renate von Bardeleben, Dietrich Briesemeister, and Juan Bruce-Novoa, 25–30. Tübingen, DE: Gunter Narr Verlag. The paper had previously been delivered in a slightly different form at the Symposium on Art and National Consciousness in Latin America, University of California, Los Angeles, November 21–22, 1981.

O'Keeffe, Georgia. 1976. *Georgia O'Keeffe: A Studio Book.* New York: Viking.

Salvador, Mari Lyn C. 1995. "Luis Tapia." In *Cuando Hablan Los Santos: Contemporary Santero Traditions from Northern New Mexico,* edited by Marta Weigle, 76–79. Albuquerque: Maxwell Museum of Anthropology, University of New Mexico.

Sorell, Víctor Alejandro. 2008. "Illuminated Handkerchiefs, Tattooed Bodies, and Prison Scribes: Meditations on the Aesthetic, Religious, and Social Sensibilities of Chicano Pintos." In *Mediating Chicano Culture: Multicultural American Vernacular,* 2nd ed., edited by Scott L. Baugh, 2–40. Newcastle, UK: Cambridge Scholars Press.

Ybarra-Frausto, Tomás. 1991. "Rasquachismo: A Chicano Sensibility." In *Chicano Art: Resistance and Affirmation, 1965–1985,* edited by Richard Griswold del Castillo, Teresa McKenna, and Yvonne Yarbro-Bejarano, 155–62. Los Angeles: Wight Art Gallery, University of California, Los Angeles.

From Man on Fire

Luis Jiménez

What I've proposed for Denver is a mustang scenic overlook. I am also proposing a series of plaques tracing the history of the American mustang from the original reintroduction of the horse by the Spaniards to the Indian pony that they developed from the mustang, then the American cow pony and quarter horse that was developed from the mustangs, and then eventually the current state of the mustangs. So you have an ascension of the cross kind of situation that leads you up to the top of the overlook and vistas: downtown Denver, Pike's Peak, and the mountains to the west.

* * *

The public sculptures reflect my own agenda. I would like to make a horse piece, just like I wanted to make a cowboy piece, like I wanted to make the *Pietà*, like I wanted to make a farmer. I want to pay tribute to the mustang, the same way that I developed the HOWL that eventually became the desert wolf (Mexican wolf), an animal on the verge of extinction.

* * *

Lo que les he propuesto para Denver es más bien un panorama basado en un mustang. También les estoy proponiendo una serie de placas que tracen la historia del mustang americano comenzando por los caballos que originalmente introdujeron los españoles, que incluya el potro indio derivado del mustang, el caballo que estaba adiestrado para encerrar el ganado, el "quarter horse," esa especie americana que desciende del mustang y que entrenan para carreras cortas, y quiero que se extienda hasta el

Luis Jiménez's artistic statements first appeared in the 1994 exhibition catalog *Man on Fire/El Hombre en Llamas* (Albuquerque, NM: Albuquerque Museum), pages 160–61. Reprint courtesy of the Albuquerque Museum, Albuquerque, New Mexico.

mustang de hoy. Así es que lo que tenemos es una ascensión de un cruce que nos conduce hasta una cima desde donde se contempla el panorama: el centro de la ciudad de Denver, Pike's Peak, y las montañas al oeste.

<p style="text-align:center">* * *</p>

Las esculturas públicas son un reflejo de mi propia agenda. Me gustaría elaborar un caballo, tal y como quise hacer una estatua de un vaquero, como en otra ocasión anhelé hacer la *Pietà*, como quise elaborar una de un indio y como tuve ansias de hacer [una estatua] de un agricultor. Yo quiero rendirle homenaje al mustang y que sucediese como con HOWL (Aullido), que eventualmente se convirtió el en lobo del desierto, el lobo mexicano, que es un animal en peligro de extinción.

Editorial Note

Scott L. Baugh and Víctor A. Sorell

Face-to-face encounters, this collection's leitmotif, hinge on the fact that at least two individuals are present before each other. The dichotomy of presence versus absence insinuates itself into such a scenario. Because of his tragically premature death, Luis Jiménez is absent from our dialogic discourse, but he is arguably present through Gaspar Enríquez's "electric" portrait. We still encounter him cara a cara. Similarly, while *Mesteño/ Mustang* is not represented photographically—given that the Artists Rights Society, representing the late sculptor's estate, denied us the right to publish an image—the sculptor, nonetheless, is discussed at length textually. And perhaps the exclusion of the image can serve the collection as a reminder of the controversial nature of public arts and their various agendas, discussed at length in several chapters in this part of the book and across the volume. Notwithstanding the sculpture's visual absence, its presence is rendered in words/verbally.

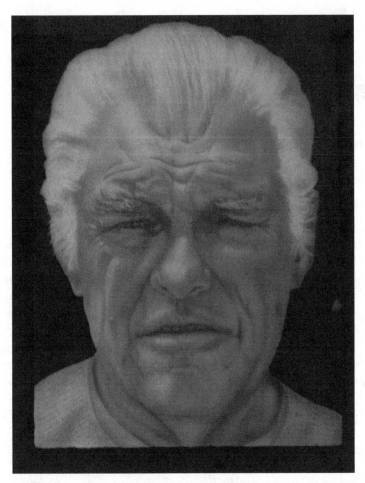

Figure 16.1. Gaspar Enríquez, *In Memory of Luis* (2006, airbrushed acrylic on paper, 41 x 29 in.), from the *De Puro Corazón* series. Gaspar Enríquez remembers Luis Jiménez: "Luis was a good friend and mentor. He helped me and a lot of other artists in finding venues for our work. We also benefited from the tremendous amount of advice he gave us. Luis also paved the way for us to break into the mainstream of the art world." (Courtesy of the artist.)

Rearing Mustang, *Razing* Mesteño

Delilah Montoya

Complicated and contradictory, he was a *patrón* who understood his world through his art. The air was charged by the energy that surrounded him. *Fue un relámpago*; he had lightning in the blood. Luis Alfonso Jiménez Jr., eldest son to Alicia Couturier Dufau Franco Jiménez and Luis Alfonso Jiménez Sr., was born on July 30, 1940. His father crossed over the Rio Grande to the United States at age nine in 1924 with his own mother, María Colín Jiménez, Luis's grandmother. Pop Luis, who was by then a famous neon sign designer and owner of Electric & Neon, Inc., explained, "You know I was never an illegal alien; I just never had my papers straight" (Jiménez et al. 1994, 146). Luis's life and art continually crossed borders that marked the primal, sensual, political, familial, and tragic. In the end, the sculpture *Rearing Mustang* remains an unfinished idea because of the sculptor's untimely death.[1] Mired in controversy, the mustang project as it was completed and installed is compromised by questions of authorship.

Luis's approach to making art layers personal and public events; his work reveals statements that express public history and political issues simultaneously in a way that subverts the stereotypical through revisionist history. Luis believed that we all, as humans, share similar baggage, and he created artwork that taps into universal dialogues. Even though certain symbols and myths are distinct to Hispanic culture, he resisted the notion that the origins of Hispanic myths were unique; instead, he believed these myths were manifestations of a universal collective unconscious. In discussing his *Southwest Pieta*, for example, Luis suggested that the images relate to Hispanic cultural expression at the same time that they revolve around Jungian archetypes that "hit at the core of [our] psyche"

(Bermingham 1985). There are also distinctly familial qualities to his work. Art, for Luis, reminds us ultimately of our own humanity.

Luis's major influence was his own life experience—from growing up as a Chicano in El Chuco (El Paso, Texas) through a prominent art career. His ability to move between the mainstream art world and Chicano cultural expression created a bridge of tolerance that fostered a wide-ranging and inclusive world view.

＊ ＊ ＊

Uneasy with labels, he avoided profiling and found racist language and practices deplorable. Luis flatly resisted categories and, instead, treated them as borders to be crossed. For instance, even though Pop Art marked Luis's New York City work, he was ambivalent about the association: "I didn't feel uncomfortable about telling people that I was post-Pop, because that's the way they classified me. . . . To a certain extent, I did have a legacy to Pop. I didn't think my work was about what Pop Art was about, but I felt that it made it easier for people to see what my work was about" (Bermingham 1985).

Alternatively, and perhaps more significantly, Chicano art has been influenced by Luis Jiménez's aesthetic sensibilities, but Luis never adhered to or even participated in the creation of Chicano art rhetoric. When asked once, "What does Aztlán mean to you and your art?" Luis replied neatly, "Nada" (Nothing). That said, Luis was nevertheless vocal about being Chicano. For him, a Chicano was an American with Mexican ancestry who settled in the Southwest. While growing up in El Paso, Luis came to understand that "Chicano" and "Mexican American" were interchangeable terms. During the development of Chicano art, the Chicano community sought out Luis as a hero, *un maestro*.[2] He was admired as an artist who maintained his "Chicano" roots while crossing over into the so-called American Art Scene. It is interesting to note that Luis participated in the major Hispanic, Latino, and Chicano exhibitions while concurrently showing in prominent mainstream galleries and museums.

＊ ＊ ＊

Luis saw his work as an American statement deriving from an American experience. As one critic put it: "Jiménez doesn't like being pegged as a Chicano artist; he thinks of his work as American. . . . Yet he doesn't deny the importance of where he was raised. 'I grew up on the border,' he said. 'The way I grew up had a lot to do with my focusing on political issues. . . . I wanted to work with the issues I'd grown up with'" (Ignatius 2002).

Although it was in New York that Luis developed key aspects of his aesthetics and activist sensibility, exemplified in the pieces *Man on Fire*

and *Tactical Police Force*, by the 1970s Luis returned to the Southwest. Initially, he established a working studio on the artist-in-residence compound in Roswell, New Mexico, where he created the *Progress I* and *Progress II* sculptures. In 1979, Luis moved his studio to his father's shop in El Paso. Between 1975 and 1985, Luis also converted an old WPA schoolhouse in Hondo, New Mexico, and he founded a legendary artist loft. To this schoolhouse studio, he would add in 1990 an apple processing plant about two miles down the road. With "the Schoolhouse" and "the Apple Shed" as his production spaces, Luis fulfilled every Chicano's dream of returning to his roots and forming el rancho with his family. He acquired acreage, an adobe ranch house, and livestock. Naga, a dog, and Black Jack, Luis's beloved appaloosa stallion, beg to be identified.

Luis demanded a great deal from himself and his art. His artistic process was complicated and typically required years of work before the actual completion of a public sculpture, as evidenced by the mustang project, which he worked on over his last fourteen years.[3] The mustang project was Luis's largest and most costly sculpture. It was also his most protracted public project. Yet it promised to be the greatest sculpture of his career to that point.

Luis Jiménez would jokingly say, "The mustang will be the death of me."

* * *

The sculpture at Denver International Airport (DIA) has aroused a heated debate.[4] *Mesteño/Mustang* has evoked a strong and overwhelming dislike in Denver's residents and visitors. Luis Jiménez understood that public artwork is successful when people identify with it. "I don't want to sound like a commercial artist," he said in 1981, "but [making art] is entirely different when you're working with a community. The work belongs to the people. It has to come from the artist but the people have to be able to identify with it" (Beardsley 1981).

Luis listened to public demands and made an effort to have his public sculpture speak for a specific community without compromising its integrity.[5] Luis designed the *Firefighter Memorial*, the *Steel Worker*, and the *Sod Buster* with the intention of lifting the working class to heroic proportions. The completed *Cleveland Fallen Firefighter Memorial* is remembered precisely because it is a memorial shaped not only by Luis's own background but by the firefighters' own communal standing as true working-class heroes, heroes who encompass local-political and universal-humanistic values. Such grassroots inspiration and depth seem compromised in the posthumously completed *Mesteño/Mustang*.

Luis sought out public sculpture projects that reflected his own agenda. In the catalog *Man on Fire*, he discusses his conceptual intentions for the mustang project. Luis writes that he had a desire to make a horse piece, just as he desired to make the *Howl* that started out as a coyote and later transformed into a Mexican desert wolf, "an animal on the verge of extinction," according to Ellen Landis's insightful reading (Jiménez et al. 1994, 136, 161). It invokes universalistic claims to ecology, suggests a political statement against American imperialism on this continent, and, at the same time, is rooted in a love for nature that surrounded him at home on his ranch. Luis infused the ethos of the wolf into the execution of *Howl*, and he stated that he wanted to pay tribute to the mustang in the same way.

Luis Jiménez regarded the appaloosa as the quintessential mustang, a Western icon that served as a living reminder of our contentious history and nature's fragile position. Luis was very concerned about protecting America's wilderness. The rampant stance of the appaloosa envisioned for the Denver International Airport suggests a battle to the death and, furthermore, the struggle for survival of an endangered species.[6]

* * *

I don't believe the posthumously completed *Mesteño/Mustang* lives up to Jiménez's vision. His intentions are carefully articulated and preserved in the designs approved by the City of Denver. Luis had envisaged Black Jack, his beloved appaloosa stallion, through multiple lithographs, drawings, a full-scale working drawing, and, crucially, *Mesteño*, an 8-foot maquette, which may come as close to the fruition of Luis's vision for the project as we may ever get.

The molded clay work and cast fiberglass completed on the *Rearing Mustang* sculpture as intended by Luis and his studio assistants before his death reveal a mastery over the material. But the posthumous effort to complete the equine statue falls short of Luis's ability to hold the edge between "high" and "low" art. Rather, *Mesteño/Mustang* tumbles into the realm of the garish. Gone are the interwoven layers of universal moral messages, public political statements, and personal family history. Gone are the appaloosa's distinctive spots, its inspired spray-paint color blends, and its sleekly engineered armature.[7] Gone is the work's ability to defy gravity as it explodes through space coated with an intense color palette, with subtle colors twirling in the light that dances across the sculpture's surface—a stylistic signature found so often in Luis's public works.

The most awkward and authorial-suspect detail, yet, are the eyes. The red incandescent bulbs found on the *Mesteño* maquette are substituted in *Mesteño/Mustang* as flat LED spotlights designed for longevity and

efficient energy usage. Unfortunately, during the daytime, the updated eyes appear as white or pink disks laid into the eye sockets of the horse, glaring out as blank shark-like eyes. At night they project out as demonic red taillights. This handling of the eyes is incongruent with his plan for the original eyes, which would glow as red, blistering bulbs from the eye socket, a Jiménez signature that was borrowed from his father's El Paso Bronco Drive-In sign. The details, lost in the currently installed sculpture, would have recalled his previous artwork and, more importantly, would most certainly have secured his vision for the *Rearing Mustang* project.

* * *

Luis's progress on the mustang project was challenged by a host of professional and personal issues—contractual lawsuits; teaching duties; marital conflict and, eventually, divorce proceedings; familial obligations, especially surrounding his children; and medical complications.[8] In Luis's mustang project, I recognize an extreme example of the inherent difficulties facing a Chicano artist working today. From 2001 through much of 2006, Luis confronted his fears, challenged his wife into filing for divorce, moved out of the old Schoolhouse, hired contract lawyers, consolidated his teaching responsibilities and other art projects, and found in me a new compañera. Amid the chaos, the Denver International Airport wanted progress on the sculpture.[9]

In the fall of 2005, Luis discovered the carburetor of his crane gummed up with sugar. By this point Luis was one month behind the scheduled completion date of October 15 and was at risk of losing the *Sodbuster* sculpture and the mustang work. DIA extended the completion date to January 31, 2006. In December Luis attached an old hoist to a constructed I beam frame; using come-alongs, he began to move the three massive sections of the mustang sculpture.[10]

* * *

Throughout the difficulties, Luis was not alone: he had a whole support system of family members and friends. Probably the most important person who kept projects moving and maintained the daily duties in the shop and on the ranch was Jesús Medina.[11] Jesús worked for Luis for well over twenty years, constructing many of Luis's sculpture projects. He would prepare sculptural armatures, cast and prepare fiberglass to be painted, and maintain equipment used in the sculpture, clay, and drawing shops. Additionally, he'd oversee maintenance of the buildings and care for livestock. By the end of April 2006, things seemed to be improving. Luis had cleared up matters with Denver and was anxious to advance the mustang project in Hondo. Luis maintained his teaching responsibilities in

Houston while still trying to make progress on the sculpture back in New Mexico. He sent Jesús Medina orders to keep progress going in the studio. Medina was one of the few people who dared argue with Luis about how things should be done. Luis bitterly complained that Jesús would make decisions without consulting him. Since Jesús was having trouble fitting the mustang's fiberglass hind legs onto the interior steel armature,[12] he cut the steel and rewelded it, thus weakening the registered welds of the metal structure fabricated by CAID Industries in 1995. Rightly worried whether the sculpture could sustain the high winds that engulfed the airport grounds in Denver, Luis welded additional steel to support the interior skeleton. Luis returned to Hondo from New York on May 28 determined to make progress on the mustang project. By June 5, he had sprayed the undercoat for the head and sent an image off to friends. During the next week, he sprayed features onto the head to formulate in his mind a visual plan of how he would proceed with the body.

<p style="text-align:center">✳ ✳ ✳</p>

On June 13, 2006, sometime after 11:00 a.m., Luis and his assistants were moving the hindquarters section of the mustang sculpture with a come-along on the bottom and a hoist on top when the hoist jammed. As Luis straddled the I beam to unjam it, Jesús saw that the hindquarters were hanging precariously and cautioned Luis, offering up another plan. Instead of heeding the warning, Luis shouted back to him, "This is my project, and I will do it my way." Jesús lowered his eyes because he could not watch what Luis was steadfast on doing. Luis let out a scream. Jesús already knew what his eyes then confirmed: Luis was pinned to the I beam by the massive sculpture. *"Te dije* [I told you], *te dije, te dije,"* Jesús cried. Luis responded, *"Yo se* [I know], get me to the hospital."[13]

Tragedy unleashed: according to a press release from the Lincoln County Sheriff's Office, Hondo EMS responded at 11:50 a.m. to the Jiménez studio for an apparent industrial accident. According to Sheriff Rick Virden, detectives investigating the incident learned that Jiménez and two of his employees were moving a large piece of statuary with a hoist when the piece "got loose," striking Jiménez and pinning him to a steel support (Borunda 2006). Monroy Montes told the *Ruidoso (NM) News* that Jiménez was straddling a beam as he and his employees were moving the hindquarters of the massive horse sculpture, using a hoist on top and a come-along at the bottom (Cromwell 2006). As they moved it one direction, it swung loose and crushed Jiménez's leg against the beam he was straddling. Medical investigator Danny Sisson said it was likely that the femoral artery was ripped open, which would cause rapid bleeding.

"They called 9–1–1," Montes said, "and they waited. . . . Everyone felt so helpless, so they loaded him in a car thinking to meet the ambulance. . . . The sheriff's office reported that Jiménez suffered severe trauma to the leg and was transported to the emergency room at Lincoln County Medical Center" (Cromwell 2006).

Luis was pronounced dead at the hospital.

* * *

Following Luis's death, the Jiménez estate in collaboration with Denver International Airport administrators began to administer the completion of the *Mesteño/Mustang*. The estate was adamant about seeing the project completed. A newly formed DIA team, with Jiménez estate advisors and commercial fabricators, proceeded to finish the execution and installation of *Mesteño/Mustang*. Trying to uphold Luis's artistic vision for the project, the Jiménez estate sought to contract the artist who had assisted Jiménez with the 1997 *Rearing Mustang* working drawing, Nöel Marquéz, to complete the painting of the body. Unfortunately, because of health issues, Marquéz left the project. Pressed to satisfy their contractual obligations, the estate commissioned Richard Lovato, an esteemed self-taught automotive spray painter. After inspecting the incomplete mustang sculpture in Hondo, Lovato asked his lifelong partner, Camilo Nuñez, to help.[14] According to an August 22, 2008, interview, Lovato said: "Nuñez sprayed the base blue; then he modeled the horse's body with Ruby Red, white, and a dark blue." Apparently, all the paint came from the cans stored in Jiménez's studio. The horse's head had faded, so Lovato fogged it to match the freshly sprayed body. Although Richard and Camilo did not work from any of Luis's models or working drawings, they completed their commission by observing and studying Black Jack, his living model. Richard stated that they would look at Black Jack while spray painting, reproducing what they saw on the appaloosa but for its spots.

On October 13, 2007, Denver International Airport took possession of the in-progress mustang project. Ultimately, the steel armature was reengineered by Kreysler and Associates so that it could sustain the wind gusts typical for the airport grounds. The three sections were fitted together to create an 8,517-pound piece of art. On February 12, 2008, it was finally installed at the intended site; this process consumed the bulk of the $350,000 of additional monies allocated to finish off the sculpture. Titled *Mesteño/ Mustang* after Luis's death, it now rears conspicuously on two hind legs. The plaque mounted at the base of the statue reads: "Completed and installed posthumously by family and studio staff."

At what point in this convoluted account does the work lose artistic integrity and become a debacle? And to what extent are we all complicit? The worth of an artist is not about how much the public desires her or his work but how the inspired work conjures up the desire for its existence. The integrity of a work of art is born from the originator—that is, the artist breathes life into it with a drive for its consummation. To do otherwise is to resist a natural impulse in the creative process. Questions should remain for us whether *Mesteño/Mustang* fulfills its original promise.

Notes

1. After Luis Jiménez's death, the contractual title used for the equine statue changed from what I understood as Luis's intended designation *Rearing Mustang* to *Mesteño/Mustang*.

2. A number of Chicanos assisted Luis in his studio and/or befriended him, such as Luis Bernal, Gilbert "Magú" Luján, Noel Marquez, Rudy Fernández, Jesús Moroles, and Benito Huerta, along with numerous non-Chicanos, such as Ted Kuykendall, Cedomir Djordjievski, Tedd Poluan, and Bruce Berman.

3. Luis communicated his original plan and subsequent revisions to me in conversations and letters. Luis's first proposal to Denver International Airport (DIA) was the integration of opposing sculptures into concourse C, depicting two Western themes: a "Trail Drive" and an "Indian Buffalo Hunt." However, in 1992 DIA accepted an alternative proposal after the first was turned down because the "buffalo stampede" was considered "distasteful" and "the appropriateness" of a non-Native person creating work that reflects Native culture was questioned. Luis then changed the Western content to a scenic overlook located on a knoll, with an appaloosa mustang at the center. The scenic overlook included a footpath lined with four plaques pertaining to the mustang's history in the West. The trail led up to a mustang sculpture that faced Pike's Peak. DIA accepted this new design and reduced the initial $450,000 budget by $150,000 because the airport was to construct the "scenic overlook." This plan was never realized; instead, by 2001 DIA proposed moving the mustang sculpture into the main terminal on the south end of level 5. In the 2004 settlement between Luis and DIA, the focus shifted to the *Rearing Mustang* sculpture rendered as a rampant appaloosa stallion, and the scenic overlook on the Peña Boulevard knoll was eliminated.

4. For example, the "Bye Bye Blue Mustang" website had, as of 2009, more than 9,000 registered members weighing in for the removal of the sculpture from airport grounds. This site called the mustang—with its red eyes and garish blue coat—"DIA's Heinous Blue Mustang" and demanded that it "has got to go."

5. Although community members in Pittsburgh initially protested against his *Steel Worker* (1982, 1990) because of his inclusion of the ethnic term *Hunky* (derogatory to Slavs and Hungarians) in the work's original title, Luis listened and elided the offensive word. When the subject matter in *Southwest Pieta* (1984) offended some viewers, the sculpture was relocated to Martíneztown, away from its initial site at Tiguex Park,

because the sculpture's content would be better understood in a Mexican neighborhood. *Vaquero* (1980/1990) was similarly reinstalled at Moody Park in Houston.

6. Luis would recite the following popular belief regarding equestrian statues in his artist talks: If the horse has one front leg up, the rider was wounded in battle or died of wounds sustained in battle, and if all four hooves are on the ground, the rider died of causes other than combat. But if the horse is rampant, that is, with both front legs in the air, the rider died in battle.

7. If one compares the completed *Mesteño/Mustang* with the 8-foot maquette, it is apparent the three mustang sections were assembled one degree higher than in the maquette, with a slight twist to the right where the hips join with the torso, introducing an uncoordinated, imbalanced stance to the sculpture.

8. Now in his sixties, his body failing, Luis experienced two stress-related heart attacks, the loss and removal of his left eye as a result of a childhood incident, and carpal tunnel operations in both his hands. Since his twenties, he had suffered chronic pain from an automobile accident that fractured the back and partially paralyzed the intestines.

9. I recall Luis commenting on the financial difficulties surrounding his attempts to complete the sculpture, especially since funds could not be secured without proof of insurance. By 1994 he had received half of the contract monies for his design concept and proposal; yet from 1994 until 2004, Luis told me, he received no further funds from DIA for the fabrication of the mustang because he was unable to secure insurance for the project.

10. The three sections consisted of the hindquarters, the torso with front legs, and the head.

11. After migrating from Mexico in the mid-1980s, Medina began working for Luis as a laborer. Hired during renovation of the Schoolhouse, he continued working as a shop assistant on the compound.

12. Kreysler and Associates, a fabricator of fiberglass reinforced composites, digitally sized up the hind legs into foam from the 8-foot maquette. Luis then covered the section with a layer of clay to make the fiberglass casting.

13. I learned of this in my conversation with employee Jesús Medina (2006).

14. Richard Lovato and Camilo Nuñez never spray-painted lowrider cars and do not understand why articles keep classifying them as such. Additionally, they do not consider themselves artists nor had they worked on any sculpture until the mustang. Richard met Luis once but did not have a conversation with him.

Bibliography

Beardsley, John. 1981. "Personal Sensibilities in Public Places." *Artforum* 19 (Summer): 43–45.

Bermingham, Peter. 1985. "Oral History Interview with Luis Jiménez." Tucson, AZ, Dec. 15–17. Archives of American Art, Smithsonian Institution. Accessed Jan. 2009. http://www.aaa.si.edu/collections/oralhistories/transcripts/jimene85.htm.

Borunda, Daniel. 2006. "Accident Kills Creator of *Vaquero* Statue." *El Paso Times*, June 14.

"Bye Bye Blue Mustang." Accessed Nov. 2009. http://www.byebyebluemustang.com.

Cromwell, Pamela. 2006. "The Artist as a Common Man." *Ruidoso (NM) News*, June 16.

Ignatius, Jeff. 2002. "Courting Dialogue, Not Controversy." *River Cities' Reader*, Dec. 3.

Jiménez, Luis, et al. 1994. *Man on Fire/El Hombre en Llamas*. Albuquerque, NM: Albuquerque Museum. Exhibition catalog.

Medina, Jesús. 2006. Interview with Delilah Montoya. Hondo, NM, June 17.

Voelz Chandler, Mary. 2007. "DIA Ready to Corral Sculpture." *Rocky Mountain News*, Oct. 31.

Kindred Spirits

On the Art and Life of Luis Jiménez

Ellen Landis

Luis Jiménez was my friend. Contradicting the premise in *When Harry Met Sally*, that a man and a woman are incapable of an intimate yet platonic relationship, Luis and I had a deep friendship for almost thirty years. We met at an opening at Hills Gallery in Santa Fe in 1977, shortly after I had arrived in New Mexico to become curator of art at the Albuquerque Museum. It was an inauspicious beginning for a friendship—we simply chatted and then went our separate ways. During that year, our paths crossed several times at artists' openings, mostly in Santa Fe galleries, and each time our chats lasted a little longer as we found that our artistic ethics and ideals overlapped.

It would be the friendship we forged that steadied Luis when he was confronted with the political backlash regarding *Southwest Pieta* (1984), a sculpture commissioned by the City of Albuquerque and funded by the National Endowment for the Arts and the City of Albuquerque's 1% for Arts program. Luis had built a maquette, and he brought it to the Albuquerque Museum for public viewing. He'd hoped for comments on the artistic merits of the piece, but in his naïveté he hadn't expected the bigoted criticism of his theme or the audacious attitude that the woman's red dress typecast the work as "too Mexican." Even more dismaying were the nasty and divisive attacks characterizing the work as being either anti-Hispanic or pro-Chicano. What Luis had intended as a stimulant to dialogue with the community somehow exposed the darkest face of man, fueled by two hundred years of simmering prejudice. At this chaotic moment, Luis turned to me as his confidante and supporter.

In a 1993 interview, Luis explained his intention to explore in his work the dichotomous nature of his community:

I really wanted to call attention to the fact that the Hispanic community in New Mexico is divided. You have the Spanish community that identifies with the early settlers, and then you have another community made up of the Mexican American or Chicano community that identifies with the children of the later immigrants whose parents came up from Mexico in the twenties after the Mexican Revolution of 1910. The difference in the two populations is that the first arrived with money, with education, and in fact had all the political control and power—as they still do in Albuquerque—I don't know about all the political power, but they certainly run the political base—and the later immigrants came in as poor people. And there's always been that division between the poor and sort of educated people. The first group refers to us—and I include myself in the second group—as *suro Matos* because they refer to us as being of mixed blood and Mestizos and having Indian blood and they think of themselves as "pure Spanish." The fact is that *nobody* is really very pure, and politically it's a really bad thing for the Hispanic community in New Mexico. I think that if there were some unity there it would actually help. (Jiménez 1993)[1]

The location originally approved for the sculpture was Tiguex Park, named in honor of the Tiguex Indians, who were early inhabitants in the area. Luis depicted several objects from the plant and animal world on the base of the sculpture—symbols and images common to both Indian and Mexican worlds. The eagle, rattlesnake, nopal cactus, and mescal cactus so important in Mexico are equally important to Native Americans. However, because of the controversy, the sculpture did not go into Tiguex Park but was instead installed in a Chicano neighborhood, where it has achieved iconic status.

For decades to follow, Luis and I confided in each other about life, about art, and about ourselves. He allowed me to come to know him in a very private way, differently, as he would explain, from his friendships with others. Because we were kindred spirits, I was asked to write this piece, and I accepted the offer in Luis's memory and in his honor, not wishing the opportunity to slip away. Our relationship had many dimensions: he came to me for curatorial advice; he came to me to discuss his various loves; we shared thoughts about our children. He often would open our

conversations with the words "OK, I want your opinion," "How would you react if . . . ," or "What do you think about . . . ?" Our most intriguing conversations, however, were about the inner forces that gave life and meaning to his art.

Everything about Luis was unique—his style, his media, and his intent. He was interested in figurative art at a time when abstraction was in fashion; he was out of step and didn't care. His imagination, his meticulous research, and his passion for a visual narrative are evident in his art, but less apparent is how much of himself Luis invested in every drawing, every sculpture, and every print. He found his everyday characters within his ethnicity, and he elevated them to a new and bold place in the history of art; he melded life into his subjects. At a time when bronze was the preferred sculpture medium, Luis spun fiberglass like his paternal glassblower grandfather might have done with glass fifty years earlier. His passion was to make public art accessible to the masses at a time when most artists were marketing to private collectors and museums. From his early works featuring barflies and the sensual/sexual depiction of a garish woman making love to a purple Volkswagen (in *American Dream*) to his later representations of country-western dancers, undocumented immigrants, farmers, horses, and death, Jiménez remained committed to the single theme of social commentary in its various forms and manifestations. Whether executed in colored pencil, fiberglass, bronze, or printer's ink, his works affected those who instantly sensed this man's lifelong love affair with art. For Luis, life and art were one and the same, and his vision of the world was emblematic of the human condition. This is his legacy.

Luis's dedication to his subjects is apparent in the power of his work—and in its surprising gentleness as well. And, oddly enough, it is expressed most powerfully in the overwhelming number of works devoted to or including animals that inhabited the border Southwest of his childhood—scorpions, rabbits, hawks, snakes, and other creatures. Luis always loved animals; at the time of his accidental death he owned appaloosa horses, peacocks, sixty-two goats, a single longhorn, and a German shepherd dog that followed him everywhere. He elevated these animals' role in society to heroic status as symbols of culture and as a way of life.

After Luis's sister, Irene, moved to a new home in Austin in 2007, she sent me an e-mail that read: "David, my brother, was here a couple of weeks ago and helped hang some of the work and we laughed because most of the lithographs were of horses! We looked at the others and they were of animals, too! And I can tell you that growing up, we lived with a menagerie of pigeons, snakes, hawks, ground squirrels, dogs, cats, birds, a

ringtail cat and a bobcat once. Louie would always drag something home to care for and something for my mother to be afraid of."[2]

People and animals trusted Luis. In his strength of character lay his tenderness, his understanding, and his affection, and these traits were evidenced in his art. Someone once told me of a time when Luis was in Roswell, New Mexico, and he happened upon a crow with a broken wing. He gently picked up the bird, took it home, and mended its wing. He called the crow Chula, and it became yet another pet. He depicted this special bird and his relationship with it in a print.

In our conversations, he always gave credit for his early sculptural influence to his father, a sign designer and modeler with the soul of an artist. Some of Luis's father's signs were in the form of animals. At the age of ten, Luis helped his father mold a 10-foot polar bear out of white cement. In retelling this experience, he used to laugh, recalling that his mother had become upset with his father because Luis's hands had bled from the lime in the cement, but his father thought it was good experience for a child. What Luis remembered most, however, was that it had been a fun project and had enabled him to spend time with his father.

That collaborative experience repeated itself when he, at age sixteen, and his father created a 20-foot horse's head with flashing red eyes for the Bronco Drive-In Theater in El Paso's Lower Valley. Luis incorporated those red light-bulb eyes into his own work repeatedly, beginning with the horse in *The Last Sunset* and culminating most recently in the rearing 32-foot *Mesteño/Mustang*, commissioned by the City of Denver for the Denver International Airport. Interestingly, because Luis died before completing the sculpture, the wrong kind of lamps were used for the Denver project. All his other works have rounded, cone-shaped red lamps for the eyes, while the Denver piece has flat lamps, which create a different and disquieting aesthetic effect.

The idea for a rearing mustang sculpture clearly evolved from the giant horse's head Luis and his father had made for the Bronco Drive-In. Luis reminisced:

These are sketches where I've actually tried to work out a bronco piece related to the old Bronco Drive-In. I'm actually thinking of somehow having the man with the lasso, with the horse rearing up in the air. I think I was just trying to work this out as a separate piece. . . . It's interesting that some of my first drawings for Denver were actually along these lines. I really liked the idea of having the horse rearing, having a long lasso, having the guy holding it and incorporat[ing] neon in it. Then I

decided that I really just wanted to simplify it, keep it as simple and easily readable as possible. I thought especially that if the man was down on the ground I would have problems with the neon, with vandalism or whatever. So I just decided to just go with the horse. Also I wanted to do a mustang piece. . . . here are some notes I made to myself, again trying to keep it simple. It says, "Simple, strong, easy to read." I mean, that's what I have to keep in mind all the time. (Jiménez 1993)

In 1988, Luis accepted a commission for a fountain in downtown San Diego because it was a project that lent itself to collaboration with his father, who had been badly injured in an automobile accident. Luis Jiménez Sr. drafted the design of the fountain's obelisk and oversaw the construction of the internal structure, while Luis Jr. went about making the pelicans for the base and the panels of dolphins, striped marlins, orcas, sailfish, abalones, and mackerels. He depicted the billfish alongside little fish because billfish swim into schools of little fish, then whip their swordbills around and injure the little ones, coming back to pick them up with their bills. Although Luis thought this would be a wonderful design element, he also liked the idea of illustrating the hierarchy of the aquatic world.

When the City of El Paso commissioned a work for the central downtown plaza, Luis proposed an alligator fountain, reminiscent of the times during his youth when his mother and grandmother took him to the plaza of this desert city, which had several live alligators in a fountain. Those creatures had fascinated Luis; he wanted to bring them back to honor them in his own way. Thus *La Plaza de los Lagartos* (the Alligator Plaza) was reborn. The gaping jaws and fiercely swinging tails came back to life in fiberglass.

Luis's proposal for a project—described as a desert arch—in Tucson, Arizona, again involved animals playing the lead role. The Catalina Mountains, near Tucson, are one of the few areas remaining in the United States where desert bighorns, a vanishing species, still live. Luis formed the arch by depicting two rams butting heads on the tops of columns that took the form of native saguaro cactus. A colonnade led to the arch, and he proposed desert animals as caps for the columns. Luis believed that this was a traditional concept for a colonnade but a new concept in materials and approach. Lacking funding, the project never materialized.

In the early 1970s, while he was living in an artists' compound in Roswell, New Mexico, he decided that he needed to know more about animals in order to make his art. He made a series of dead animal sketches

that became important resources for him. He worked from actual frozen carcasses and kept these cadavers in his freezer, taking them out in order to draw them. When a cadaver he was working with began to thaw and lose its shape, he would gather it up, put it back in the freezer, and retrieve another stiff specimen.

Occasionally, when times were lean, Luis would go out and poach a deer. When he planned to go out to hunt deer, he would put brown paper over his windows. It amused him that the other artists in the compound thought he covered the windows because he had a nude model in the studio; little did they know he had shot a deer out of season and was drawing it, then eating it.

Most of the animals in Luis's studio were road kill, but there were a few exceptions, such as his pet snake. As he told it:

The rattlesnake was not a real rattlesnake. I had a bull snake that size that lived in my studio. It was a pet; her name was Honey. I rescued her—she was almost a road kill. I picked her up after she had been hurt. Then she recovered and she stayed around the studio and ate mice. But I also picked up a lot of dead rattlesnakes and a lot of road-injured and road-killed animals. Some animals I shot, like the jackrabbits. (Jiménez 1993)

He also became quite interested in coyotes. One day, when he was returning to Roswell from Santa Fe, as he related the story:

[I] came along in the road and found a coyote, a large female in her winter coat, that had her back broken. She was pulling her back end around and howling in the middle of the road. She had her back end paralyzed. I didn't have a gun at the time, so I killed her with my bare hands. I felt really bad about doing that. At the same time I was very happy too that I had gotten a coyote because I really wanted one. I have this thing about coyotes. I've never shot a coyote, been close to them and all that, so I did a study of that coyote. . . . Because that image stayed with me, again in 1976 I did the *Howl* print [of the coyote], which is an important print, and I thought that was as far as it went. I was surprised that it went that far. But at that point it was going beyond the portrayal of a coyote-dog. It was already becoming something else; it was becoming more primal kind of. Eventually I began doing lots of studies of the Mexican wolf and then the sculpture of the *Howl*. (Jiménez 1993)

In this sculpture, Luis's coyote had become the desert (Mexican) wolf, an animal hovering, as he put it, "on the verge of extinction" (Jiménez et al. 1994, 161).

While still in Roswell, he began to infuse animals and birds into nearly all of his work. He even included animals in portrayals of his grand-mother—interesting portrayals, as she had no pets. The fiberglass sculp-ture *Woman with Cat* showed her with a cat in her lap. A drawing he did in honor of her one-hundredth birthday and gave to her as a gift was a portrait of her sitting in front of a mirror, brushing her hair, a scene familiar from his youth. In this work, Luis included a little parrot he had given to his grandmother; she let that bird have the complete run of her house. In the drawing the bird's place of prominence on top of the mirror was symbolic: his grandmother's death troubled him for a long time, and this drawing is a tribute and memorial to her.

Animals were Luis's salvation and ultimately his destruction. *Mesteño/ Mustang*, the towering figure of a rearing horse—the sculpture Luis had always wanted to create—was the piece that caused his death. It was ironic that Luis died while working in his studio, monumentalizing an animal, taking it from the ordinary and making it as heroic as he had made his human subjects throughout his long career. In the end, it would be the wild horse the artist so admired and respected that tragically would bring his life to an untimely close and prove Luis's mortality.

Notes

1. From a taped interview I did in the summer of 1993 with Luis Jiménez for the 1994 retrospective exhibition *Man on Fire* at the Albuquerque Museum, New Mexico. Please also see the catalog from this exhibit.
2. Irene Branson (Luis's sister), e-mail to author, August 6, 2008.

Bibliography

Jiménez, Luis. 1993. Interview with Ellen Landis. Albuquerque, NM.
Jiménez, Luis, et al. 1994. *Man on Fire/El Hombre en Llamas*. Albuquerque, NM: Albuquerque Museum. Exhibition catalog.

Occupying a Space Between Myth and Reality

The Sculpture of Luis Jiménez

Charles R. Loving

The sculpture of Luis Jiménez reflects not only the trajectory of his life but also his observations on the confluence of histories, mythologies, and cultures found in the American West. His subjects included sex, death, war, American automobile culture, American myths, manual laborers, and humans' struggle against nature. His tone was raw, bawdy, and sardonic. His was a unique American voice, informed by keen observation of the natural world, popular working-class culture, "high art," and cultural politics. His goal was for us to be attuned to and, where necessary, to react against multiple realities found in America in the last years of the twentieth century.

Jiménez first used his signature material, fiberglass, in the 1960s as a student at the University of Texas at Austin. He also studied at the Ciudad Universitaria campus of the Universidad Nacional Autónoma de México in Mexico City, where he admired the works of the Mexican muralists, particularly those by José Clemente Orozco. In 1961 Jiménez moved to New York City, where he was immersed within mainstream American 1960s culture as manifested in the art world by the Pop Art movement. He returned to El Paso in 1972 and spent the remainder of his life creating art in the American West.

During the first three decades of his life, Jiménez was exposed to materials that profoundly influenced the manufacture of his mature sculptures: the glowing, garish colors, the smooth, reflective surfaces, and the gracefully flowing forms of neon light, as well as the expressive plastic modeling capacity and highly reflective surface of finely sanded and painted fiberglass.

His artistic sources included santos and other popular devotional images of Mexican Americans; the realism, figuration, and political subjects of the Mexican muralists; American Regionalists' interest in everyday life; the fetishistic hyperrealism and consumer-product imagery of Pop Art; mainstream Western art, such as Frederic Remington's *Bronco Buster* and Michelangelo's *Pietà*; and, quite possibly, underground comics.[1]

His cultural influences ranged from "low" to "high." That is, Jiménez's interests included lowriders and custom-painted cars, country-western music and honky-tonk bars, the heroism of the common person, rock 'n' roll counterculture, and the anti–Vietnam War protest movement. At the same time, he was attuned to Mesoamerican mythology, Native American history and traditions, and Catholic iconography.

An early sculpture, *American Dream* (1969, fiberglass, 58 x 34 x 30 in.), combined Jiménez's interests in cars and girls (he was nineteen years old) with a growing awareness of Pop Art. The sculpture (which the author would like to rename *Herbie Gets Lucky*) depicts a supine female with arched back mounted by a Volkswagen Beetle. While Jiménez was hardly the first artist, or teenager, to combine sex with automobiles, his versions — which included sculptures, drawings, and prints — demonstrated an early facility for human and automobile anatomy. The sculpture also foreshadowed his mature skill at combining sleekly flowing and voluptuous forms into a single, fully integrated and masterfully composed three-dimensional form. In fact, the artist took pride in the way that he mirrored the forms of the automobile's hubcaps and the female's breasts (Jiménez et al. 1994, 67). With this sculpture, Jiménez found in high-glosspainted fiberglass a visual medium for the irreverent, psychedelic voice of the American 1960s — spoken elsewhere on T-shirts, on posters, on album covers, and in counterculture publications. A survivor of the 1960s, Jiménez never fully outgrew the subversive spirit of the times; instead, protest became an enduring element of his art.

The cartoonlike character of the figure and car tempers the carnal activity depicted in *American Dream*; the figures resemble toys or the soft sculptures of Claes Oldenburg. There is no such consideration in the troubling follow-up on the dangers of human and machine coupling: *Birth of the Machine-Age Man* (1970, fiberglass, 43 x 99 x 28 in.). This sculpture is an all-too-realistic, anatomically detailed depiction of an exultant woman birthing a robot. The viewer is confronted by yet another supine female with spread legs and arched back, but here with arms raised and hands clasped above her head. The black machine-age man has partially emerged, helmet first, accompanied by a glittering silver umbilical

cord. While an unusually dark image for Jiménez, as a form it is elegantly conceived and, indeed, foretells a compositional device seen in later sculptures, such as *Sodbuster: San Isidro*—the coupling of two figures into a single elongated and flowing form. In *Sodbuster* it is a man and ox that are joined. The sleekly flowing form of *Birth of the Machine-Age Man* is accentuated by the extremely lustrous gloss surface Jiménez utilized on the figures—they appear to be drenched in sweat and amniotic fluid. Jiménez prized this surface quality, which was achieved by finely sanding the sculpture and then applying multiple layers of acrylic urethane paint, followed by additional layers of clear urethane. The sculpture also harks back to Jiménez's early work in his father's business: two ribbons of blue neon encircle its base, suffusing the sculpture with a cool, glowing light suggestive of a laboratory experiment.

A third, late-1960s image is *Man on Fire* (1969, fiberglass, 89 x 60 x 19 in.). It was likely inspired by Orozco's *Man in Flames* (1939), painted on the chapel dome of the Hospicio Cabañas, Guadalajara. Like the Orozco model, Jiménez's *Man on Fire* depicts a revolutionary—in this case, one involved in public protests seen in America in the 1960s. A contemporary drawing by Jiménez depicts a man about to throw a Molotov cocktail, while in the sculpture, a resolute standing nude male is himself engulfed in red and orange flames. While *Man on Fire* may or may not be a descriptive self-portrait, it is a depiction of the artist as a proud and unwavering figure, one resisting Anglo versions of Chicano history and embracing protest as a means for political change.

End of the Trail (with Electric Sunset) (1971, fiberglass with electric lights, 84 x 84 x 30 in.) is Jiménez's acknowledgment of the poor treatment and inaccurate representation given Native Americans by Anglo culture. Jiménez's rider is hunched forward, fatigued by his journey and the weight of the long, drooping spear he carries. The side view frames a setting sun between the horse's front and rear legs, a sunset made tawdry by working light bulbs. The sculpture and its title allude both to the end of Native Americans' natural, independent, and proud lifestyle, eradicated by the usurpation of America by European "settlers," and to the way their history has been trivialized by American literature and films—the means by which many Anglos (mis)understand the history and culture of Native Americans.

Similarly, *Vaquero* (1987–88, fiberglass, 198 x 144 x 120 in.) refutes another myth of the American West, by asserting that the first cowboys in America were Mexican. The vaquero rides a horse bucking its rear legs, with front legs planted astride a cactus. A graceful S-shaped curve

is formed from its base to the top, beginning with the downward-curving neck of the horse as contrasted with the rider's backward-canted body, continuing to his left arm curling forward over his head and, at the top, his hand holding a pistol. The image was controversial and was not erected on its proposed site because some were not comfortable with the idea of a Mexican cowboy, especially one brandishing a gun.

In comparing the two riders from *End of the Trail (with Electric Sunset)* and *Vaquero*, one is struck by how much more accomplished the latter sculpture is, with its daring cantilevered form, the full integration of rider and horse, the elegant way that it interacts with the space it occupies, and the richer and more subtle use of color. That is, *Vaquero* evidences the artist more fully realizing control over his chosen media, fiberglass spray painted with acrylic urethane paint.

Another controversial public commission, with loaded meaning for the Chicano community, was *Southwest Pieta* (1984, fiberglass, 120 x 126 x 72 in.). Critic Charles Dee Mitchell explained:

> The sculpture, which was commissioned for Tiguex Park in Albuquerque, depicts a scene from ancient Mexican myth: Popocatepetl holding his dead lover Ixtacihuatl draped across his lap. The image of the mythological lovers, who are supposed to have been transformed into two of Mexico's major volcanoes, is familiar from the gloriously lurid pictures featured on illustrated calendars and black velvet paintings. In Jiménez's version, Popocatepetl is given Spanish facial characteristics while Ixtacihuatl's features are more indigenous American. Jiménez saw the works as a dialogue on the Spanish and Indian mix that gave rise to the Mexican-American population, but New Mexico residents claiming direct Spanish lineage objected to the image. Rumors spread that it represented a Spaniard raping a Tiguex Indian woman, a legendary incident recorded in the area some 300 years before. In a replay of the *Vaquero* controversies, the sculpture was moved to the working-class Mexican neighborhood of Martíneztown. (Mitchell 1999, 100)

It is interesting how discreetly Jiménez depicted the more typically nude, and often highly eroticized, Ixtacihuatl. Here, her body is nearly entirely cloaked, in stark contrast to popular imagery of Ixtacihuatl and to Jiménez's earlier depictions of female figures in *Birth of the Machine-Age Man* and in *American Dream*. Jiménez's restraint in representing the female figure allows the larger commentary on racial heritage to dominate—evidencing the mature voice of an artist fully in control of the content of his public art.

This quieter approach to both subject and content is also present in his final work, *Mesteño/Mustang* (2008, fiberglass, 32 feet in height), a public sculpture made for the Denver International Airport. Setting aside his typical desire to challenge misperceived histories of the various cultures found in the American West, Jiménez appears to have created, instead, a visual ode to the widely admired wild mustang. Completed by his son and studio assistants after Jiménez's tragic death while working on the sculpture, *Mustang* towers four to five times greater than life size as it rears up on its hind legs. Perhaps, like much of his earlier art, it is a bit autobiographical. Jiménez must have felt an affinity to this powerful, independent animal that once freely roamed the artist's beloved American West, harking back to a time before the uniquely beautiful landscape was compromised by later inhabitants who overlaid it with revised histories and political symbols.

While this is clearly a romantic notion, it is attractive to see *Mesteño/Mustang* as the guardian of the spirit of Jiménez — an artist who was intent upon using art to resist the myths of Anglo culture. That is, Jiménez can be understood as an artist who sought to reveal the truth and beauty of the American West in his own visual terms.

Notes

1. While the author is not aware of any evidence that Jiménez read, collected, or copied imagery from underground comics, they were pervasive during the 1960s and 1970s, and it seems likely that Jiménez would have been exposed to them. Similarly, the erotic content of his early work, as depicted in images of hypervoluptuous women engaged in sexual activity and by contour drawings devoid of modeling associated with the recording of light and shadow on three-dimensional forms, suggests subject and stylistic influences.

Bibliography

Jiménez, Luis, et al. 1994. *Man on Fire/El Hombre en Llamas*. Albuquerque, NM: Albuquerque Museum. Exhibition catalog.
Mitchell, Charles Dee. 1999. "A Baroque Populism—Louis Jiménez." *Art in America* 87, no. 3 (March): 100–105.

A Conversation with Mel Casas and Rubén C. Cordova

Mel Casas's *Humanscapes* is a series of 153 paintings the artist completed from 1965 to 1989. The following interchange on the origins and evolution of the series derives from telephone conversations between Mel Casas and Rubén Cordova in 2008.

<center>❊ ❊ ❊</center>

Rubén C. Cordova (**RCC**): What does *humanscape* mean?

Mel Casas (**MC**): I was thinking in terms of what to do, thinking of mind and human nature. I didn't invent the word in the beginning—it was inspirationally set. I hit upon the idea for the series while doing the small ones. The 6-foot by 8-foot ones confirmed what I had been doing. That was around 1965.

I was searching when I made the 4-by-5-foot and the 4-by-4-foot paintings. The 6-by-8-foot paintings are smaller than a cinema screen, but they gave me the sense of scale I wanted for a person standing in front of it.

RCC: Did you intend social criticism in the early *Humanscapes* that had an explicit cinematic setting?

MC: Yes, because I wanted to put cinema in the context of social life. . . .

I was driving, going up San Pedro Avenue [in San Antonio, Texas,] in a car towards [Interstate] Highway 410. It was the San Pedro Drive-In movie theater. I could only see part of the screen. I saw a big female face, and it was talking. The image was above the tree line. I knew the character was talking, but it looked like she was munching on the trees. I kept on driving,

but I realized the surrealistic ambiguity would be something to deal with. It was a busy street, traffic was moving fast, so I didn't see anything else. But when you are ready for something, it doesn't take much.

Sometimes we let little insights go without doing anything with them, and we shouldn't. . . . This experience got my mind going, the possibility of working with that concept. It hit me that I should do that concept in painting. The sight of the "outsight" gave me an "insight."

The point wasn't to illustrate what I saw. It was to use this experience, this insight, to make art. When you start out, you don't know the scale, the color, the format that you are going to use. I was in search of these things. I didn't want to duplicate what I saw, but to utilize the incongruous world that I was looking at and make it work for painting. When you see something like that, it opens up a new vantage point. I was ready for that kind of stimulation.

RCC: Why did you feel that the format of the paintings mattered so much?

MC: If I make the format of the paintings all the same, the visual concentration is on the content. If I change the format, the vertical, the horizontal, then the emphasis seems to go on the periphery of the formats. You have to have a very strong image to keep it from doing that. It's a visual groping, if you may. . . .

As you proceed, the process of painting changes. The paintings evolve. I wanted to give paint credit as paint, not as illusion. I still use a lot of heavy paint. In the real small ones, I tried using heavy paint. I wanted the painting to be precious because of the paint, not because of the subject matter. What's that French word for preciousness, *bijou*?

RCC: Yes, it's often translated as "jewel." In *Humanscape 125 (CIBOLA)*, the screen image is a rough-textured field of gold, with brown and black accents that recalls some of the landscapes of Anselm Kiefer. In the foreground are seven connected dots; that must stand for the seven cities of gold.

MC: *Cibola* is the word the Indians used to get rid of the Spanish; they would point, indicating to go further north to the desert.

RCC: And in *Humanscape 131 (NACHOS)*, the texture of the paint is as thick and gooey as nachos themselves. How much paint did a work like this take?

MC: Jars and jars of paint. I mix my own paint. Dry pigments and acrylic. I pour the paint. I didn't use a brush, so I need[ed] heavy paint.

RCC: Didn't the pouring begin in the southwestern period?

MC: In the southwestern series, the paint got really thick.

RCC: I notice that the impasto was very thick in the dots in *Humanscape 112 (A Dotting Thomas Painting)*. Then the painting after next, *Humanscape 114*, was the first of the southwestern-themed paintings. Was there something you liked about the materiality of the dots that you wanted to continue?

MC: Yeah. I liked the spontaneity. . . . I did notice as the work progressed that I used heavier paint—more impasto. I wanted more the physical reality of the paint as opposed to the illusion created by the paint. I realized that social-erotic subjects are less dangerous than social-political ones.

RCC: Do you single out any paintings as more significant or important than any others?

MC: All of them, since genetically, they are all mine. Therefore, all are interdependent. Time will answer your question. . . . I cannot have made the better ones without also making the poorer ones. So to me, all of them are good. I couldn't make one without the other. . . . They all grew out of each other.

RCC: Are there elements of resistance in your *Humanscapes* that have a particular relevance to a Chicano audience or that depended upon a Chicano sensibility, experience, or point of view when you painted them?

MC: No. As a matter of fact, my paintings are totally confrontational.
 We have people of Spanish descent who don't speak Spanish. People live here all their life but they don't know Spanish. They go to restaurants and they can't read the menu, so they say, "Just give me the number two plate." Many Hispanics, they don't want to learn Spanish, because they would be regarded as foreign.
 In 1961, when I came here [to San Antonio], the Spanish spoken here was atrocious. The Hispanics here acted in a comic form, like the

stereotypes of the movies in the 1930s and 1940s. Maybe because it is the seat of [the] Alamo.

We were different in El Paso. We were very aggressive. I give credit to my dad. He taught me many things. In elementary school, I raised my hand and told my teacher, "My dad said you stole all this land." I was sent to the principal, and I told him: "It's true, it was taken by force." And the principal did not agree or disagree. That's how we were in El Paso.

Humanscape 2 speaks of actions. It confronts you and says: "You ignorant bastard, don't you know the language?"

RCC: It seems more than a coincidence that your involvement in the Con Safo art group corresponded to an intense period in which your painting was at its most political.[1] Could it be that all those discussions about art and politics had an effect on your subject matter in the early 1970s?

MC: It was the time of the Vietnam War and the time of the youth protests. The blacks wanted equality, then the Mexican Americans got involved. I didn't have that many students of Mexican descent at a given time. But at that time, they started coming in. And I wanted to be noticed.

I was in a strange situation. I got into teaching by default. It was a good situation. My money came from teaching, not art. I was able to paint what I wanted. Painting as search. I didn't have to worry about the art market. If I sold it, it was like gravy. A lot of artists at that time wanted to be known right away, but they weren't ready. I was very involved with my students, and I really enjoyed teaching.

Strangely enough, the group members were very young. Most were students. The older artists didn't want to be involved. Some of the artists didn't want to deal with politics. They said they only wanted to make art for art's sake. To say "art is for art's sake" is to deny that we live in society. It's a dream world.

Women, blacks, Hispanics—they began demanding rights. It all came together.

RCC: Why do you use the word *Hispanic* now, when you were so adamant about the use of the term *Chicano* back then?

MC: César Chávez was agrarian. He led an agrarian movement. It was seasonal. They followed the cycles of the season. People forget now, but the first strike was led by Filipinos. They were smart because they boycotted green grapes, which have to be picked right when they are ripe, in a

short period. I used *Hispanic* as a term because some of the Filipinos were Spanish speaking. So I use linguistic terms rather than pigmentation or other categories. Spanish was important at one time. But now English is dominant, the most dominant language in the world. Spanish is no longer very significant.

RCC: Are you disavowing the term *Chicano*?

MC: No, I grew up with it. It's more specific. The term is limited to people of Mexican descent.

RCC: In your artist's statement published in the catalog for your 1968 exhibition [titled *Mel Casas Paintings*] at the Mexican American Institute of Cultural Exchange in San Antonio, I'm sometimes not certain if you are referring to the audience *within* your *Humanscapes*, or the *external viewers* of the *Humanscapes*, or some conflation of the two. Could you clarify this?

MC: It's a deliberate ambiguity, because the viewers of the *Humanscapes* are voyeurs. They are interfering in something private, at the same time that they are viewing the pictures. . . .

One of the influential critics for all of us at the time was Marshall McLuhan.

RCC: *The Mechanical Bride?*

MC: Precisely. How did you know?

RCC: There were a great many theorists whose work could be relevant to this series. . . . Your choice of language has commonalities with *The Mechanical Bride*, which treated film posters, advertising, comics, et cetera. McLuhan also used aphoristic phrases that were boxed off with a line. They parallel your own aphoristic devices. In addition to McLuhan, were there other theorists whose work influenced your views?

MC: Not really. In a way I was more involved with social and political developments. I was interested more in semantics, in the play of connotation and denotation. I always paid close attention to word choice and to the differences between connotations and denotations. It interested me to see which words people used.

RCC: Did critical discussions of films that treated voyeurism as a topic have an important role in the development of your *Humanscapes*?

MC: Yes and no. I was thinking about social and political elements. And technology. It triggers us to respond. The newer the technology, the newer the response.

Now we tend to think of voyeurism as sexual. *Molestar* in Spanish is a respectable word, but in English [*to molest*], it's sexual. Though they came from the same Latin source. It's playing with language, being conscious of it. When it comes to sexual intent, sometimes I'm the guilty party.

RCC: *Humanscape 56 (San Antonio Circus)* — is this a reference to fiesta queens and HemisFair?

MC: Fiesta, the ideal of kings and queens. We left the old world to start another one with kings and queens. Fiesta [San Antonio] is in conjunction with the Alamo and is a fake patriotism based on fake history. When we repeat a lie over and over again, with time it becomes real. Because it becomes more distanced from the beginning.

RCC: Does this painting address cultural appropriation and racial exclusion?

MC: It was a social register affair. It became an outlet for releasing social and racial tensions. Now someone invented El Rey Feo, "King Ugly," maybe so Hispanics could participate. Had this existed when I made this painting, I would have included a clown for sure.

RCC: Did you appropriate the images of the Indians in *Humanscape 62 (Brownies of the Southwest)* from a particular source?

MC: No, they are stereotypes. Not portraits. . . . José Vasconcelos [conceptualized *la raza cósmica*, which influenced the naming of] Mexicans "the race of bronze." Here they are stereotypic Indians and the Frito Bandito. Sometime before I made this painting, the Frito-Lay corporation gave out little plastic trinkets of the Frito Bandito in the packages. I took one to the jewelry department at San Antonio College to make a copy in silver. But they burned it and destroyed it. I didn't get my silver image. Protests caused a recall or an end to distribution of the plastic toy bandito. We became aware — it's a learning process. So I was not able to get another copy.

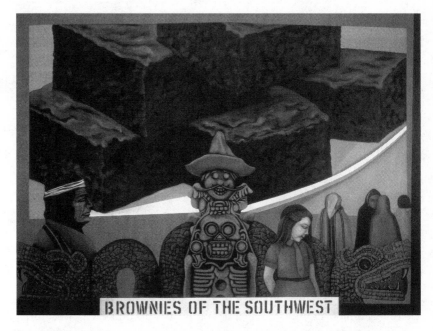

Figure 20.1. Mel Casas, *Humanscape 62 (Brownies of the Southwest)* (1970, acrylic on canvas, 72 x 96 in.). Contrasting José Vasconcelos's philosophical conception of Mexicans as the Cosmic Race with a grand future, here Casas shows them as stereotyped, trivialized, diminutive, and demeaned. (Photo by Rubén C. Cordova; courtesy of same.)

I called the company and asked for one. A representative told me that they were never made or distributed. I asked how I got one, and he said he didn't know how. Years later I found another one in a flea market, so I have one now to prove that they really existed.

RCC: So in a way you've enlarged and immortalized this trinket in your painting.

MC: And killed it too.

RCC: Tell me about the serpent.

MC: The two heads speak of bilingual culture. . . . Mexican Americans live in two cultures. We do things every day to negotiate these cultures. But the experience is often one of conflict, or a split between cultures.

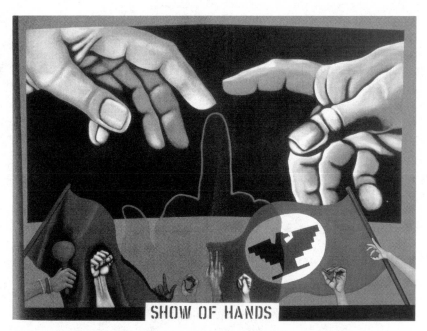

Figure 20.2. Mel Casas, *Humanscape 63 (Show of Hands)* (1970, acrylic on canvas, 72 x 96 in.). Even a seemingly universal hand gesture may have divergent and possibly contradictory meanings according to contexts and cultural complexity and specificity. (Photo by Rubén C. Cordova; courtesy of same.)

Schizothymia is unconscious, in contrast to deliberate biculturalism, which is conscious.

RCC: I love the way the elements of the Frito Bandito and the Greenstone Monster echo and reflect one another in a series of visual rhymes: the circular eyes, the teeth; the bandit's moustache is an inversion of the skeleton's collarbone; the pistols rhyme with the skeleton's earrings, which are emblematic of Quetzalcoatl. The twinned serpent heads are doubled yet again by a grim skeleton and a grinning, comic bandit.

MC: Yes. They become one.

RCC: In *Humanscape 63 (Show of Hands)*, is the Indian rattle included to show Indian heritage?

MC: Correct.

RCC: What does the black flag represent?

MC: Black flag—anarchy, nihilism. When people get desperate they want to wipe everything away and start all over again with a better model. But they don't have one, so they have to make one up. It's all experimentation.

RCC: Why do you use the UFW flag as a counterpoint to the anarchist flag?

MC: It's a new organization. It represents hope or aspiration. That doesn't mean either one is correct. In the end, farmworkers ended up being farmworkers. Maybe they got more money, sanitary facilities. And some got out of farmwork. You have to have more; you have to have education.

RCC: But isn't the UFW an emblem for the entire Chicano movement?

MC: Correct. . . . The hands [portrayed in the painting] spell out love. But the individual gestures are obscene in particular places. Love and obscenity —it's a series of contradictions. So it depends where you are.

RCC: So you are reveling in the ambiguity and manifold meanings of these gestures?

MC: Images, like music, are universal. At least to me. I read music. You have to read them. . . . The beauty of painting is that you can say it more simply with imagery than with words.

RCC: Do you ever feel that you could have or should have spelled out your intentions in a more explicit manner?

MC: The *Humanscapes* are deliberately ambiguous. If I spell everything out, I'm making an illustration, and I didn't want to make illustrations. That wasn't the point. The point was to make art.

Notes

1. The Con Safo art group formed in 1968, initially as El Grupo, and remained together through the mid-1970s. Con Safo was founded by Felipe Reyes and included

fellow San Antonio artists Jose Esquivel, Rudy Treviño, and Roberto Ríos, along with Mel Casas. See Cordova (2011) for more information about the group.

Bibliography

Cordova, Rubén C. 2011. *Con Safo: The Chicano Art Group and the Politics of South Texas*. Los Angeles: Chicano Studies Research Center, University of California, Los Angeles.

McLuhan, Marshall. 1951. *The Mechanical Bride: Folklore of Industrial Man*. New York: Vanguard.

Vasconcelos, José. [1925] 1997. *The Cosmic Race/La Raza Cósmica*. Baltimore, MD: Johns Hopkins University Press.

Brown Paper Report

Mel Casas and Con Safo

(Born December 19, 1971)

Chicano: another word for: dignity, self-awareness, survival, humanity, identity, messianic goals. People in harmony with themselves.

Brown Vision: if Americana was "sensed" through blue eyes, now brown vision is demanding equal views— polychrome instead of monochrome. Brown eyes have visions too. It's George Washington and Che Guevara homogenized into one. It's Tejerina [*sic*] reclaiming the southwest and it's César Chávez synthesizing farm workers into the mania that is middle class Americana. It's a promise to be—as middle class Americana is a product of a promise to pay.

Utopian facet??? Brown Dream

Con Safo: (Zafarse) Safarme.

Safo, fa, adj.—nadie esta *safo* de una mala hora [no one is *safe* in a bad time]

Con Safo: Act of defiance

Is a state of mind

Alienation verbalized

"Brown Paper Report" first appeared in 1971. It has been reproduced in *La Movida Con Safo* (1975), Mel Casas Papers (1966–91), local no. AAA 3316–3317, Archives of American Art, Smithsonian Institution, Washington, DC, and Rubén C. Cordova's *Con Safo: The Chicano Art Group and the Politics of South Texas* (Los Angeles: Chicano Studies Research Center, University of California, Los Angeles, 2011), page 63.

Clandestine Act
Profanity that craves sacredness
Sgraffiti with a purpose
Cry of anguish
Cry for help
State of anxiety
Social rejection
A demand for identity
Language of the ghetto
Language of the gutter
Language of futility
A demand for acknowledgement
A divorcement from responsibility
A seeking of responsibility of anticipation
I don't believe I have been recognized?
If you think evil of me—likewise!
We have been here before
Critical Point
Not Pax Americana but the social consciousness of
Americana.

If the scribbling of C/S on walls, bridges, monu-
ments, et al. [*sic*] brings to mind vandalism—it's
because we are more material orientated rather
than socially aware.

A Contingency Factor

Mel Casas and Con Safo

- WE ARE AN ACT OF PROVOCATION
- WE ARE A POINT OF CONTENTION
- WE ARE VISUAL ABRASION
- WE ARE ICONIC FRICTION
- WE ARE VISUAL PROJECTIONISTS FOR THE CHICANOS
- WE ARE THE PRIMORDIAL ENGRAMS OF CHICANISMO
- WE ARE ARTISTS. . . . C/S

CON SAFO (C/S) ARTISTS:

A Contingency Factor

Invariably we are asked: Are you Chicano artists? The question is but the proof of the melting pot fallacy. Thus, how can we be otherwise but Chicanos. Physically, psychologically, and philosophically we are viewed as outsiders and programmed to consider ourselves as such. The outcome has been disassociation through introspection and forces personal evaluation. The C/S (Con Safo) approach is based on the concept of establishing an identity through visual means. The hope is that visual congruity will in turn give us psychic harmony—a statement of our evolving condition and

"A Contingency Factor" first appeared in Con Safo's brochure for their group exhibition in 1972 at the Mexican American Cultural Center (MACC) in San Antonio, Texas. It has been reproduced in *La Movida Con Safo* (1975), Mel Casas Papers (1966–91), local no. AAA 3316–3317, Archives of American Art, Smithsonian Institution, Washington, DC, and Rubén C. Cordova's *Con Safo: The Chicano Art Group and the Politics of South Texas* (Los Angeles: Chicano Studies Research Center, University of California, Los Angeles, 2011), page 67.

position as Chicanos. Artists are bound to the obligation of interpreting their environment and reacting to it. Chicano artists are duty bound to act as spokesmen and give visual reality to the Chicano vision. We are iconoclasts, not by choice but by circumstances—out to destroy stereotypes and demolish visual clichés. We hope, in the process, to encounter new pure forms that will act as catalysts for a visual nascence and awaken the dormant Chicano potential. Because we are Chicanos we are not anti-anglo or anti-mexicano. We are very cognizant of how they have failed us. We are pro-human and because of it we are CHICANOS. For this reason we feel the images produced by Chicano artists, to have any validity, must offer more than physical reality. The Chicano artist must be on guard against the proclivity to search for easy iconographic solutions. Chicano Art must continue to engage itself with the profound experiences of its age—this is the CHICANO AGE—and man's commitment to them.

As Chicano artists we must edit our contemporary visual and psychological reactions to Chicanismo, and remember that how we handle visual space in our paintings will reflect our concept of environmental freedom.

There is a resistance, from the Chicanos, against assimilation into a "pure" Mexican society and Anglo-American society. Chicanismo is the process of synthesis of these cultures in varying dosages as suits personal and group tastes.

A process of cultural secession (social internalization process) must be initiated in order to allow us to begin to view ourselves with our own eyes and arrive at our own definition about our state of existence and express the nature of our concern for this state.

Cultural genocide (aggression) has been inflicted upon the Chicano, however there is now a nascent awareness that has spawned a flurry of cultural activity in an attempt to resuscitate and regenerate a wounded culture.

Getting the Big Picture

Political Themes in the *Humanscapes* of Mel Casas

Rubén C. Cordova

This chapter is structured as a virtual exhibition drawn from a series of large-scale paintings by Mel Casas called *Humanscapes*. The exhibition is made up of eight groupings of three paintings, all of which have identical structures and dimensions. They are listed in the order they are to be hung (left to right). Each thematically similar group is arranged like a partially opened triptych, bringing the trio of paintings into dialogue with one another. The gallery is imagined as a continuous perimeter of paintings that are set at an angle to one another, with relatively little blank wall space between them. Casas wanted the spectator to be engulfed in a cinematic-like space: by situating the paintings in close proximity, the desired effect is amplified. This design enables a large quantity of paintings to be fitted into a relatively small museum space. All paintings can be viewed from varying distances. Additionally, the visitor can pivot from a central location in the gallery and scan the entire exhibition.

The *Humanscapes* series began in 1965, when Casas serendipitously caught a glimpse of a distant drive-in movie screen, and this surreal experience inspired Casas to create 153 paintings over the next twenty-four years. Most of the earliest *Humanscapes* explicitly reproduced cinema or drive-in theaters. They were equipped with ghostly, mannequin-like audience members, who functioned as surrogates for the viewers of the paintings. By mid-1967, these spectatorial scenarios became increasingly improbable. Several developments defused the explicit cinematic setting: the formerly passive spectators became fleshed-out actors on their own stage, endowed

with color, substance, and volition. As these foreground figures gained autonomy, they turned away from the screen, toward the viewer of the painting. The subsequent *Humanscapes* nonetheless reference the cinematic image in their proportions, in their scale, and in the large, isolated, screenlike image in the upper portion of the paintings. Signs situated in the foreground of five paintings developed into punning subtitles. Commencing with *Humanscape 40 (Game)* (January 1968), each *Humanscape* has a tripartite structure: a pithy subtitle text (executed in block letters, in emulation of signs); a shallow foreground space (usually filled with several figures or images); and a large, curved screen image (a reminiscence of the drive-in screen Casas saw in 1965). After using the 6-by-8-foot format in *Humanscape 33* (July 1967), Casas utilized it for the rest of the series because, as he put it, it best "expressed the ratio of cinema to the real world."[1]

From 1967 through early 1970, Casas addressed the sexual revolution in what he called "socio-sexual works."[2] He began making politically explicit paintings in early 1968 and concentrated on "socio-political works" from 1970 through 1975. From 1975 through 1981, Casas frequently analyzed aesthetics, the art market, and the art world at large. Commencing in 1982, the final thirty-six *Humanscapes* all treat southwestern themes, images, and clichés. While all of Casas's *Humanscapes* have political significance, this chapter addresses his most politically explicit works, most of which date from 1968 through 1977. These paintings broach the theme of resistance, often in the context of Vietnam-era politics and Richard Nixon's controversial presidency. They are also the works for which Casas is best known.

Casas defines the *Humanscape* as "visual conundrums" and "a riddle whose answer depends or refers to a pun and has only a conjectural answer" (Casas 1976, 1). He chose to utilize a common title and numbers to refer to paintings in this series because this gave them a sense of anonymity. Marshall McLuhan had emphasized that anonymity was a hallmark of mass society. At the same time, the uniform structure provides the commonality that links the series together. In his view, art has a unique role and responsibility: "sometimes art is the only place where society can honestly examine its deepest needs and fears" (Goddard 1988, 7-H).

Casas characterizes his *Humanscapes* as "totally confrontational." He attributes his aggressive stance to his father's example and to his El Paso roots. Casas, who served as a professor of studio art at San Antonio College, contrasts his adopted city to his native city: "When I first came to San Antonio, it seemed like an oppressed, colonial city. Everyone knew their place. Either you conformed to the status quo, or you were treated like an alien.

The Hispanic population seemed remarkably docile to me after growing up in El Paso, where there was more openness about relations" (Goddard 1988, 7-H). The *Humanscapes* were fueled by a confluence of social movements: the civil rights movement, the Black Power movement, the Chicano movement, the feminist movement, and violent protests against the Vietnam War. Casas notes that the simultaneity of these emerging forces created a highly charged political atmosphere that stimulated his work.[3] As part of his process, Casas made production notes and analytical diagrams for the *Humanscape* paintings, and he later shared these with his students and colleagues.[4] At the same time, even Casas's most topical responses to political events are so ironic, oblique, and open-ended that they are often too cryptic to decipher without extended analysis.

The Virtual Exhibition

Group One: On-Screen Slogans

The second, fourth, and fifth *Humanscapes* with subtitles have phrases instead of images on the background screen. These phrases convey political messages in a manner that is presumably less ambiguous than images. Since Casas did not continue utilizing phrases, he must have preferred images.

Humanscape 41 (Yield) (February 1968) is the second *Humanscape* with a subtitle. The subtitle "yield" is superimposed over two solemn-looking women who face away from each other in the foreground. They confront the option broadcasted on the screen: "War is profitable. Invest your sons." This is Casas's ironic commentary on the cold economic calculations and concomitant human costs of the Vietnam War. As depicted, two foregrounded women holding babies appear oblivious of five nearly identical women, each with eyes shut and holding her own baby. A number or a question mark is stenciled over each baby. These marks invoke their unpredictable destinies. Casas's imagery demands that mothers face a choice; some will "yield" their children, and the "yield" of this "investment" will be death.

Humanscape 43 (Obscenity) (February 1968) likewise features a text (along with dollar signs) instead of an image on the screen. As Casas points out, the text "$KILL$" indicates that "dollars kill" and "the skills of war are killing."[5] The foreground images consist of bayoneted rifles, soldiers' helmets, and the stiffly upraised arm of a man in business attire. This gesture

indicates the businessman's approval of what Casas has termed the "business of war."[6] The subtitle "obscenity" is Casas's commentary on the economic motives behind wars like that in Vietnam.

Humanscape 44 (Autism) (May 1969) has the following on-screen text: "SILENCE is Golden, it's also YELLOW." Five well-dressed figures (and a woman who could be either nude or in an evening dress) stand in the foreground. The silent man and woman in the center have expressions of smug bemusement. The two men on the viewer's left engage in furtive communication. The man on the right is distressed. The cryptic screen phrase needs to be read in light of the subtitle "autism" as a withdrawal into cowardice. The business suits suggest the material wealth that is at stake in acts of courage.

Group Two: Political Polarization

Humanscape 49 (Meta-Ethics) (October, 1968) has three human-shaped silhouette targets in the screen image and four shotgun-wielding men in the lower foreground. One shotgun is aimed directly at the spectator. As the artist notes, "there's a world of difference between looking at a bull's eye target and one that is a silhouette of a human being."[7] The letters *U*, *S*, and *A* are stenciled on the targets in recognition that few other countries permit such untrammeled access to firearms, from hand guns to assault rifles. The National Rifle Association (NRA) advocates unrestricted access to firearms. It argues that gun ownership is constitutionally guaranteed, yet, as Casas points out, the NRA often emphasizes hunting as a justification.[8] The implication here—suggested by the targets—is that the guns are potentially for hunting human beings, hence the subtitle. Gun control became a debate topic following the assassinations of Martin Luther King and Robert Kennedy. Guns in this painting point toward the casket in *Humanscape 47 (Still Life)*.

Humanscape 80 (Remember Left Is Loose Right Is Tight) (March 1976) has a sign with the inverted words "American Screw" and four screws and one nut in the screen field. The largest of these extends to the foreground. The subtitle is a mnemonic device for the directions in which to tighten and loosen screws. American politics and sexual mores are intertwined.

Humanscape 47 (Still Life) (August 1968) has a screen image with a decidedly generic-looking still life: a slice of apple pie with a fork, a cup of coffee, a crystal wine decanter, three pears, and bouquet of flowers. A casket in the lower right foreground is draped by an American flag that bears the initials "KKK." Viewers immediately recognized the acronym

for the Ku Klux Klan, but Casas suggests in an interview that the *K*'s also refer to John F. Kennedy, Robert F. Kennedy, and Martin Luther King Jr.[9] "KKK," then, serves a double function: it represents the intolerance of white supremacists while it commemorates civil rights martyrs, two of whom were assassinated the year the painting was made. And yet the disproportionately large apple pie is a key to the painting's meaning: Casas is implying that the Ku Klux Klan is as American as apple pie. (A year earlier, in 1967, future Black Panther H. Rap Brown had declared: "Violence is as American as cherry pie.") One could also read the initials on the flag to signify "death to the Klan." On a linguistic level, the terms for "still life" in French, *nature morte*, and in Spanish, *naturaleza muerta*, translate literally as "dead nature." Figuratively, this is akin to "dead life." The painting is a tribute to lives that have been stilled—as well as a condemnation of the forces that contributed to their demise. Visually and linguistically, *Still Life* is deliberately esoteric. In the left foreground, a solitary female faces the viewer. Her hair shrouds her face. This silent witness evokes the ancient Egyptian mourners who were paid to wail at funerals. The grief is so great it cannot be adequately addressed.

Group Three: Racial Beauty

Humanscape 58 (American Beauty) (September 1969) references both the rose (the screen image) and the racially exclusionary concept of beauty represented by the nude, which is ironically duplicated in a reverse, riposte-like manner. The nude is grafted into the foreground. As Casas notes, "American beauty is not only physical beauty, it's also racial beauty. We are bombarded by this constantly on TV" (Quirarte 1973, 133). As critic David Hickey points out, the red, white, and blue colors and the phrase "American Beauty" generate "a subliminally *prescriptive* definition of 'Beauty in America,' couched in terms of a WASPish combination of 'American' colors" (1988, 30).

Humanscape 56 *(San Antonio Circus '69)* (June 1966) treats the curious fair known as "Fiesta San Antonio," which appropriated aspects of Mexican celebrations. Though ostensibly a celebration of Mexican heritage, Fiesta San Antonio was controlled by representatives of the city's ruling class. Consequently, people of Mexican descent were excluded from the fair's premier activities. The annual parade of Anglo fiesta queens has long been the city's most ostentatious social event. In this painting, eight vacant-eyed queens with preposterous tiaras—one of them surmounted by dollar signs—form a pyramid in the lower foreground. Their skin is

rendered with patches of unnatural colors, including red and green. If they seem unreal, it is because they have no real substance. They are what they pretend to be: a masquerade of royalty. The supreme queen's head is superimposed over the open mouth of the roaring tiger that fills the screen image behind her. She appears to be in danger of being devoured. Perhaps the tiger, which is behind bars, represents the righteous anger of the excluded people of color, who have been dispossessed of their land and property, stripped of their culture, enslaved, forced onto reservations, incarcerated, denied the full rights of citizenship, and compelled to live in segregated cities. Two giraffes use their preposterously long necks to get into the picture, a mocking commentary on those humans who live for the photo op. Like the tiger behind them, they are painted with a high degree of psychological characterization—in stark contrast to the masks below. These rare specimens from both the human and the animal kingdoms confirm that the circus is indeed in town.

Humanscape 66 (Sacred Cow-Bull) (April 1972) features a nude blond woman who represents what Casas has called "the Ideal American Woman," which Casas often compares to a Barbie doll. She stands before an American flag, "a Totem (sacred), not to be questioned."[10] A bull, which looks at the woman, is flanked by two cows. The latter symbolize, in Casas's words, "the great 'udder' American-mammiferous obsession."[11] Neither the ideal beauty nor the flag—nor the actions taken in its name— are open to question, for they are infallible exemplars, sacred cows.

Group Four: Stereotype

In a manner befitting its theme, the composition of *Humanscape 70 (Comic Whitewash)* (October 1973) is unusually dynamic: the perimeters are filled with the muscle-bound members of DC Comics' Justice League of America. Batman, Superman, and Thor spring into action from the left, while Hawkman, Spiderman, and Captain America descend from the right. The screen image is a star-spangled blue field whose center has been whitewashed with dripping, de Kooning–like "heroic" brushstrokes. A Chicano boy, who is clad in a white T-shirt, looks away, having already internalized these comic book cultural ideals. His thought balloon says, "Wow," reflecting his apparent awestruck wonder. Bombarded with cartoon images and "cartoon thoughts," the child could wish he were, as the artist described in 1973, "two-dimensional."[12] And in this case, as the artist emphasized in his production notes as well as in an interview more than three decades later, the "WoW" is actually "'MoM' upside down."[13] The

child is asking: "'How come all the superheroes don't look like me?' It's about comic lies, racial lies, white lies, you can go on and on."[14] The following are among the boy's other questions: "MoM, what is my image?" and "MoM, if I am not a hero, am I a villain?"[15] Casas contrasts his use of comics to that of Pop artist Roy Lichtenstein, who "stuck with the comic technically, with the Ben-Day dot matrix. . . . I was involved with the message matrix."[16]

Humanscape 62 (Brownies of the Southwest) (July 1970) is the artist's most frequently exhibited and reproduced painting. The word "Brownies" at the bottom of the painting references five entities: the "quintessential American junk food," through the screen image (Cortez 2002, 37); North American Indians, represented by generically stereotypical representations; the junior category of the Girl Scouts, represented by a young girl in uniform; Mesoamerican culture, represented by the double-headed-snake mosaic pendant; and modern Mexicans, represented by the image of the Frito Bandito. The two-headed serpent originally represented a dualistic version of Quetzalcoatl. In this painting, Casas views that icon as an emblem of schizothymia (split culture, on an unconscious level, as opposed to a conscious biculture), dichotomous nature (Quirarte 1973, 85), and bilingual culture.[17] The double-headed serpent is doubled once more by the heads of the skeletal figure (identified by Casas as Xolotl, the deformed twin of Quetzalcoatl) and the Frito Bandito, an infamously stereotypical cartoon character used to advertise Fritos corn chips (Bender 2003, 180; Noriega 2000, 28–50; Nuiry 1996). The snake, the skeleton, and the bandit appear to be synthesized into a grandiose jade monument. Jade and the color green were synonymous with preciousness in Mesoamerican culture. The bandit was inspired by a miniature Frito Bandito eraser that Casas attempted to have cast in silver to wear on a chain. After that project's failure, the stereotypic bandit migrated to this picture.

The undulating two-headed mosaic serpent is perfectly symmetrical. The Frito Bandito and the skeletal figure serve as brilliant counterpoints to the serpent. Their forms echo and reflect each other in a series of visual rhymes: the circular eyes; the teeth; the bandit's moustache, an inversion of the skeleton's collarbone; the pistols (emblematic of a stereotypic image of a bandit) rhyming with the skeleton's earrings (whose tear shape is emblematic of Quetzalcoatl); the bandoliers of bullets, which seem to be continued by the cropped hair ornaments atop the skeleton's head. The skeletal figure's arms could even read as the bandit's legs: the bandit seems to ride the skeleton like a horse. When he made this painting, Casas referred to the Frito Bandito as "the Brownie Monster" (Quirarte 1973, 85).[18]

Figure 23.1. Mel Casas, *Humanscape 68 (Kitchen Spanish)* (1973, acrylic on canvas, 72 x 96 in.). Casas interrogates the perpetuation of ethnic caste systems. (Photo by Rubén C. Cordova; courtesy of same.)

Since Xolotl is often identified as a monster, here monster rides monster. The emblematically grimacing skeleton and the comically grinning bandit join, like two heads on a surreal totem pole. In contrast to José Vasconcelos's conception of Mexicans as the Cosmic Race with a grand future, here they are stereotyped, trivialized, linked with all dark things that are dismissed as diminutive, and demeaned.

Humanscape 68 (Kitchen Spanish) (March 1973) is one of Casas's most caustic works. The subtitle and cartoon image of a servant girl are derived from an illustrated instructional booklet designed to enable "housewives" to boss around their Spanish-speaking maids.[19] Two women with pinched, severe features loom on the right side of the painting. A drawn curtain "suggests domesticity" and theatricality (Cortez 2002, 37); it also recalls the series' cinematic genesis. A disinterested girl stands in the far left foreground. The maid is framed on either side by a wrinkled English bulldog and an agitated young boy. Her speech bubble reads: "*Sí niño* [Yes boy], *Sí niña* [Yes girl], *Sí señoras* [Yes ladies], *Sí gato* [Yes cat], *Sí perra* [Yes

dog]." This robotic response makes her seem like a "mechanized stereo-type" befitting her two-dimensional representation, which makes her "less real" than her employers, "or even their pets" (Cortez 2002, 37). None-theless, an act of resistance is encapsulated within the maid's apparently all-obeisant response. Since a slang connotation of *perra* is "bitch," the cartoon maid is actually, subversively, insulting her boss on the right.[20] Someone who learns Spanish to command servants rather than to "read great literature" wouldn't know she was being insulted.[21] Nor would an English-only viewer. The screen image behind the maid features kitchen sinks "blown-up for impact as an image of domestic duty."[22] The running faucet signifies that the maid is a "wetback," an undocumented worker.[23] This status makes her particularly vulnerable to the whims and desires of the household members. The cat, whose head is superimposed over the maid's genital area, is the key to another layer of meaning.[24] The bulldog is trying to get at the cat. The old matron restrains it with a taut leash. Her wrinkled jowls and neck echo those of the dog, implying that it could be a surrogate for her husband. Bulldogs were bred for bullbaiting and are famously tenacious: they symbolize Anglo might and tend to be associated with imperial power and right-wing politics. The maid will likely be sub-ject to unwanted sexual advances from the elder male. But she is more for-midable than one might guess at first glance, and she will not suffer abuse silently. The agitated child and Anglo girl provide an optimistic note, for they are "unwilling pupils to the perpetuation of the ethnic caste system."[25]

Group Five: United Farm Worker Imagery

Humanscape 65 (New Horizons) (December 1971) features a partial view of a UFW banner as a screen image. It is set against ocean waves, the "sym-bol of life."[26] Down below, anonymous farmworkers labor in a lettuce field that stretches endlessly to the horizon. The flag is so large that the central circle reads as the sun. Its meaning is ambiguous: it can be viewed either as a sunrise or a sunset, "depending on whether one is optimistic or pessi-mistic."[27] The status of the workers is more clear: the "sea of lettuce"—the Spanish word *lechuga* is slang for money—will "'crop' into someone else's pocket."[28] *Humanscape 63 (Show of Hands)* (December 1970) features an indigenous presence in the right foreground: an Indian hand "rattling out a protest."[29] It's followed by the clenched "fist of a white conservative. . . . the word love is spelled out" one letter at a time on a black, yellow, brown, and white hand.[30] The brown hand is simultaneously a V and a peace sign.[31] The next hand holds a marijuana cigarette. The last hand

holds a birth control pill while it forms the OK sign. The pill had become even more controversial when Pope Paul VI unexpectedly condemned all forms of "artificial" birth control in 1968 (Allyn 2000, 108–9). Though one might assume that the last gesture signals the artist's approval of the previous signs, Casas's intent was more complex: "the hands spell out love" and the individual gestures are obscene in particular places; love and obscenity enact a "series of contradictions."[32] The artist is contending that however widespread or seemingly universal a hand gesture might appear to be, such gestures have divergent—even possibly contradictory—significations in different locales and for different audiences. Casas revels in these contradictory meanings and assumes that most viewers would have widely divergent interpretations of these signs.

Unfurled behind the row of hands are two flags: a black anarchist flag and a United Farm Workers' banner. The former represents the "nihilism" of anarchy: "when people get desperate they want to wipe everything away and start over again."[33] The UFW banner, by contrast, is that of a "new organization" that "represents hope or aspiration."[34] Contrary to most readings of this painting, Casas did not intend to imply that either position was necessarily "correct" or destined to prevail.[35]

The screen image modifies a detail of Michelangelo's *Creation of Adam*, a mural painted on the ceiling of the Sistine Chapel in Rome. God's hand is poised to impart the spark of life to Adam's hand. Casas describes his version of the hands as "frigidly depicted in the frozen art of touching."[36] These stiff hands have the blue cast of corpses in rigor mortis or of marble hands that reflect the cold blue light of an electronic screen. To this iconic near meeting of famous fingertips, Casas adds a middle digit from a third, equally monumental hand. This gesture is "not a put-down" of Michelangelo or the Renaissance. Casas calls it an "act of defiance,"[37] which was also the first of twenty-two definitions of "Con Safo" in his "Brown Paper Report" (1971). Many of the definitions in this contemporaneous manifesto are also relevant to *Show of Hands*, including "Profanity that craves sacredness" (Casas 1971). According to the artist, "the new world should have started anew and created a new culture."[38] Though the title *Show of Hands* implies an unambiguous vote or gesture, the painting instead calls for recognition of the complexity and specificity of culture and meaning.

Humanscape 73 (Chicano Image on the Move) (November 1974) features the head of UFW leader César Chávez as a screen image. Lettuce and grapes had been the primary products of UFW boycotts, so Casas deploys them as symbols. Chávez's head is dripping blood in a "curtain of martyrdom," revealing a "'grapeshot' effect."[39] Here Casas is referencing

the equivalences that are made between grape juice and blood in Catholic iconography and ritual. Blood symbolizes varieties of sacrifice, both human and economic.[40] A pattern of lettuce leafs forms the background behind Chávez's head: "linguistically [lettuce] can be money" and it also "produces money."[41] The road—like the rows of produce in *Humanscape 65 (New Horizons)*—has no destination in sight. The future is unknown. Casas offers six possibilities, from "escape" to "nowhere."[42]

Group Six: Nixon-Era Politics

Humanscape 64 (Greening of America) (September 1971) references the book written by Yale law professor Charles A. Reich (1970). Reich's argument was enormously appealing to a readership that hoped for social transformation without violence or conscious effort: "There is a revolution coming. It will not be like revolutions of the past. It will originate with the individual and with culture, and it will change the political structure only as its final act. It will not require violence to succeed, and it cannot be successfully resisted by violence. . . . This is the revolution of the new generation" (1970, 4). Reich further argued that the "culture, clothes, music, drugs, ways of thought, and liberated life-style" of rebellious youth was "part of a consistent philosophy . . . both necessary and inevitable" that would eventually include "all people in America" (1970, 4).[43] He postulated a postpolitical utopia.

Casas's screen image consists of lavender wallpaper with a repeating pattern of green marijuana leaves and an enormous hand-rolled marijuana cigarette that juts down at an aggressively oblique angle. Casas characterizes the wallpaper as a sign of the "new American way of life."[44] The joint is "a phallic symbol jolting America into the brutal reality of its make-believe reality."[45] This reflects Reich's view: "in a society that keeps its citizens within a closed system of thought, that depends so much on systematic indoctrination, and an imposed consciousness, marijuana is a maker of revolution, a truth serum. . . . It takes people outside the closed system, releases them from domination of their thoughts, and makes unreal what society takes most seriously" (1970, 259).

The foreground image consists of two flag-draped figures before a fountain. Behind them the grass field (also a punning reference to marijuana) is divided into three zones, which represent Reich's three levels of consciousness: the first is characterized by the nineteenth-century worker, farmer, and small businessman; the second by early-twentieth-century organizational society; and the third by the new, emerging generation

(Reich 1970, 16). Casas describes the central fountain as "the mythical Fountain of Youth watering the fields of the new Americana."[46] The figure on the left is a male with long hair and a headband. He is cloaked in a flag, which is simultaneously an act of protest and a form of patriotism.[47] He holds a dove, the time-honored symbol of peace. Since only men were subject to the American draft, the dove could symbolize cowardice as well as peace.[48] The male is mirrored on the right by a nearly identical figure that is female. This mirroring acknowledges "the unisex tendency of the Youth Culture."[49] Both figures are symbolically rendered in black and yellow because these colors have negative associations in the United States (racism and cowardice). The woman holds a female marijuana plant because it is the female "that produces the intoxicating effect."[50]

Having addressed the youth culture in *Humanscape 64 (Greening of America)*, Casas turns his attention to President Richard M. Nixon and his inner circle in *Humanscape 69 (Circle of Decency)* (July 1973). The screen image consists of a close-up of a nude female torso that is spread-eagled over a vestigial American flag. According to Casas, this represents "the rape of America."[51] A large black dot blots out the woman's genitalia. A man with a Mickey Mouse head, wearing a gray suit, stands beneath the censored crotch. His conical hat is the "fulcrum of the country," and his Mickey Mouse face renders Nixon a "cartoon unmasked."[52] Nixon's arms and two fingers on each hand are extended in his characteristic "victory sign" pose—in opposition to the significations of love and peace that this sign holds in *Humanscape 63 (Show of Hands)*. Nixon, who extended the Vietnam War into Cambodia and Laos, is ironically dubbed the "Prince of Peace," surrounded by five "faceless" surrogates who represent "the essence of their malfeasance" rather than their individual identities.[53] Each head is eclipsed by a solid black dot (an artistic stratagem now identified with John Baldessari), like the one on the body above. Casas appropriated these dots from the black censorship circles that were placed on the covers of pornographic magazines.[54] Magazines had to abide with this restriction before they could pass through the mail.[55] While society would not tolerate representations of the naked human body, Nixon and his staff represented the entire United States. Casas considered Nixon—especially in this pose—and his cabinet to be "so obscene, so corrupt, they should get the same treatment."[56] Casas finished this painting in July 1973. Within weeks, a congressional resolution to impeach Nixon (for the war rather than for Watergate) was introduced.

In *Humanscape 67 (Ellsberg the Pentagon's Mockingbird)* (June 1972), Daniel Ellsberg, the whistleblower who leaked the Pentagon Papers, stands

in the center foreground. His arms are spread, as if he were crucified or taking flight, because he has a "martyr complex" and a "compulsive desire to expiate his guilt."[57] Casas cites Todd Gitlin to explain the significance of Ellsberg's gesture: "The new heroism consists in conspicuously throwing one's own complicity back in the face of power, and thereby struggling to free oneself of it. . . . The act is a direct, unmistakable rejection of one's past participation in evil. What is different about the new heroes is that they know they have been accomplices, not merely in the passive sense. . . . Ellsberg knows what advice he gave between 1964 and 1967, in the Pentagon and in Vietnam. The new heroism has a specific political location; it happens within the most potent institutions of social control" (Gitlin 1971, 447–48). A bald eagle situated in front of Ellsberg mimics his pose while it encases the subtitle within red, white, and blue fields that recall military decorations. As the eagle faces to the viewer's right, Ellsberg faces left. His black sweater marks Ellsberg as a villain. To leftists, he was initially a villain for his role in the Vietnam War (for which he redeemed himself). To rightists, he *became* a villain by acts they believe constituted treasonous espionage. The doves of peace fly in from the left side, while a predatory—and deceptively colored—white hawk flies in from the right. Ellsberg's spread arms seem to make him a bird wrangler who keeps the doves and the hawk from one another.[58] Mockingbirds are mimics. For this reason, Casas depicted a mockingbird in the screen image, for Ellsberg is also "a duplicator."[59]

Group Seven: Anatomical Analysis

Humanscape 85 (S. Africa is Pachydermatous) (October 1976) has a screen image comprised of red, white, and blue horizontal stripes, elements of the Transvaal Vierkleur flag. The Transvaal was a founding province of the Union of South Africa (1910–94). Its flag is synonymous with the legal system of racial segregation known as apartheid, which utilized four racial categories: white, black, coloured (mixed), and Indian. In the *Humanscape* the blue stripe is largely eclipsed by a large anatomical cross section of human skin. By transposing this cross section with the flag stripes, Casas emphasizes that color is not even skin-deep. All humans are the same, under the outermost layer of skin. The red, white, and blue stripes could also stand for the U.S. support of apartheid. Four white elephants fill the foreground space, an indication that the apartheid policies are outmoded and impractical. Their thick skin can be taken as a metaphor for South Africa's imperviousness to criticism. The aggressive poses of the first three

represent bullish stubbornness; the rear view of the last elephant could refer to apartheid as an asinine position. Pachydermata, which means "thick skin," is an obsolete order of animals that erroneously grouped thick-skinned animals together. The title implies that South Africa's racial categories should likewise be rendered obsolete.

Humanscape 72 (Anatomy of a White Dog) (July 1974) has an enormous purple bone as a screen image. The foreground shows four depictions of a ferocious German shepherd, which represents fidelity and watchfulness.[60] The four permutations represent—from right to left—pleasant, anatomic (with an X-ray view of some of its bones), warning, and attacking (the dog appears to leap into the screen). The title is written in white letters, except for the words "of" and "white," which are in black. The subtitle refers to dogs trained by whites to attack blacks in the American South. Casas associates the screen image thighbone with doom. He described its shape as "phallic—a threat to white male supremacy."[61] Anglo sexual insecurity is thus posited as a source of antiblack prejudice. The word "anatomy" refers not only to the physical structure of the bone but to Casas's analytic critique as well. Similarly, "dog" could refer to racist Anglos and to their "dogging" of people of color as well as to the attack dogs themselves.

Humanscape 71 (Apocalypse 2001) (June 1974) features four horses with X-ray views of their skeletons: three of them breach the confines of the screen. They represent lust and "the destructive and uncontrolled forces of nature."[62] A horse also serves as the vehicle of Death, whose skeleton we can see only part of. Death wields an enormous scythe that appears to be made of bone. Its destructive path is symbolized by a buzzard and three human skulls. Casas cites the prophet Jeremiah, the Book of Revelation, and the seventeenth-century English poet Abraham Cowley in this apocalyptic vision.[63] It was inspired by contemporary millennial prophecy: "There was talk that when the planets aligned, it would be the end of the world. That would happen in 2001."[64]

Group Eight: Technologies of War

Humanscape 83 (Teaching a Young Dog Old Tricks) (June 1976) features a detail of a glassy-eyed toy dog in the screen. The faux-fur dog represents the naïveté and playfulness of youth. Its left paw extends out of the screen, as does its red felt tongue, which appears to be vulnerable to a blast that hits one of three toylike tanks in the lower foreground with a resounding comic book "BLAAM." Casas notes: "It's a play on the phrase 'You can't teach an old dog new tricks.'"[65] Children are indoctrinated with war toys,

only to grow up and face the *real* horrors of war, which are foisted on them by the "old dogs."

Humanscape 81 (Media Culture) (May 1976) is Casas's take on the myopia of the mass media. It features four camera-wielding men and a host of microphones. The screen image consists of nothing but military camouflage, framed on either side by film sprockets. The cameramen have captured nothing but camouflage because they "can't see the real thing."[66]

Humanscape 87 (Phallocratic Race) (May 1977) features four erect penises on the screen, against a field of fleshy pink. Except for their different colors (white, brown, yellow, and black) they are virtually identical. Three large missiles rest on launchers in the foreground. Casas explains: "It's the racial battle over and over again. Pigmentation is the excuse to kill one another. Who has more, who has less, who is better, who is worse."[67] He concludes: "It's a useless, pointless, idiotic competition. But we do it."[68]

Conclusion

A confluence of social movements and the media bombardment of presidential election years precipitated a group of politically themed *Humanscapes*, some of which were intertwined with sexual themes. Having challenged the political status quo with these paintings, Casas trained his sights on the artistic status quo. He became an artistic mockingbird, mimicking abstract styles and making ironic commentaries on them, until the spring of 1982, when Casas began using the southwestern clichés. These, too, manifested various forms of resistance through to the end of the *Humanscape* series in 1989.

Notes

1. This essay is informed by many conversations and personal communications with Mel Casas. In particular, an in-person interview in San Antonio, Texas, in September 2008 between Casas and the author, as well as telephone conversations in February and March 2008, are cited below.

2. Readers may consult Casas's artist statement (1968).

3. From personal communication with Casas in 2008.

4. Only a few of these notes and diagrams have been transcribed and published; readers may consult Hickey (1988) and Kelker (2013) for more details. See also Cordova (2005, 2009, 2011). Photocopies of all of the diagrams are held in the Mel Casas Papers, 1966–91, Archives of American Art, Smithsonian Institution, Washington, DC.

This essay is informed by the notes and diagrams for *Humanscapes* 62 through 73 (1970–76); see notes below.

5. From personal communication with Casas in 2008.

6. Ibid.

7. Ibid.

8. Ibid.

9. Ibid.

10. See Casas diagram for *Humanscape 66 (Sacred Cow-Bull)* (1972).

11. Ibid.

12. See Casas diagram for *Humanscape 70 (Comic Whitewash)* (1973).

13. From personal communication with Casas in 2008.

14. Ibid.

15. See Casas diagram for *Humanscape 70 (Comic Whitewash)* (1973).

16. From personal communication with Casas in 2008.

17. See Casas diagram for *Humanscape 62 (Brownies of the Southwest)* (1970). He also confirmed these points in personal communication in 2008.

18. See Casas diagram for Humanscape 62 (Brownies of the Southwest) (1970).

19. *Kitchen Spanish with "Panchita": A Handbook for Housewives* by Berenice Gibbon and Barbara Elliott (1966) was a conversation and phrase book for, as the title suggests, English-speaking housewives. Illustrations in the book were by Rosalio Ortiz.

20. See Casas diagram for *Humanscape 68 (Kitchen Spanish)* (1973). He also confirmed this in personal communication in 2008.

21. From personal communication with Casas in 2008.

22. See Casas diagram for *Humanscape 68 (Kitchen Spanish)* (1973).

23. Ibid. He also confirmed these points in personal communication in 2008.

24. Ibid. He also commented on this in personal communication in 2008.

25. Ibid.

26. See Casas diagram for *Humanscape 65 (New Horizons)* (1971).

27. Ibid.

28. Ibid.

29. See Casas diagram for *Humanscape 63 (Show of Hands)* (1970).

30. Ibid.

31. Ibid.

32. From personal communication with Casas in 2008.

33. Ibid.

34. Ibid.

35. Ibid.

36. See Casas diagram for *Humanscape 63 (Show of Hands)* (1970).

37. From personal communication with Casas in 2008.

38. Ibid.

39. See Casas diagram for *Humanscape 73 (Chicano Image on the Move)* (1974).

40. From personal communication with Casas in 2008.

41. Ibid.

42. See Casas diagram for *Humanscape 73 (Chicano Image on the Move)* (1974).

43. Reich's *Greening* speedily engendered a volume of critical essays from divergent political viewpoints (Nobile 1971). Rick Perlstein views *Greening* as an "antidote" to a slew of alarmist or apocalyptic best sellers of the era that include *The Late Great Planet*

Earth, The Population Bomb, Beyond Freedom and Dignity, and *Future Shock* (2008, 542–43). He explains the reasons for the book's popularity: "Mr. Reich answered a need. His New Jerusalem would just sort of *happen.* Automatically. No more riots, no more cataclysms, no more protests, no left, no right—no politics" (2008, 543).

44. See Casas diagram for *Humanscape 64 (Greening of America)* (1971).

45. Ibid.

46. Ibid.

47. Casas confirmed this in personal communication in 2008.

48. See Casas diagram for *Humanscape 64 (Greening of America)* (1971).

49. Ibid.

50. Ibid.

51. See Casas diagram for *Humanscape 69 (Circle of Decency)* (1973).

52. Ibid.

53. Ibid.

54. Ibid.

55. Casas noted this in personal communication in 2008.

56. From personal communication with Casas in 2008.

57. See Casas diagram with three pages of notes for *Humanscape 67 (Ellsberg the Pentagon's Mockingbird)* (1972).

58. Ibid.

59. Casas commented on this in personal communication in 2008. By photocopying and releasing the documents that became known as the Pentagon Papers, Ellsberg exposed a pattern of systematic deception on the part of the Kennedy, Johnson, and Nixon administrations. The *New York Times* began publishing the Pentagon Papers on June 13, 1971. Nixon failed to suppress their publication. Nor could he capture Ellsberg, who surrendered on June 28, 1971. In 1970 Ellsberg had signed a letter to the *New York Times* accusing Nixon of "vastly expanding this immoral, illegal, and unconstitutional war" (Perlstein 2008, 577). Nixon felt Ellsberg was mocking his power. According to Perlstein, he "snapped," and destroying Ellsberg became a "White House crusade" (2008, 578).

60. See Casas diagram for *Humanscape 72 (Anatomy of a White Dog)* (1974).

61. Ibid.

62. See Casas diagram for *Humanscape 71 (Apocalypse 2001)* (1974).

63. Ibid.

64. From personal communication with Casas in 2008.

65. Ibid.

66. Ibid.

67. Ibid.

68. Ibid.

Bibliography

Allyn, David. 2000. *Make Love, Not War. The Sexual Revolution: An Unfettered History.* New York: Little, Brown.

Bender, Stephen W. 2003. *Greasers and Gringos: Latinos, Law, and the American Imagination.* New York: New York University Press.

Casas, Mel. 1968. "Artist's Statement." In *Mel Casas Paintings*. San Antonio, TX: Mexican American Institute of Cultural Exchange. Exhibition catalog.

———. 1971. "Brown Paper Report." In *Con Safo: The Chicano Art Group and the Politics of South Texas*, edited by Rubén C. Cordova, 63. Los Angeles: Chicano Studies Research Center, University of California, Los Angeles, 2011.

———. 1976. "Human Scapes." In *Mel Casas Humanscapes*. Houston: Contemporary Arts Museum. Exhibition catalog.

Cordova, Rubén C. 2005. "Con Safo." In *Encyclopedia Latina: History, Culture, and Society in the United States*, 4 vols., edited by Ilan Stavans and Harold Augenbraum, 1:380–81. Danbury, CT: Grolier Academic Reference.

———. 2009. *Con Safo: The Chicano Art Group and the Politics of South Texas*. Los Angeles: Chicano Studies Research Center, University of California, Los Angeles.

———. 2011. "The Cinematic Genesis of the Mel Casas *Humanscape*, 1965–1970." *Aztlán* 36, no. 2: 51–87.

Cortez, Constance. 2002. "Aztlán in Tejas: Chicano/Chicana Art from the Third Coast." In *Chicano Visions: American Painters on the Verge*, edited by Cheech Marín, 32–42. Boston: Bulfinch Press.

Gibbon, Berenice, and Barbara Elliott. 1966. *Kitchen Spanish with "Panchita": A Handbook for Housewives*. Rev. ed. Harlingen, TX: B & K.

Gitlin, Todd. 1971. "Daniel Ellsberg and the New Heroism." *Commonweal* 94, no. 19: 447–50.

Goddard, Dan. 1988. "Art That Crosses Borders: Mel Casas Lands Austin Retrospective." *San Antonio Express News*, August 21, 1-H, 7-H.

Hickey, David. 1988. "Mel Casas: Border Lord." *Artspace: Southwestern Contemporary Arts Quarterly* 12, no. 4: 28–31.

Kelker, Nancy L. 2013. *Mel Casas: Artist as Cultural Adjuster*. Lascassas, TN: High Ship Press.

McLuhan, Marshall. 1951. *The Mechanical Bride: Folklore of Industrial Man*. New York: Vanguard.

Nobile, Philip, ed. 1971. *The Con III Controversy: The Critics Look at the Greening of America*. New York: Pocket Books.

Noriega, Chon A. 2000. *Shot in America: Television, the State, and the Rise of Chicano Cinema*. Minneapolis: University of Minnesota Press.

Nuiry, Octavio Emilio. 1996. "Ban the Bandito! Madison Avenue Takes a More Sophisticated Approach to Latino Stereotypes." HispanicMagazine.com (July). Accessed March 26, 2008. http://www.hispaniconline.com/magazine/PDF/July%20 1996%20Ban%20the%20Bandito.pdf.

Perlstein, Rick. 2008. *Nixonland: The Rise of a President and the Fracturing of America*. New York: Scribner.

Quirarte, Jacinto. 1973. *Mexican American Artists*. Austin: University of Texas Press.

Reich, Charles A. 1970. *The Greening of America*. New York: Random House.

Revisiting My Alamo

Kathy Vargas

It's interesting to me that one of my favorite pieces almost didn't exist. To put that statement in context: the *My Alamo* series was to be part of an exhibit called *From the West*, a Chicano view of the American West, and it was a theme I'd never carefully considered.

I think that when we view artists' work we should do it in the context of what was occurring in their personal lives at the time an idea overtook them. When Chon Noriega, curator of *From the West*, called with the offer that I participate in this project, I was really preoccupied. My mother had begun her long process of dying, which she completed in 1996. And at the same time, the workplace I loved was beginning to go through a difficult transition.

In the midst of these events, Chon was offering me a "commission." A commissioned piece of work is a curator's way of coaxing an artist to do an "assignment." It sits in some gray area between two opposing poles: doing work completely for yourself or doing it for someone else. The challenge is to find a middle ground: to find your own way to tell a story that the commissioning agency is interested in hearing. It's easy to get derailed by a commission. One is in the middle of an interesting thought but is then required to go off on a tangent, becoming consumed by a new idea—and being consumed is really the only way to do the work. To complicate matters further, I was already in the middle of another commissioned project for *Hospice: A Photographic Inquiry*.[1]

Chon was asking me to consider the American West? Really?! The only concept I had of the West was from the TV fantasies I'd watched when I

was a child—Roy Rogers and Dale Evans, Hopalong Cassidy, and Davy Crockett. But those icons were incongruous with my notion of myself as an indigenous/Chicana being. My first impulse was to say no to the project. But the idea of the West wouldn't let go. I kept thinking about it, dreaming it. That image of an "Indian Fighter," Davy Crockett held up as the epitome of Americanism to thousands of children. John Wayne made perfect in his violent patriotism, killing Mexicans for his country—which wasn't even his yet; it was Mexico. My own loving mother, dying now, had plopped me as a child in front of the TV set to learn how to pronounce English correctly. (At the time hardly anyone on TV had an accent.) They all spoke beautifully, but what they were saying!! Even a child could figure out there was something wrong. Someone had to address the errors.

So my response to the project became a resounding yes, and I decided to use what I'd learned from *Hospice* on this new project. The method and technique of these two projects are inextricably intertwined: photographing people again, the use of long passages of text, even the idea of the silver shrine. These two series are married in ways I never thought about until I finished my own visual eulogy to my deceased family members—in much the same way that I created visual memories for the families of the *Hospice* project.

For me, the flow of ideas has to be organic. So as my mother began her dying and as I shared in the family memories of others through the *Hospice* project, I realized that my perception of the West had to be about shared familial memories, the last of which would be stored in me once my mother passed away. Soon I realized that everything "West" flowed to one place: the Alamo, San Antonio's iconic legacy. I'd lived in San Antonio all my life, and I love my city. San Antonio wouldn't be San Antonio without the Alamo—for better and for worse.

Ideas came quickly after I decided to focus on the Alamo. There was so much "Alamo" around: not only the site itself but Alamo muffler shops, Alamo car rentals, Alamo funeral homes, and Alamo social clubs. I had to pick through it all and remember those Alamo memories that were uniquely mine.

I started with my great-great-grandfather: I worked backwards, from my father, Ambrosio Vargas, to his father, Andrés; to his father, Ambrosio; to his father, Juan Vargas, patriarch Indian of the Vargas family (another would-be Aztec who my father eventually realized was most likely Zapotec). He claimed to have been "pure blood," which was unlikely, since the Spaniards had been around for a while, but a good myth. So I depicted him as a myth, but that's not why he and all the characters in *My Alamo*

are blurred. He became blurred only when I couldn't do what I'd first wanted to do.

I'd meant to find old family photos to rephotograph, much as I'd done for *Hospice*, using vintage images of the deceased. But the few photos that existed of Juan Vargas were grainy Xerox copies from fading newspapers. Certainly there weren't any of him at the Alamo, since photography was first introduced three years after that battle. So I was forced to use human models for *My Alamo*. When I'd photographed the living survivors of the deceased for the *Hospice* project, it felt good to work with people after years of using only inanimate objects for still lifes. I'd made documentary photos of people in the early 1970s to 1980s, but this was different. Having had the experience of "commanding" my still-life subjects, I was ready to "direct." One challenge was to bring real characters to life. That absence of Juan Vargas's image made me desperate to revive him: hence the blur, the "living move."[2]

Reading about Juan Vargas in order to depict him, I envisioned him as one of those countless, nameless Tejanos picked up by General Antonio López de Santa Anna on his march toward the Alamo. He was there to swell the troops, given only a broom. Mexico, along with the United States, had "Indian" problems—still does. Brown Juan would've been seen by Santa Anna as more indigenous than European, and since there probably weren't enough guns to go around anyway, he got a broom. Not a bad weapon if you're to the rear, which he probably was. But I always teased my dad that Juan had "swept up" after the battle. I liked his noncombatant role, since at the time of my teasing the Vietnam War was ongoing.

About Juan Vargas there are some concrete facts along with the mythology. In a newspaper interview written shortly before his death he said he'd brought his family to Tejas in 1830, settling on a sizeable plot of land on the East Side of San Antonio, where I still live. Close by there's a short street named Vargas. He was 114 when he died, missing the seventy-fifth anniversary of the Battle of the Alamo by a few months. He was scheduled as an honored guest at that celebration, the "enemy" coming to the feast. Wouldn't that have been a cause for rejoicing? Maybe not; what if someone had remembered he was "Mexican" and called him names? When remembering the Alamo, one never knows.

Having referenced the reality of the Alamo in the person of Juan Vargas, I then wanted to "enshrine" American history. I'd created truly reverent shrines for *Hospice*, but the Alamo shrines are tongue in cheek. The photograph within the silver mat is of something that is "revered" by the dominant culture, in this case the gun: the implement for conducting wars over

land and who has a right to live on it. (Almost two hundred years later we're still shooting at each other across the U.S.-Mexico border.) Funny thing about the gun: it's a cap-and-ball pistol that actually belonged to Juan Vargas. He must have left it at home when he took off for the Alamo.

<p style="text-align:center">* * *</p>

To make these new "shrines" unique I embedded little Alamos inside the silvered mat.[3] Some of the work on *Hospice* influenced the layout for the twelve photographs of *My Alamo*. For *Hospice*, I'd created triptychs. For *My Alamo*, diptychs feature, on the left, a real person or persons and, on the right, a shrine to some "Alamo" ideal. I retained the altarpiece concept, recognizing and issuing something sacred. For *Hospice*, the altarpiece was open; for *My Alamo*, it was closed. Both use text. I felt the *My Alamo* series needed words; sometimes photos aren't enough, not if you really want someone to understand the story. The *Hospice* photos had text, but in those cases the text was framed separately and placed beneath the images. In *My Alamo*, the text was shorter but also more critical to the story, so the images had to be designed to make the text a visual element of the whole. Empty spaces in each photo would deliberately be left blank when the picture was taken in order to provide room for the text. Once those complicated conceptual decisions were made, creating the photos was pretty straightforward.

The second diptych recalls my young cousins from Michigan. Coming to visit, they'd demanded to be taken to the Alamo. These cousins were from my mother's side of the family. She crossed the border in the early twentieth century as part of a typically sad story. Outlaws or revolutionaries killed most of the Soriano/Salcedo men, and the remaining boys and women fled for the border. The family dropped members at various stops along the way. One aunt married and stayed in Laredo, Mexico. My great-grandmother, grandmother, great-aunt, mother, and uncle came to San Antonio. A great-uncle kept going, to Michigan, and raised his family there. Those were the cousins, my age, who wanted to see the Alamo: home of Davy Crockett, Indian Fighter and interloper (but we didn't know the truth of it at the time). We got coonskin hats and had our pictures taken in front of the Alamo by those old photographers who developed images on the spot, long since faded. Now, recreated.[4]

On television we'd watch *Davy Crockett*, "King of the Wild Frontier."[5] But the dichotomy between being Indian and extolling the heroism of an Indian Fighter was warped, to say the least. Or maybe not; after all, the Indian Juan Vargas was nominally fighting on the other side. In the shrine, Davy shares space with a fading *papel picado* Alamo. Over time, papel

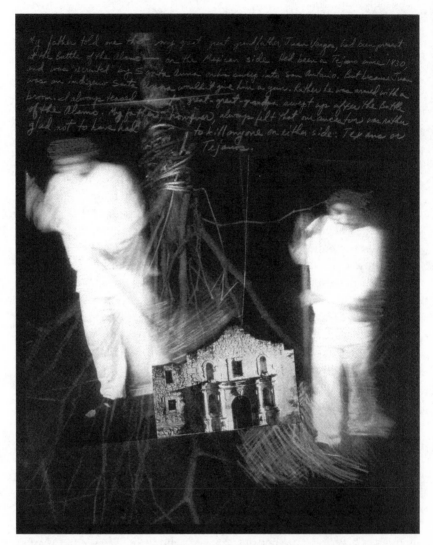

Figure 24.1. Kathy Vargas, *My Alamo* (1995, series of 12 images, each 20 x 16 in., in 6 pairs: [a] hand-colored silver gelatin prints and [b] mixed media with 10-x-8-in. hand-colored silver gelatin print), #1a. This series is about the artist's "usually ambiguous relationship to and with the Alamo," a highly controversial Texas landmark that "figured in her family history and identity." (Photographs courtesy of the artist.)

Figure 24.2. Kathy Vargas, from the *My Alamo* (1995) series, #1b.

picado (perforated tissue paper) has become quite popular, and Davy isn't on TV anymore.

The third diptych is about the Order of the Alamo, which is one of San Antonio's very splendid social organizations: lots of money and lots of history—mostly on the other side of the Alamo walls, the ones Juan Vargas was modestly storming. Socially those walls are probably difficult to storm, though I don't know. I never tried.

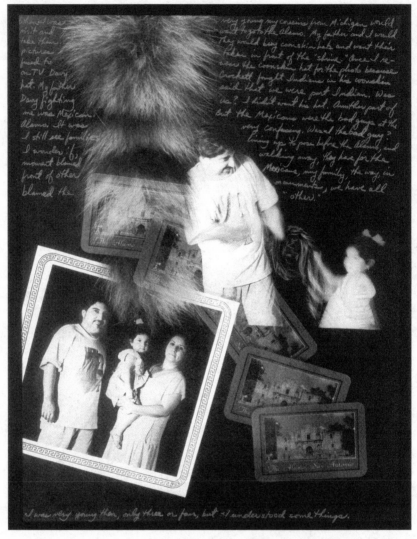

Figure 24.3. Kathy Vargas, from the *My Alamo* (1995) series, #2a.

This topic mattered more to my mother. She was aware of being excluded and knew when I was five that I wasn't likely to be a member of the club, the Order of the Alamo. Yearly it crowns a new queen, princess, and several duchesses. The gowns they wear are gorgeous and inordinately expensive. My mother was addicted to the parade, which showcased them. Maybe she wanted me to be a duchess or at least to be able to make the choice. I wanted to want it too, to please her.

Figure 24.4. Kathy Vargas, from the *My Alamo* (1995) series, #2b.

At this point in my life, I've been a welcome guest in the homes of former duchesses, nice ladies who use their gowns and trains as Christmas tree skirts. Once I shared laughter and a meal with an Alamo "insider" who refused to be a duchess because it just wasn't who she was. Times have changed, though I still have absolutely no clue how one becomes a member of the Order of the Alamo, much less a duchess. It doesn't matter anymore. One of the tree-skirt dresses is enshrined, along with the wealth it represents.

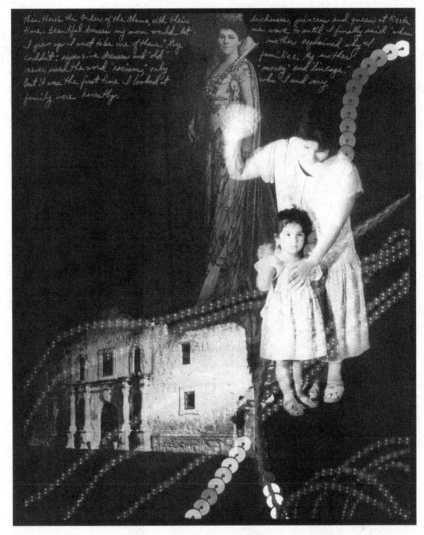

Figure 24.5. Kathy Vargas, from the *My Alamo* (1995) series, #3a.

The next three diptychs in the series are from my adult years. In my late teens, a film company came to town to make the movie *Viva Max!*[6] (My friend Carolyn and I would mill at the perimeter.) The plot was amazing: the Mexicans were retaking the Alamo! This time we were going to win! Then I remembered that we'd won the first time; we'd just taken a huge shellacking of racism in the intervening century and a half for having had the audacity to be victorious. The audacity of Jerry Paris, the film's

Figure 24.6. Kathy Vargas, from the *My Alamo* (1995) series, #3b.

director, recalling both the original outcome and the intervening years was a milestone. However, he didn't escape unscathed. The Daughters of the Republic of Texas, into whose hands and hearts the reverent memory of the Alamo had been entrusted, were outraged. They banned the film crew from entry to the Alamo and even tried to halt their shooting the façade. I believe the film eventually used the set that had been constructed for John Wayne's *The Alamo* (1960), a much more acceptable film.

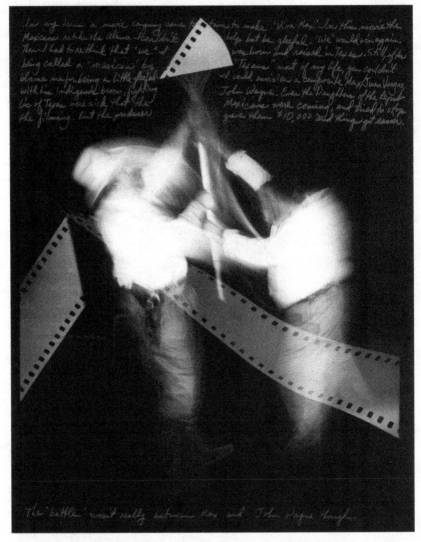

Figure 24.7. Kathy Vargas, from the *My Alamo* (1995) series, #4a.

In defense of the Daughters, they do a good job of preserving historical artifacts from the Alamo. I've used their library for research. But, at the time, their response was pretty funny. After all, it was only a movie. Jerry Paris smoothed things over by donating $10,000 to the upkeep of the Alamo, and the Daughters seemed less distressed. Maybe it was the money or the reverence it implied. Either way, a precedent had been set, a going rate for forgiveness.

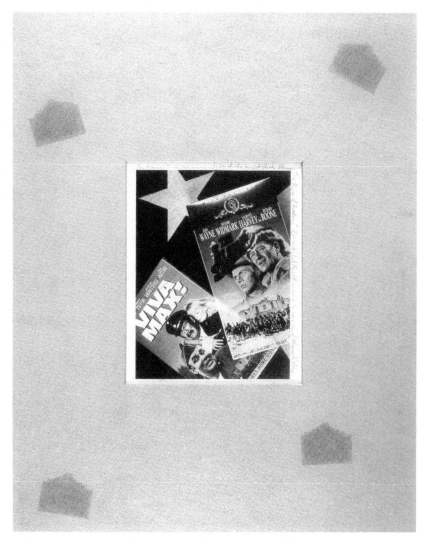

Figure 24.8. Kathy Vargas, from the *My Alamo* (1995) series, #4b.

The real problem wasn't John Wayne versus Max, though. (My friend David Gonzales posed as the darker Max. John Wayne was played, ironically, by a Native American friend named Charles.) Both movies and their heroes were enshrined in Hollywood: it's not only the films but the symbols they bestow that's significant. The more important battle came sometime in the late 1980s and 1990s, with a film called *Alamo, the Price of Freedom* (1988). Playing at a film arcade across from the Alamo, it was a

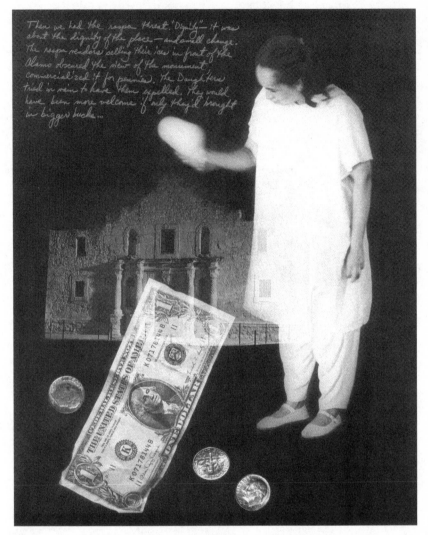

Figure 24.9. Kathy Vargas, from the *My Alamo* (1995) series, #5a.

regular favorite of the tourists, but it used slur words and racist expressions against "Mexicans."

More than 150 years after the Battle of the Alamo, we were still the enemy. The Chicano community rose in protest and boycotted the businesses that had commissioned the movie. Eventually changes were made; I believe the film was re-edited and things calmed down. Notably, this serves as a reminder, even in these supposedly post-Chicano, postracism,

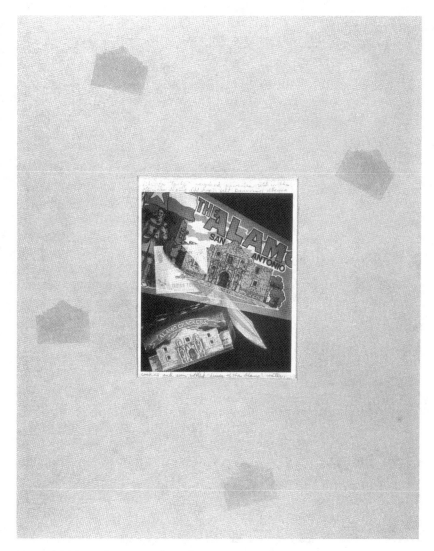

Figure 24.10. Kathy Vargas, from the *My Alamo* (1995) series, #5b.

times that racism lurks, waiting for an opportunity. Now that there's a wall at one of our borders to keep brown people out, will racial hatred/racial tension return with more force?

The next diptych is also about money, but this time small change. The large number of mostly Chicano *raspa* vendors was supposedly cluttering the view of the Alamo with their merchandise, so most of them were chased off. (It was that façade problem again.) My friend and fellow artist

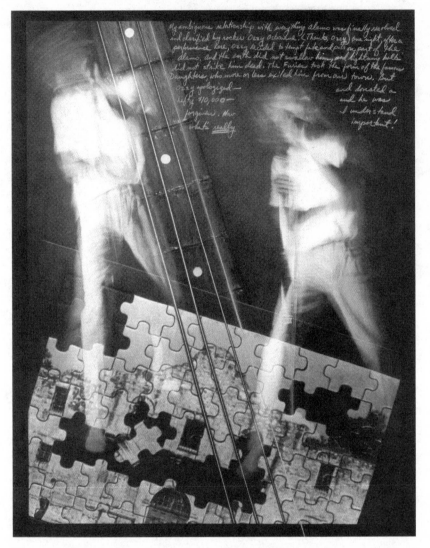

Figure 24.11. Kathy Vargas, from the *My Alamo* (1995) series, #6a.

Diana Rodríguez posed in her own indigenous clothes to represent those of us who are still here.

For the shrine, I went on a research expedition/visit with my friend Sue Finn from San Francisco. She had to see IT, so we ended up at the huge Alamo store on the grounds of the "shrine." I was shocked by bottles of Heroes of the Alamo water selling for three dollars (and this was in 1995, when bottled water wasn't yet that popular). It reminded me of visits to

Figure 24.12. Kathy Vargas, from the *My Alamo* (1995) series, #6b.

religious shrines, where pilgrims receive small vials from the fountain of a saint, perhaps for a donation. But this was a hard-cash enterprise for plastic bowie knives and other Alamo kitsch. I'm sure these souvenir sales help with the upkeep of the place, but the comparison to relics from Lourdes was inescapable.

The last set of photos represents my perfect karmic revenge in the persona of Ozzy Osbourne. I'd been a rock photographer for a short while

in the 1970s. My first photo teacher, Tom Wright, is a rock photographer extraordinaire. The combined irreverence and idealism of rock 'n' roll in the 1960s set me free to be a true American: a critic as well as a believer.

So what did Ozzy do? He came to San Antonio and pissed on the Alamo! In his defense, he didn't pee on the building itself but on the cenotaph of heroes, which was constructed long after the battle. From what I understand, it was after a long show and a lot of drinking. He'd heard so much about the Alamo that he wanted to see it. But with all that alcohol in his system, something had to give. And since he was almost alone there, with just a few friends along, he relieved his bladder in his own, inimitable, rock 'n' roll manner.

Well, someone ratted Ozzy out, and the Daughters were not pleased. I can't say I blame them. If someone relieved himself or herself on my front lawn after I'd worked more than a century to keep my beloved neighborhood in good order, I'd be angry too. Ozzy was banned from the city and told he'd never play San Antonio again.

At the time, San Antonio was a top venue for rock acts, so Ozzy was definitely in trouble. Fortunately for him, someone told him what the going rate for forgiveness was. He coughed up $10,000 and an apology, and he was allowed to play San Antonio again. So I enshrined some cash and a loud rock guitar. My friend Diana's son, Hector Rey, himself a talented musician, posed as Ozzy. His guitar posed as itself. The key to this diptych is the unfinished puzzle. The construct of the myth of the Alamo is ongoing. Each generation will remake it. That's why this series is *My Alamo*— "My" Alamo, my personal relationship with this monument.

The only thing that remains is for me to talk about the diptych that doesn't exist. It should be right after the *Viva Max!* pieces. In my late teens, I along with many of my fellow baby boomers protested the war in Vietnam, and our favorite demonstration venue was the Alamo. But the commission called for only twelve pieces for *From the West*. I always meant to add one afterward. But then I learned that the silver powder I was using was deadly, so I had to be happy with what I'd already done. Some day I may tell people what I would've enshrined had I made those last two photographs.

Notes

1. The work for *Hospice: A Photographic Inquiry*, commissioned by the Corcoran more than a year before, already had me off on a tangent, albeit an interesting one.

Philip Brookman was curator of photography and media arts at the Corcoran Gallery in Washington, DC, and Jane Livingston and Dena Andre were curators for the project. The *Hospice* project also had exactly the same deadline as *From the West*. I was tempted to get back to my studio and think my own thoughts, using the insights I'd gained from working on *Hospice* for *From the West*.

2. I used the same concept a year later in a series of portraits of my friends. I called the series *The Living Move*.

3. I later learned that the silver/aluminum powder I used was lethal, so I stopped using it. Hence, only two complete copies of the *My Alamo* series exist: one owned by the Mexican Museum in San Francisco, the other by Chicano art collector Joe Díaz.

4. The models for this family group, as well as for the next one and for the image of Juan Vargas, were artist Miguel Cortinas, his wife, Patricia, and daughter Victoria.

5. *Davy Crockett, King of the Wild Frontier* is a live-action Disney movie, theatrically released in 1955 and featuring Fess Parker as Davy Crockett and Buddy Ebsen as his Tennessee buddy Georgie Russell. Running a little over 90 minutes, the movie is a compilation of the first three episodes of the television miniseries *Davy Crockett*, which aired on the *Disneyland* series on ABC in 1954 and 1955 and was reaired on NBC in the 1960s. The Disney shows are largely responsible for a Davy Crockett craze in the mid-1950s and for the popularity of "The Ballad of Davy Crockett" theme song.

6. *Viva Max!* (1969), a mock-heroics comedy, stars Peter Ustinov as General Maximilian Rodrigues de Santos, who leads a faction of the Mexican Army into Texas.

Bibliography

The Alamo. 1960. Directed by John Wayne. Batjac Productions–United Artists.

Alamo, Price of Freedom. 1988. Directed by Kieth Merrill. Bonneville Entertainment–Texas Cavalcade.

Brookman, Philip, Jane Livingston, and Dena Andre, eds. *Hospice: A Photographic Inquiry*. Washington, DC: Corcoran Gallery. Exhibition catalog.

The Caballero's Way. 1914. Directed by Webster Cullison. Eclair American.

The Cisco Kid. 1931. Directed by Irving Cummings. Fox Film Corporation.

———. 1950–56. Produced by Frederick W. Ziv. Ziv Television.

Davy Crockett. 1954–55. Five episodes of the *Disneyland* television series. Directed by Norman Foster. Walt Disney Productions–ABC Television.

Davy Crockett, King of the Wild Frontier. 1955. Directed by Norman Foster. Walt Disney Productions.

Henry, O. 1904. "The Caballero's Way." In *Heart of the West*. New York: Doubleday.

In Old Arizona. 1929. Directed by Irving Cummings. Fox Film Corporation.

The Lone Ranger. 1949–57. Produced by George W. Trendle. Apex–ABC Television.

Noriega, Chon A., ed. 1995. *From the West: Chicano Narrative Photography*. San Francisco: Mexican Museum. Exhibition catalog.

Viva Max! 1969. Directed by Jerry Paris. Commonwealth United Entertainment.

Malinche y Pocahontas, *Breaking Out of the Picture*

Robert C. Buitrón

As a Chicano, I grew up watching Hollywood and television Westerns, and I had all the requisite accouterments—sombrero, gun belt, pistols, and cowboy boots. The "American Way" permeated my being. It entered by way of entertainment. Hollywood was the school board, the theater was the classroom, and John Wayne was the instructor.[1] I wanted to be on the winning side, and these movies influenced my perception of my cultural background and identity. I was ashamed to see myself depicted as a lowly Mexican but defiant to claim that I was Mexican. I didn't recognize the conflict until I comprehended the significance of the civil rights movement during my years in high school in the late 1960s and early 1970s. President John F. Kennedy's "New Frontier" metaphor was evolving.

The "New Frontier" as well as the "old frontier" inspired the photographic series I created, *El Corrido de Happy Trails (starring Pancho y Tonto)*, which includes the image *Malinche y Pocahontas Contando la Historia de Pancho y Tonto*.[2] At issue was the distortion and erasure of a Mexican presence and influence in the mythological construction of the American West. The "old frontier" and "New Frontier" reinforced the U.S. public perceptions of Mexicans as untrustworthy, as agents of economic destabilization who lower wages, as criminals, and as a group who resist learning English and assimilating.[3]

Drawing upon John F. Kennedy's invocation of a tradition and the very essence of national life that Frederick Jackson Turner and Teddy Roosevelt wrote about in the 1890s and that Roosevelt exploited during his presidential campaign and administration, the photo series asserts the Mexicans'

Figure 25.1. Robert C. Buitrón, *Malinche y Pocahontas Contando la Historia de Pancho y Tonto* (Malinche and Pocahontas Tell the Story of Pancho and Tonto) (originally titled *Malinche y Pocahontas Chismeando con Powerbooks* [Malinche and Pocahontas Gossiping with Powerbooks]) (1995, black-and-white silver gelatin print, 16 x 20 in.), from the series of images collectively titled *El Corrido de Happy Trails (Starring Pancho y Tonto)* (1995). Injecting a *rasquache* sensibility into his series, the artist acknowledges the assertion of a "Mexican presence" and history sometimes distorted or lost between the "old frontier" and the new high-tech frontiers. Here, for example, Malinche and Pocahontas are empowered beyond their laptop computers as leading female protagonists in the artist's provocative scenario. (Photograph courtesy of the artist.)

presence and history in the "old frontier" and the roles they played in the American West. In Kennedy's presidential campaign and administration, he manipulated a tradition of epic proportions to sustain the frontier ethos. The "New Frontier" asserted control over the crises of nuclear threat, of the space race, and of a new direction for and renewal of an American tradition of heroic struggle to achieve greatness.

By the time of the 1960 presidential election, the movie and television industries had firmly fixed the American frontier myth in the imaginations

Figure 25.2. Robert C. Buitrón, *Seeking Indians—Mexicans Need Not Apply* (1995, black-and-white silver gelatin print, 16 x 20 in.), from the series of images collectively titled *El Corrido de Happy Trails (Starring Pancho y Tonto)* (1995). Hollywood films and mainstream television have traditionally mystified and romanticized Indians while relegating Mexicans to the margin of the frontier myth, Buitrón explains, lost somewhere "in the shadows of the American presence and the Indian absence." (Photograph courtesy of the artist.)

of the American people, including Chicanos and Indians. Advancement into the new frontier inspired the American public, and it inspired popular culture. The new frontier cowboys of the 1960s television series *Star Trek* left the range and horse-warped into space on the starship *Enterprise*; in the 1970s they defeated evil and scoundrels in pitched laser battles on the dusty particle streets of battle stars (with the assistance of New Age retro-Indian spiritualism—"the Force" of *Star Wars*); in the 1980s and 1990s the new frontier cowboys hyperhorsebacked to planet earth to roam the virtual range as cybercowboys rounding up digital nihilism and Cimarron circuits, with the help of their Rastafarian sidekicks,[4] and back again into quadrants of space (where no real person has gone) to find a Chicano Chakotay, playing an Indian lost in space.[5]

In 1995, the year I made the *Malinche y Pocahontas* image, Disney released its animated feature film *Pocahontas*. The film generated discussion about the myths and accounts surrounding Pocahontas, especially within the Native American community. It prompted me to ask: What if the most important woman in the conquest history of the Americas, known as Malinche, had not made contact with the Spaniards and Hernán Cortés? Could the Aztecs have negotiated a more favorable outcome? If this had occurred, would there still have been a Jamestown and the appearance of perhaps the second most important woman in the conquest of the Americas, popularly known as Pocahontas? Imagining that scenario, I think little would have changed historically.

I imagined another scenario. What if Malinche and Pocahontas could meet and exchange their stories of what transpired? They would tell their accounts through two characters who represent that moment of intersection and collision between natives and foreigners, as filtered and disseminated through Hollywood, radio, and television. The construction of this scenario and image hinged on a complex critical question: How would I channel the premise of my visual narrative—which conflates U.S. history as presented in the U.S. education system, the portrayal and treatment of Mexicans and Indians in the media, the way I saw this interaction played out in my extended family, and the compression of 500 years—into a satire that examines memory, media, and message?

So where should they meet to brainstorm and record an accounting? A coffeehouse is *the* place to hang out in the 1990s. To establish themselves as contemporary with the times, they bring their laptops to create a new corrido, a digital codex. I chose these two women to open the scene to the unfolding story, as they were not just any two women. These are two women of mythic stature, albeit one, Malinche, as a cursed sellout and the other, Pocahontas, as fetishized princess-savage. Their lives affected the lives of the two protagonists in their corrido; they have an omniscient perspective of what transpired; and their subordinate roles in history parallel the subordinate roles Pancho y Tonto played in *The Cisco Kid* and *The Lone Ranger*.[6]

As a storytelling device, Malinche and Pocahontas appear as characters in *Malinche y Pocahontas Contando la Historia de Pancho y Tonto*, a 16-by-20-inch black-and-white silver gelatin print. Their placement, in the foreground, emphasizes their roles as tellers, creators, and narrators of a story, which by Western quest conventions is always told from a male point of view. Pancho y Tonto occupy the background, annoyed and once again subordinate to the leading roles. The coffeehouse is not a saloon, so

they can't muscle their way to the front to take control. Control is one of the themes of the story and the point for the presence of Malinche and Pocahontas. Malinche and Pocahontas are in control, laughing, looking energetic, and typing away; and they know the ending. Unfortunately and disappointingly, it's a Macondo kind of ending, as suggested by the figure wearing a T-shirt bearing the name Macondo.[7]

The punch line is the knowledge Malinche and Pocahontas possess. One sees it in their expressions and gestures. Theirs is a sense of confidence that is absent in Pancho y Tonto. These are two women who know what to do and how to succeed. They're finally in the limelight and not letting go. The picture captures them in the middle of an exchange of ideas, inspiring each other. They're hot on the trail of a bewildering plot. Perhaps they're conjuring a scene where Roy Rogers and Dale Evans cross the border, playing second fiddles to Pedro Infante or Vicente Fernández, or maybe Roy and Dale pick lettuce to the soundtrack of "Happy Trails."

As in the movies or in a written story, the main characters (and the readers or audience) don't suspect a thing; they don't pick up the clue of impending doom. And this is where Malinche y Pocahontas see an opportunity to break out of the picture and let the moral of the story play itself out without a sunset in the horizon.[8]

Notes

1. John Wayne epitomized the perception of American self-reliance and frontier individuality as portrayed by Hollywood. On a more significant level, he symbolized the political and moral ideals of America, ensuring that justice and democracy prevailed. Ironically, the first John Wayne movie that influenced me was *The Alamo*, in which he played Davy Crockett. This was a movie about the struggle for independence from an "oppressive" regime. Many years later I attributed the appeal of this John Wayne movie to the influence of another Hollywood power—Disney—and its series on Davy Crockett. Indeed, all of John Wayne's roles in Westerns affirmed the American myth, and I was one of numerous young boys indoctrinated to the view his movies espoused.

2. I changed the title from *Malinche y Pocahontas Chismeando con Powerbooks* to *Malinche y Pocahontas Contando la Historia de Pancho y Tonto* after showing the series for the first time in the exhibition *From The West: Chicano Narrative Photography*, at the Mexican Museum, San Francisco, in 1995. The change occurred mainly for two reasons. First, the old title contributed to a stereotype of women as unrelenting chatterboxes, making them second-class people and subordinates in all male-dominated systems (e.g., society, movie industry, economics, etc.). This depiction contradicted the notions I was addressing in the series—the portrayal and perception of Mexicans and Indians as inferior second-class people. Second, I changed the sequence of the images, choosing *Malinche y Pocahontas* as the beginning one. I wanted women, especially

these two women who played a major role in history, to be in the forefront of a story that history and cultural practice had diminished or ignored them in or excluded them from.

3. American history and sentiment repeat themselves today in the early part of the twenty-first century with the erection of the "tortilla wall" along the Mexico-U.S border.

4. Expanding on Kennedy's "New Frontier" and Space Race, I see not only *Star Trek*, from the mid-1960s, but also George Lucas's *Star Wars* saga, starting in 1977, and William Gibson's novel *Neuromancer*, from 1984, as continuations of American expansionist ideology and the Western myth in science fiction. *Episode I* of the *Star Wars* franchise, released in 1999, stirred no small controversy in the popular media over the character of Jar Jar Binks, voiced by Ahmed Best.

5. The actor Robert Beltran plays Chakotay, who is the commander, or first officer, in the fourth incarnation of the *Star Trek* television series franchise, *Star Trek: Voyager*, which ran from 1995 to 2001. The character Chakotay was born to an unnamed American Indian tribe, who rebels against the Federation by joining the Maquis, a rogue outfit with the goal of destabilizing the Federation's rule. The original *Star Trek* series was first broadcast in 1966.

6. *The Cisco Kid* is based on the short story "The Caballero's Way" by O. Henry, published in 1904. The Cisco Kid film character was established in the 1929 film *In Old Arizona*, with Warner Baxter playing the Cisco Kid. Later versions included the television series first broadcast in 1950, syndicated, and continued until 1956. Duncan Renaldo played the Cisco Kid and Leo Carrillo portrayed Pancho in the TV series. Contemporary with *The Cisco Kid* was *The Lone Ranger*, running on television from 1949 to 1957 and featuring Clayton Moore in the lead role and Jay Silverheels as the sidekick, Tonto.

7. Macondo is the fictional town in Gabriel García Márquez's *One Hundred Years of Solitude* and other stories, home to his Buendía family. Macondo follows a type of "course of empire," starting as a sleepy village, growing to a thriving city centered around a banana plantation, and eventually falling and being swept from the map by a windstorm.

8. The people I asked to play the characters in the series were important in two ways: one, they understood and agreed with the premise of the project; and two, they were cast to play the appropriate character. Many in the "cast" are artists, writers, or art-related professionals. The coffee shop I selected was Jumping Bean, located in the Pilsen area of Chicago on 18th Street (and still in operation as of this writing). The players include the late Lydia Mendoza Huante as Malinche, Susana Sandoval as Pocahontas, Tony Castañeda as Pancho, and Encarnación Teruel as Tonto. Their interpretations of my direction and the characters were crucial to the execution of each image. I wish to thank them for their contributions.

Bibliography

The Alamo. 1960. Directed by John Wayne. Batjac Productions–United Artists.
The Caballero's Way. 1914. Directed by Webster Cullison. Eclair American.
The Cisco Kid. 1931. Directed by Irving Cummings. Fox Film Corporation.

———. 1950–56. Produced by Frederick W. Ziv. Ziv Television.

Davy Crockett, King of the Wild Frontier. 1955. Directed by Norman Foster. Walt Disney Productions.

García Marquez, Gabriel. [1967] 1970. *One Hundred Years of Solitude* [Cien años de soledad]. Translated by Gregory Rabassa. New York: Harper.

Gibson, William. 1984. *Neuromancer*. New York: Ace.

Henry, O. 1904. "The Caballero's Way." In *Heart of the West*. New York: Doubleday.

In Old Arizona. 1929. Directed by Irving Cummings. Fox Film Corporation.

The Lone Ranger. 1949–57. Produced by George W. Trendle. Apex–ABC Television.

Pocahontas. 1995. Directed by Mike Gabriel and Eric Goldberg. Walt Disney Pictures–Buena Vista Pictures.

Star Trek. 1966–69. Produced by Gene Roddenberry. Desilu Productions, Paramount Television.

Star Trek: Voyager. 1995–2001. Produced by Rick Berman et al. Paramount Network Television.

Star Wars. 1977. Directed by George Lucas. Lucasfilm–20th Century-Fox.

Star Wars: Episode I—The Phantom Menace. 1999. Directed by George Lucas. Lucasfilm–20th Century-Fox.

Turner, Frederick Jackson. [1893] 1920. *The Frontier in American History*. New York: Holt.

From "Many Wests"

Chon A. Noriega

The usual focus on space—the West—is understood as an instance of nation-state formation, rather than of individuals in search of freedom, property, and marriage on the frontier. In other words, I want to echo William S. Hart and reintroduce citizenship as the genre's central dilemma. But unlike Hart, I want to draw attention to how the very binary oppositions that he introduced into the Western—the loner cowboy and society, lawlessness and community, landscape and town—do not so much describe the geopolitical space of American citizenship as determine its key players.[1] Those who are left over—Mexican, Indian, Chinese, black—are cast as an external threat even though they share the same space. They are there (physically), yet not there (rhetorically), an exclusion that has at times been written into law or government policy and has been contested in the name of the rights of citizenship.[2]

Calling attention to geopolitical space does more than place national boundaries within a historical perspective in which we acknowledge that the Southwest used to be the northern half of Mexico—although, in the scheme of things, that's not a bad place to end up. Rather, a geopolitical framework understands the time-and-space of the Western as the textual displacement or subordination of other histories. For the Mexican-descent

Chon Noriega's curatorial remarks are excerpted from the "Cowboys and Indians" section of his essay "Many Wests," which first appeared in the 1995 exhibition catalog *From the West: Chicano Narrative Photography* (San Francisco: Mexican Museum), pages 9–10. Reprint courtesy of the author and the Mexican Museum, San Francisco, California.

215

population, this includes issues of language and translation, communal versus individualistic legal definitions of land ownership, and political representation—all of which, by the way, continue to be sites of struggle. Still, calling everyone within the West an American does not resolve the problem, since the underlying conflicts between groups and cultural systems continue long after a nation has set its borders and imagined itself as a limited, sovereign community.[3]

The problem with borders is that they are more or less invented or imagined, much like the communities they are designed to contain.[4] This is not to suggest that communities do not exist, but rather to note the way in which borders manifest, as Étienne Balibar notes, "the contradiction between the pretension of the modern state to constitute a 'community' and the reality of different forms of exclusion" (quoted in Castañeda 1993, 283). This contradiction operates within national borders as well as across them. Consider all the "Mexicans" who populated the Southwest of the Western; by all rights, these were Mexican Americans. Legally, Mexicans who remained north of the new border, imposed after the Mexican-American War (1846–48), became U.S. citizens. But in social practice and popular culture, Mexican Americans continue to be referred to as "Mexicans" up until the Chicano civil rights movement (1965–75) and have been subject to various large-scale deportation programs since the so-called repatriation of the Depression. In the foundational fictions that secured the once-Mexican territories to the imagined communities of the United States, the Mexican American functioned as what Blaine Lamb (1975) calls the "convenient villain" of the discourse on the Southwest, appearing as a necessary, though marginal, character in newspapers, government documents, dime novels, popular songs, plays, and, later, silent films.[5]

Notes

1. It is of note that historians often compare Hart's films to the works of Frederic Remington and Charles M. Russell and to documentary photography of the Old West. See, for example, Fenin and Everson (1962, 75) and Buscombe (1988, 30).

2. On the nineteenth century, see Almaguer (1994) and Saxton (1990). On the twentieth century and Mexican American struggles for civil rights and "first-class citizenship," see García (1989).

3. Benedict Anderson in *Imagined Communities* concludes: "Ultimately it is this fraternity that makes it possible, over the past two centuries, for so many millions of people, not so much to kill, as to willingly die for such limited imaginings" (1991, 6–7).

4. On imagined communities and invented traditions, see Anderson (1991) and Hobsbawm and Ranger (1983).

5. I borrow Doris Sommers's phrase "foundational fictions" for the nineteenth-century romances in Latin American fiction in which sexual unions become allegorical of concurrent nationalist movements and nation-building projects (1991). See also Lamb (1975).

Bibliography

Almaguer, Tómas. 1994. *Racial Fault Lines: The Historical Origins of White Supremacy in California*. Berkeley: University of California Press.

Anderson, Benedict. 1991. *Imagined Communities: Reflections on the Origins and Spread of Nationalism*. Rev. ed. New York: Verso.

Buscombe, Edward, ed. 1988. *The BFI Companion to the Western*. New York: Da Capo.

Castañeda, Jorge G. 1993. *Utopian Unarmed: The Latin American Left After the Cold War*. New York: Vintage.

Fenin, George N., and William K. Everson. 1962. *The Western: From Silents to Cinerama*. New York: Orion.

García, Mario T. 1989. *Mexican Americans: Leadership, Ideology, and Identity, 1930–1960*. New Haven, CT: Yale University Press.

Hobsbawm, Eric, and Terrence Ranger, eds. 1983. *The Invention of Tradition*. Cambridge: Cambridge University Press.

Lamb, Blaine Press. 1975. "The Convenient Villain: The Early Cinema Views the Mexican-American." *Journal of the West* 14, no. 4: 75–81.

Saxton, Alexander. 1990. *The Rise and Fall of the White Republic: Class Politics and Mass Culture in Nineteenth-Century America*. London: Verso.

Sommers, Doris. 1991. *Foundational Fictions: The National Romances of Latin America*. Berkeley: University of California Press.

Topographies of the Imaginary

Kathy Vargas's My Alamo and Robert C. Buitrón's El Corrido de Happy Trails

Jennifer A. González

To be in the presence of the photograph is to be involved in an imaginary landscape where time is arrested, distances are crossed, and the dead are resurrected. The parallels created between photographic practice and the efforts of memory have been noted by philosophers like Henri Bergson, who writes, "Whenever we are trying to recover a recollection, to call up some period of our history, we become conscious of an act *sui generis* by which we detach ourselves from the present in order to replace ourselves, first in the past in general, then in a certain region of the past—a work of adjustment, something like the focusing of a camera" ([1896] 1991, 133). Such conceptual parallels suggest that photographic practice is more than an aid to memory: it has come to define the very mechanisms of human memory and perhaps even consciousness itself.

Artists Kathy Vargas and Robert C. Buitrón testify to this relation between photographic memory and real memory, between the landscape of the psyche and the landscape of the image. For each, the past is a domain dominated by the politics of the photograph: film images, advertising images, and archival images work to ground their understanding of childhood seen through the politics of the Mexican stereotype and the Western hero. In their artworks, new theories of remembrance and historical discourse emerge, blending an imaginary topography with a political realism of the present.

In *El Corrido de Happy Trails (starring Pancho y Tonto)*, Buitrón offers a set of impossible spatial and temporal conjunctions in order to explore

the ways Hollywood archetypes developed within a system of inequality, not only for Indians but also for Mexicans and Mexican Americans. Eight staged photographs place the two figures (friends of the artist in costume) in a series of face-offs; overall the Mexican Pancho comes out a little less valued than the Indian Tonto in scenes like a casting call titled *Seeking Indians—Mexicans Need Not Apply*. Echoing the artist James Luna's photographic series *Half Indian/Half Mexican*,[1] Buitrón's images offer a view into the parallel but unequal forms of disenfranchisement of both Indians and Mexicans in American popular culture. The Indian is valued as a romantic link to a precontact age, whereas the Mexican is debased for his or her mestizo heritage and working-class status. Both are imaginary figures constructed in the white imagination to inhabit the unreal narratives of *The Cisco Kid* and *The Lone Ranger*, two films that would frame discourses of the American West for several generations.[2]

One image in the series places Pancho and Tonto in the background of a café, with the foreground occupied by two women who smile at each other over laptop computers, titled *Malinche y Pocahontas Contando la Historia de Pancho y Tonto*. These real yet mythologized women, who played an important role in initiating a cascading history of cultural contact between the indigenous of the Americas and European invaders, hold the dual status of traitor and ancestor. La Malinche is the name given to a Nahuatl woman from the Mexican Gulf Coast who played an important role in the Spanish conquest of Mexico. She acted as interpreter, advisor, lover, and intermediary for Hernán Cortés and also gave birth to his son, considered the first mestizo. Pocahontas was a Virginia Indian who famously saved the life of John Smith, a member of the Jamestown, Virginia, settlement. Her union with John Rolfe in 1614 is considered the first interracial marriage in American history. Buitrón's playful gesture is to bring them together in an impossible meeting place, a contemporary café, where they not only gossip and communicate via the latest technology, they also weave a time-warped narrative of the past. Part myth and part metahistory, the story they tell eventually becomes that of the American West in which Tonto and Pancho will play a subordinate, supporting role. It is difficult to tell whether Buitrón's image is an indictment of these women and their sellout relation to colonial domination or a validation of the role they play as memory keepers who find a way to survive the European conquest, despite the odds.

Either way, Buitrón's photographic device invites us to consider what it would mean for these four larger-than-life subjects to meet in the present. Several spatial registers operate in the overall series: the mythological

Western frontier of the Americas, the psychic landscapes produced by film and other mass media as a kind of extended horizon of cultural possibility, the modern-day city where such histories and memories collide (i.e., the Jumping Bean café in Chicago), and the domestic sphere where such myths are maintained by individual families (see other images in the series, such as *Identity Surfing* and *Pancho y Tonto Exchange Birthday Gifts*). Each topology locates the formulation and maintenance of these transhistorical imaginary subjects and the photographs work to create the artificial condition of their meeting.

There is a similar artificial collapse of time and space in the work of Kathy Vargas, but in an entirely different emotional register. While Buitrón's images operate as engaging and humorous interventions into the strange anonymity of classic stereotypes, Vargas works in an autobiographical mode to unravel and personalize the iconic images of the American West. As a native of San Antonio, Texas, the artist decided to examine the Alamo—a historical monument where the Mexican army defeated U.S. troops after a heated battle. The wealthy women who comprise the so-called Daughters of the Alamo keep the memory alive, spinning the tale of U.S. bravery and maintaining the dignity and prominence of this icon of Texan heritage. In Vargas's photographic series *My Alamo*, a set of images recount personal stories about the artist's relationship to this historic landmark along with delicately layered images that serve as ambivalent shrines to an idealized past. Emphasizing the highly personal nature of her images as compared to the vast commercial apparatus that surrounds the Alamo, Vargas writes, "I had to pick through it all and remember those Alamo memories that were uniquely mine."[3]

With subtlety and grace, the layered visual negatives provide gestures and movement over and above an otherwise static architectural façade, revealing the bodies of Mexican American workers and family members in the place of heroic U.S. Western figures, such as Davy Crockett and Daniel Boone. The images are composites or montages, allowing for juxtapositions of time as well as space. They are almost like private collections of souvenirs, tumbling around in the darkness of memory. The images are accompanied by poetic textual accounts of visits to the monument and thoughts about Mexican working-class labor, childhood, and racial exclusion. Although archival elements are included, the images are atmospheric rather than literal and seem haunted rather than staged. Indeed, haunting is perhaps one way to understand how architectural spaces, particularly monuments, can come to dominate a landscape that is already

imaginary. Architecture both preserves and elides history; buildings are the ideal object for imaginary projections of the past precisely because their walls cannot speak, even when innumerable subjects have walked their halls. If the American West was ever really a "frontier," it was always already occupied by ghosts. The resurrection of these ghosts, in the form of present-day citizens whose histories are repressed and elided, is part of what forms the underlying power of Vargas's work.

Vargas's images and the handwritten narratives on the margins construct an alternative vision, a countermemory, of the Alamo and ultimately formulate representable conditions for other social subjects that would otherwise remain invisible and mute. Perhaps the shrines can be seen to lay previous Alamo "ideals" to rest. For George Lipsitz, "Countermemory looks to the past for the hidden histories excluded from dominant narratives. But unlike myths that seek to detach events and actions from the fabric of any larger history, counter-memory forces revision of existing histories by supplying new perspectives about the past. Counter-memory embodies aspects of myth and aspects of history, but it retains an enduring suspicion of both categories" (1990, 213).[4] The countermemories offered by Vargas are not abstract but topological, articulating a vision of the past that links myth with history in such a way as to invite viewers to better understand their construction and reconstruction across a spatial register. Evident in Vargas's work is the fact that racism also operates across physical space. The question of insider/outsider status is literalized by the monument as well as the social organizations that support it and provide (or deny) access to it.

The photographic series of Buitrón and Vargas produce a visual mapping of the ideological and social relations that are created at the intersection of Hollywood cinema, commercial advertisements, historic monuments, economic realities, cultural myths, and even personal anecdotes. The photographs combine for what might be called topographies of the imaginary—impossible, invented sites that nevertheless exist to the degree that they shape both consciousness and relations of power. Rejecting realist or documentary uses of this classically indexical medium, their works creatively explore photography's limits as the ground for a new articulation of the past in the present. The work invites us to understand not only that the past is a landscape that has been constructed for us to inhabit (comfortably or uncomfortably) but also that we may have our own critical role to play in the remapping and retelling of this always unfinished narrative.

Notes

1. *Southern California Cultural Journalism* ran a profile of James Luna in June 2012. For more information, see Gordon Johnson's report (2012). See also "James Luna: Artifacts and Fictions" in Jennifer González's *Subject to Display: Reframing Race in Contemporary Installation Art* (2008).

2. The Cisco Kid character, from O. Henry's short story "The Caballero's Way," appears as early in cinema as 1914 in a film by the same title, but it was Warner Baxter's portrayal in the film *In Old Arizona* (1928) that established the story's popularity. Cesar Romero, Gilbert Roland, and Duncan Renaldo serially revived the character over the next three decades, frequently with a sidekick, often named Pancho and best remembered through Leo Carrillo's performance. By midcentury, the character shifted from silver screen to television screen and remained a popular, if stereotypical, figure. Tonto, and sometimes alternately Chief Thundercloud, rides alongside the Lone Ranger initially in radio serials and in film as early as 1938, but it was Jay Silverheels's portrayal in the 1955 film and the television series that ran five seasons, from 1949 to 1957, that set the character in popular memory. For more information on the stereotypical aspects of these characters and their actor counterparts, see discussions by Francis M. Nevins and Gary D. Keller (2008), Scott L. Baugh (2012), and Chadwick Allen (1996).

3. See Kathy Vargas's earlier chapter in this collection.

4. George Lipsitz contrasts his own notion of "counter-memory" with that developed by Foucault in the following manner: "Foucault's perspective offers an important critique of dominant ideology about myth and history, and it contains a healthy suspicion of totalizing narratives. Like Jean-François Lyotard, Foucault worries that historical writing tends to celebrate the oppressions of the past and present as necessary and inevitable. . . . Yet in a world where dialogue, curiosity, and conflict create webs of interdependency, no single story can be understood except in relations to other stories. A 'monotonous finality' could do violence to the 'singularity of events,' but refusal of all totality could just as easily obscure real connections, causes, and relationships—atomizing common experiences into accidents and endlessly repeated play" (1990, 213–14).

Bibliography

Allen, Chadwick. 1996. "Hero with Two Faces: The Lone Ranger as Treaty Discourse." *American Literature* 68, no. 3: 609–38.

Baugh, Scott L. 2012. *Latino American Cinema*. Santa Barbara, CA: Greenwood.

Bergson, Henri. [1896] 1991. *Matter and Memory*. Translated by N. M. Paul and W. S. Palmer. New York: Zone Books.

González, Jennifer A. 2008. *Subject to Display: Reframing Race in Contemporary Installation Art*. Cambridge, MA: MIT Press.

Johnson, Gordon. 2012. "From the Rez: James Luna's Hybridized Indian Performance Art." *Southern California Cultural Journalism*, June 19. http://www.kcet

.org/arts/artbound/counties/san-diego/from-the-rez-james-lunas-hybridized-indian
-performance-art.html.

Lipsitz, George. 1990. *Time Passages: Collective Memory and American Popular Culture*. Minneapolis: University of Minnesota Press.

Nevins, Francis M., and Gary D. Keller. 2008. *The Cisco Kid: American Hero, Hispanic Roots*. Tempe, AZ: Bilingual Review Press.

Where Carnales *Were, There Shall Unprodigal Daughters Be*

Kathy Vargas's *My Alamo* and Robert C. Buitrón's *Malinche y Pocahontas*

Asta Kuusinen

In reconfiguring the canonized national history of the West, Robert C. Buitrón can be regarded as a comedian and Kathy Vargas as a satirist. Irreverent and subversive, the artwork of both photographers is dedicated to bringing down the celebrated images of the mythic West; that is, the West with "the *one* inner meaning for *our* national experience," as stated by Chon Noriega in the opening essay of the catalog for the exhibition *From the West: Chicano Narrative Photography*, in which both artists were featured (1995, 11). With great sophistication, Noriega's and Jennifer González's essays in this catalog elaborate upon the possibilities of a narrative reading of the photographic work as a way to instill heterogeneity, depth, and breadth into the representations of the nation. Apart from subverting great historical narratives, however, both Buitrón and Vargas also touch on something more intimate and forbidding in their depictions of la familia, an idealized Mexican American family.

For la familia is not what it used to be. Something within it has shifted, eroding the very foundations of its integrity. Of course, the Chicano family never was of one blood, its origins deeply rooted in *mestizaje*, the mix of European and American Indian ancestry. Yet it is not so much race that is at stake in Buitrón's photograph *Malinche y Pocahontas Chismeando*

con Powerbooks but gender, class, and—at their intersection—the legitimate parenthood of la raza.[1] Unlike in the other images of the series *El Corrido de Happy Trails (starring Pancho y Tonto)*, the male characters stay put, idling at the back of the trendy café. The foreground shows a lively encounter between the two young ladies, who are busy chatting over their notebooks, perchance interpreting, rewriting, and mediating cultural codes, as they have traditionally done in numerous human encounters in the Americas.

The scene is hilarious because it knocks the standard heterosexual relation between a man and a woman down from its privileged position at the top of the social hierarchy. Indeed, this Pocahontas does not mediate between Tontos and Captain Smiths; nor does this Malinche attempt to translate between warring Native males and colonizing European males. The males in the image do not communicate at all, in fact, not even with the viewer. Malinche and Pocahontas, comfortable like the author Sandra Cisneros while she is sipping her drinks with *las girlfriends* in Venice, Paris, or Buenos Aires,[2] have taken over the predominantly "white" space of middle-class style, delighting in each other's company and exchanging messages by means of social media. The serious business of nation building does not seem to be one of their concerns; instead, they make jokes, and the butt of their amusement is not hard to guess—men.

Between their *chismes* (gossip) on the opposite sex, the ladies might occasionally point at one or another rather interesting finding online and raise their eyebrows, nodding. "Listen, girlfriend, this *gabacha* [white girl] here is not so stupid, throws in some pretty good political-historical questions about scientific origin stories, you know, about contests for naming meanings and possibilities, reproductive freedoms and constraints, social pathology and inherited tendencies in human behavior, including sex roles," says Malinche.[3] "It is that cyborg woman, isn't it, what's her name—Donna Haraway?" surmises Pocahontas, "talking about her ironic dream of a common language for women in the integrated circuit . . . sounds familiar, you know. High tech serves us all right, we've done our homework, we can read, we can live on the boundaries. Who the hell needs another innocent, all-powerful Mother breeding another phallocentric Family of Man, *¿qué no?*" And on and on Malinche and Pocahontas weave their webs, sipping their mocha lattes, joking about men, and programming a code for a "Cyborg Manifesto *Numero Dos*." The site of their rendezvous could very well be one of the popular cafés in downtown San Antonio, Texas, not too far from the tourist-infested Alamo square. Kathy Vargas's series of photomontages, titled *My Alamo* (1995), focuses on the

very same historical site, the fortress of the Alamo, where the birth of the nation turned out rather paroxysmal.

Perhaps more than any other geographical location at the U.S.-Mexico borderlands, the Alamo carries the symbolic weight of interracial violence and nationalistic bigotry. In the early eighteenth century, it was one of the original five missions along the San Antonio River. After being secularized, it came to serve as a military base for Spanish, rebel Texan, and then Mexican troops. Today the Alamo is the most celebrated tourist attraction in Texas, while remaining a politically contested site for researchers, writers, and local folk alike. This scuffle appears to be vaguely acknowledged even in the visitor brochure published by the Daughters of the Republic of Texas, an association that has been the owner and caretaker of the site since 1905. However, the acknowledgment of a "debate" about "the facts" concerning the siege of the Alamo is quickly followed by the sweeping rhetoric of nation building: "While the facts surrounding the siege of the Alamo continue to be debated, there is no doubt about what the battle has come to symbolize. People worldwide continue to remember the Alamo as a heroic struggle against overwhelming odds—a place where men made the ultimate sacrifice for freedom. For this reason the Alamo remains hallowed ground and the Shrine of Texas Liberty" (Daughters of the Republic of Texas 1997).

Cerebral rather than corporeal, Vargas's *My Alamo* series reorganizes with care and consideration the elements of the sacrosanct myth of origin. For the site of the "birth of the nation" also marks the site of Vargas's personal *herida*, the wound, which she needs to attend to—not by remembering, or forgetting, or renarrating, but by finding the right voices with which to speak out her anger. Yet the skillful aesthetics of the photographs tend to interweave the artist's anger within the multilayered, subtly colored compositions of handwritten commentary, clippings borrowed from popular culture, and fabricated family snapshots depicting scenes from everyday life. Vargas comments on her series of images on the Alamo: "Some of my recollections of the Alamo are humorous; some are serious. Most of them have a bite, but it's a bite I did not invent. It's a bite that recurs in the inherent aggression and often in the racism that is part and parcel of standing before war monuments and thinking oneself to be on one side or the other, either by choice or because history gives us no choice" (Lippard and Wilson-Powell 2002, 68).

Thereby, she "authenticates" her lived experience as a testimony, that is, as a forthrightly subjective narration, reflective of its own status and embedded in material fragments, communal practices, and personal memories of everyday life in San Antonio in the 1950s and 1960s. In the final

analysis, however, Vargas herself refrains from pointing to the ultimate meaning of her own reconfiguration of the contested place. She acknowledges that "trying to think of myself as victor or vanquished in relationship to the Alamo, I couldn't come up with a concrete conclusion—hence my ambiguity" (Lippard and Wilson-Powell 2002, 68). This is the tension that puts the layered elements of her images in a perpetual dynamic dialogue with one another, a suspension of belief that precludes any final resolution of the enduring social conflict and the coherence of its historical representations.

In the case of *My Alamo*, then, the substance of contested space solidifies around an extremely hard core, a stone construction, whose thick walls and cavernous interior resemble a very corporeal place of origin, a womb. Despite the evocative connotations, it is hard to perceive an urban public space beyond the reach of the empirical, "rational" parameters of description often guarded by historians as well as by mass media. One of the first attempts to this effect was made by the philosopher Henri Lefebvre, who maintains, "It is true that explaining everything in psychoanalytic terms, in terms of the unconscious, can only lead to an intolerable reductionism and dogmatism; the same goes for the overestimation of the 'structural.' Yet structures do exist, and there is such a thing as the 'unconscious'" ([1974] 1991, 36). Lefebvre postulated a revival of psychoanalysis on the premise that cities as well as nations could have an "unconscious," repressed life of their own. Underneath the spatial practice of everyday experience, this repressed life takes place in representational space, that is, in space that is predominantly nonverbal in nature, appropriated by imagination and the unconscious (Lefebvre ([1974] 1991, 33). The State of Texas makes a case in point for Lefebvre's argument.

Perceived through a "subconscious" register, the *My Alamo* series descends deeper into the psychodynamics of la familia than does Buitrón's photographic representation of Chicano gender trouble. Its humor has a dark edge. It is not only a revision of the historical grand narrative from an "other" point of view but also a visual reenactment of a family trauma, which involves a development story and a rite of passage in various stages that lead to the acquisition of new symbolic language and psychological healing. As such, it coarticulates the public spaces of politics, economics, and institutions with the private spheres of domestic affairs, reproduction, and sexual stratification in a manner sensitive to the issues of representation pointed out by Lefebvre.

The complex Freudian fable embedded in *My Alamo* unfolds through a series of crisis situations in which Vargas, as a child, works out the parameters of her identity by rebelling and negotiating her position amid

conflicting messages from various father and mother figures. The second photomontage of *My Alamo* calls upon the social convention of making self-images by staging models, whose pose imitates a family snapshot (complete with the father on the right, the mother on the left, and the child in the middle). This photograph inside the artwork confirms the existence of ideal family life, love, cohesion, continuity, normalcy, and dignity. However, the harmony of the family portrait becomes disrupted by a giant-size raccoon tail ominously hanging over the scene, almost brushing over the worried face of the little girl in her mother's arms. The frozen expressions of the characters' faces appeal to the viewer's empathy by asserting their subjectivity and vulnerability, but at the same time, their eyes anxiously respond to the ideological interpellation of the scrutinizing "I" of the camera. The family becomes "framed" against the black screen, first as Indian and then as Mexican—in short, as enemies in the garden of Texas.

The Oedipal drama is externalized in a public scene in which the girl flings down the fur cap her father has purchased for the snapshot-to-be-taken. For her, Davy Crockett's coonskin cap does not function as a symbolic token of power and homosocial bond (as it does for the male members of the family, despite their racial otherness), but as a stigma of being "bad," like Hollywood Indians on TV, and therefore left outside of that bond. The father's inability to reconcile or even perceive the irony inherent in his own behavior is the source of the girl's revolt against him. The girl's encounter with the law of the symbolic thus signifies her rejection of the patrimonial teachings endlessly repeated for audiences of ritual performances before national monuments.

An equally disheartening scene occurs during the annual Fiesta San Antonio pageant when the child realizes that neither her biological mother, as a *chingada* (screwed one), nor she herself, as a *malcriada* (ill-bred one), can ever become members of the "royalty" parading through the town, for the fiesta queen is always elected from women of Anglo descent. In Vargas's family drama, therefore, at stake are not only the Indian mother versus the European mother but also their alternates—such as La Malinche and La Conquistadora,[4] two of the female symbols inhabiting the Chicana "soulscape." Carrying regalia reminiscent of both Queen Victoria of England and Our Lady of the Conquest of Spain, the phallic queen haunting the mother and child dyad merges the Anglo and the Hispanic colonizer in a single matriarchal authority that categorically denies the mestiza girl's desire for autonomy, "pure" identity, and the right of speech.

The final images of the series let loose the unprodigal daughter herself. Enter Ozzy Osbourne, Vargas's Oedipal proxy and the former singer of the British heavy metal band Black Sabbath. Osbourne once committed

a sacrilege against the shrine but got away from the revenge of the Alamo angels.[5] The photomontage reveals a blurred double exposure of a man frantically shaking a microphone, framed by the artist's written testimony: "One night, after a performance here, Ozzy decided to tempt fate and piss on part of the Alamo. And the earth did not swallow him, and lightning bolts did not strike him dead."[6] Not even the purified Alamo spring water bottled for the on-site tourist shop was potent enough to remove the human stain administered by Osbourne's urine. His bodily fluids seemed to possess a formidable deconstructive power in exposing the way high culture structures itself around the "pollution" taboo to ward off all things low, grotesque, carnal, and sexual, all things that question the purity of historical myths. Osbourne's "transdressing" body thus turned into a privileged site of oppositional, underclass politics, wielding power through the carnivalesque strategy of the false king.

By any standard, a Chicana avowing an ideological progenitor who is white, British, working class, of low culture, in bad taste, and notoriously prodrugs is subversive indeed, although perhaps not so surprising a choice in light of Vargas's past career as a documentary photographer of rock 'n' roll bands. Osbourne's figure harkens back to the countercultures of the 1960s and 1970s, the hotbed of cultural and political opposition, where the artist locates the origins of her commitment to civil activism. The so-called British Invasion of the United States by rock 'n' roll music electrified the sociopolitical protests of that time period, crossing national boundaries and forging ethno-racial solidarities by reviving a musical genre rooted in black culture. The artist's personal choice in deploying one of the most irreverent icons of European popular culture to mock dogmatic formulations of identity politics certainly removes any taint of racial (or gender) essentialism from her work. Similarly, in Vargas's vision, the disturbing image of otherness, the colonial *unheimlich*, rather than carrying some uncanny racial or ethnic markers, seems to be circumscribed by multiple identities emerging from class-based alliances, a subject not well considered in critical thought until very recently.

This essay expounds upon the crucial role of historical narratives, symbols, and geographical sites in the construction of Mexican American identity. At least since the civil rights era, Chicana and Chicano visual artists have powerfully participated in the reinterpretation of these narratives, shunning dialectical models of explanation and revising Mexican American history—with all its complexities and paradoxes—through the shifting fates of the idealized popular myths and icons. "The Texas myth is essentially a creation myth," contends the author Michael Ennis, "and disabusing true-believers of their interpretation of Genesis is always a risky

business" (2004, 6). Yet the contestation of those kinds of myths appears to be one of the driving forces behind the works of many Mexican American artists, including Buitrón and Vargas.

Notes

1. *Malinche y Pocahontas Chismeando con Powerbooks* is part of Robert C. Buitrón's 1995 photographic series *El Corrido de Happy Trails (starring Pancho y Tonto)*, which was on display in the exhibition *From the West: Chicano Narrative Photography*. After the exhibition, he retitled the piece *Malinche y Pocahontas Contando la Historia de Pancho y Tonto*, which he explains in his essay in this collection.

2. See Sandra Cisneros's collection *Loose Woman: Poems* (1994), in particular the poems "Las Girlfriends" (105–106) and "Still Life with Potatoes, Pearls, Raw Meat, Rhinestones, Lard, and Horse Hooves" (108–110).

3. The imagined dialogue between Malinche and Pocahontas in this paragraph is composed of paraphrased quotes from Donna Haraway's landmark publication *Simians, Cyborgs, and Women: The Reinvention of Nature* (1991), particularly from chapter 8, "A Cyborg Manifesto: Science, Technology, and Socialist-Feminism in the Late Twentieth Century" (149–81). See pages 93 and 177.

4. La Conquistadora, a sculpture carried by the Spanish troops during the reconquest of New Mexico after the bloody Pueblo Revolt in the late seventeenth century, still embodies the myth of a peaceful coexistence of the Spanish and the Indians in the Southwest. So, too, in the following quote: "In his remarkable re-entry without bloodshed into Santa Fe that made him famous throughout Old and New Spain, Don Diego [de Vargas] led an army of the Reconquest under the banner of Our Lady. All along the trail, he undertook to meet with the Indian chieftains and won them over by the force of his personality and presence. Displaying Our Lady on the royal standard he carried, he told them that both Indians and Spaniards could now live in peace together under so tender a Mother who loved them all alike" (Horvat 2002).

5. To MTV News Online in 1992, Ozzy Osbourne said: "I can honestly say all the bad things that ever happened to me were directly attributed to drugs and alcohol. I mean, I would never urinate at the Alamo at nine o'clock in the morning dressed in a woman's evening dress sober" (quoted in Liao and Everett 1999). He was thrown in jail and banned from ever playing in San Antonio again. Years later, however, the Daughters of the Republic of Texas decided to accept his apology (enhanced by a donation of ten thousand dollars) and lifted the ban.

6. Vargas's handwritten comment on her photomontage.

Bibliography

Cisneros, Sandra. 1994. *Loose Woman: Poems*. New York: Knopf.

Daughters of the Republic of Texas. 1997. *The Story of the Alamo: Thirteen Fateful Days in 1836*. San Antonio, TX. Tourist brochure.

Ennis, Michael. 2004. "Texas Vision: Through the Looking Glass of History." In *Texas Vision: The Barrett Collection; The Art of Texas and Switzerland*, edited by Edmund P. Pillsbury, 1–61. Dallas: Meadows Museum, Southern Methodist University Press. Exhibition catalog.

González, Jennifer A. 1995. "Negotiated Frontiers." In *From the West: Chicano Narrative Photography*, edited by Chon A. Noriega, 17–22. San Francisco: Mexican Museum. Exhibition catalog.

Haraway, Donna. 1991. *Simians, Cyborgs, and Women: The Reinvention of Nature.* New York: Routledge.

Horvat, Marian Therese. 2002. "*La Conquistadora*: Our Country's Oldest Madonna." Tradition in Action website. http://www.traditioninaction.org/religious/a008rp.htm.

Lefebvre, Henri. [1974] 1991. *The Production of Space.* Translated by Donald Nicholson-Smith. Cambridge: Blackwell.

Liao, Min, and Everett True. 1999. "Excellent Real Rock Quotes." *The Stranger.* http://www.thestranger.com/seattle/excellent-real-rock-quotes/Content?oid=429.

Lippard, Lucy, and MaLin Wilson-Powell, eds. 2002. *Kathy Vargas: Photographs, 1971–2000.* San Antonio, TX: McNay. Exhibition catalog.

Noriega, Chon A. 1995. "Many Wests." In *From the West: Chicano Narrative Photography*, edited by Chon A. Noriega, 9–15. San Francisco: Mexican Museum. Exhibition catalog.

A Conversation with Willie Varela and Scott L. Baugh

This Burning World, a dual-screen, two-channel experimental video, was the centerpiece of Willie Varela's *Crossing Over* exhibition, which showed in El Paso, San Antonio, Dallas, and Austin, Texas, from 2002 to 2004.[1] The idea of a "burning world" is provocative, and as a trope it enacts several important ideas that can be revisited across the life-span of this installation. This interview, then, borrows from several interchanges between Willie Varela and Scott Baugh almost five years apart: the earlier during visits in and around the artist's home in El Paso in August 2003; and five years later via e-mail and telephone, from May through August 2008. The combined effect might be aphoristic, somewhere in between conversation and essay, in sets of concise statements about *This Burning World* and our burning world, but it also allows for moments of reflection and consideration between the period when the work was first shown and five years after.

<div align="center">* * *</div>

Scott L. Baugh (SLB): How would you explain your use of the "burning world" trope?

Willie Varela (WV): [2003] I think the first and most valuable starting point would be the title, *This Burning World*. My particular take on this is that I wanted to make a piece about what someone can make of all the images in our world every day—the "forest of signs," we might say.[2]

Our world would clearly not be the same without all of these images. I'm trying to make sense of all these images that surround us every day; I want to make some sense out of this and that our world is *burning* right now, burning with frustration and rage, and rightly so. . . .

I wanted to make a piece about all the many types of imagery that I've encountered and worked with, have created either firsthand or have been able to appropriate from television, movies, and even the Internet—and especially imagery that dealt with death, with destruction, and with violent violations, violations of the body, of individuals' sovereign space, and of our minds, through the types of visceral imagery that does imprint itself on us. And, depending on how sensitive one is and especially how sensitive to violent imagery, the piece can begin to create a sense that we are living in a very crucial time.

[2008] The title actually was inspired by the band Swans. They had a CD out called *The Burning World* (1989), and the songs were so dark and death obsessed and fatalistic that I very much identified with them, especially since I came upon the CD when I was going through my divorce.

So the "burning world" can refer to the individual, myself, since I have gone through some very difficult times lately, and at that time still had a very strong recollection of my feelings when I was suffering.

The other aspect of the title refers to the many parts of the world which are undergoing great strife and internal conflict: Darfur, Sudan, most of Africa, now Georgia, Serbia in the recent past, any place in the world where there is "a world" that is filled with bloodshed and denial of human rights.

Overall, the dual-screen piece attempts to encompass various "worlds" that exist simultaneously in time and that contrast with whatever reality one is experiencing at the time.

SLB: The visual imagery seems at times spiritual and at other times especially vulgar, uncanny, and at times commercial, et cetera. More interesting, the spiritual-material balances in the video form—video as art. Do the two channels compete with each other, vying for attention? Or, more often, synthesize into something more?

WV: [2008] In aligning the two channels, I would say that I was trying to construct some sequences that did seem to sync up and others that obviously didn't. The sacred and the profane definitely played throughout. After all, we are bombarded daily with all kinds of images, most of them designed to sell us things. We are inundated with images that are intrusive and vulgar and visceral so as to grab our attention and hold it. My video was attempting to critique this type of imagery. In that aim, images at times did "compete" for the viewer's attention and at other times were soothing and reassuring.

At any rate, these images were meant to be seen more than once in order to truly grasp the overall arc of the piece.

Once again, the images are personal in nature, in that they reveal my own obsessions and concerns, at least in terms of the images that were used. I wanted there to be some questioning as to why certain images were juxtaposed and how they related to the viewer's "image world." Everybody comes equipped with tens of thousands of images in their own personal image bank, and it just depends on which images move them. I wanted the dual-screen format to present more possibilities, more options in terms of meaning. I wanted for the viewer to perhaps at times be confused but interested and at other times to be shocked or stunned or sometimes even uplifted. I wanted the piece to have that power.

The dual images perform two functions: in sync, they present the viewer with some continuity and coherence; for some of the images to not sync up, therefore, they challenge the viewer to make meaning out of the juxtaposition. It is difficult to handle two streams of thought at the same time, but it is possible for an impression to be made and, further, for this impression to linger in the mind long after the experience is over.

[2003] Implicit in the organization of the images throughout *This Burning World* is the freedom that's naturally or organically allowed to the viewers. The meanings are very often quite ambiguous.

If I wanted to create a pointed social critique of American society, then I'd write an essay or a book. This is a video art installation piece. It is meant to be experienced at a given time on various levels. For that reason I didn't want to make connections that were always so terribly obvious that one might be able to say, "Ah, there's that connection between sex and violence, that connection between consumerism and nature," and so on. One could do that with a very careful reading of the synced-up images, reading themes throughout the piece. But maybe it is and maybe it isn't. Every viewer will perceive something different.

[2008] So *This Burning World* was designed for multiple viewings and for multiple meanings to arise from these repeated viewings. While I realize most viewers won't see it more than once or may read only small chunks of it, I believe that most viewers will come away with something from having engaged the various worlds in the video.

As for the idea of synthesis, I don't necessarily deny that I tried to sync up certain images in order to aim at a certain meaning, but, on the whole, the images were assembled intuitively in such a way [as] to give rise to multiple meanings. And, yes, they do synthesize into something more, a

collection of "worlds," each world with its own integrity; within this integrity, they have even more power to make meaning when juxtaposed with other images.

And, of course, it was not designed to be a narrative piece but rather a piece that had to be assembled in the minds of the viewers. All of us have already been trained to follow a narrative, but we have not been taught to deduce meaning from something that is nonlinear, nonnarrative, something that is meant to be assembled, like a puzzle. Oftentimes, these kinds of experiences can be very enriching and stimulating; they can open the mind to multiple concepts.

SB: How does *This Burning World* function differently, say, from just being a video text, as part of the installation and being shown within gallery space?

WV: [2003] *Crossing Over* is an installation designed to work with scale. Absolutely. I had that in mind as I shot and selected imagery, its size and scope. A lot depends, of course, on the place, on the kind of projection and wall space that any given showing place might have. You might say that the installation changes with its space.

That's something that's interesting in all of this, because the final version—one might say the "definitive text"—becomes elusive in installations.[3] Meanings shift as a piece like *This Burning World* is screened in different facilities. I'm learning something about the influence of space on a piece like *This Burning World*.

[2008] I wanted the scale to be a positive addition to the piece. The bigger the better—at least what was able to be accommodated in a given space. I would say that overall *This Burning World* was well presented at the four spaces where it was shown. But the scale was absolutely important. It had to be large in order to confront the preconceptions of the viewer, and it had to be large in order to get at the viewer in a certain way.

I wanted the scale to be as assaultive as it could be, and I wanted the scale to make the viewer reconsider size as a consideration connected with meaning. Through size, a new meaning would come to the images, and with size the viewer was taken in[to] the "world" of the piece itself.

SB: How might the personal and political aspects interact in *This Burning World*? Do the formalist techniques—flickers, loops, the attention you draw through dual-framed imagery, et cetera—support the personal-political or detract from it or both?[4]

Figure 29.1. Stills from *This Burning World* (2002, 2-channel color and black-and-white video and sound installation, 30 min.), produced, shot, and edited by Willie Varela. Frames from this video art piece's two side-by-side synched streams of abstract imagery, which are accompanied by a pulsating electronica soundtrack: on the left side of the screen, viewers see a blurry negative monochrome of waves crashing on a beach, superimposed with a title card paraphrasing Blaise Pascal, "All the evil in men comes from one thing alone, their inability to remain at rest in a room"; on the right side of the screen, found footage relates an eye operation, swab and suture visible against the human eyeball. (Photographs courtesy of the artist.)

WV: [2003] If, as an artist, you are making experimental film, if you are making experimental video, if you are working in the multimedia installation, if you are making anything that is not primarily oriented toward entertainment and commercial success, you are essentially resisting the powers that be. Resisting! The personal and the political are intertwined in this resistance.

By definition, everything I do is in resistance. But it's not always or necessarily a resistance that comes out of extreme anger or hatred or the desire to try to *make* people better than they are. And every artist whom I respect, by definition, is in resistance to mainstream expression, whether it's commercial cinema or it's contemporary music and the rest.

So when you talk about resistance, I think it's a question of are we talking about something that's driven by anger, that's driven by irritation, that's driven by being pissed off at the way things are, or has it become something deeper. That just happened to me. I couldn't make a film to please an imagined broad audience if my life depended on it. I wouldn't even presume to want to make something for you that I think you would like.

The question becomes, for me, then, how angst ridden do you want to be about it? How lonely and isolated and angry do you want to be because

of it? And I think to be angry, to be isolated, to be pissed off is really the province of the young. It's a good thing. Young people should be pissed off at our national cinema, at the commercialism of cinema. But I am a middle-aged man now, and I have been through all of that, and I have obviously charted my path. I have come to be the kind of artist where I want whatever audience I have out there to be primarily moved by the work, even if it takes a while to be moved by the work.

[2008] The personal and the political are always interwoven.

After all, I can only be me. And therefore my personal and political concerns are necessarily intertwined in a body of imagery that will constantly veer from one type of imagery to the other. So I mixed these images intuitively in such a way as to keep the viewer off balance, always having to read and reread the images in such a way that meaning is elusive, shifting.

Many aspects of our lives, however personal they may seem to be, are often mediated by forces outside our own personal space—the world, the government, the state—which intrude on our lives in many different ways. And, thus, our lives become "political." There are very few places left to hide anymore, and so our lives often take on a deep complexity and resonance.

It is for this reason that my piece had so many different types of imagery, some images dealing with nature and its place in our world and other images that were man-made and resonate in a different way than those images that are natural and self-contained. The special effects throughout the piece were designed to enhance the images, to punch them up, to make them more real. And by doing this I was able to make the piece truly a piece of media art, as it bore very little resemblance to the empirical world.

Notes

1. The *Crossing Over* exhibit included *This Burning World* (2002) along with three other video-art pieces and a collection of eighteen photographs. The exhibit opened in October 2002 in El Paso, with the videos screening at the Main Gallery at the University of Texas at El Paso through December 2002 and the photographs on view at the El Paso Museum of Art through February 2003. The exhibit then traveled to San Antonio, the videos showing at Artpace from April to July 2003 and the photographs, at Blue Star Art Space from April to May 2003. Videos and photographs were shown in adjacent spaces at the McKinney Avenue Contemporary in Dallas from September to October 2003 and at the Mexic-Arte Museum in Austin from January to March 2014.

2. In *Mythologies*, Roland Barthes describes the iconography of Abbé Pierre as a "forest of signs." His physiognomy, his face, his haircut, his beard—those aspects that

"disguise" the abbé characters, Barthes insists, force us to ponder the "enormous consumption" of the images by the public ([1957] 2012, 48).

3. In the context of the conversation on authoritative texts, readers may be interested in Barthes's 1977 collection of essays, *Image-Music-Text*; both "The Death of the Author" and "From Work to Text" were referenced in the 2003 conversation. Consider also Michel Foucault's explanation in "What Is an Author?" of the "author function" ([1979] 2000, 549–50) as well as Wayne Booth's discussion in *The Rhetoric of Fiction* of the "implied author" ([1961] 1983, 71–72); both concepts theoretically allow an ideal source of information distinct from the actual creator of a text but also convey a sense of authorship.

4. On these terms as they relate to this question, readers may want to see books that were referenced in other parts of the 2003 and 2008 conversations, including Sitney's *Visionary Film* (2002), Gidal's *Materialist Film* (1989), LeGrice's *Abstract Film and Beyond* (1977), and Rees's *History of Experimental Film and Video* (1999) as starting points.

Bibliography

Barthes, Roland. [1957] 2012. *Mythologies*. Translated by Richard Howard and Annette Lavers. New York: Hill and Wang.

——. 1977. *Image-Music-Text*. Translated by Stephen Heath. New York: Hill and Wang.

Booth, Wayne. [1961] 1983. *The Rhetoric of Fiction*. 2nd ed. Chicago: University of Chicago Press.

Foucault, Michel. [1979] 2000. "What Is an Author?" Translated by Josue V. Hatari. In *Criticism: Major Statements*, 4th ed., edited by Charles Kaplan and William Davis Anderson, 544–58. Boston, MA: Bedford.

Gidal, Peter. 1989. *Materialist Film*. New York: Routledge.

LeGrice, Malcolm. 1977. *Abstract Film and Beyond*. London: Studio Vista.

Rees, A. L. 1999. *History of Experimental Film and Video*. London: BFI.

Sitney, P. Adams. 2002. *Visionary Film: The American Avant-Garde, 1943–2000*. 3rd ed. New York: Oxford University Press.

Swans. 1989. *The Burning World*. Uni Records–MCA, compact disc.

In This Burning World, *Willie Varela Resists*

Kate Bonansinga

The room was silent and dark except for a few pools of light. Two were diffused and on the ceiling, emanating from square telephone-booth-sized pillars. A third spotlighted a long table, with a chair at one end facing a glowing television at the other. Next to this was a doorway into another room and another world entirely—one of sound and movement, where images, some discernable, others not, pulsed across a drive-in-movie-sized screen. This otherworldly place was that of *This Burning World*, Willie Varela's magnum opus and the largest of the four video works included in the exhibition that I cocurated, *Crossing Over: Photographs and New Video Installations by Willie Varela*, which ran from October to December 2002 at the University of Texas at El Paso's Main Gallery.

Willie Varela is a self-taught artist who has been documenting the world around him since 1971 in both still and moving pictures. He is an outsider to the art world because of his self-constructed, shape-shifting identity that defies being categorized as "Chicano," a term in favor during the 1970s through the late 1990s, Varela's most productive years. Though he grew up in a Spanish-speaking household of first-generation Mexican American parents, today he speaks English only, which he learned from watching television; though his given name was Guillermo, he adopted the name Willie as a child; he went back to Guillermo in the 1990s, though Willie is the one that has stuck with him. He uses mass media as a material in his art but also critiques it, and thus his work condemns the very force that feeds it. He, in his words, keeps "one eye pointing north and the other pointing south, with the occasional luxury of both eyes actually gazing

inward" (1994, 96). He resists inclusion and categorization, and so does the art that he creates.

In August 2000 I began work as the director of University Art Galleries at the University of Texas at El Paso (UTEP), and by coincidence I met Varela about a month later in the hallway of the Department of Art. A visiting artists and exhibitions series anchored the programming at the university galleries, which grew to be the Stanlee and Gerald Rubin Center for the Visual Arts in 2004. One of my curatorial focuses was on artists who respond to the border milieu, universalizing in art its struggles and tensions. The El Paso/Juárez metropolis is the largest binational urban environment in the world. Downtown El Paso is about a mile from downtown Juárez, and their proximity privileges them to draw upon each other's human resources and energy but it also makes brutally evident their economic disparities. In addition, the proximity distinguishes this area from other large border metropolises: downtown San Diego is, for example, about twenty miles from downtown Tijuana.

El Paso is Varela's territory, one he views, not as a divided place, but rather as a seamless zone of action. He has lived here his entire life,[1] and this city is among his most important subjects.[2] His art conveys connections and disconnections, understandings and misunderstandings. These themes are relevant to the border but transcend it, as well, and define many aspects of contemporary society. These are also the messages of *This Burning World*, where footage of El Paso/Juárez comes together with footage appropriated from a host of sources, including television and the Internet, to create an atmosphere of tension and mystery. Portrayals of death, fire-eaters, wrestlers, and violent sections of cartoons interspersed with gruesome scenes from Hollywood movies convey, in the artist's words, "destruction, consumerism, and culture eating itself" (Bonansinga 2002, 15).[3] A soundtrack by Carter McBeath pounds and screams. This dual-screen projection is part video, part collage, and part sound installation. It defies definition.

Over the course of the 2000–2001 academic year, Varela and I had several discussions about his background, his ideas, and the fact that he had never been offered the opportunity to design video installations, nor had his photographs been produced at a large scale. Though his video work had been screened nationally—and at high-profile art exhibition venues, such as the Whitney Museum of American Art in New York City—his reputation was as a filmmaker, and he had never been offered a solo exhibition as a visual artist. A gallery environment would provide audiences an opportunity to experience Varela's work as it had never been experienced

before. For *This Burning World*, in particular, the viewer would be empowered to walk up to the image and then back away from it, becoming more physically involved with the work than would be the case in a traditional cinema setting, where the audience is seated and passive. Because it is dual screen and repeats on a loop, the chaos it conveys is ongoing, relentless: an unending cycle. The images move quickly; they are nonnarrative.

This Burning World's subject matter and style place Varela ahead of the curve, given the areas of inquiry of most artists of Mexican American descent at the time that Varela was achieving artistic maturity in the 1980s and 1990s. Most expressed their ideas through painting, sculpture, and photography, and the works were rooted in a rural polemic and narrative representation. The exception was Harry Gamboa Jr., a Los Angeles–based multimedia artist and writer who confronted the dominant white culture and various perspectives of Chicano culture. Gamboa and three other artists (Gronk, Patssi Valdez, and Willie Herrón) formed the conceptual performance group Asco that "sought to critique *el Movimiento* [the Chicano civil rights movement] that began in the 1960s and strip it of its romantic nationalist agenda," providing a postmodern voice to the Chicanismo (Gaspar de Alba 1998, 148).[4] But even Asco's subject matter, their point of inquiry, was national and ethnic identity. Varela's is not, which is another reason why he and his art are notable, and it is another way he defies predictable categories.

Instead there are strong connections between Varela's artwork and that of the globalized artists, whose artwork had become the cornerstone of our exhibition programming at UTEP. Chronologically Varela belongs to the Chicano era, but his art functions more like that of artists ten to twenty years his junior. Like Gamboa, he was one of the first artists of Mexican descent to use time-based media and to embrace a more urban aesthetic, and because of this he presaged artists such as Mario Ybarra Jr., Julio Cesar Morales, Leo Villareal, and numerous others born in the 1960s and 1970s. Varela describes himself as "an artist who happens to be Chicano . . . an international citizen" (Bonansinga 2002, 17).[5] He, like his successors, rises above his ethnicity, nationality, and place of residence and resists such identifiers. He crosses the U.S.-Mexico divide almost daily; it does not deter him. He considers the world to be without boundaries.

With these tools for arguing the importance of exhibiting Varela's work, in fall 2001 I decided to seize the opportunity to showcase *This Burning World* in a gallery setting and began to solidify support for the project.[6] In spring 2002 William Thompson, my cocurator, and I together selected eighteen images from the hundreds of 4-by-6-inch prints that Varela

shared with us; true to his calling to produce nonprecious art, Varela has his photographic negatives printed at Wal-Mart. Likewise, video is an inherently and notoriously populist media, one that many sculptors used in the 1970s because it was a noncommodifiable art form. Today's art world enthusiastically accepts time-based media, to the point that it dominates many international biennials. In the broader world, digital photography and video are so widely used that the simulated is perceived as actual and experience does not seem complete until it is documented. But this, of course, was not always the case.

Varela and I designed the exhibition to emphasize the urgency of his imagery.[7] *This Burning World* appropriated media images of the World Trade Center bombing, which occurred about a year prior to the opening of the exhibition. Viewers were forced to repeatedly look at the burning towers, as well as the other manifestations of the Taliban reactions to U.S. arrogance, such as the gruesome images of the decapitation of *Wall Street Journal* reporter Daniel Pearl. These were spliced with images of the Ku Klux Klan, Adolf Hitler, Nazi death camps, the assassination of John F. Kennedy, break-dancers, movie stars, religious icons, all changing at rapid-fire pace, permitting no time to rest the eyes, the mind, or the emotions. McBeath's sound track accentuated the tempo and exacerbated the discomfort caused by the images, yet another strategy conveying Varela's critique of our society's focus on violence and materialism. All of the imagery recalled events, many of which are buried in Americans' aggregated subconscious, products of the nation's obsession with "progress" and power. History repeats itself; overconsumption leads to destruction. Varela unearthed painful memories, asking us to mourn loss, to look back instead of forward, and to question the validity of certain goals and values. His confrontational footage challenged us to reassess our personal roles in our own histories and our own destinies.

The other three sculptures in the exhibit's first room functioned to create a transitional environment between the outside world and the space of *This Burning World*. *Detritus, the Remix* and *Night Walking* were each emitted from a 17-inch television set that sat on a shelf about 4.5 feet above the ground inside a white modernist pillar that was drilled with a pair of peepholes. The pillars prompted associations with X-rated peep shows and confessionals, but Varela has a more erudite source: Marcel Duchamp's *Étant donnés* (1946–66), the enigmatic environment to which Duchamp devoted himself during the final decades of his life.[8] The experience of these two works was a focused one compared to that of *This Burning World*, characterized by overwhelming scale and an overload of visual

information. *Business as Usual? Thoughts on the Events of September 11, 2001* most directly recreated a domestic television-viewing environment. The viewer sat at one end of a table strewn with ephemera documenting the World Trade Center destruction. The TV was perched at the other end, displaying visual documents of various cataclysmic events. In retrospect, I realize that *This Burning World* was the only true video installation in the exhibition because it effectively consumed the space and the viewer. The others were sculptures, and for these Varela drew upon the processes of the early video pioneers of the 1970s and 1980s, such as Nam June Paik and Vito Acconci, who acknowledged the television set and its objecthood.

Crossing Over was hosted by three other venues in Texas after closing at UTEP. When I approached the larger nationally known exhibition spaces accustomed to exhibiting video art and to allocating it theater-sized rooms about hosting the show, they were unable to fit it into their exhibition schedules. Of the venues that supported the exhibition, some of them decided, with Varela's permission, not to include the ephemera on the table of *Business as Usual?* While this exclusion may have benefited the piece aesthetically, it weakened it conceptually, because the newspaper and magazine clippings further emphasized the point that today's overabundance of media images has a negative impact on our collective consciousness and moral state. Some venues diminished the scale of the screens for *This Burning World*, and others did not allocate it a separate space, decisions that meant *This Burning World* did not achieve its full potential. To feel absorbed by the visual information was an important part of its point: consumerism is a pervasive and definitive force in contemporary culture, the screen its omnipotent and omnipresent champion.

Notes

1. Varela lived in San Francisco for two years in the late 1970s, but otherwise has been in El Paso.
2. Though El Paso is far from a center of artistic activity, Los Angeles being the closest at a day's drive away, the city's location is not the cause of Varela's identity as an outsider to the art world.
3. Quotation is from a May 2002 interview with the artist in El Paso, Texas, and appears in my *Crossing Over* exhibition essay (2002).
4. Chicano film scholar Chon Noriega credits Asco with being postmodern.
5. Quotation is from a May 2002 interview with the artist in El Paso, Texas, and appears in my *Crossing Over* exhibition essay (2002).

6. David Taylor, professor of photography at New Mexico State University in Las Cruces, agreed to supervise his graduate students in the master printing of 30-by-44-inch C prints from Varela's 35mm negatives. After Taylor's buy-in, William Thompson, then curator at the El Paso Museum of Art, agreed to be my cocurator for the exhibition. Our two institutions would share the exhibit, with photographs on view at the museum and video installations at UTEP.

7. Varela and I together advised a furniture maker in the creation of the pillars for *Detritus, the Remix* and *Night Walking*, the table for *Business as Usual? Thoughts on the Events of September 11, 2001*, and the temporary walls that would enclose *This Burning World*.

8. *Étant donnés*, now on view at the Philadelphia Museum of Art, can be visually accessed only through peepholes. The foreground is an odd landscape dominated by what looks to be a reclining nude female, legs splayed open. "I love the fact that you have to look through these little peep holes at this very sexually charged material . . . [the holes] only add to that sense of the forbidden," states Varela (Bonansinga 2002, 14–15). The viewer became voyeur.

Bibliography

Bonansinga, Kate. 2002. "Records of Desire: Four Video Installations by Willie Varela." In *Crossing Over: Photographs and New Video Installations by Willie Varela*. El Paso: El Paso Museum of Art, University of Texas at El Paso. Exhibition catalog.

Gaspar de Alba, Alicia. 1998. *Chicano Art Inside/Outside the Master's House: Cultural Politics and the CARA Exhibition*. Austin: University of Texas Press.

Varela, Willie. 1994. "Chicano Personal Cinema." *Jump Cut* 39 (June): 96–99.

Sense and Sensibilities

Discontinuing Conventions in/for Willie Varela's *Burning World*

Scott L. Baugh

This Burning World (2002)—a 30-minute, two-channel video art installation[1]—presents its viewers with a thematic and formal assault. It does not arrest those viewers, however. On the contrary, its nonlinear narrative, its highly suggestive and eclectic array of visual-aural imagery, its discursive dynamism all encourage in viewers a greater engagement than conventional texts: and that may be just the point! For viewers so beguiled by media entertainment that lulls them to sleep, *This Burning World* disrupts that slumber and awakens viewers to see a world on fire, a mediated world on fire.[2]

This Burning World, sometimes hyperbolically, alarms its viewers with a moment of reflection not only to contemplate the grisly truth that humanistic values bear far too little weight in our early-twenty-first-century world but also to recognize just how media forms and narrative structures play into this imbalance. *This Burning World*, as do the majority of Willie Varela's independent experimental videos and films, resists convention—convention deeply seated in mainstream American society as well as in popular cinema. That convention itself engenders its own forms of resistance may feed the struggle around *This Burning World* and our burning worlds. *This Burning World*'s political statement is one of art, as its artistic statement is one of politics. It clearly registers a claim on racial and ethnic social politics in globalized American cultures, and it does so in the larger context of equally crucial and provocative issues. Willie Varela has described himself as an artist who happens to be Chicano, a Chicano who

happens to make art, and one whose "fluid" identity cannot be prescribed or restrained adequately.[3] And as much as in any of his artwork, *This Burning World* resists similar external categorization. Perhaps the enigma of *This Burning World* is bound into the seeming comfort and convenience, the conventionality, of continuity.

Continuity in cinema draws parallel meanings from the linear flow of film through a projector and the placement of shots and scenes in narrative order to exhibit the "logic" of a story world. In spite of compressions and omissions, tricks on our eyes through manipulation of time and space, mainstream-style editing joins shots in order to appear seamless. Traditions of Hollywood and popular worldwide cinemas have valued "invisible" editing. That is, the most effective editing, in accordance with this classical paradigm, is that of which viewers remain unaware; one crucial result, viewers are at least partially unaware of the ways the camera and cutting control our interpretive responses, our emotions, and our identification with the imagery. Critics like Kaja Silverman point out that there's a kind of sleight of hand in this manner of art, particularly as the "machinery of enunciation" furtively attributes and assigns meaning to fictive-narrative qualities (1989, 232). As video art, *This Burning World* interrogates not only social and cinematic conventions but also, perhaps even more crucially, the values predominantly attached to them—and normalized by them—for all audiences on the widest possible range of issues. All the more abrupt because it does not announce itself as such, *This Burning World* flashes its viewers with moments of a kind of cinematic-linguistic code switching through its montage.[4] Varela's experimental aesthetics enact *un espejismo*, an optical illusion, that paradoxically both unites and disassociates sign from signifier and, like a pinprick, instantaneously exposes the process of reading for mainstream viewers. By performing careful orchestrations of nonlinear montage, compounded across two channels, *This Burning World* discontinues, if momentarily only, the "matching" of fictional events alongside their real-world counterparts to replace and recontextualize them in the viewers' imaginations.

* * *

Starting at 2 minutes and 43 seconds into the piece and running a little over 80 seconds, viewers see on the right side of the screen seventeen shots in succession, which may be technically described and organized into twelve meaningful segments, in order:

1. an underlit medium view of Varela's own shadowy silhouette, camera in hand and up to face, 2.5 seconds in duration;

2. cut to a black-and-white shot tracking left from ground level up into a tree canopy and the sky beyond, creating a tracer effect, 3.5 seconds in duration;

3. cut to an overhead shot of an eye operation, a close-up on the eyeball itself as a suture stitch strains the human tissue in one direction and a swab wipes blood in another, 5 seconds in duration;[5]

4. cut to repurposed video footage of the now well-known "falling man," 9.5 seconds in duration;[6]

5. cut to a long shot meandering through a wax museum, right pan past characters that include a Goomba and Mary Poppins, 5 seconds in duration;

6. cut to a quick shot of a statue's hand, then a shot of the face of that statue, revealing a representation of the Virgin Mary and then the camera tilts down the body of the statue to an adoring worshiper, 4 seconds total in duration;

7. cut to an oblique angle close-up of a blue-eyed, blonde-haired print model's face, light glaring garishly off one of her eyes, about 4 seconds in duration;

8. cut to nonrepresentational images, like static on a television screen or reminiscent of the horizontal graphic fields of a Mark Rothko painting, a little over 9 seconds in duration;

9. a quick, very wide shot of a bomb being exploded, then cutting to two shots, each about 1.5 seconds in duration, of a soldier leaping, falling, and then a detail of a gas-masked face, all three of these shots unified by green coloration reminiscent of a view through night vision goggles;

10. cut to a shaky close up of a human head, presumably male, hidden in shadows, about 1.5 seconds long;

11. cut to a traveling shot from inside the artist's car as it passes through a tunnel and into the light outside, about 7.5 seconds, and this dissolves to a medium shot that tilts up the body of a statue for about 5 seconds and then, for another 2 seconds, holds on the statue's head;

12. and, finally, a slow-motion close up of a human eye, a few jump cuts interrupting the action, and at times the camera lens blurring and diffusing the image into an array of colors and then tightening back into focus on the seeing and being-seen eyeball, 15 seconds in duration.

Mainstream viewers likely bring conventional expectations to their reading of this sequence and initially are frustrated as interpretive associations

across the twelve segments are difficult to prove. A few observations from
the technical descriptions above, however, may highlight some significant
patterns in *This Burning World*.

Across the seventeen shots in this sequence, only once does Varela use
a dissolve between shots instead of a cut. For the majority of these cuts,
each image remains distinct and disjointed from the contiguous images.
However, the two images of the Virgin Mary statue connect thematically
and create a momentary continuity, perhaps a miniature story contextual-
ized in religious iconography, and probably offering a pause of relief for
mainstream viewers struggling to interpret the sequence. But, for example,
does the tilting camera movement down the body of the statue somehow
align with the oblique angle on the print model's face, these three shots
representing, perhaps juxtaposing, identities of women? Similarly, the
three sequential shots with night vision technology coloration may con-
nect by formal effect and begin to reinforce themes across the battle foot-
age, even hinting at a political statement. That these three shots of battle
footage share these similarities leads mainstream readers to *want* to con-
nect them, perhaps even sensing "jump cuts" between them and trying
to fill in missing story information to help them make sense of the shots.[7]
It is precisely at these moments that *This Burning World* borrows from
mainstream continuity's logic, but it does so only to place greater attention
on the larger objectives of challenging that paradigm and interrupting the
conventionality that surrounds it. And the single dissolve in this 80-second
sequence offers a puzzle to mainstream viewers, its imagery from a driving
car is difficult to connect to the statue, even with the shots overlapping on
top of each other (as well as the synced image on the left channel at this
moment and the fullest range of context from the rest of the 30-minute
piece). It is clear that the objective here is not for the viewer to find any
singular and simple interpretations to this artwork but rather to pay closer
attention to its rich complexity.

As is often the case in *This Burning World*, the frenetic pace and com-
plex nature of one channel is balanced against a slower pace on the op-
posite side. Here, the right channel's seventeen shots are balanced against
six shots on the left channel over the 80-second sequence. These six shots
may be technically described and organized into four meaningful seg-
ments, in order:

1. repurposed and recolorized imagery from Jean-Luc Godard's *First
 Name: Carmen* (1983), where a long, high-angle shot of waves
 crashing on a beach serves as background for a superimposed title,

philosopher Blaise Pascal's claim that evil derives from our "inability to remain at rest in a room" scrolled across the center of the screen from right to left in small type, 26 seconds in duration;

2. three successive high-angle shots gradually moving into a coyote's carcass on the roadside: in full view, dollying left and up, 22.5 seconds in duration; close shot on the head, 6 seconds in duration; and a detail on the locked, snarling mouth, 5 seconds in duration;

3. *First Name: Carmen* quoted again, another wide shot of waves crashing against rocks, this time polarized and with a title scroll quoting poet W. B. Yeats's demand that we begin to live "when we conceive life as tragedy," 9.5 seconds in duration;

4. and, finally, running a little over 38 seconds in total, a split screen of nine simultaneous images from a home movie of the artist's daughter playing, jumping in the air, and spinning, her smiling face accentuated by the size, angle, and slow motion of the shot.

The complications of interpreting this text grow as the two channels are considered in sync with each other. For example, the right-pan movement in the right channel's wax museum may act like a matching cut with the counterclockwise dolly around the left channel's coyote carcass; or, as the left channel's cut to the coyote's snarling teeth follows immediately the right channel's cut from adoring worshiper to print model, the potential juxtapositions among these three images are punctuated; and the right channel's battle footage syncs with Yeats's life and tragedy claim on the left. So amplifying questions about conventional expectations, how the two channels dialogue with each other can be considered also for fuller explanations.

<p style="text-align:center">*　　*　　*</p>

In this 80-second two-channel sequence, viewers are likely to find analyzing the visual-aural montage, the continuity—or, rather, precisely discontinuity—of even one of the channels as cumbersome and cryptic as they found deciphering the numbered segments lists of this essay; grammatical devices in the verbal discourse, like semicolons above, probably riddle the transitions among syntactical parts and connections among their ideas as much as cuts and dissolves might in cinematic discourse. Viewers may closely read the cinematic discourse and attempt to draw inferences on the basis of the long-instilled "logic" of narrative continuity proffered by most cinematic texts—Hollywood feature films, documentaries, practically all broadcast and television coverage, even most video and digital video "art" texts—and, as a result, this logic serves as the basis of our mainstream

viewership expectations. In *This Burning World*, however, we are likely left with more questions and uncertainty than with the immediacy of any answers or comfort, but we may also be left with a heightened awareness of the images as images.

The filmmaker's own appearance offers a presence, but does that suggest more than a personal attachment to the art? Does traditionally Catholic imagery reflect on the artist's familial background and its conscription in Chicano cultural expression? Might images of fashion models be interpreted fairly as a statement on our consumer culture and the means of advertisement, perhaps as a critique of the human objectification involved in these processes? Do the ghastly images of the roadkill somehow connect with the graphic depictions of the eyeball surgery, similar in their technical and material emphasis on animal bodies? Might the home movie convey a beauty of innocence and youth that somehow connects back to the nature imagery and reminds us of a general precept, beauty in nature? And might that innocent, youthful beauty, striking in its personal and familial connection back to the artist, conflict with the material, sensual superficiality of the fashion model? Do the military and political images somehow connect? Does the historical material on wars somehow connect with 9/11 media coverage? Wax-mummified Mary Poppins and Goomba?! Our interpretive attempts may hit roadblocks or meander.

There may be hints here, though. For instance, inclusion of the "falling man" imagery, which Varela utilized merely months after the terrorist attacks, foretells of the controversies that would surround this single image over years to follow and of the legacy of 9/11. Both separated and joined by the cut in the right channel, this "falling man" image aligns with the recurring image of the eye operation, both of which sync with Pascal's claim in the left channel that may be understood as an urging for contemplation and attunement. The eye operation image quite literally presents viewers with the cinematic representation of a suture—a medical procedure of stitching to hold disconnected tissue together. The suture has been used as a trope in film theory since the mid-1960s to help explain, as Jacques-Alain Miller describes, the means by which subjects emerge within discourses as well as the relation of those subjects to the *logical chain* of segments of meaning in the subjects' discourse ([1966] 1977, xx).[8] The eye surgery imagery in *This Burning World* perhaps delivers the punch line of a joke on mainstream style; yet the self-reflexive tone is unsettling or haunting and not humorous. The eyeball imagery, as repurposed cinematic text in *This Burning World*, reveals the magician's trick to the captivated audience:

it explains the prestige, it acts out the legerdemain, and it even literally shows the trompe l'oeil by which mainstream aesthetics so frequently have left viewers fooled and truth disguised.[9]

* * *

We viewers draw relatively simple kinds of inferences in movies and television shows, and we should be doing so closely and carefully; however, more often mainstream texts tend to rely on hackneyed associations and simple conventions to represent reality and to draw us into certain interpretations. The visual pun of *Burning World*'s eye suture remains self-aware as it acts and reenacts cinema's communication and symbolism. And perhaps this is only amplified by the verisimilitude of the nonfiction footage as it is repurposed in a *Burning World* art installation.

Mainstream viewers read audio and visual information, see shot after shot seamlessly edited together in classical style, and can imagine typically an artificial story world, characters moving in a place and time, and the meanings that arise from the way those images are conveyed. Too often, simple stories and their simple lessons are simply absorbed by their viewers. No doubt the familiarity and reliability of convention has good in it; after all, there's safety and security in knowing that other drivers will heed their turn at an intersection, and there's no small comfort in sharing certain social customs and cultural traditions. But in overrelying on convention, readers may lose grasp of the importance and meaning of the values that are being, and not being, conveyed: they may lull into a dull torpor, a somnambulant trance. Willie Varela's experimental art resists conventionality. Perhaps what *This Burning World* does best is that it shakes its viewers back awake, alarms viewers into paying attention, alerts viewers to the manner in which images can recreate our understanding of the world, and reminds viewers that resistant imagery can carry certain sensibilities that we as human beings use to understand ourselves and our world around us.

There are no easy or simple interpretations of *This Burning World*—or of this burning world, for that matter. And *This Burning World* likely does not present that much of a challenge to the monolith that is commercial cinema and all of the surrounding conventions, but it does leave a mainstream viewer more aware of the conventions that dominate the world and mainstream media. Willie Varela's art does discontinue the notion, though, that conventional aesthetics should ever simplify the social complexities of the world in which we live: we should always try to see things as they are and let those things inform our sensibilities.

Notes

1. Willie Varela's *Crossing Over* exhibit configures *This Burning World* alongside three other videos and a collection of eighteen photographs. See Kate Bonansinga's neighboring chapter for a curatorial discussion of these pieces. *This Burning World* is included in the collection, *Video Art by Willie Varela* (2013), distributed by the Chicano Studies Research Center of the University of California, Los Angeles.

2. It is tempting to draw a comparison to the landmark German Expressionist film *The Cabinet of Dr. Caligari* ([1919] 1920), in which a carnival performer hypnotizes a somnambulist into murdering their neighbors. Its experimental style draws particular attention to the ideological values and themes of authoritarianism and individual responsibility and has been widely discussed as an allegory for Weimar Germany.

3. Willie Varela has mentioned this in several conversations over the last decade, and he has made this statement publicly in interviews. Please see my discussion of the artist in *Latino American Cinema* (2012) as well as his "Chicano Personal Cinema" essay (1994).

4. Code switching can most effectively be defined as a literary concept in which one discourse combines two or more language varieties while maintaining original aspects of syntax, vocabulary, and sound. Code switching is more complex than simply borrowing from one language for another in that it requires its readers to remain fluent in both original languages while also establishing a new multilingual mix and speech practice in the conversation. I am here using the linguistic basis of code switching to suggest that a similar mix can occur across languages and discourses.

5. *This Burning World* includes the nonfiction footage of the surgery, taken from a science-related television program, as a reference not unlike a quotation in an essay. It is distinct from other repurposed footage in that it is not altered in any perceivable way, whereas other borrowed material is manipulated, sometimes obtrusively, through editing effects, overlays in multiple exposures, color variances, and other techniques. Although in conversation Willie Varela denied that the eyeball and surgery imagery alludes to any single source, it is again tempting to draw a comparison to the landmark Surrealist film *Un Chien Andalou* ([1929] 1960) and its disturbing "cut" twelve shots after the opening title card, *"il était une fois . . ."* (once upon a time . . .).

6. *This Burning World* repurposes footage from *9/11: The Falling Man* (2006), an 80-minute documentary directed by Henry Singer about the images that surrounded the news reports of the September 11, 2001, attacks on the World Trade Center in New York City. Emphasis is on one still image by Associated Press photographer Richard Drew, which has seen its fair share of controversy.

7. A "jump cut" refers to a relatively small portion of a narrative sequence that interrupts the sequence's continuity and matching shots across the story time, place, and action. The film editing convention known as the "30-degree rule," in fact, prohibits the camera from varying its placement as a point of reference in a scene, in order to maintain consistency and convenience for viewers.

8. In addition to Miller and Silverman, readers interested in "suture" or "the system of the suture" as a cinematic concept may read Stephen Heath's *Questions of Cinema* (1981) as well as landmark articles by Jean-Pierre Oudart ([1969] 1978), Daniel Dayan (1974), and William Rothman (1975).

9. French *léger de main* translates to English "light of the hands," as in sleight of hand, but it suggests, too, the quick-handed work of a pickpocket thief. *Trompe l'oeil* translates to "fools the eye."

Bibliography

Baugh, Scott L. 2012. *Latino American Cinema*. Santa Barbara, CA: Greenwood.

The Cabinet of Dr. Caligari. [1919] 1920. Directed by Robert Wiene. Kino on Video.

Un Chien Andalou. [1929] 1960. Directed by Luis Buñuel. Transflux Films.

Dayan, Daniel. 1974. "The Tutor-Code of Classical Cinema." *Film Quarterly* 23, no. 1: 22–31.

Drew, Richard. 2001. "The Falling Man" (Associated Press photograph). *New York Times*, Sept. 12, A7.

First Name: Carmen. 1983. Directed by Jean-Luc Godard. International Spectrafilm.

Heath, Stephen. 1981. *Questions of Cinema*. Bloomington: Indiana University Press.

Miller, Jacques-Alain. [1966] 1977. "Suture (Elements of the Logic of the Signifier)." *Screen* 18, no. 4: 24–34.

9/11: The Falling Man. 2006. Directed by Henry Singer. Darlow Smithson Productions.

Oudart, Jean-Pierre. "Cinema and Suture." [1969] 1978. Translated by Kari Hanet. *Screen* 18, no. 4: 35–47.

Rothman, William. 1975. "Against 'The System of the Suture.'" *Film Quarterly* 29, no. 1: 45–50.

Silverman, Kaja. 1989. *The Subject of Semiotics*. New York: Oxford University Press.

Varela, Willie. 1994. "Chicano Personal Cinema." *Jump Cut* 39 (June): 96–99.

Video Art by Willie Varela. 2013. Directed by Willie Varela. Produced by Mike Stone. Chicano Studies Research Center, University of California, Los Angeles.

Tracking the Monster

Thoughts on *Señorita Extraviada*

Lourdes Portillo

The film *Señorita Extraviada* (2001) was made with the intention of shedding light on the murders of women in Ciudad Juárez, Mexico. What I did not know was that it would take me on a journey unlike any I had been on before.

Over a twelve-year period prior to my arrival, approximately five hundred young women were systematically murdered, many the victims of perverse sex crimes, in Ciudad Juárez, which is just across the border from El Paso, Texas.

By the time I arrived in 1998, the population was terrified and silenced. Word of the spectacular murders had slowly leaked to the press. The way lurid pictures of the girls' dismembered bodies were published only added to the brutality of their murders. The girls became disposable objects of voyeuristic curiosity, not human beings deprived of their young lives.

Their deaths had remained no more than statistics for the press for nearly ten years. But the increasing number of murders was devastating to the community: for the victims' families, these girls were their loved ones, whose deaths caused unending grief. The media treated the deaths as something mysterious—the work of a serial killer, organ thieves, or a cult engaged in satanic sacrifices—a source of endless speculation.

In Juárez, I found a deafening wall of silence raised by everyone, from leaders of women's organizations to common citizens; all were too terrorized to speak out. Even the authorities, when questioned, gave only confused responses. Which gave me nothing to grab onto. There was no

Figure 32.1. Behind the scenes of *Señorita Extraviada* (2001, in Spanish and English with English subtitles, color Super 16mm film and digital video, 74 min.), produced, written, directed, and narrated by Lourdes Portillo. Director Lourdes Portillo and cinematographer Kyle Kibbe among the crew on location to film *Señorita Extraviada*. The experimental documentary reports on the hundreds of young women kidnapped, raped, and murdered in and around Ciudad Juárez, Mexico, since 1993. (Photograph courtesy of the artist and Xochitl Films.)

way to make a documentary in which any approximation of journalistic objectivity could be claimed.

The monster had no head or tail.

* * *

A small human rights group, Comité Independiente de Chihuahua Pro-Defensa de Derechos Humanos (CICH), invited us to a *rastreo*, a search in the desert for the bodies of women. It was there, during that first search in the enormous desert, that we met several members of the victims' families. They were to become the protagonists of *Señorita Extraviada*. They spoke eloquently about their experiences and their suspicions. In that afternoon, I saw a harrowing panorama of what might actually be taking place. A picture emerged, carefully painted by the testimonies of those same people who suffered through the ordeals. My world was shaken to its core.

Figure 32.2. From the making of *Señorita Extraviada* (2001). A surviving
mother being filmed for an interview segment in Lourdes Portillo's experimental
documentary. The mystery of the disappearances and murders proves confound-
ing, given the layers of complexity and complicity involved. Portillo and her
crew reveal the most reliable sources of information, direct testimonies from the
family members of the missing young women. (Photograph courtesy of the artist
and Xochitl Films.)

The fear experienced by the people of Juárez became part of my own
daily life for the next four years. I continued to seek out the victims' rela-
tives, the same ones I had met in the desert.

One of them was Eva Arce, who, with her limited resources, followed
the trail of her daughter's murder as only a mother could. She discovered
information that neither the authorities nor the media had acknowledged.
She recorded it in a series of humble little notebooks, convinced that
someday these notes would help justice prevail.

Another was María Talamantez, who not only was repeatedly raped in
the police station but also was shown an album of photographs of the girls
as they were being murdered. She is a brave and righteous woman whose
testimony helped bring pieces of the puzzle together.

Irene Blanco, a dignified and intelligent member of the upper class,
fought for justice and nearly paid with the life of her son. She became a
ringing voice in that desert of silence.

Figure 32.3. From *Señorita Extraviada* (2001). Felipe Nava holds a picture of his missing daughter, María Isabel Nava. The documentary, visually poetic yet probing in its investigation, relates personal stories that resonate with complex political issues. (Photograph courtesy of the artist and Xochitl Films.)

These were the stories that spoke to me and became the heart of my film. These voices were the most important because they rang true and demanded justice. This was the beginning of the journey of making the film, during which we uncovered an endless web of complicity by the government, the police force, and the powerful, many of them members of the wealthiest families in Juárez.

* * *

Figure 32.4. From *Señorita Extraviada* (2001). A *rastreo*, a search party of family and friends, tracking for the missing body of María Isabel Nava. (Photograph courtesy of the artist and Xochitl Films.)

For the film we made a decision to show the "living" girls rather than the mutilated bodies that had been lasciviously photographed and published. Through this strategy, the film touches viewers, who feel compassion for the young women. Once the film was finished, it received international attention because the girls were humanized for the first time. Up to that moment they had been just numbers or "poor brown women," not human beings who deserved action and justice on their behalf. The film put a face on their suffering. It takes a strong stance. It is not objective journalism. It evokes compassion and demands action.

Meanwhile, in Juárez, groups of activists were being infiltrated, and many were lured with money or threatened with death to drop their advocacy efforts. I therefore decided to travel with the film and to speak out about what was happening. The murders continued flagrantly, and in November 2001, eight bodies were found in one place, a shocking occurrence even in Ciudad Juárez. It was a message, but to whom? And from whom?

* * *

I traveled endlessly—to Italy, Greece, Norway, Canada, Spain, and other countries—to get the word out and to gather signatures and letters directed

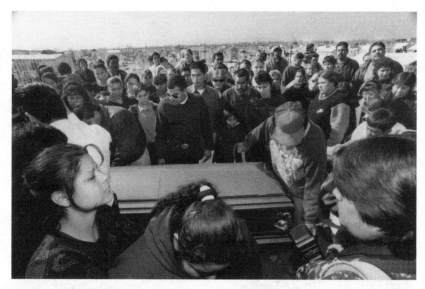

Figure 32.5. From *Señorita Extraviada* (2001). A gathering at the cemetery, burying María Isabel Nava. (Photograph courtesy of the artist and Xochitl Films.)

to both President Vicente Fox and President George W. Bush, then in office. In many countries I spoke to influential journalists who have taken it upon themselves to carry the banner for justice in Ciudad Juárez. No foundations were willing to support this human rights crusade, so I refinanced my house in order to take a year off to do this work.

In San Antonio, Texas, I met up with a friend, Mexican filmmaker María Novaro. We decided that *Señorita Extraviada* needed to be shown in Mexico. Maria set out to organize screenings and returned to Mexico with a single VHS cassette. She organized many screenings in Mexico City.

Pirated copies of the film were produced and disseminated, and for the first time people were mobilized to action. There was an outdoor screening in the plaza in Coyoacán, a suburb of Mexico City, with two thousand people in attendance. No one had heard the details of what had been occurring in the northern state of Chihuahua. Following the screening, Elena Poniatowska and Carlos Monsiváis, leading intellectuals of Mexico, initiated a discussion about the murders that galvanized many to action. The women of Juárez became a cause as Mexican women's groups and human rights groups started organizing around the issue. In December 2002, ten thousand people marched to the Zócalo in the heart of Mexico

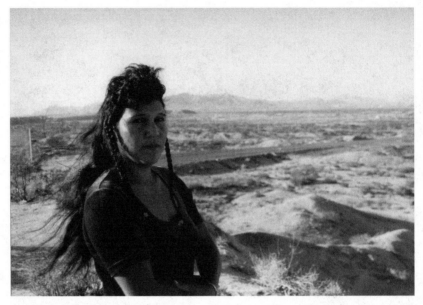

Figure 32.6. From *Señorita Extraviada* (2001). One survivor, María Talamantez, stands on the desertscape outside Ciudad Juárez. Her story emphasizes the potential for institutional corruption and vast complicity in the unresolved mystery. (Photograph courtesy of the artist and Xochitl Films.)

City, where the National Palace is located. The marchers demanded that President Fox order a federal investigation into the murders.

Earlier that year, Marta Lamas, a noted writer, handed the film to the president's wife, Marta Sahugún; Lamas commented that after seeing it, Sahugún was indignant. Yet throughout his term of office, President Fox considered these murders to be strictly the state of Chihuahua's problem. Why? How many young women must be murdered for the federal government of Mexico to take a stand? It has recently been reported that various levels of government and organized crime are implicated in the killings.

Today, the culprits are becoming more sophisticated in covering up the crimes. The authorities have been briefed by public relations firms and now know how to answer journalists' questions without giving out any information. What is behind these crimes? Who has that much power?

During his time in office, President Felipe Calderón, Fox's successor, waged a war on the drug cartels that left thousands of men and women dead and a population that was terrorized by the violence on the part of the cartels and, more poignantly, on the part of the authorities and the

Mexican army. Women continued and continue to be the victims of all of them. If only Mexico and the world had seen the serial murders of women as a sign of a more malignant era coming, one that is intrinsically tied to corruption and narcotics trafficking. What might have been if only the authorities had acknowledged such obvious signs?

<p style="text-align:center">* * *</p>

Young women continue to disappear, and dead bodies are still found strewn in the desert. Nowadays, no one reports their disappearances. Mothers continue to seek justice in a state where the government is deaf to their demands. The international human rights community must take a stand and demand an international investigation to put a stop to these crimes.

Beyond this immediate tragedy are its implications for the world's poor. As national economies become globalized, the poorest workers are systematically gathered in one place—the factory—and remain unprotected from commercial interests by their own governments.

The factories where they work, the maquiladoras, have become the new "killing fields." They offer open doors for globalized crime, where impunity for killers is the order of the day. At this level of globalization, one's worth is measured in dollars and cents. In a world where wars are waged for oil and life and human rights are devalued, it is not unthinkable that girls are used as disposable objects of perverse sex killings. A woman's murder is a nonevent today in a culture where women have been historically devalued.

In 2003, Judge Baltazar Gaston invited me to the Universidad Complutense in Madrid, where I was to show my film. There I had the pleasure of meeting Dr. Rita Segato, an intelligent and dedicated Argentine anthropologist and human rights activist. Our conversations based on her research on mafia organizations suggested to me that indeed the ritual killings of women were directly connected to the mafias of men vying for power within the flourishing organized crime structures of Mexico. Rita explained to me how the ritual murder of women can be used as a fetish for further power.

There is no doubt in my mind, based on the recurrent similarities in the girls' disappearances and the marks on their corpses, that their murders have been part of brutal rituals. Meanwhile, the government, by never seriously investigating and, therefore, allowing the murderers to go unpunished, remains complicit in the continuation of the murders. The murdered girls were the canaries in the mine: they foretold what was to come, and the Mexican authorities did not heed the signs. Throughout the early years of the twenty-first century, there has been talk of Mexico being on

the brink of collapse because of the organized crime cartels and their wars for power. Violence is out of control, and now there is no one to stop it.

In our time, we have seen the artist and the media become tools of the great corporations, used to further the marketing of goods. As independent artistic visions wither, it is all the more critical that film become an activist tool, bearing witness to effect change.

<p style="text-align:center">* * *</p>

The journey that *Señorita Extraviada* took me on was unexpected and terrifying. The outpouring of feeling and compassion from audiences made me accept the challenge of becoming a human rights worker as I traveled with the film from place to place. The nerve it touched in people was also a burden. I lived in a dark world, a place of suffering and pain, but one I felt obliged to inhabit. And yet *Señorita Extraviada* only approximates this dark world and helps viewers to recognize and appreciate the suffering and pain of the victims and their families.

The art of film can be used in the service of the unprotected, and the documentary film can take a stance to inform, activate, and promote understanding and compassion. Our task was and is to communicate *heart to heart*. Our task is to join our forces to put an end to the violence and brutality perpetrated on the innocent. To track the monster. To sound out for those without a voice!

My hope has been that *Señorita Extraviada* would inform its audiences and propel them to just actions. This documentary film has fulfilled that promise. I believe that *Señorita Extraviada* has made a profound impact in bringing the stories of these young women and their families—not to mention the global escalation of femicide—to the attention of many and inciting progress toward social justice and human rights. Of course I was not alone in my journey. The success of *Señorita Extraviada* was made possible by the efforts of many. I gratefully acknowledge the loyalty, commitment, and artistry of the crew who worked on the film. The production was a collaborative effort between the activists, the subjects of the film, the crew members, and the foundations and funders who supported the project. The independent film community was crucial in its support for and funding of the film. It was all these forces working together that gave *Señorita Extraviada* life.

Between Anger and Love

The Presence of *Señorita Extraviada*

Bienvenida Matías

Shoes. New ones, old ones. Some in a store window, others as evidence in a desert crime scene. Lourdes Portillo's film speaks on behalf of all women invisible to society.

Every time I view *Señorita Extraviada* (2001) I feel an incredible anger at how society has deemed poor working-class women to be expendable, not worthy of comprehensive investigations in their disappearances or deaths. We are made invisible when we are perceived as not well educated, coming from marginalized communities, not being part of the middle class. Not worthy of a proper funeral. Not worthy of having our family and loved ones know where and how we ended up. This is such a different treatment from that given to middle- or upper-class white women who have disappeared under mysterious circumstances.[1]

My anger builds slowly as I watch the documentary. Many times I have played it for my documentary cinema and production students, mostly young twenty-somethings and many women of color. As I watch their faces take in the litany of potential killers—the Egyptian, the Rebel gang, the bus drivers' gang, a lone American citizen who crosses the border, the police, and the seemingly never ending list of rapists and murderers—I wonder how many women in my classes have been raped. How many did not go to the police for fear of being accused of being a tease, of having asked for it, of leading men on. Or they don't tell their families for fear of being branded unclean, of bringing shame and dishonor to themselves and their loved ones. To whom can they turn?

That is where my appreciation for Lourdes grows. For she is giving voice to the women of Juárez and by extension to all women who have suffered rape or other forms of sexual abuse. Lourdes makes us look at the

263

faces of these young women. She holds her camera on their faces. With these images she tells us, "That could be your picture, the picture of your sister, or the picture of your friend."

This point is not lost in our working-class communities. It's not just a problem in cities around the world, like Juárez, that attract young women to jobs where long hours and burnout at an early age are the norm. I know women in urban settings like New York or rural communities in Minnesota who are out of the house early in order to get to work or who come home late at night. Yes, it's not just in Juárez. Maybe we don't have—no, better yet, we have not identified—as many disappeared young women as in Juárez, but similar crimes are being committed in our own backyards. I now also think of the young women in India and in other countries: they can be raped, strangled, or burned. They are also invisible, also expendable. Their crime was to go to the movies, take a bus home, or, worse, want an education.

Shoes. Some new objects in a window display, some evidence in the desert. Lourdes keeps going back to these images. They speak of the precarious presence we have in this material world. My niece once said, "Titi, all I have is the clothes I wear. That's how the world sees me." She did not have to go on. I knew that as an eighteen-year-old working-class woman she felt she did not have much to contribute to the world. She could carry her belongings in one suitcase. Studying, getting a college degree was a difficult task that would take her years to accomplish. In the meantime, it was about the clothes, nothing outrageous, just simple T-shirts, pants, and shoes that showed her as a smart, strong woman dealing with problems far too intricate for her young years. The clothes make the woman, the clothes identify the body. Or so we think.

The clothes, the shoes, the hair ties. All can be bought by many young women in different stores. Same goods. Maybe worn differently to project your own personality onto the mass-produced garment. Again the anger comes up. Would I be able to identify my niece's clothes from a pile of similar working-girl outfits? How did the parents of the women in Juárez do it? Was it the scent of their daughter's soap, which even the desert can't take away? Was it a tiny coffee stain on a blouse? Or was it that deep parental love that causes you always to know who is your child?

Lourdes gives dignity to the parents. They are strong, for they have worked hard to have a few possessions. This is not a sentimental look at the working class: oh, see how noble they (we) are! It's about people who have suffered a deep loss.

In her own words, Lourdes "works to create a feeling of love for the girls" (Torres 2004, 71). I would go further: she works to create a feeling of love for the parents, the family, the community, and by extension us, her audience. With Lourdes's film, we understand our own marginalization even without having to put it into words.

Somewhere in between the love and anger, I try to find some meaning. The shoes are part of the imagery in *Señorita Extraviada* that reveal a certain presence for the women who have been "made invisible," who have been "disappeared."

As an accomplished film artist who has produced and directed independent projects and someone who has served on a number of film and media boards, I have a special appreciation for Lourdes and her work. At the 2005 national conference of the National Association of Latino Independent Producers (NALIP), of which I was the cochair, we honored Lourdes with the Lifetime Achievement in Producing Award. Many of the conference participants were thrilled to meet her and to hear her talk about her work. In an article on the event, Victor Payan described the filmmakers in the audience as "rebels like *Señorita Extraviada* director Lourdes Portillo, who was received by conference-goers like the grand dame she is" (2005). I remember walking into the room where Eugene Hernández, editor of *Indiewire*, had led the conversation with her. At the end of the session, the young women were around Lourdes not wanting to let her go, wanting to hear more about how she crafted her films, to learn about how she continued to work.

I did not see a rebel. I saw a woman who had staked out her territory, a filmmaker who had carved out a career in a difficult world. Films about Latinas—whether they are mothers of disappeared children (*Las Madres: The Mothers of Plaza de Mayo*), a famous singer and her fans (*Corpus: A Home Movie for Selena*), or a young immigrant coming to terms with the connection between her new and old lives (*Después del Terremoto/After the Earthquake*)—are never an easy sell.[2] It goes back to the shoes. It goes back to how we are perceived.

It has never been easy becoming a filmmaker, but for women of color the challenge was greater. To walk into a white man's world, particularly when Lourdes started, meant needing to be very sure of what you wanted or needed to say in your work. This is not to be confused with self-confidence. This is about what propels you to create, what pushes you to find money for a documentary, what is so deep inside you that if you don't get it out, you might burst or go crazy. Or get angry. I don't see it as being

a rebel. I see it as finding your voice. Giving your voice as a filmmaker to others who don't have it. And that's easier said than done.

I don't know Lourdes personally. I don't know her family story or her background. I do know her from her work, though, through which she speaks to me. She speaks to many young filmmakers. They are drawn to her work because they see/hear a strong voice that pushed back labels. They see a strong hand that shaped a narrative that says, "You are important, even if people don't want to remember your name." The images of the young women of Juárez are connected to the images the mothers in Argentina carry as reminders of their missing children. Lourdes's work is woman centered; it's about family, community, and survival. She celebrates our lives. As she walks, she leaves deep tracks that many filmmakers follow, and she invites audience members to rethink how they, and we all, look at our young women.

Notes

1. Two recent examples come to mind—an intern in Washington, DC, and a student on vacation in the Caribbean—where it seems no expense is spared in tracking down the potential killer. The skeletal remains of Chandra Levy, an Ohioan working as an intern for the Federal Bureau of Prisons, were discovered in a park in northwest Washington, DC, in May 2002, concluding a thirteen-month search, according to a CNN online report (2002) in which a headline emphasizes how "time is excruciating pain" while a loved one is missing. Natalee Holloway, a student from Alabama, was declared legally dead in January 2012 after her disappearance in Aruba in May 2005. According to CBS (Preschel 2009) and other television reports at the time, hundreds of volunteers, FBI agents, members of the Dutch military, and even specially trained divers all participated in the search for the body, which lasted more than two years.

2. Lourdes Portillo has written, directed, and produced artwork that has focused, as she states, "on the search for Latino identity" (2012). Her work is richly varied—across film and video, encompassing both documentary and satire, narrative and collage.

Bibliography

CNN. 2002. "Chandra's Mom: 'Time Is Excruciating Pain.'" May 1. Accessed Mar. 22, 2009. http://edition.cnn.com/2002/US/04/30/chandra.levy/index.html.

Corpus: A Home Movie for Selena. 1999. Directed by Lourdes Portillo. Women Make Movies.

Después del Terremoto/After the Earthquake. 1979. Directed by Lourdes Portillo. Women Make Movies.

Las Madres: The Mothers of Plaza de Mayo. 1986. Directed by Susana Muñoz and Lourdes Portillo. First Run Features.

Payan, Víctor. 2005. "Independent Latino Filmmakers Invade Surf City." *OC Weekly*, Mar. 10. Accessed Mar. 22, 2009. http://www.ocweekly.com/2005–03–10/film/now -with-less-edward-james-olmos.

Portillo, Lourdes. 2012. Artist's website. Accessed Oct. 10, 2012. http://www.lourdes portillo.com.

Preschel, Jill. 2009. "Aruba Divers Find Nothing." CBS News, Feb. 11. Accessed Mar. 22, 2009. http://www.cbsnews.com/news/aruba-divers-find-nothing/.

Señorita Extraviada. 2001. Directed by Lourdes Portillo. Women Make Movies– Balcony Releasing.

Torres, Hector A. 2004. "A Conversation with Lourdes Portillo." *Film & History* 34, no. 1: 66–72.

The Eye of Pain/El Ojo del Dolor

Claire Joysmith

In *Señorita Extraviada*, the volcanic force of truth and pain is documented through a highly compassionate gaze, a precise camera eye. The events and circumstances documented from real life were mainly unknown at the time *Señorita Extraviada* was made and first released. Or they were known as isolated fragments, often "safely" removed because of their geographical and cultural distance from Mexican and international realities beyond the northern border zone. In recent years this has changed—exponentially and kaleidoscopically—as the eyes of many now gaze on the hard facts regarding the Ciudad Juárez femicides and feminicide per se.[1]

In *Señorita Extraviada*, the conscious political intention (the term understood in the most generous sense) of the testimonial act of documenting brings into play a wide emotional scope and depth achieved through the subtleties of Chicana filmmaker Lourdes Portillo's considerable expertise. Holding both camera and heart in hand, she addresses—like fire branded on the density of air—the spectator's core vulnerability. The mastery of the invisible sutures makes this documentary film as implacable as it is impeccable. It is a brittle cactus needle piercing the heart: an individual heart, to be sure, yet also, and necessarily so, a collective one.

Señorita Extraviada—a title that wears its irony well—is, in fact, an ode to vulnerability. It is also, paradoxically enough, an ode to human rage gone berserk. It is an ode to hurting hate, kindled by a quivering vulnerability identified in female Otherness and its elusive innocence, the pristine presence of which unleashes irrational fury: an uncontained volcano that erupts, perverse, surfacing as flowering fire.

A persistent irony is that this precarious vulnerability, this ephemeral innocence, lays bare truths under other layered truths, undressing pain, revealing an unbounded, borderless emptiness. And the terrible-sad refuge desire rises, against all reason, to observe itself reflected in female Otherness by reproducing pain, through an addiction to self-consuming insatiability. That is, to perversely experience being violated by wounding the elusiveness of purity, using the hardest available weapon against the self, against a female Other: lost in violence, sadism, watching red running in the mind's eye (open, closed, by day, by night), the aggressor is no more. And dies thus: drop by drop, facing the victim, facing a self-reflection.

Lourdes Portillo's *Señorita Extraviada* is a *mater dolorosa* that holds the corpus of human insanity of all times in a maternal embrace.[2] In this sense the film is also an ode to the compassionate gaze toward female Otherness—directed with impeccable sensibility and a technical caliber that a documentary film such as this demands. As mater dolorosa, the film recognizes these women as marked by gender and by violence: as women born without original sin, yet without an intervening Virgen to protect them.

For this very reason, *Señorita Extraviada* is also a poem to solidarity, birthed by anger, the same anger—although self-censured in many cases—that also arises and overflows in spectators who feel into these stories, who know there are so many others, untold, all of them about lives prematurely cut short: the silence that lurks on lips, that the mind cannot easily quell. Who but an activist-filmmaker-artist committed to portraying unspeakable truths, those that howl in the dark to "be," to be released; who else but a politically engaged Chicana, her anguish intervening, a wounded healer with a cactus needle piercing her heart, would dare gaze where other angels fear to tread?

It is quite clear that only a Chicana endlessly crossing multiple borders, fully engaged and pained by the knowledge of being a witness—camera in hand—would allow herself to be willingly harassed by the images, by the excruciating experiences, of women who make a daily living by the morning- and night-shift sweat of their brows. Only a Chicana witnessing the way these women live, half live, die—in the very same northern Mexico motherland that birthed her—could create a film such as *Señorita Extraviada*, destined to be shared with many others.

And so the umbilical cord of this northern Mexico motherland is stretched to its limits—never quite severed—leaving it to hurt and bleed when it reaches those setting forth on a life quest toward the north, El Norte: the abundant use-and-discard USA culture that assumes the guise of José Guadalupe Posada's *La Calavera Catrina* (the depicted incarnation

of laughing Death, wearing a festive flowered hat), which exacts the lives of so many Mexicans, steals their children and mothers alike, in exchange for slices of hope. Only a Chicana familiar with a cactus needle piercing her heart—without ever being able to extract it, since that would exact her own lifeblood—and who has felt what it means to live on the razor's edge of multiple borders, would be willing to cross borders of repeated rubber-stamped pain, surrendering herself entirely to creating this polyvocal offering for us as spectators. Always with the wise aid of her trade.

Señorita Extraviada is a testimonio poem,[3] pristine and political, that renders with honesty and compassion human pain at breaking point, that which destroys itself/Others, suffering boundless and repeated agony—whether as victim or aggressor (in Spanish the grammatical gender of *la víctima* as female and *el agresor* as male is scarily appropriate)—since both are in some ways interchangeable mirror images.

As spectators, we find ourselves face-to-face with multiple *"heridas abiertas,"* unmeasurably painful multiple wounds, for which Chicana writer and cultural philosopher Gloria Anzaldúa's proposal may prove a grounded and healthy reminder: "there is never any resolution, just the process of healing" (2005, 100). The continued nature of this process favors political, creative, compassionate, tangible, and spiritual forms of activism, for which Lourdes Portillo's opus provides both the seed and the fertile soil—in addition to an inspired and inspiring continuity of each unique healing process.

* * *

En *Señorita Extraviada* la fuerza volcánica de la verdad y del dolor queda documentada por una mirada en exceso compasiva y doliente, de oficio cuidado, exacto. Los eventos y las circunstancias de la vida real que se documentan resultaban en aquel entonces desconocidos. O conocidos únicamente de manera fragmentada, a menudo percibidos como lo suficientemente lejanos y ajenos como para no producir sobresalto alguno, debido a la distancia geográfica y cultural de las zonas fronterizas del resto del país y del extranjero.

Es únicamente en años recientes que el giro de la mirada ha llegado a posarse con mayor detenimiento—exponencial y caleidoscópicamente—en los hechos y números duros relacionados con los feminicidios en Ciudad Juárez y con el feminicidio mismo.[4]

En *Señorita Extraviada* la intención política consciente (en el más amplio y generoso sentido de este término) de la documentación testimonial misma conlleva una gran gama y carga emotiva lograda mediante las sutilezas de oficio de la cineasta chicana Lourdes Portillo. Con cámara y

corazón en mano ella se dirige—como fuego dibujado en la densidad del aire—a la esencia vulnerable de quien es espectador. La maestría de las suturas invisibles hace de este filme documental una obra tan implacable como lo es impecable que se clava como espina de nopal en el corazón: un corazón individual, aunque también necesariamente colectivo.

Señorita Extraviada—título con dejo de ironía—es de hecho una oda a la vulnerabilidad. Es oda también, de manera paradójica, a la desquiciada rabia humana, al odio dolido, enardecido por esa vulnerabilidad trémula identificada con la Otredad fémina y su inasible inocencia, cuya pristinidad desata una furia irascible: volcán incontenible que brota, perverso, a flor fuego de piel.

Y como ironía tenaz, esa misma precaria vulnerabilidad, esa misma inocencia—espuma mar de vida—devela una verdad bajo tantas otras, desnuda dolores y vacíos sin fronteras. Y surge el terrible-triste refugio deseo, contra toda razón, de observarse reflejado en la Otredad femenina mediante la reproducción del dolor, mediante una adicción a la insaciabilidad que se consume a sí misma. Es decir, al experimentar lo perverso de sentirse ultrajado, de herir la pureza luz inasible, haciendo uso de la más dura arma contra sí mismo/las demás: perderse en la violencia, en el sadismo, ver el rojo correr frente a los ojos (abiertos, cerrados, de día, de noche), ya no ser. Morir así: gota a gota, ante la víctima reflejo.

Señorita Extraviada de Lourdes Portillo es mater dolorosa que contiene y sostiene el desquicio humano de todos los tiempos en el tierno regazo.[5] En este sentido es también oda a la mirada compasiva hacia las Otras, dirigida por la impecabilidad que exige la forma misma de un filme documental de este calibre técnico y sensible. Esta mirada de mater dolorosa las reconoce marcadas por su género y por la violencia: como mujeres nacidas sin pecado original, pero también sin Virgen que interceda por ellas, que las proteja.

Por ello, Señorita Extraviada es también poema a la solidaridad que la rabia ha parido, esa rabia que también surge, se desborda—aun cuando se autocensura en muchos casos—en quienes participan como espectadores del sentir de tantas historias, del saber que hay tantas otras sin contar y truncar: ese silencio que ronda las bocas y que la mente no logra acallar. ¿Quién sino una activista-artista-cineasta comprometida con el develar de las verdades indecibles, las cuales aúllan en lo nocturno por SER, por ser liberadas; Quién sino una chicana politizada, la angustia activa, una wounded healer con espina de nopal clavada en el corazón, se atrevería a pisar terrenos escabrosos, a clavar la mirada dónde los ángeles no suelen hacerlo?

En lo personal, me parece claro que sólo una chicana que cruza fronteras multivalentes y múltiples, comprometida con el dolor de saberse testiga—cámara en mano—permitiría que la asedien imágenes y vivencias tan puntuales de aquellas mujeres quienes viven a diario—sean turnos matutinos, vespertinos o nocturnos—del sudor de su frente. Sólo una chicana testiga del vivir, del vivir a medias y del morir de estas mujeres—en la misma madre tierra norteña que igual la parió a ella—podría crear un filme como *Señorita Extraviada* con la idea-destino de compartirse.

Y es que el cordón umbilical queda doliente-sangrante, sin cercenarse del todo, en el andar-búsqueda hacia el norte, al Norte: a esos USA de la abundancia que usan y luego tiran, *a use-and-discard culture* que juega a la Catrina posadesca, cobrando vidas mexicanas, robándose al igual madres e hijos, a cambio de trozos de esperanza. Sólo una chicana que sabe de la espina de nopal encajada en el corazón—sin jamás poder arrancarla, porque se arrancaría la propia sangre de vida—y que bien sabe lo que es vivir en el filo de la navaja de tantas fronteras, sería capaz de cruzarlas refrendando el dolor, entregándose de lleno, con la ayuda sabia de su oficio, para crear y ofrendarnos esta oda plurivocal a nosotras/os como espectadores.

Señorita Extraviada es un testimonio poema,[6] prístino y politizado, que exhibe con honestidad y compasión lo humano doliente que se quiebra, que destroza (a)fuera de sí, (auto)destruyéndose, que sufre agonía reiterada sin mesura—ya sea como la víctima o el agresor (aquí el uso de los géneros gramaticales en español son espeluznantemente apropiados)—intercambiables en el ir y venir transfrontereado del reflejo reiterado y desdoblado.

Como espectadores, nos encontramos frente a frente con múltiples "heridas abiertas," frente al dolor desmesurado ineludible, ante lo cual podría resultar saludable y aterrizado recordar la propuesta de la escritora y filósofa cultural Gloria Anzaldúa cuando escribe: "nunca hay una resolución, sólo el proceso de sanación" (2005, 100). Un proceso continuo que permite activarse de maneras políticas, espirituales, creativas, compasivas y concretas, para lo cual la obra de Lourdes Portillo provee semilla e incluso terreno fértil que se inspira y a la vez inspira la continuidad de cada proceso único de sanación.

Notes

1. This essay was originally written several years ago, prior to the present-day upgraded interest in feminicide in Ciudad Juárez, on the Mexico-U.S. border, and elsewhere in Mexico.

2. From the Latin, *mater dolorosa* translates literally as "sorrowful mother" and references the Virgin Mary. A medieval hymn, for example, contextualizes mater dolorosa around the pain the Virgin felt at the Crucifixion and the maternal sorrow felt by a mother for her sacrificed child (the lament for the dead Christ).

3. Borrowing from the legal context of expert witness testimony as evidence in a case, testimonio as a literary genre complicates traditional notions of third-person objectivity and first-person subjectivity in relating an event. Particularly in Latin American cultures and often related to some form of violence, this genre is associated with autobiographical information and human rights issues. The subject "I" in testimonio inevitably speaks for a collectivity, thereby causing it to become a political and ethical statement, as suggested by John Beverley (2004); such political and ethical statements, too, are aspects of the "eye" of pain.

4. Este ensayo fue escrito originalmente hace ya varios años, previo al interés actual en aumento relacionado a los feminicidios en Ciudad Juárez, en la frontera de México y los Estados Unidos y en otras partes de México.

5. Del latín, *mater dolorosa* se traduce literalmente como "madre dolorosa" y se refiere a la Virgen María. Un himno medieval, por ejemplo, contextualiza a la mater dolorosa en relación al dolor que siente la Virgen María ante la crucifixión de su hijo; es decir, se trata del dolor maternal por el hijo sacrificado (el lamento por el Cristo muerto).

6. Tomado del contexto jurídico testigo perito, es decir, testimonio como prueba en un caso, el testimonio es un género literario que complica las nociones tradicionales de objetividad/subjetividad, tercera/primera persona al relatar un evento que a menudo implica alguna forma de violencia. Este género se asocia a la información autobiográfica así como a cuestiones de derechos humanos, sobre todo en el contexto de américa latino. El "yo" en el testimonio hace referencia ineludible a una colectividad y por lo mismo se convierte en una declaración política y ética, tal como lo sugiere John Beverley (2004); es decir, a ese "eye" (*I*, o "yo" en inglés), ese "ojo" —individual y colectivo—del dolor.

Bibliography

Anzaldúa, Gloria E. 2005. "Let Us Be the Healing of the Wound: The Coyolxauhqui Imperative—La Sombra y el Sueño." In *One Wound for Another/Una herida por otra: Testimonios de Latin@s in the U.S. Through Cyberspace (11 de septiembre de 2001–11 de marzo de 2002)*, edited by Claire Joysmith and Clara Lomas, 92–103. Mexico City: Centro de Investigaciones sobre América Norte, Universidad Nacional Autónoma de México; Colorado Springs: Colorado College; Whittier, CA: Whittier College.

Beverley, John. 2004. *Testimonio: On the Politics of Truth*. Minneapolis: University of Minnesota Press.

Resisting the Violence of Values

Lourdes Portillo's *Señorita Extraviada* as Performative Utterance

Mónica F. Torres

Lourdes Portillo's *Señorita Extraviada* is a powerful re-presentation of the violent crimes against young women in Ciudad Juárez in the last two decades. Portillo navigated challenging circumstances to document what has been and what remains a difficult and dangerous environment for women in general and for young women in particular. Since 1993, the bodies of hundreds of women have been discovered in the outlying areas of the El Paso–Juárez international megalopolis.

Some would argue that the greatest strength of this documentary is the way in which the filmmaker so fully captures the acts of resistance that these women and their family members have engaged in during the course of this tragedy: women fighting off the attacks of their abusers; parents contesting authorities' denials of the violent realities of the women's abductions, assaults, and murders; families, friends, and supporters organizing solidarity marches, memorial vigils, and informational meetings to publicize the crimes against the women and to develop strategies for intervening with the institutional representatives who seem unwilling or unable to solve these crimes.

Some spectators might think that Portillo, as documentary filmmaker, has done her job: thoughtfully and thoroughly recording the stories of the women and their families. However brilliantly she has done this, I want to suggest that *Señorita Extraviada* is even more powerful than that

description suggests. In an interview done prior to the making of the film, Portillo hints at another purpose. She tells interviewer Fred Salas that this film will be "about the disposability of Mexican women. How easy it is to kill them and get rid of them and use them. They are just like raw material" (Salas 1998). Portillo suggests that this film will go beyond mere *documenting* to function also at the level of social critique—that it will interrogate the cultural assumptions and values that make possible the abduction, murder, and disposal of young women in this border city.

In *How to Do Things with Words*, J. L. Austin articulates a critical distinction in linguistic utterances: the *constative*, language that essentially describes or reflects the nondiscursive world, and the *performative*, language that asserts or creates the reality it describes ([1962] 1975, 5–6, 12–13). When a judge says, "I sentence you to twenty-three years in jail" or a mother says, "I name you Lourdes," she has quite literally constructed reality. What is important to note is the shift in how we view language— from a tool that reflects the material world to one that is constitutive or at least coconstitutive of/with it. While it seems clear to me that *Señorita Extraviada* can be understood as a constative utterance, essentially describing or reflecting the reality that exists in Juárez, it can also be argued that this film is a performative utterance. To make this argument, I begin with this critical question: What feature of the material world is this film constituting?

Portillo starts to provide an answer early in the film. Within the first few minutes, she says that she is coming to the desert to "track down ghosts." When I first heard this, I assumed that she meant the murdered women, many of whose bodies were buried in the desert landscape of northern Mexico. And perhaps this is true. Many of the film images show searchers in the desert, looking for women's bodies. When I think of Portillo as a critic, however, I think there must be other ghosts, ghosts that may be hiding in the bright light of common sense or in the shadows of bureaucracy—social values and assumptions as well as legal and economic structures that encourage or support the idea that Mexican women are disposable.

Portillo exposes some of these assumptions. She includes footage of the governor of Chihuahua in which he suggests that the women are, perhaps, responsible for their demise: "We have found a pattern. The girls hang out in certain places with certain people, and they develop relationships with bad people, with gang members, who later become their aggressors." Portillo's inclusion of this footage does two things. One, it exposes, in rather raw form, a key cultural assumption, that there are "good

women" and "bad women," certainly a firmly established dichotomy in plenty of cultures, including Mexican; and two, it suggests that the bad women deserve what they get. By this time in the documentary, Portillo has already problematized these assertions by providing portraits of the women as something other than bad girls who make bad decisions that get them in trouble. They are, through Portillo's lens, daughters, sisters, workers, and friends. Given the documentary's more well-rounded images of the young women, the governor appears to be ill informed at best and misogynist at worst. What this makes clear, however, is that an attitude that allows for the easy dismissal of hundreds of women in Juárez is so firmly entrenched in the culture that it can be asserted with impunity from the highest government levels.

Portillo also calls into question economic structures that subordinate the health and safety of women to corporate profits. While she does not engage in a lengthy discussion, she makes the point more than clear. At one moment in the film, the narrative, accompanied by visual imagery of heavy traffic in fast motion, says that globalization may be spinning out of control. Later, one of the witnesses suggests that the Mexican government has made such major investments in the maquiladora industry that it cannot risk any scandals. And finally, Portillo implies that government and industry value the economic vitality the *maquilas* bring without acknowledging the cost to its laborers, many of them young women. These women, activist Victoria Caraveo tells us, "are the ones that make beautiful televisions and parts for cars and shoes. . . . They are part of the fortunes of a lot of people." Portillo points at the global economy as a system that allows for, maybe even depends on, seeing Mexican women as interchangeable, perhaps even disposable, parts of the production system.

Portillo makes visible the values underlying the assumption that women in Juárez are less important than government investments or televisions, automobiles, and clothing. But her critique operates at yet another level — the deeply theoretical.

In *Representing Reality*, Bill Nichols raises a fundamental problem for a filmmaker like Portillo: "The mortality of the body presents a continual challenge to documentary. It eludes all strategies of representation" (1991, 236). How, then, does Portillo make a film about these women? At first glance, Portillo engages in what appears to be a very straightforward recovery of their images, their names, and their stories through the rather conventional use of documentary photographs and witness testimony. Throughout the documentary, we see snapshots and newspaper photographs of them. And always, each image is accompanied by the victim's

name and the date of her disappearance. We hear mothers and fathers, brothers and sisters tell stories of their lost daughters and sisters.

I want to argue that Portillo's use of images and stories is significantly more complex than straightforward recovery. Her use of photographs is ontologically purposeful. Working in an era when digital photography has problematized the ontological stability of the photograph, Portillo employs photographs of the abducted and murdered women again and again. Working in an era that assumes the endless play of signifiers, Portillo persistently employs photographs as signifiers. As a filmmaker, Portillo knows how to destabilize images, how to play with signifiers. In an earlier film, *The Devil Never Sleeps* (1994), she is quite clear about the inability of images to capture any sort of absolute image or final truth. In that documentary, she playfully highlights the subjectivity of photographic and filmic images. But in *Señorita Extraviada*, she does not do that. She relies on the historical stability of photographs, at least in part, because she is working so hard to keep these women, and their experiences, from being disappeared or dismissed yet again. The images, the names, the stories are all meant to assure us that the women existed.

Portillo uses witness testimony in the same way. For some time, scholars in a range of fields, including documentary film, have understood that witness testimony is less than reliable. But Portillo wants to grant certain forms of testimony epistemological solidity. In the film, Portillo, as narrator, says that there are only a few people whose information she can trust: "I find myself mistrusting everything I am told and everything I read. The only reliable sources of information are from the victims and their families." The statement is in sharp contrast to her work in *The Devil Never Sleeps*. In that film, Portillo leads spectators to understand that the closest friends and family members offer little insight into the death of Portillo's Uncle Oscar. In *Señorita Extraviada*, she grants the families epistemological privilege. Why? Perhaps it is because the murdered women are already less than visible. None has the privileged public persona of her Uncle Oscar, a successful businessman and politician. Portillo brings the Juárez women into view by foregrounding the stories of the mothers and fathers, sisters and brothers who saw, heard, and touched them. In granting the family witnesses epistemological privilege, she counters assumptions of disposability with assurances of ontological stability.

Portillo is challenging a fundamental premise commonly asserted in the postmodern age—that knowledge is not objective and cannot yield absolute answers even to our most pressing questions. Perhaps the Portillo who made *The Devil Never Sleeps* would agree. In the circumstances of

Ciudad Juárez, where women are disappearing and dying and being disposed of, Portillo must challenge ontological and epistemological assumptions such as these.

Portillo uses one other strategy to secure visibility for the women and their experiences. She exploits a critical tension inherent in the situation in Juárez: absence/presence. Early in the film, immediately before the titles and shortly before the introduction of Portillo's narration—"I came to Juárez to track down ghosts and to listen to the mysteries that surround them"—a montage of images hints at this tension between absence and presence. A young woman, about the age of many of the victims, walks in the desert. Revealed in multiply exposed eye-level full shots, she moves left to right across the frame, her image appearing and disappearing, reappearing and disappearing again. Immediately after, a girl, much younger than most of the victims, follows in the first's footsteps, appearing and disappearing as she crosses the desert landscape. The effect is haunting: these young females, caught in the mysteries surrounding their disappearances, appear suspended somewhere between presence and absence. While the scene occupies only five seconds of the 74-minute film, its trace persists.

Perhaps the most consistent deployment of the absence/presence strategy is Portillo's metonymic use of shoes. Throughout the film, Portillo includes images of new shoes displayed on store racks in shopping malls. Girls and women—young and very much alive—eye the shoes, wait to try them on or perhaps purchase them. Those images contrast with others of old shoes, dirty and twisted out of shape, carelessly tossed or perhaps carefully buried deep in the desert. Each image potentially signifies women's bodies: new shoes, the vitality of young women; damaged shoes, the brutality of the injuries and the murders of the young women.

What seems even more powerful, in terms of Portillo's critique, is the tension that exists between these polar opposites. The new shoes may invoke the bodies of the living, but they also call forward the bodies of those women who will never wear them again. The damaged shoes are metaphors for the dead women, but they also signal the vulnerability of the young women who may be found one day wearing them. Exploiting the tension between the old and new, Portillo complicates the distinction between presence and absence. In doing so, she not only secures visibility for women in the film, both dead and alive, she also refuses to allow spectators to dismiss or deny the violent experiences that many women have suffered and the threatening circumstances in which many women continue to live.

As many know, the Juárez abductions and murders are no closer to being solved than they were when Portillo made her film. In January 2009, the *El Paso Times* reported that the state of Chihuahua recorded 86 killings of women in Juárez in 2008, a one-year record over the previous high toll of 48 in 1995 (Washington Valdez 2009). Two years later, in 2011, the *El Paso Times* cited the deaths of 130 more women in Juárez. Chihuahua's attorney general, Carlos Manuel Salas, noted that these murders stemmed from domestic violence, organized crime, and gender crime and reflected a "painful and slow" fight for the vindication of women's rights (Ortega Lozano 2011). Women continue to die. Legal and political officials continue to be ineffective. Families and friends continue to resist through collective protest. While Portillo documents these realities, and they must be documented, she also asks spectators to engage another reality: one in which we move beyond the document to acknowledge and challenge the cultural values that allow the young women of Juárez to be treated like "raw material" to be used and discarded.

Bibliography

Austin, J. L. [1962] 1975. *How to Do Things with Words.* 2nd ed. Cambridge, MA: Harvard University Press.

The Devil Never Sleeps. 1994. Directed by Lourdes Portillo. Women Make Movies.

Nichols, Bill. 1991. *Representing Reality: Issues and Concepts in Documentary.* Bloomington: Indiana University Press.

Ortega Lozano, Marisela. 2011. "130 Women Killed in Juárez this year; Chihuahua AG Says Fight for Women's Rights Painful and Slow." *El Paso Times*, Aug. 24. Accessed Jan. 2, 2012. http://www.elpasotimes.com/juarez/ci_18747536.

Salas, Fred. 1998. "Interview with Film Director Lourdes Portillo." *In Motion Magazine*, Dec. 6. Accessed April 2, 2008. http://www.inmotionmagazine.com/lp.html.

Señorita Extraviada. 2001. Directed by Lourdes Portillo. Women Make Movies.

Washington Valdez, Diana. 2009. "UN Officials to Visit Slain Women's Families in Juárez." *El Paso Times*, Jan. 26. Accessed Feb. 9, 2009. http://www.elpasotimes.com/news/ci_11559343.

From Yo Soy Chicano *to* Resurrection Blvd., *Thirty Years of Struggle*

Jesús Salvador Treviño

In June 1970, I produced a three-part study of Latinos in the motion picture and television industry for the Los Angeles–based public television station KCET. I titled it *Image*. For the study, dear to my heart, it took me months of laborious research to properly situate the status of Latinos in Hollywood and, at the same time, explain a mystery: the dearth of Latino writers, producers, and directors. I discovered that Latinos had made a modest impact as actors during the development of Hollywood motion pictures from their inception back in the 1920s, but for the most part we had been excluded from entry into the Hollywood workforce early on. In subsequent decades we were, therefore, precluded from participating in the upward rise in the industry. The telling statistics that glared at me: virtually no writers, directors, and producers. In 1969 Spanish-surnamed people comprised only 3 percent of the entire Hollywood industry workforce; most of those workers occupied lower end jobs behind the screen — janitors, gardeners, and maintenance personnel.[1]

Given these statistics, it was no surprise that the portrayal of Latinos *on the screen* was riddled with negative stereotypes. Writers and producers with little knowledge of Latinos wrote them into mainstream Hollywood productions to play as foils (the Latin lover, the tempestuous Latina spitfire, the greasy Mexican villain, the comic relief sidekick) to American cinema's heroes and heroines. Rarely did we see a motion picture with a Latino theme or protagonist. Occasionally, a movie in which Latinos were

principal characters would surface, like A *Medal For Benny* (1945), *The Lawless* (1950), *The Ring* (1952), or *Viva Zapata!* (1952).

Missing throughout the development of American cinema and later television were stories and depictions of the Mexican American and other Latinos in the United States as real people, with professions, concerns, and lives outside the stereotypic; in other words, missing were stories written, produced, or directed by Latinos ourselves. That a handful of Latino actors—such as Ramón Novarro, Lupe Vélez, Anthony Quinn, Ricardo Montalbán, Gilbert Roland, and Carmen Miranda—had risen to some prominence at various times in the history of American cinema and television was a tribute to their abilities as actors as much as a result of the industry's need for foils mentioned previously.

This was the situation when I conducted my survey. The only recurring Latino characters on American television then were played by Freddie Prinze (whose mother was Puerto Rican) in the series *Chico and the Man* (1974–78) and Desi Arnaz (who was Cuban) in reruns of the ubiquitous show *I Love Lucy*, which originally aired in the 1950s. At the time I recall thinking that, if we were to bring about change, it would be the result of my generation of activists taking the bull by the horns. I resolved to do all that was possible to speed this process along. Little did I know that the breakthrough on American television would not come for another thirty years.

In 1970 I was working as a field producer for KCET, covering stories and issues dealing with the Mexican American community of Los Angeles. I recalled a passage written by Carey McWilliams in his book *North from Mexico*, at the time the only history of Mexican Americans around.[2] McWilliams did a masterful job of recounting Mexican American history to the 1960s and was acutely aware that the story of Mexican Americans must be written by Mexican Americans themselves. He wrote: "There has yet to be written, for example, a novel of Southwestern experience written by an American-born person of Mexican descent or a significant autobiography by a native born Mexican" ([1968] 1990, 268). I resolved to take over where McWilliams had left off, to be that chronicler of contemporary history of Mexican Americans, or, as we were now calling ourselves, Chicanos. I proposed to KCET's station manager, Charles Allen, the idea of a documentary chronicling the presence of Mexican Americans in the United States.

I originally envisioned a one-hour documentary dealing with Chicano history. My approach was to present in a popular format the history of Chicanos in this country. "I want to give a face to my people," I said to

Allen at the time. "We need to know our history." Allen, with a national audience in mind, suggested that I expand on the idea to include coverage of the contemporary issues facing Mexican Americans in the present. We soon agreed that I would undertake a documentary that would chronicle the contributions made by Chicanos to American history and explore the issues of inequality and discrimination currently facing Chicanos. My boss commented that it seemed like an awfully big order for a one-hour film to tackle, but he gave me the go-ahead and assisted me in approaching potential funders. A few months later, the Ford Foundation awarded me a grant of $35,000, an enormous sum at the time.

The first question I had to address: How do you tell the complex story of an entire people, both past and present, in an hour of American television? I hit on the idea of telling the story of Chicanos using parallel structure. I had already written extensively about Chicano history in the United States for the *Ahora!* program at KCET in 1969. I resolved to script a historical narrative, which I would visually fill in with archival photos and, when photos did not exist, with dramatic recreations and stylistic impressionism. I would then intercut this narrative with material taking a more journalistic approach to contemporary issues as I interviewed current leaders and activists of the Chicano struggle.

I shot *Yo Soy Chicano* with a three-man crew over a period of about six months. Much of this time was spent traveling throughout Aztlán (California, Arizona, New Mexico, Texas, and Colorado) to film Chicano activist leaders such as José Ángel Gutiérrez, Rodolfo "Corky" Gonzales, Dolores Huerta, Salomón Baldenegro, and Reies López Tijerina. *Yo Soy Chicano* was the first documentary written and produced by a Latino to be broadcast nationally on American television.[3] Prior to this time, in American documentaries Latinos were known only through their depictions as farmworkers in the classic 1960 CBS News documentary *Harvest of Shame*.

Yo Soy Chicano was a first. But within a short time, other Chicanos found opportunities to document our history, issues, and themes. It is not surprising that the first efforts by Mexican Americans at self-determination in media should come through television documentaries. Chicano attorneys had broken the ground by challenging television stations using the Fairness Doctrine of the Federal Communications Commission (FCC), which required stations to provide programming for all sectors of their audiences.[4] To placate Chicano activists and conform to FCC regulations, stations soon created token talk shows focusing on Mexican American affairs, usually broadcasting them early on Sunday mornings.

Figure 36.1. From the making of Yo *Soy Chicano* (1972, in Spanish with English subtitles, 16mm color and black-and-white film, 60 min.), produced and written by Jesús Salvador Treviño. Yo *Soy Chicano* was the first nationally broadcast documentary about Mexican Americans. It provided a historical overview from the time of the Spanish conquest of the Americas through the civil rights movements of the 1960s and 1970s, profiles on leading Chicana/o figures, and examinations of key cultural issues. The film was innovative in its incorporation of dramatic re-creations; here the crew rehistoricizes 1940s pachucos. (Photograph courtesy of Gayla Treviño.)

Chicano media activists took advantage of these shows to produce the first documentaries on Latino life in the United States. Some of the earliest documentary films written, produced, and/or directed by Chicanos, following the broadcast of Yo *Soy Chicano*, were A *la Brava: Prison and Beyond* (1974), *The Unwanted* (1975), *Cinco Vidas* (1977), and *Agueda Martínez: Our People, Our Country* (1977).

By the mid-1970s, as a community we were ready to take the next step, and that was the production of our own long-form dramas. Efraín Gutiérrez directed a series of four-walled dramas titled *Please Don't Bury Me Alive* (1976), *Amor Chicano Es para Siempre/Chicano Love Is Forever* (1978), and *Run, Tecato, Run* (1979), and Moctesuma Esparza produced the Alejandro Grattan–directed film *Only Once in a Lifetime* (1979). I wrote and directed the Mexican-financed feature film *Raíces de Sangre*

Figure 36.2. From the making of *Yo Soy Chicano* (1972). Jesús Salvador Treviño and his film crew traveled to New Mexico to film Reies López Tijerina speaking in front of a classroom. In the 1960s and 1970s, the civil rights activist headed a campaign to restore New Mexican land grants to the descendants of their Spanish and Mexican owners; he famously led an armed raid on the Rio Arriba County Courthouse in Tierra Amarilla, New Mexico, in 1967. (Photograph courtesy of Jesús Salvador Treviño.)

(Roots of Blood) (1977). What was notable about these films is that they were the very first narrative films to be written, produced, and directed by Latinos in the United States with Latino themes and, of course, featuring Latino actors in principal roles.

After more than sixty years of exclusion, we had finally insinuated our-selves into Hollywood.

In subsequent years, other Mexican Americans and Latinos began to make their presences known in Hollywood with such productions as *Zoot Suit* (1981), *The Ballad of Gregorio Cortez* (1982), *Seguín* (1982), *El Norte* (1983), *La Bamba* (1987), and *Stand and Deliver* (1988). These and other films presaged the more recent success of films directed by Guillermo del Toro, Alejandro González Iñárritu, and Alfonso Cuarón.

Latinos finally achieved success at the box office by the mid-1980s. Luis Valdez's 1987 blockbuster motion picture *La Bamba* demonstrated

that Latinos could write, produce, and direct motion pictures that were financially and artistically successful. But we still lacked a presence on American television. Attempts were made. In 1967, public television station KCET decided to produce a one-season drama series about an East Los Angeles family titled *Canción de la Raza* (1968–69), with hopes of proving a market and prompting commercial television to take a look at the Mexican American experience. But there were no takers. In 1983 Paul Rodriguez attempted to break through on mainstream television when he starred in *AKA Pablo*, produced by Norman Lear (creator of the hit *All in the Family*), but due to poor ratings the network canceled the series after airing only three episodes. In 1987, Benjamin Bratt starred as a police detective in a pilot for a network drama series, *Juarez*, but the series never aired; and in the 1990s, Cheech Marin developed a comedy series for Fox featuring the comedy group Culture Clash, but the network canceled the project without even airing the pilot.

On December 21, 1998, Dennis Leoni, a writer from Tucson, Arizona, invited me to lunch. Leoni, whose heritage was Mexican American and Italian, had worked his way up the ranks of writing for television dramas in Hollywood. He had written a powerful drama, titled *Resurrection Blvd.*, about an East Los Angeles family who had been involved in boxing for three generations and were on the verge of producing a middleweight champion in the eldest son. Dennis was interviewing various directors in anticipation of getting a green light to produce a two-hour movie based on his script.

We hit it off. After reviewing some of the TV shows I had directed (by then I had segued from documentary filmmaking to directing prime-time American television) and learning that I had grown up in East Los Angeles, Dennis offered me the job. A few months later, Showtime approved the script for production as a Showtime movie.

From the onset Dennis and I had hopes that the two-hour film would prompt Showtime executives to approve a television drama series based on what we were now thinking of as "the pilot." Indeed, Dennis had pitched Jerry Offsay, the president of Showtime, the idea of a drama series based on his script. But Showtime executives were reluctant to commit until they were convinced that the characters and story had enough universal appeal to attract a mainstream American audience.[5]

We went into preproduction in July 1999. Dennis and I were in agreement that we would do everything possible to staff the production with Latino crew behind the camera as well as the actors in front of the camera. Within a short time we had an exciting ensemble cast that included

Tony Plana, Elizabeth Peña, Cheech Marin, Michael DeLorenzo, Nestor Carbonell, Nicholas González, Ruth Livier, Mauricio Mendoza, Marisol Nichols, and Daniel Zacapa. We also had hired Latinos in key production roles, such as the director of photography, the head of make-up, the head of wardrobe, the casting director, and the location manager. Filming began on August 26, 1999. The film was shot in twenty-three days.

In the *Resurrection Blvd.* story, the patriarch of the Santiago family, Roberto (played by Tony Plana), seeks to groom a champion, fiercely driving his three sons and imbuing them with a passion for boxing. When the eldest son, Carlos (Michael DeLorenzo), is on the brink of becoming a champion, a gang member whom he had beaten up retaliates and shoots him, leaving him crippled. The youngest son, Alex (Nicholas González), then leaves medical school to take up the family tradition. To everyone's surprise, it is he who becomes the first boxing champion in the Santiago family.

As filming neared completion, Dennis and I began to discuss how we might enhance the chances that Showtime would approve a series based on the motion picture. Though the original script ended with a celebration of the youngest Santiago brother's boxing victory—a "closure ending"—I felt instead we needed to end the film in a way that suggested there was a deeper story yet to follow.

I pitched Dennis the idea of shooting two endings to the film. I would shoot the scripted version, in which the eldest brother joins in to celebrate his younger brother's victory, the victory that might have belonged to him had he not been shot. But I also offered an alternative ending, in which the eldest brother walks away from the celebration, depressed, and the familial bond between the two brothers is damaged. The story would not be resolved but, rather, left open-ended. This would give substance to the possibility of a series based on the ongoing rivalry between the two brothers.

In my director's cut I concluded the film with the open-ended version. When my cut was completed, Showtime arranged for a public screening of the two-hour movie before a test audience made up of several hundred people, only a few of whom were Latinos. Dennis and I sat in the rear of the theater next to Jerry Offsay, who had insisted on being at the test screening.

We held our breaths and awaited the audience reaction at the end of the movie.

The response was overwhelming! People cheered and applauded, and in the question-and-answer session that followed, it was clear that audience

members wanted to see the saga of the Santiago family made into a television series. A few days later, Showtime gave us the green light to produce the first thirteen episodes of a drama series called *Resurrection Blvd.*

Resurrection Blvd. was another first—a nationally broadcast drama series about a Latino family, in English, on American television. It ran for three years, from 2000 to 2002, and was followed by two other Latino drama series, *The Brothers Garcia* (2000–2004) on Nickelodeon and *American Family* (2002, 2004) on PBS.

Thirty years after I had conducted my study, Latinos were finally represented in a genuine and realistic manner on American television— propelled by a new generation of Latino writers, producers, and directors.

Notes

1. Hearings were held in Los Angeles before the U.S. Equal Opportunities Commission on Utilization of Minorities and Women in "certain major industries" on March 12–14, 1969. Five major studios were invited to attend, but only two sent representatives (Walt Disney Studios and Universal Studios), angering the commission members and resulting in subpoenas for employment records from the other studios. The subsequent study was published in August 1977 as *Window Dressing on the Set: Women and Minorities in Television.* The conclusion of the commission was that "since the 1950s and 1960s . . . minorities and women continue to be under-represented on local and network work forces" (1977, 3).

2. Since that time Dr. Rodolfo Acuña's *Occupied America: A History of Chicanos* (2007) and F. Arturo Rosales's *Chicano! The History of the Mexican American Civil Rights Movement* (1997) have filled in many of the missing gaps in Chicano history.

3. The original proposal that went to the Ford Foundation was titled *La Raza History.* After we received the production funds, Charles Allen urged me to find a less clunky title for the film. Since I intended to write the film's narration in the first person and since the film was to be a montage of different Chicano personalities, it made sense to call it *I Am Chicano.* During production, I switched the title into Spanish, *Yo Soy Chicano.*

4. The Federal Communications Commission, created in 1934, initiated the Fairness Doctrine in 1949. It held that broadcasters must provide airtime for discussion of controversial matters of public interest and must air contrasting views on these matters. In the 1960s and 1970s Chicano groups leveraged the Fairness Doctrine to get airtime for Chicano issues. The Fairness Doctrine was abolished in 1987 under President Ronald Reagan's deregulation policies.

5. While *The Jeffersons* (1975–85) and *The Cosby Show* (1984–92) had proven the crossover appeal of African American characters to mainstream American television audiences, at this time the appeal of Latino characters was still questionable in the minds of many television executives.

Bibliography

Acuña, Rodolfo. 2007. *Occupied America: A History of Chicanos*. 6th ed. New York: Longman.

A la Brava: Prison and Beyond. 1974. Directed by Ricardo Soto. University of California Extension Media Center.

Agueda Martínez: Our People, Our Country. 1977. Produced by Moctesuma Esparza, directed by Esperanza Vasquez. Esparza/Katz Productions.

Ahora! 1969. Produced by Jesús Salvador Treviño. KCET-PBS.

AKA Pablo. 1984. Produced by Norman Lear and Rick Mitz. Embassy–ABC Television.

American Family. 2002, 2004. Produced by Gregory Nava, Barbara Martinez Jitner, et al. El Norte Productions/20th Century-Fox/KCET-PBS.

Amor Chicano Es para Siempre/Chicano Love Is Forever. 1978. Directed by Efraín Gutiérrez. Chicano Arts Film Enterprises.

The Ballad of Gregorio Cortez. 1982. Directed by Robert M. Young. Embassy Pictures–NEH-CPB.

La Bamba. 1987. Directed by Luis Valdez. New Visions–Columbia Pictures.

Broadcasters and the Fairness Doctrine: Hearing Before the Subcommittee on Telecommunications and Finance of the Committee. 1989. 101st Cong. House Committee on Energy and Commerce, Subcommittee on Telecommunications and Finance.

The Brothers Garcia. 2000–2004. Produced by Jeff Valdez and Bruce Barshop. SíTV–Nickelodeon Network.

Canción de la Raza. 1968–69. Produced by Edward Moreno. California State Department of Education.

Chico and the Man. 1974–78. Produced by James Komack. Wolper Productions–NBC.

Cinco Vidas (Five Lives). 1977. Produced by Moctesuma Esparza, directed by José Luis Ruiz. Educational Media Corp.

The Cosby Show. 1984–92. Produced by Marcy Carsey and Tom Werner. NBC Television.

Harvest of Shame. 1960. Produced by Fred W. Friendly and Edward R. Murrow, directed by Fred W. Friendly. CBS News.

I Love Lucy. 1951–57. Produced by Desi Arnaz. Desilu Productions–CBS Television.

Image. 1970. Produced by Jesús Salvador Treviño. KCET-PBS.

The Jeffersons. 1975–85. Produced by Ron Leavitt, Jay Moriarty, Michael G. Moye, and George Sunga. Embassy–CBS Television.

Juarez. 1987. Produced by Joe Reb Moffly. Big Name.

The Lawless. 1950. Directed by Joseph Losey. Pine-Thomas/Paramount Pictures.

McWilliams, Carey. [1968] 1990. *North from Mexico: The Spanish-Speaking People of the United States*. New York: Greenwood. Translated as *Al Norte de México: El Conflicto entre Anglos e Hispanos*, translated by Lya de Cardoza (Mexico City: Siglo Veintiuno, 1976).

A Medal for Benny. 1945. Directed by Irving Pichel. Paramount Pictures.

El Norte. 1983. Directed by Gregory Nava. Cinecom/American Playhouse–PBS.

Only Once in a Lifetime. 1979. Produced by Moctesuma Esparza, directed by Alejandro Grattan. Sierra Madre.

Please Don't Bury Me Alive/Por Favor No Me Entieren Vivo. 1976. Directed by Efraín Gutiérrez. Chicano Arts Film Enterprises.

Raíces de Sangre (Roots of Blood). 1977. Directed by Jesús Salvador Treviño. Corporación Nacional Cinematográfica–Desert Mountain Media.

Resurrection Blvd. 2000–2002. Produced by Dennis E. Leoni and Robert Eisele, directed by Jesús Salvador Treviño et al. Showtime.

The Ring. 1952. Directed by Kurt Neumann. King Brothers.

Rosales, F. Arturo. 1997. *Chicano! The History of the Mexican American Civil Rights Movement.* 2nd rev. ed. Houston, TX: Arte Público Press.

Run, Tecato, Run. 1979. Directed by Efraín Gutiérrez. Chicano Arts Enterprises.

Seguín. 1982. Directed by Jesús Salvador Treviño. American Playhouse–KCET-PBS.

Stand and Deliver. 1988. Directed by Ramón Menéndez. American Playhouse–Warner Bros.

The Unwanted. 1975. Directed by José Luis Ruiz and Frank del Olmo. NLCC Educational Media.

Viva Zapata! 1952. Directed by Elia Kazan. 20th Century-Fox.

U.S. Commission on Civil Rights. 1977. *Window Dressing on the Set: Women and Minorities in Television.* Washington, DC: U.S. Government Printing Office.

Yo Soy Chicano. 1972. Directed by Jesús Salvador Treviño. Cinema Guild/KCET-PBS.

Zoot Suit. 1981. Directed by Luis Valdez. Universal Pictures.

A Conversation with Dennis
Leoni and Christine List

Dennis E. Leoni is a writer, producer, director, and the president and CEO of Patagonia House, the production company that developed and produced *Resurrection Blvd.* for Showtime Networks. *Resurrection Blvd.* ran for three seasons, from 2000 to 2002, and was the first dramatic series in the history of American television to be written, produced, and directed by Latinos.

Leoni was born in Tucson, Arizona, attended the University of Arizona, and began his career in the entertainment industry as an actor and stuntman at the famous Western movie location Old Tucson. He has appeared in such movies as *Buffalo Soldiers* (1979) and *Johnny Mae Gibson, FBI* (1986). Leoni has written, produced, and directed programming for many of the major networks and studios, including NBC, ABC, CBS, HBO, Showtime, Paramount, Disney, and Sony. His credits include theatrical films, made-for-TV movies, and broadcast TV and web serials, such as *The Commish* (1994), *McKenna* (1995), *Covington Cross* (1992), *Hull High* (1990), and *Los Americans* (2011). His work on *Resurrection Blvd.* stands as a landmark in Chicano cultural production.

The following material is taken from a telephone conversation in December 2007.

<center>✻ ✻ ✻</center>

Christine List (**CL**): Can you tell the story of how *Resurrection Blvd.* developed from your original pilot about a family in Tucson to the story of a family of boxers from East LA?

Dennis Leoni (**DL**): I submitted *La Reforma*, a semiautobiographical script about my family and my grandmother. It's sort of my *Wonder Years*.

Showtime loved the writing, but they thought it was much too soft and sweet. So I went home, and I was watching Showtime, thinking, how do I make this fit for the network? A boxing match came on with two Latino fighters, so I thought, how about if I marry the boxing to the family drama?

CL: What was your collaborative relationship like with Jesús Treviño on the series?

DL: Jesús was great. He's such a Chicano activist, and being very proud of the culture, he brought a lot of that to the show. Visually, he wanted to add the "bumpers" of East Los Angeles, which are the interstitial little pieces between the scenes. That was a good thing in some respects. It showed a slice of life that America doesn't always see. When I say "America," I mean the Anglo society in the United States.

I originally did not want to set the show in East Los Angeles. I wanted to do it in a place that wasn't so conspicuously Chicano, but Showtime [executives] felt that all Mexicans come from East Los Angeles. To this day I am conflicted. I would rather have set it in a place that wasn't so Latino, Chicano oriented, only because I think it would have made it more palatable to the American audience and [would have said] that we do not all come from East Los Angeles.

CL: You've said in previous interviews that with *Resurrection Blvd.*, one of the things you were trying to develop was the theme of unity among Latinos. Could you elaborate on that, please?

DL: You know, growing up, I was not much of an activist. My mother and my grandmother and my family gave me a great pride in who I am and the idea of being a Mexican American, but we didn't really think about ourselves, myself and the other Mexican kids in Tucson, as activists.

I think now, speaking to them, they are much more activist and [are] resentful of some of the things that went on that we experienced as kids, but we did not really think about prejudice or bias growing up. We were so busy just having fun growing up that we didn't really worry about those things.

And so when I came to Los Angeles, it was not just Mexicans. It was much more of a melting pot, even in terms of Latinos. I started meeting all these different people, and it seemed to me that the organizations all preached unity, whether it's economic or social, or [it's] cultural pride in the fact that we all speak Spanish. But the truth of it is, there is nationalistic pride which divides us.

Anyway, the idea was to bring all kinds of different Latinos together, and so we had Tony Plana and Elizabeth Peña, who are Cuban. Michael DeLorenzo is a Puerto Rican. Mauricio Mendoza is a Colombian. Daniel Zacapa is Honduran. The other three are Mexicans. It was really about, within the business, creating this Latino thing as all-encompassing, as opposed to balkanizing.

The idea thematically is that *Resurrection Blvd.* is about family. You'll notice that in the characters, when they get away from the family, they're unhappy. With the family, they're happy. So my thought on all that was, as Latinos, we need to stick together. Politically, socially, economically, culturally, in every way, we are stronger. Obviously, if we vote as a block, we have much more clout, politically.

CL: Most of the Latino characters in *Resurrection Blvd.* are partially or totally bilingual. Can you talk about the writing strategies you used to incorporate Spanish into the show?

DL: I actually wanted it to be as much English as possible. It was on an English-language station, but I did want to enculturate the show by having some Spanish spoken. All the titles of the episodes are in Spanish, and I thought that that's a good thing. There're lots of people who do speak Spanish, and Spanglish is what I grew up with.

CL: I like how you used the character of the undocumented worker as a way to showcase different attitudes of the family toward Mexico and their Latino heritage. You had the father react in one way, and the sons react in another way.

DL: I wanted to point out the fact that there are a bunch of Mexicans and Latinos that are already here, and they feel like, "We're in, let's close the border off." And it's like, wait a second, wait a second.

CL: The son calls the father out on that.

DL: Yeah, this undocumented worker comes. All he wants to do is work hard and contribute to the economy.

It infuriates me when I see these guys on television, and they characterize the undocumented workers as people who are criminals and vagrants. You never see Latinos on the corner with a cup in their hand, saying, "I'm homeless."

CL: I thought you brought these issues into the show in such a beautiful, nondidactic way.

DL: I was always taught that the best kind of writing is the parable-analogous type of writing, like Aesop's tales, where the story is about one thing, but it's really about something else. They suck you in with the entertainment, and then, by the end, you realize, hey, that was about something else. That's the best kind of writing.

CL: Did you make a conscious effort to bring Latina writers onto your staff?

DL: I did, and I actually wanted one other one who wouldn't come—Evelina Fernández. She's an incredible playwright. But anyway, yes, I tried to get some Latinas. We had Maria Elena Rodriguez on the staff early on. We also had Nancy De Los Santos come and do a freelance script. She did a terrific job. Rosemary Alderete came and did a freelance script and did a terrific job.

I wanted to try to give as many Chicanos an opportunity as I could. I shouldn't say "Chicanos," because that excludes all the Cubans and all the Puerto Ricans and all the other Latinos whom we tried to give an opportunity to on the show. Two of the young writers whom we brought on the show have become executive producers.

CL: Great.

DL: The other producers have moved up, too. Jack LoGiudice, who isn't a Latino, became an executive producer. We gave opportunities to everybody. I wanted to give opportunities to women in general, too. Nancy Malone, who is a terrific director, came and directed. She's Irish Latina. Sylvia Morales, we brought her into the Directors Guild [of America]. We actually put five Latinos, single-handedly, into the Directors Guild, including myself.

CL: Impressive.

DL: Michael DeLorenzo, Tony Plana, Elizabeth Peña, and Sylvia Morales. We changed the numbers. We changed our presence in the Directors Guild single-handedly, so I'm very proud of that.

CL: Can you talk about the look and the sound of *Resurrection Blvd.?*

DL: Well, the look, obviously Jesús had a lot to do with that. Our production designer, John Iacovelli, had a lot to do with that also, because he's the one who did all the sets.

One of the most important things about the way the show was put together, and something that was very important to me, was the music. I wanted to do a really eclectic style of music. We had everybody from Tito Puente to Tom Petty, Carlos Santana to B. B. King. Sometimes Jesús would really push, and the studio, too, would push to make it very ethnocentric. They wanted it to be very Latin. I wanted to pull it back a little bit and say, hey, we live in the United States. These are United States Latinos, and they listen to all kinds of music, the way I listen to all kinds of music.

CL: Do you think there's a Chicano or Latino aesthetic that you bring to the show? Do you think that there is a Chicano or Latino aesthetic about your work?

DL: I don't think naturally there is, because I don't think in those terms. I think of myself as an American, because I was raised here. I was growing up, and my whole educational basis was very biased. We didn't learn about Mexican history, except in terms of how it related to the United States. So there're a lot of things that I didn't know, coming into this.

But on the other hand, I am who I am, and every day I look in the mirror, and I know who I am and where I come from. That's why you see the little house at the end of *Resurrection Blvd.*, which is my logo of my company, Patagonia House. It's a little adobe that still stands in Patagonia, Arizona, which is halfway between Tucson and Nogales.

I don't think another producer who is not Latino could have done this show quite as authentically as I could, because that's my experience. Growing up on the west side of Tucson with my grandparents, it's just a Latino culture.

CL: I read that the pilot for *Resurrection Blvd.* was tested with a predominantly non-Latino audience and that the numbers were fantastically positive. Why do you think the industry is still resistant to putting Latino characters on the air?

DL: I think because most of the executives who buy shows don't necessarily see us as primary entities within the culture. Let me put it that way.

It's not that there is an overt racism, but it's sort of this . . . They don't see our lives [as being] as important as theirs or other people's lives. And then there's the other part of it, which is the marketplace.

I've spoken to [producer] Moctesuma Esparza about this, because I am frustrated by the Latino marketplace. We don't seem to gravitate toward our own programming. Something is made; everybody says, "Well, why do I have to watch that?" I understand that. But I went to see a little movie in Burbank called *Tortilla Soup* (2001), which stars Hector Elizondo and Elizabeth Peña and Paul Rodriguez. Now LA County is 44 percent Latino. I think there were only two couples in the entire theater who were Latino. It's sort of disappointing. Even our numbers on *Resurrection Blvd.*, 55 percent of our audience was Anglo. Only 15 percent of our audience was Latino, and the rest were black. So we had a huge African American audience.

CL: That's interesting.

DL: You know, what is that, 30 percent? So it's disappointing that we don't support our own programming. Trying to make Latinos understand that the only way we're going to get more and more programming is if we watch that programming. To be honest, while there is a bias within the executive ranks of who buys the shows, if tomorrow the DVD of *Resurrection Blvd.* was bought by all 35 million Latinos in this country, do you know how many shows we would have like *Resurrection Blvd.* on the air?

But, you know, part of it is promotion. I went into Costco the other day. They don't carry *Resurrection Blvd.* I went into the Wal-Mart. They don't carry *Resurrection Blvd.* And Latinos are a huge part of their marketplace. So we don't get a fair shake when it comes to promotion or the whole marketing side. The DVD, the first season of *Resurrection Blvd.*, was not marketed properly. We didn't get any marketing money.

CL: What do you attribute that to?

DL: We're expected to perform with *The Sopranos* and *Deadwood* and *Sex and the City.* When they get promoted, the culture hammers us with that. Part of the problem is also the media. When *Resurrection Blvd.* came out, we got a ton of media, but it was the kind of article like, "Well, you've got the weight of the world on your shoulders now." You know what I mean?

CL: Like what they've done with the reviews of [the CBS drama series] *Cane*, more recently?

DL: If the show doesn't make it, Latino programming is in big trouble. And that was basically the tone of many of the articles across the country. I didn't think that that was fair. They should have just come and said, "Hey, this is a good family drama. Forget that they're Latinos." I told the media that. "Forget that we're Latinos." You know, judge us on the merit of our show.

I mean, look at the movies. We have no movies. Now we've got directors out of Mexico coming and doing movies here, which is obviously terrific, but those Mexican directors have been franchised in their own country. We, as Chicanos in this country, are disenfranchised . . . The playing field isn't level.

CL: I wanted to know what you feel the role of the Writers Guild [of America] is in opening or closing doors for Latinos in the industry.

DL: It's not really the guild, the organization of the guild, but all of the writers who are show runners in the guild. They have to understand that they need to diversify their staffs and to try to give different and new perspectives and mentor some people who need an opportunity. I think too many times they say, "We can't find good Latino writers," which is total nonsense.

CL: I wanted to ask you what you thought about the strategy that the National Hispanic Media Coalition and the NAACP and the other media activist groups used in 1999 when they threatened the boycotts of the networks. There was a memorandum of understanding signed. Do you think that was a good strategy, and do you think that the networks are honoring the memorandum?

DL: I actually wish there were some kind of boycott. Something has to be done to change this, you know. I see it as patronizing. They [the networks] threw us a bone. That's not what needs to happen. They give you one show, and then they say, "Well, that's it. That's all they need. That's all we have to have. The quota is filled . . ."

CL: Can you discuss your role as a media activist?

DL: My role? I don't want to be one . . . I want to be one in the sense that I want to be an executive producer who does shows that are multicultural, that reflect our society, that have the proper sensibility of tolerance and are

progressive socially, not just this "bang-bang, shoot 'em up" entertainment that we seem to have now. I just want to be a guy who does a good show that says something about something, and that's the way I would like to do my activism.

CL: You've worked with the National Latino Producers Academy, which is a project of NALIP [National Association of Latino Independent Producers]. What things do you stress when you work with young Latino and Latina media makers?

DL: I try to express to them that they need to not have a chip on their shoulder, because it just creates cynicism. I try to teach them to work hard and try to not only work hard, but work smart. Figure out what the marketplace is. Figure out how to change those things. Try to support each other. Network as much as possible. Really, networking is the answer to everything, because people work with people whom they know, they trust, and they like.

De-Essentializing Chicanismo

Interethnic Cooperation in the Work of Jesús Salvador Treviño

Juan J. Alonzo

In his recent autobiography, *Eyewitness: A Filmmaker's Memoir of the Chicano Movement*, Jesús Salvador Treviño recounts that by 1984 public funding for documentaries was so scarce that he abandoned filmmaking because it was no longer an economically feasible profession (2001, 184).[1] Inconceivable as it may seem, Treviño—who was by then a seasoned television producer and acclaimed for his films *América Tropical* (1971), *Yo Soy Chicano* (1972), *Raíces de Sangre* (1977), and *Seguín* (1982)—could not find work in either the film or television industry. While the initial success Treviño experienced is emblematic of the emergence of a politically conscious Chicano/a film aesthetic announcing itself to the world just as the Chicano/a movement was underway, the consequent hiatus into which he was forced is paradigmatic of the obstacles Chicano/a filmmakers would continue to encounter in an entertainment industry determined to keep ethnic voices at the margins. It is all the more remarkable, then, that Treviño eventually returned to filmmaking and television production and, moreover, that he has become one of the most prolific and recognized Chicano/a producer-directors working in Hollywood. In addition to his documentaries, Treviño has written, directed, and produced episodes of such popular television shows as *NYPD Blue*, *ER*, *Star Trek: Voyager*, *Babylon 5*, *Dawson's Creek*, *Crossing Jordan*, *Bones*, and *Law & Order: Criminal Intent*. One of his most distinguished achievements has been as co–executive producer for the Showtime series *Resurrection Blvd.* (2000–2002), for which he also directed many episodes.

The thirty-year time span between *Yo Soy Chicano* and *Resurrection Blvd.* represents a remarkable career arc for Treviño, one that is all the more noteworthy for its consistent message—that Latino/as belong behind as well as in front of the camera. As creators of their own stories behind the camera, they maintain relative control over the means of expression and tell stories from their unique perspective more so than happens in most commercial entertainment; as the subjects in front of the camera, they make a claim for their rightful presence in U.S. society. We find in Treviño, underlying the urgency of promoting the Latino/a presence on both sides of the lens, a passion for social justice and equality that runs as a constant theme in his personal as well as his commercial work. In Treviño's own words: "I came to see that if I were to continue in my efforts to advance the ideals of social justice and equality . . . I would need to be clever about doing so. . . . I needed to remain a high-profile player in mainstream media if I was to continue my efforts for social change. I have found that the most effective way to advance my ideals is to make my livelihood directing commercial fare, creating Latino opportunities where and when I can, while producing my own films on the side that more openly express my beliefs" (2001, 367). Comparing Treviño's groundbreaking documentary *Yo Soy Chicano* with his more recent work in *Resurrection Blvd.*, we find a coherent logic in his thematic and stylistic approaches as they relate to telling the authentic stories of the Chicano/a community. Perhaps more centrally, his work demonstrates an abiding interest in the political potential of inter-Latino/a and interethnic cooperation.

Treviño filmed *Yo Soy Chicano* at the beginning of the Chicano/a movement. The film takes inspiration from the historical and political events that impacted the Mexican American community, including the Mexican cultural legacy, immigration issues, economic and educational disenfranchisement of Chicano/as, the farmworkers' struggle, the Vietnam War, and police brutality in Los Angeles. As he told a colleague at KCET (the Los Angeles public television station where he worked as a producer for the show *Ahora!*), "I want to make a film that will encompass the entirety of the Chicano experience in America" (2001, 227). Although it will carry the viewer into the Mesoamerican past, *Yo Soy Chicano* opens with a montage of the present period that includes a Chicano/a rock band playing the opening song. When the music goes silent, the first voice-over announces, "I am Chicano. I was born in a barrio in the Southwest of what is now called the United States." These words are spoken over images of city streets and a desert landscape. The rest of the movie will interweave an expansive Mexican and Chicano/a history with profiles of

Figure 38.1. Behind the scenes of *Yo Soy Chicano* (1972). Stunning visuals, poetic narration, and original music made *Yo Soy Chicano* a tour de force. Daniel Valdez of El Teatro Campesino, the theatrical company formed in 1965 alongside the United Farm Workers Union, wrote and performed music for *Yo Soy Chicano*. (Photograph courtesy of Jesús Salvador Treviño.)

four contemporary Mexican American leaders—Dolores Huerta, Rodolfo "Corky" Gonzales, Reis López Tijerina, and José Ángel Gutiérrez.

Yo Soy Chicano resembles Luis Valdez's *I Am Joaquín* (1969)—the cinematic adaptation of Corky Gonzales's poem "Yo Soy Joaquín" ([1967] 1972)—in its attempt to recreate the varied history of the Mexican presence in the United States; yet Treviño's movie rejects the essentialist politics of *I Am Joaquín*. Valdez's film, as Chon Noriega points out, "frame[s] the cultural and national period and . . . delineate[s] its historical, political, and aesthetic vision" at the same time that it sets forth "a worker-based ideology and cultural identity that are rooted in a pre-Columbian mythopoetics and the 500-year history of *mestizo* resistance" (1992, 156). "Yo Soy Joaquín," in other words, embraces an exclusively nationalist and essentialist Chicano/a identity. And while the original poem's importance

rests on its exposure of "the discontinuities that will mark the procession of Chicano culture . . . over the course of the next quarter century" (Pérez-Torres 1995, 77), in contradistinction, the film version of the poem is less indeterminate, and far more dogmatic, in its expression of cultural nationalism. This is perhaps due to *I Am Joaquín*'s visual emphasis. The film uses camera movement to bring still photographs to life and combines music with Valdez's reading of "I Am Joaquín." Valdez chooses journalistic photographs of Chicano/a movement demonstrations, images of urban plight and pollution, and historical images from Mexican history and culture—Aztec warriors, Mexican Revolutionary photographs, mural art—to tell an agonistic story of the Chicano/a experience in the United States. Because Valdez reads the poem in a defiant monotone, the viewer is left with a sense that Mexican American culture is fixed and separatist, a purely oppositional culture.[2]

Yo Soy Chicano maintains a critical relationship to the dominant culture, but its tone is measured, and its focus is on Chicano/as' contributions and efforts to enact social change. Significantly, Treviño's film consciously experiments with several formal approaches—placing him in productive dialogue with an international film culture[3]—in order to produce a dynamic story about the Chicano/a experience. For instance, in his retelling of the events at Tierra Amarilla, New Mexico, where in 1967 land-grant activist Reies López Tijerina and the Alianza de Pueblos Libres forcefully took control of the county courthouse, Treviño actually recreated the Alianza raid on the courthouse. Filming on location, Treviño and his film crew very quickly reenacted the events, and the resulting scene, employing a fast-moving hand-held camera, lends the story an urgency it would not otherwise have had if Treviño had simply relied on interviews and static location shots. At other moments in the film, Treviño brings history to life by having actors play the roles of important Mexican resistance figures, such as Juan Cortina and Ricardo and Enrique Flores Magón, in scenes that mix painting, photography, and live action.

Yo Soy Chicano's most significant innovation may be found at the core of its message, where the film embraces inclusiveness and cooperation between different groups. By virtue of its title, *Yo Soy Chicano* would appear to be concerned only with Mexican Americans, yet this is not the case. As Treviño demonstrated in his production of *Soledad* (1970), which shows the inhumane conditions faced by Chicano/a and African American inmates at Soledad State Prison in California, the goal of social justice transcends any single group, and a greater social justice is attainable only when different groups work cooperatively.[4] In her interview for *Yo Soy*

Chicano, Dolores Huerta, who was then the vice-president of the United Farm Workers, discusses the aims of her organization in these terms: to "get power for the powerless. . . . [The farmworkers] are forced by not only economic and social but also racial discrimination. This is true of the Mexican farmworker, the black farmworker, the Arabian, and many times even the poor white farmworker." Similarly, in his interview in the film, José Ángel Gutiérrez, leader of La Raza Unida Party, discusses the importance of establishing coalitions between Chicano/as and other Latino/a groups, such as Puerto Ricans and Cubans, in order to expand political power.

Of course, the imperative for interethnic cooperation also applies to the film and television industry, where different minority groups often compete for scarce opportunities. When Treviño made *Yo Soy Chicano*, he was aware that he was fighting an industry that was satisfied to award Chicano/as mostly demeaning and secondary acting roles while denying Chicano/as and other Latino/as entry into writing, directing, and executive positions. In 1969, persons of Hispanic descent made up only 2 percent of the workforce in Hollywood (Treviño 1982, 170–71).[5] Had it not been for Treviño's successful production work on the show *Ahora!* on the Los Angeles public television station KCET, the opportunity to make *Yo Soy Chicano* may have never materialized. Fast-forward thirty years, and, sadly, the Latino/a presence in public and commercial media remains relatively unchanged. As Chon Noriega points out, "Latino directors accounted for 2.3 percent of available work within the industry" in 1999 (2003, 131).[6]

It is no surprise that Treviño, as an activist filmmaker, inflects his work with the concerns of his Chicano/a culture; furthermore, his efforts to open opportunities for Chicano/a and other Latino/a filmmakers is also commendable. Together with the creator of *Resurrection Blvd.*, Dennis E. Leoni, Treviño sought to open doors for other Latino/as to direct episodes of the series. Treviño explained his motivations in an interview at the time of the series: "As a community, Latinos haven't had a presence on American television, . . . haven't been able to cultivate a strong tradition of directors, writers, and producers. Although we do have directors and writers who work mainstream television, in comparison to our numbers and our potential, there are very few. I wanted to do this show because we needed a show like this. I hope *Resurrection Blvd.* will be the beginning of many shows about Latinos on American television and breaks some of those barriers. We're hoping that down the road we're going to be able to give opportunities to people who we feel are ready to direct episodic [TV shows], but haven't had the opportunity, because at a certain point a show like

this has a responsibility to cultivate and create opportunities for Latinos" (Hope 2000, 59–60).

In *Resurrection Blvd.*, Leoni and Treviño created possibilities for several Latino/a directors to collaborate in the creation of the series, among them the veteran documentarian Sylvia Morales, as well as three of the cast members—Elizabeth Peña, Tony Plana, and Michael DeLorenzo. More than half of the series' episodes were directed by Latino/as. As Darrell Hope noted at the time of the show's production, *Resurrection Blvd.* "has the distinction of being the only English-speaking dramatic series to feature a predominantly Latino cast and the first with a Latino presence on both sides of the camera" (2000, 59).

Resurrection Blvd. treats the stories of an LA-based Chicano/a family working toward the American Dream through professional boxing. While the main dramatic arc is about the struggles of the male family members to become champions, the series develops multiple story lines. We see a daughter's ambition for an independent and professional life, an aunt raising her son alone, a father dealing with his wife's death. Throughout the series, the family must contend with various social and institutional forces, including the boxing profession's sometimes racist structures of power. And while *Resurrection Blvd.* is undoubtedly about the contemporary Chicano/a experience, it features a broad cross section of cultural viewpoints and aspirations. The series develops stories in which the Chicano/a boxer works with an African American trainer, in which interethnic romance flourishes, and in which members of an older generation of Latino/as must face their own internal discrimination against immigrants. In the end, *Resurrection Blvd.* is about the American experience, about the necessity of seeing how seemingly disparate groups share similar hopes, and about how apparently separate communities actually overlap and coalesce. With his work on *Resurrection Blvd.*, Treviño proposes a world close to his own lived reality; it is a world in which people of diverse cultural and ethnic backgrounds act together to advance the common goals of social justice and equality.

Over a period of thirty years, Treviño has maintained a vision of developing film and television stories by and about Latino/as. *Yo Soy Chicano* remains a landmark for Chicano/a cinema. And working with Dennis Leoni on *Resurrection Blvd.*, Treviño has achieved a great measure of success in regard to this goal, and he has shown that creating inter-Latino/a and interethnic alliances within Hollywood and in society at large can yield great benefits for these diverse communities.

Notes

1. In *Eyewitness* (2001), Treviño provides a full account of his participation in the Chicano/a movement and describes the making of several of his films, including *Yo Soy Chicano*.

2. For an extended analysis of the cultural politics of the Chicano/a movement, see Rafael Pérez-Torres, *Movements in Chicano Poetry: Against Myths, Against Margins* (1995).

3. See *Eyewitness* for discussion of the various film techniques Treviño experimented with, including the use of still photography combined with live action, a technique used by Chris Marker in his 1962 film *La Jetée* (Treviño 2001, 253).

4. Treviño coproduced *Soledad* with Sue Booker, a fellow producer at KCET. In this film, Treviño and Booker acted as true guerrilla filmmakers, shooting some of their footage practically undercover in order to accurately render the terrible conditions at Soledad State Prison.

5. Treviño's essay "Chicano Cinema" (1982) constitutes an early delineation of a Chicano/a film aesthetic and also discusses the need for Chicano/as and other Latino/as to take control of the means of production at all levels.

6. See Chon Noriega's 2003 essay in *Film and Authorship*, which is adapted from a chapter of the same title in Noriega's book *Shot in America* (2000). Noriega elaborates on Treviño's achievements as a media activist.

Bibliography

Ahora! 1969. Produced by Jesús Salvador Treviño. KCET-PBS.

América Tropical. 1971. Directed by Jesús Salvador Treviño. Cinema Guild/KCET-PBS.

Babylon 5. 1993–98. Warner Bros. Television.

Bones. 2005–. Fox Network Television.

Crossing Jordan. 2001–7. Sony Pictures–NBC Television.

Dawson's Creek. 1998–2003. The WB Television Network.

ER. 1994–2009. NBC Television.

Gonzales, Rodolfo "Corky." [1967] 1972. *I Am Joaquín/Yo Soy Joaquín: An Epic Poem.* New York: Bantam Books.

Hope, Darrell L. 2000. "Jesús Treviño's Long Road to *Resurrection Boulevard.*" *DGA Magazine* (May): 58–62, 76.

I Am Joaquín. 1969. Directed by Luis Valdez. CFI.

Law & Order: Criminal Intent. 2001–11. NBC Television.

Noriega, Chon A. 1992. "Between a Weapon and a Formula: Chicano Cinema and Its Contexts." In *Chicanos and Film: Representation and Resistance,* edited by Chon A. Noriega, 141–67. Minneapolis: University of Minnesota Press.

———. 2000. *Shot in America: Television, the State, and the Rise of Chicano Cinema.* Minneapolis: University of Minnesota Press.

———. 2003. "'Our Own Institutions': The Geopolitics of Chicano Professionalism." In *Film and Authorship*, edited by Virginia Wright Wexman, 131–51. New Brunswick, NJ: Rutgers University Press.

NYPD Blue. 1993–2005. ABC Television.

Pérez-Torres, Rafael. 1995. *Movements in Chicano Poetry: Against Myths, Against Margins*. Cambridge: Cambridge University Press.

Raíces de Sangre (Roots of Blood). 1977. Directed by Jesús Salvador Treviño. Corporación Nacional Cinematográfica–Desert Mountain Media.

Resurrection Blvd. 2000–2002. Produced by Dennis E. Leoni and Robert Eisele, directed by Jesús Salvador Treviño et al. Showtime.

Seguín. 1982. Directed by Jesús Salvador Treviño. American Playhouse–KCET-PBS.

Soledad. 1970. Produced by Jesús Salvador Treviño. KCET-PBS.

Star Trek: Voyager. 1995–2001. UPN Television.

Treviño, Jesús Salvador. 1982. "Chicano Cinema." *New Scholar* 8:167–80.

———. 2001. *Eyewitness: A Filmmaker's Memoir of the Chicano Movement*. Houston, TX: Arte Público Press.

Yo Soy Chicano. 1972. Directed by Jesús Salvador Treviño. Cinema Guild/KCET-PBS.

Editors and Contributors

Editors

Scott L. Baugh is associate professor and coordinator of the Film and Media Studies program at Texas Tech University, teaching multicultural American cinema, among other topics. He was born and raised in Texas. He earned his doctorate from Oklahoma State University in 2001, specializing in film and multicultural/multiethnic American studies.

Baugh's research and writing focus on multicultural American cinema, with special attention to Chicana/o, Latina/o, and Latin American studies. His publications include *Latino American Cinema: An Encyclopedia of Movies, Stars, Concepts, and Trends* (Santa Barbara, CA: Greenwood, 2012) and the edited collection *Mediating Chicana/o Culture: Multicultural American Vernacular* (Newcastle, UK: Cambridge Scholars Press, 2nd rev. ed., 2008). With Mike Schoenecke he guest edited back-to-back special issues of *Film & History: Interdisciplinary Journal of Film and Television Studies* (volume 34, number 1 [Spring 2004], and volume 34, number 2 [Summer/Fall 2004]) focusing on Latin American film history, the earlier issue earning the American Historical Association–Film and History League's Outstanding Research Award. He guest edited, with Willie Varela, a special double issue of *Journal of Film & Video* (volume 57, numbers 2–3 [Fall 2005]) on experimental/alternative film, video, and digital media arts. His articles on Chicana/o cinema have appeared in *Quarterly Review of Film and Video, Journal of Film & Video, Film & History*, and the *Columbia Companion to Film and History*. He has been solicited to contribute a chapter on Latina/o cinema and art manifestos to the upcoming *Routledge Companion on Film and Politics*, and he is compiling an edited collection on writings by and about Willie Varela.

Baugh founded and served as organizing chair of the Chicana/o Culture: Literature, Film, Theory section for the annual meetings of the Congress of the Americas/Congreso de las Américas, the International Vernacular Colloquium, and the Popular Culture Association/American Culture Association (PCA/ACA), as well as of the Chicana/o Culture section of the Southwest/Texas PCA/ACA. He was elected to and served on the governing board of the PCA/ACA from 2004 to 2010.

Born and raised in Mexico City, **Víctor Alejandro Sorell** first immigrated north to the Canadian cities of Vancouver in 1956 and Montreal in 1960 and subsequently to Mount Carroll in 1966 and Chicago, Illinois, in 1969. He studied at Shimer College, focusing on comparative literature, and the University of Chicago, specializing in art history and social thought. He was a faculty member and administrator at Chicago State University (CSU) some forty-two years, but for several hiatuses elsewhere.

Sorell is university distinguished professor of art history, emeritus, having retired in 2010. He also renounced his long-held position as associate dean of the College of Arts & Sciences. Additionally, between 1995 and 2005, he served as institutional director of the CSU–University of Minnesota MacArthur Foundation Undergraduate Honors Program in International Studies. He has held a number of visiting professorships at the University of Chicago, Michigan State University, the University of California, Los Angeles, and the School of the Art Institute of Chicago. Between 1980 and 1983, he served as a senior program officer with the division of public programs at the National Endowment for the Humanities in Washington, DC, charged with, among other duties, advocating for increased grant solicitation from Chicana/o applicants. He was a founding member, in 1975, of a community arts organization, el Movimiento Artístico Chicano, based in Chicago.

A career researcher, Sorell is recognized as one of the pioneers in the appreciation, documentation, critical interpretation, and promotion of Chicano art history, a once-neglected branch of American art. Toward that end, he chaired the executive committee of the *Chicano Art: Resistance and Affirmation* (CARA) project at UCLA. Within the purview of Chicano art history, the public art forms of the mural, photograph, and poster have commanded much of his attention. Since about 1993, in the course of investigating Guadalupana imagery in New Mexico—under a Rockefeller Fellowship in the Humanities awarded through the University of New Mexico's Southwest Hispanic Research Institute, with which Sorell remains affiliated as a research associate—he launched a documentary

study of paños (cloths/handkerchiefs) and tattoos done inside la pinta by prison inmates. This subject is addressed in part in an essay Sorell contributed to a book of which he's also coeditor, *Nuevomexicano Cultural Legacy: Forms, Agencies, and Discourse* (Albuquerque: University of New Mexico Press, 2002). Also active as an exhibition curator and documentary film consultant, he cocurated an exhibition of the work of Carlos Cortéz Koyokuikatl and edited the catalog, *Carlos Cortéz Koyokuikatl: Soapbox Artist and Poet* (Chicago: Mexican Fine Arts Center Museum in collaboration with Chicago State University, 2001). Organized during 2000 on the occasion of Hispanic Heritage Month, the exhibition at CSU was dedicated to Dr. Julián Samora, in whose memory Cortéz executed a commemorative print. Sorell has also served as a consultant in the area of art history for films about César Chávez, José Clemente Orozco, and the Mexican Revolution of 1910. Currently he is on the international advisory board of *Latino Studies* and the editorial board of the Critical Documents Series of 20th-Century Latin American and Latino Art, a multiyear digital archive and publication project of the International Center of the Arts of the Americas at the Museum of Fine Arts, Houston, Texas. Additionally, he sits on the steering committee for *96 Acres*, a Chicago-based multiyear project deploying cultural interventions at and around Cook County Jail.

Contributors

Juan J. Alonzo is associate professor of film studies in the Department of English at Texas A&M University. He earned his PhD in English from the University of Texas at Austin. His areas of concentration include twentieth-century American cinema, literature, and culture, with a specialization in Chicano/a literature and film studies. Alonzo is interested in exploring literature and popular culture's engagements with modernity and literary and cinematic representation of ethnic identities. His publications include *Badmen, Bandits, and Folk Heroes: The Ambivalence of Mexican American Identity in Literature and Film* (Tucson: University of Arizona Press, 2009) and "Chicano/a Traditions in the American Novel" in *A Companion to the American Novel*, edited by Alfred Bendixen (Chichester, UK: Blackwell, 2012).

Sculptor/artist **David Avalos** was born in San Diego, California, and raised in Old Town National City (O-T-backwards N-C). He came of age as an artist at the Centro Cultural de la Raza in San Diego, where he learned to

work collaboratively and across disciplines. At the Centro he cofounded the Border Arts Workshop/Taller de Arte Fronterizo, an interdisciplinary, binational group devoted to socially and politically engaged art of the U.S.-Mexico border region. His work focuses on cultural and economic issues important to Chicanas and Chicanos. Avalos finds alternative means to disseminate his art and ideas both within and without a museum context. He was involved in a number of public art and collaborative projects that highlighted immigrant labor issues and that continue to receive national and international attention. He has received individual visual artist's fellowships twice from the National Endowment for the Arts as well as from the California Arts Council for his assemblage sculptural work. In 1988 he entered the graduate program in visual arts at the University of California, San Diego. The MFA he received at UCSD led to work at California State University San Marcos, where, as a professor in the School of Arts, he continues to learn about the art-making process from his students and colleagues.

Kate Bonansinga is associate professor of art history and director of the School of Art, College of Design, Architecture, Art, and Planning at the University of Cincinnati. She holds an MA in art history from the University of Illinois at Urbana-Champaign and an MBA from New Mexico State University. She is author of *Art at the Edge: Twelve Case Studies in Curatorial Practice at the U.S./Mexico Border* (Austin: University of Texas Press, 2013). Bonansinga was the founding director of the Rubin Center for the Visual Arts at the University of Texas at El Paso, where she regularly curated exhibits and also established an undergraduate minor in museum studies and taught courses in curatorial practice. In 2002, while at UTEP, she cocurated (with William R. Thompson) the *Crossing Over: Photographs and New Video Installations* exhibit of Willie Varela's work. She is interested in museums as dynamic sites for learning, in the impact of art in gallery and nongallery settings, and in the current methods that artists employ to make a difference in society and culture.

Photographer/artist **Robert C. Buitrón** is also an independent curator, writer, and educator. He received his MFA from the University of Illinois at Chicago in 1996 and his BFA from Arizona State University in 1980. In 1978 he cofounded the artist-run nonprofit organization Movimiento Artístico del Río Salado in Phoenix, Arizona. He has taught at the University of Minnesota and at the School of the Art Institute of Chicago. He currently teaches photography at College of DuPage in Glen Ellyn, Illinois,

and is a photography lecturer at Chicago State University. In addition to his contribution to the *From the West* exhibit in 1995, a more recent exhibition, *Inflating Culture*, opened in Tucson, Arizona, in 2005, featuring a new series of artworks. He has exhibited his photographs throughout the United States as well as in England, Germany, Mexico, and Spain. Among the awards he has received are a National Endowment for the Arts Fellowship, the Art Matters Foundation Fellowship, and an Illinois Arts Council Visual Artist Fellowship.

Painter/artist, writer, and educator, the late **Mel Casas** has been described as an elder statesman of the Chicano movement of the late 1960s and 1970s. A native of El Paso, Texas, Melesio Casas earned a BA in arts from Texas Western College (now the University of Texas at El Paso) in 1956 and an MFA from the University of the Americas in Mexico City in 1958. Casas's paintings are frequently included in art surveys for their expression of Chicanismo, but the designation was a source of both political connection and playful ambivalence for the artist. He lived and worked in San Antonio, Texas. In the early 1960s, Casas began teaching at San Antonio College, and there he founded an art mission that has since turned into a legacy across generations. Casas was professor emeritus of art, design, and painting at San Antonio College.

Patricio Chávez has curated significant art exhibitions related to Chicano visual arts, including the *La Frontera = The Border* exhibit (1993), cocurated with Madeleine Grynsztejn, and *Graficas: Obras Politicas* (1996), cocurated with Richard A. Lou and Marco Anguiano. He has longstanding ties to the Centro Cultural de la Raza in San Diego, California, and currently sits on its board and community advisory council. Chávez earned his MFA at the University of California, San Diego, and he teaches in the Department of Ethnic Studies at the University of San Diego and in the Art Department at Mesa College in San Diego.

Rubén C. Cordova is an art historian, curator, and photographer, with a BA in semiotics from Brown University and a PhD in history of art from the University of California, Berkeley. He has taught at UC Berkeley, the University of Texas–Pan American, the University of Texas at San Antonio, Sarah Lawrence College, and the University of Houston. His book *Con Safo: The Chicano Art Group and the Politics of South Texas* (Los Angeles: Chicano Studies Research Center, University of California, Los Angeles, 2009) is the first book on a Chicano art group. It received honorable

mention at the 12th Annual International Latino Book Awards (2010) in the category of best English-language art books. Cordova is writing a comprehensive five-part study of Mel Casas's *Humanscapes*. The first part was published in *Aztlán* (volume 36, number 2 [Fall 2011]), which will be reprinted in a forthcoming anthology by Duke University Press. The chapter in the current volume is the third part of the study. Cordova has curated or cocurated more than twenty exhibitions, including several devoted to Mel Casas's *Humanscapes*.

Sallie Gallegos is a writer, educator, and friend of Nicholas Herrera since childhood. Among her published writing is *Stone Horses* (Albuquerque: University of New Mexico Press, 1996), a novel set in Depression-era New Mexico. She is a native New Mexican who was raised on a ranch in rural El Rito, where her father was born. She teaches English for the U.S. Department of Defense Dependent Schools at the Guantanamo Bay Naval Base in Cuba.

Jennifer A. González is a professor in the History of Art and Visual Culture Department of the University of California, Santa Cruz. She earned her BA from Yale University and her doctorate from the University of California, Santa Cruz, in history of consciousness. Her scholarship focuses on contemporary theories of visual culture, semiotics, museums, material culture studies, and public and activist art in the United States. She produced a video study of artists and their communities, *Contemporary Site Works* (1999), featuring Santa Cruz local arts. Her publications include *Pepón Osorio* (Minneapolis: University of Minnesota Press, 2013), which was second-place winner among best art books in the International Latino Book Awards in 2014; *Subject to Display: Reframing Race in Contemporary Installation Art* (Cambridge, MA: MIT Press, 2008), which was a finalist for the College Art Association's Charles Rufus Morey Book Award; and her chapter, coauthored with Guillermo Gómez-Peña, in *Race and Classification: The Case of Mexican America*, edited by Ilona Katzew and Susan Deans-Smith (Stanford, CA: Stanford University Press, 2009).

Artist **Ester Hernández** may be best known for her depiction of Native/Latina women through pastels, paintings, prints, and installations. Born in the San Joaquin Valley of California to a Mexican/Yaqui farmworker family, she is an internationally acclaimed San Francisco–based visual artist and graduate of the University of California, Berkeley. She illustrated author Sandra Cisneros's book *Have You Seen Marie* (New York: Knopf,

2014). Her work reflects political, social, ecological, and spiritual themes. She has had numerous solo and group shows throughout the United States and internationally. Her work was part of the Smithsonian Institution's "Our America: The Latino Presence in American Art" exhibition (2013–14). Hernández's work is included in, among others, the permanent collections of the Smithsonian American Art Museum and the Library of Congress, both in Washington, DC; the San Francisco Museum of Modern Art; the National Museum of Mexican Art in Chicago; the Museo Casa Estudio Diego Rivera y Frida Kahlo in Mexico City; and the Victoria and Albert Museum in London. Her artistic and personal archives are housed at Stanford University.

Artist **Nicholas Herrera** works in wood carving and other types of sculpture as well as oil painting. He is a self-taught artist, who creates santos (saint-inspired imagery) and altarpieces in the form of bultos (three-dimensional) and retablos (two-dimensional). His artwork reflects the tradition of santos while challenging and updating it. His work is held in private collections and in public repositories, including the Smithsonian Institution's National Museum of American History in Washington, DC; the American Folk Art Museum in New York; the Albuquerque Museum of Art and History in New Mexico; the Museum of International Folk Art and the Museum of Spanish Colonial Art in Santa Fe, New Mexico; the Harwood Museum of Art and the Millicent Rogers Museum in Taos, New Mexico; Regis University in Denver, Colorado; and the Museum of the American West at the Autry National Center in Los Angeles.

The late sculptor/artist **Luis Jiménez** may be as well known for his large-scale public art as he is for their reflection of his incisive views of United States Southwest and mainstream American culture. With family ties to El Paso, Texas, and professional ties to the New York City art world, Jiménez ultimately chose to reside and create in New Mexico. Frequently working in fiberglass and epoxy, Jiménez made art that dispelled common-held assumptions about industrial, popular, and fine arts and that merged Mexican/American and European traditions. His work has been shown in museums throughout the United States and is in the permanent collections of the Metropolitan Museum of Art in New York; the Smithsonian American Art Museum in Washington, DC; the Art Institute of Chicago; the Centro Cultural Arte Contemporaneo in Mexico City; and other institutions. Public art, with its large audiences, often attracts attention and engenders controversy, and Jiménez's sculptures, with their bold depictions

and unabating social and environmental agendas, were more controversial than most. His *Vaquero* (1980/1990), *Southwest Pieta* (1984), *Sodbuster* (1980/1981), and *Hunky—Steel Worker* (1990) all stirred public debate, but perhaps none as much as the *Mustang/Mesteño* (2006) sculpture that he was working on at the time of his tragic and untimely death.

Born and raised in Mexico City, **Claire Joysmith** was brought up trilingually and quatriculturally. She is professor at the National Autonomous University of Mexico (UNAM) and has taught creative writing for Earlham College in Richmond, Indiana. She studied at UNAM and London University's Queen Mary College. Her academic and creative work focuses on bilingual and transcultural expressions and translation. Her essays, translations, and poetry have been published in the readers *Chicana Feminisms* (Durham, NC: Duke University Press, 2003) and *Poetic Voices Without Borders*, volumes I and II (Arlington, VA: Gival Press, 2005, 2009), the second volume earning a 2009 U.S. National Best Book Award for Fiction and Literature, as well as in the journals *Signs, Debate Feminista, FIAR, Blanco Móvil, Diálogo*, and *Literal*, among others. She contributed to the collective introduction to the twentieth-anniversary edition of Gloria Anzaldúa's *Borderlands/La Frontera* (San Francisco: Aunt Lute Press, 2007). She is editor of *Las Formas de Nuestras Voces: Chicana and Mexicana Writers in Mexico* (Berkeley, CA: Third Woman Press, 1995) and of *Speaking Desde las Heridas* (Mexico City: Universidad Nacional Autónoma de México, 2009) and coeditor of *One Wound for Another/ Una Herida por Otra* (Mexico City: Universidad Nacional Autónoma de México, 2005). Among her translations are Roger Bartra's *The Imaginary Networks of Political Power* (New Brunswick, NJ: Rutgers University Press, 1992), Joan Logghe's *Sofia: Poems* (Albuquerque, NM: La Alameda Press, 1999), and *Cantar de Espejos: Poesía Testimonial Chicana por Mujeres* (Mexico City: Universidad del Claustro de Sor Juana, 2011), of which she is also editor. Joysmith received the Sor Juana Inés de la Cruz UNAM Award in 2013.

Asta Kuusinen is a Finnish scholar and artist. She is a senior lecturer at the University of Eastern Finland. She earned her MFA in 1999 from the University of New Mexico and her doctorate in North American studies in 2006 at the University of Helsinki with her dissertation on Chicana art photographers Laura Aguilar, Celia Álvarez Muñoz, Delilah Montoya, and Kathy Vargas. Among her publications on Chicana photography are

"*Ojo de la Diosa*: Becoming Divine in Delilah Montoya's Art Photography" in *Aztlán* (volume 33, number 1 [2008]), "The Machine in the Desert: Decolonial History and *El Límite*" in *Mediating Chicana/o Culture: Multicultural American Vernacular*, edited by Scott L. Baugh (Newcastle, UK: Cambridge Scholars Press, 2nd rev. ed., 2008), and "Looking Through the Eye of the Goddess: Delilah Montoya's Photoinstallation *La Guadalupana*" in *Chicana/o Art: A Critical Anthology*, edited by Jennifer A. González, Tere Romo, Chon Noriega, and C. Ondine Chavoya (Durham, NC: Duke University Press, forthcoming).

Ellen Landis is a curator, art historian, writer, and educator. She studied at New York University and the University of California, Berkeley, with a concentration in Italian Renaissance painting and graduate work in Greek archaeology and sculpture. Since 2008, she has served as curator for Grounds for Sculpture, a forty-two-acre public sculpture park located in Hamilton, New Jersey, founded in 1992. She has acted as consultant for numerous museums and galleries and curated private collections, including several exhibitions of Rodin's sculptures. Formerly, Landis served as curator of art at the Albuquerque Museum of Art and History, where she oversaw many projects and exhibits of significance to Chicano visual arts, including the 1994 *Man on Fire* exhibit on the art of Luis Jiménez, her long-time friend.

Guisela Latorre is associate professor in the Department of Women's, Gender, and Sexuality Studies at Ohio State University. She specializes in modern and contemporary U.S. Latina/o and Latin American art, with special emphases on gender and women artists. She earned her doctorate in art history from the University of Illinois at Urbana-Champaign in 2003. Her first book, *Walls of Empowerment: Chicana/o Indigenist Murals from California* (Austin: University of Texas Press, 2008), explores the recurrence of indigenist motifs in Chicana/o community murals from the 1970s to the turn of the millennium. Her other publications include "Border Consciousness and Artivist Aesthetics: Richard Lou's Performance and Multimedia Artwork" in the *American Studies Journal* (number 57 [2012]), "New Approaches to Chicana/o Art: The Visual and the Political as Cognitive Process" in *Image & Narrative* (volume 11, number 2 [2010]), and "Icons of Love and Devotion: Alma López's Art" in *Feminist Studies* (volume 34, numbers 1–2 [Spring/Summer 2008]). Latorre's research activities include the coeditorship of the feminist journal *Frontiers: A Journal*

of Women Studies and work on a book project about the graffiti and mural movement in Chile during the postdictatorship era. She teaches classes on Latina/Chicana feminism, visual culture, and Latina/o art.

Writer/producer/director **Dennis Leoni** is the president and CEO of Patagonia House, the production company that developed and produced *Resurrection Blvd.* for Showtime Networks. Leoni was born in Tucson, Arizona, attended the University of Arizona, and began his career in the entertainment industry as a stunt person and actor but found work behind the camera safer. In 2011, he wrote and directed *Los Americans*, produced through V Studio. In 2010 and 2011, he appeared as himself in the *Latino 101* comedy show on NUVOtv.

Scholar/media artist **Christine List** is professor and program coordinator of the Communication, Media Arts, and Theatre Department at Chicago State University. She holds a doctorate from Northwestern University's radio/television/film program. She is an award-winning filmmaker whose work includes *No Nos Tientes: The Students of Guatemala* (1994), narrated by Edward James Olmos. List has served as an evaluator for numerous grants organizations, including the National Endowment for the Arts and the film studies committee of the Fulbright Commission. She has published various articles on Latino/a cinema, as well as a book on the history and theory of Chicano/a cinema, *Chicano Images: Refiguring Ethnicity in Mainstream Cinema* (New York: Garland, 1996). With Christine Houston, the creator of the NBC television series *227*, List is currently cowriting *The Screenwriter's Guidebook: Inspiring Lessons for Film and Television Writers,* and she is in production on a feature-length documentary about the African heritage of Russian poet Alexander Pushkin.

Artist **Yolanda López** may be best known for posters and paintings that challenge and subvert stereotypical imagery and aspects of injustice predominant in American culture. Born and raised in Logan Heights in San Diego, California, López was active in the arts and student movements in San Francisco in the late 1960s and participated in Los Siete de la Raza, an artist-activist group. She returned to Southern California in the early 1970s, studied at San Diego State University, and earned an MFA in visual arts from University of California, San Diego, in 1978. She has taught studio art and lectured at UCSD and the University of California, Berkeley, has worked as a translator in the National School District in National City and in the Chula Vista Police Department (both in San Diego County),

and has recruited for the U.S. Census Bureau. She has produced two movies, *When You Think of Mexico* (1985) and *Images of Mexicans in the Media* (1986), and she curated the *Cactus Hearts/Barbed Wire Dreams* exhibit (1988). López has contributed work to the Galería de la Raza in San Francisco, and her artwork appears in the permanent collections of the National Museum of Mexican Art in Chicago, the South Bend Museum of Art in Indiana, the Brooklyn Museum in New York, and elsewhere.

Photographer/artist **Richard A. Lou** explores in his art the acts of subjugation that happen across and within communities. He earned his MFA in 1986 from Clemson University in South Carolina. In addition to being an artist, he is a writer, curator, and educator, and he is professor and chair of the Department of Art at the University of Memphis. Lou has exhibited his work in venues worldwide, including the Museo de Arte Carrillo Gil in Mexico City; Cornerhouse Art Gallery in Manchester, England; Aperto 90, La Biennale di Venezia, in Venice, Italy; Istanbul Contemporary Art Museum in Turkey; Dong-A University in Busan, South Korea; the Museum of Photographic Arts and the Museum of Contemporary Art in San Diego, California; the Otis School of Art and Design in Los Angeles, California; the Newport Harbor Art Museum in Newport Beach, California; the Mexic-Arte Museum in Austin, Texas; the National Museum of Mexican Art in Chicago; the Walker Art Center in Minneapolis, Minnesota; MIT's List Visual Arts Center in Cambridge, Massachusetts; the Grey Art Gallery at New York University; and the Dia Art Foundation and Artists Space, both in New York.

Charles R. Loving is director of the Snite Museum of Art and curator of the George Rickey Sculpture Archive, University of Notre Dame. He earned a BFA from the University of Wisconsin, Milwaukee, in 1980; an MFA from the University of Utah in 1982; and an MA from the University of Utah in 1985. Loving worked with noted landscape architect Michael Van Valkenburgh to create the eight-acre Notre Dame Sculpture Park, which opened in 2013, and he organized the sculpture park's inaugural exhibition, entitled *Reclaiming Our Nature*. In 2009, he coorganized a symposium on American sculptor George Rickey, "Abstraction in the Public Sphere: New Approaches." His publications include *Richard Hunt: Extending Form* (Notre Dame, IN: Snite Museum of Art, University of Notre Dame, 2012) as well as essays and interviews in *The Acquisition and Exhibition of Classical Antiquities*, edited by Robin F. Rhodes (Notre Dame, IN: University of Notre Dame Press, 2008), *Selected Works: Snite*

Museum of Art (Notre Dame, IN: University of Notre Dame, 2005), *Face-to-Face: Examining Identity* (Notre Dame, IN: Snite Museum of Art, University of Notre Dame, 2003), and *Presage of Passage: Sculpture for a New Century*, compiled by Herman C. Du Toit (Provo, UT: Brigham Young University Museum of Art, 1999). Loving was recipient of a Distinguished Alumni Award, College of Fine Arts, University of Utah, in 2011.

Bienvenida (Beni) Matías is a filmmaker, educator, and media advocate. She is a founding member and former board chairperson of the National Association of Latino Independent Producers (NALIP) and was its acting executive director. She has served as executive director of several media arts nonprofits, including the Association of Hispanic Arts, Dance Films Association, the Center for Arts Criticism, and the Association of Independent Video and Filmmakers (AIVF), and was also publisher of the AIVF's magazine, *The Independent*. She has been executive in charge of production at WNYC-TV and director of production at Independent Television Services. Some of her credits include producing and directing *The Heart of Loisaida* (1979) and *Through Young People's Eyes* (1981) with Marci Reaven and coproducing *Antonio Pantoja: ¡Presente!* (2009) for director Lillian Jiménez. She is currently making *¡Coquito!* with Tami Gold and Sonia González-Martínez, funded by Latino Public Broadcasting. As a consultant, she works with filmmakers developing all aspects of documentary production. Much of her effort involves mentoring young people in the art and business of the social issue documentary. She has taught at Hunter College–City University of New York and New York University's McGhee Division. She has a degree in film production from La Escuela Oficial de Cinematografía in Madrid.

Artist/photographer/printmaker **Delilah Montoya** was born in Texas and has deep familial roots in northern New Mexico. She studied at the University of New Mexico, earning an MA in printmaking in 1990 and an MFA in studio art in 1994. She is professor and area coordinator in the School of Art at the University of Houston. Her photographic and installation work appears in public collections, including the Los Angeles County Museum of Art; the Wight Art Gallery at the University of California, Los Angeles; the Hammer Museum in Los Angeles; the Mexican Museum in San Francisco; the National Hispanic Cultural Center Art Museum in Albuquerque, New Mexico; the Museum of Fine Arts in Santa Fe, New Mexico; the Museum of Fine Arts in Houston, Texas; the National Museum of Mexican Art, Chicago; the Bronx Museum of the Arts, New York;

and the Smithsonian Institution in Washington, DC. She published the photographic book *Women Boxers: The New Warriors* (Houston, TX: Arte Público Press, 2006), and she has curated several exhibits, including *Chicana Bad Girls* (2009) with Laura E. Pérez at Gallery 516 in Albuquerque and *Detention Nation* (2015) at the Station Museum of Contemporary Art in Houston.

Chon A. Noriega is professor of cinema and media studies and director of Chicano studies at the University of California, Los Angeles, where he also directs the UCLA Chicano Studies Research Center (CSRC). He earned his doctorate in modern thought and literature from Stanford University. He has diverse research interests in Chicano studies and in film and other arts. He is author of *Shot in America: Television, the State, and the Rise of Chicano Cinema* (Minneapolis: University of Minnesota Press, 2000) and coauthor of *Phantom Sightings: Art After the Chicano Movement* (Berkeley: University of California Press, 2008) and *L.A. Xicano* (Seattle: University of Washington Press, 2011). He is currently completing a book on Puerto Rican multimedia artist Raphael Montañez Ortiz and a longitudinal study of online and social media strategies among nearly 180 art museums in the United States. He has edited anthologies on Latino, Mexican, and Latin American cinema, as well as the collected works of Carmelita Tropicana and Harry Gamboa Jr. Since 1996, he has been editor of *Aztlán: A Journal of Chicano Studies*, and he is editor of three book series and the CSRC's Chicano Cinema and Media Art DVD series. He is cofounder of the National Association of Latino Independent Producers, established in 1999, and served two terms on the board of directors of the Independent Television Service. He has also curated numerous film programs and art exhibitions. He currently acts as adjunct curator at the Los Angeles County Museum of Art, and in 1995 he curated the *From the West* exhibit.

Tey Marianna Nunn is director and chief curator of the Art Museum at the National Hispanic Cultural Center in Albuquerque, New Mexico. Previous to that she spent nine years as the curator of contemporary Hispano and Latino collections at the Museum of International Folk Art in Santa Fe, New Mexico. She earned her PhD in Latin American studies from the University of New Mexico, where her research focused on Spanish colonial, contemporary Latin American, and Chicana/o and Latina/o art history and history. She is the author of *Sin Nombre: Hispana and Hispano Artists of the New Deal Era* (Albuquerque: University of New

Mexico Press, 2001). Nunn has curated such acclaimed exhibits as *Sin Nombre: Hispana and Hispano Artists of the New Deal Era* (2001), *Cyber Arte: Tradition Meets Technology* (2001–2), *Flor y Canto: Reflections from Nuevo México* (2002), *Meso-Americhanics (Maneuvering Mestizaje): De la Torre Brothers and Border Baroque* (2008), *Stitching Resistance: The History of Chilean Arpilleras* (2012–14), and *¡PAPEL! Pico, Rico y Chico* (2015). Nunn is active in issues concerning Latinos and museums and has been elected twice to the board of trustees for the American Alliance of Museums. She also serves as a trustee on the boards of the Western States Arts Federation and Rancho de la Golondrinas. A recipient of numerous research fellowships from the Smithsonian Institution and the Bogliasco Foundation, Nunn was voted Santa Fe Arts Person and Woman of the Year in 2001. She was awarded the 2008 President's Award by the Women's Caucus for the Arts of the College Art Association. In 2014, Nunn was honored by Los Amigos de Arte Popular with the Van Deren Coke Award for outstanding contributions to expanding the knowledge of Mexican and Latin American folk art.

Carmella Padilla is a writer and editor who lives with her husband, artist Luis Tapia, in Santa Fe, New Mexico. Padilla writes extensively about intersections in art, culture, and history in New Mexico and beyond. She is the author of several books, including *The Work of Art: Folk Artists in the 21st Century* (Santa Fe, NM: International Folk Art Alliance Media, 2013), *El Rancho de las Golondrinas: Living History in New Mexico's La Ciénega Valley* (Albuquerque: Museum of New Mexico Press, 2009), and *Low 'n' Slow: Lowriding in New Mexico* (Albuquerque: Museum of New Mexico Press, 1999). She coedited *A Red Like No Other: How Cochineal Colored the World* (New York: Skira Rizzoli, 2015), a book exploring the global history and use in art of cochineal, a red insect dye from the Americas. She also cocurated an exhibition on the subject, *The Red That Colored the World* (2015), at the Museum of International Folk Art in Santa Fe. Padilla is the recipient of the 2009 New Mexico Governor's Award for Excellence in the Arts.

Laura E. Pérez is associate professor in the Department of Ethnic Studies at the University of California, Berkeley, where she is also a core faculty member of the doctoral program in performance studies and an affiliated faculty member of the Department of Women's Studies and the Center for Latin American Studies. Pérez received her PhD from Harvard University

and a joint BA/MA from the University of Chicago. Pérez curated UC Berkeley's first Latina/o performance art series; cocurated, with Delilah Montoya, *Chicana Badgirls: Las Hociconas* (2009) in Albuquerque, New Mexico; and curated *Labor+a(r)t+orio: Bay Area Latina@ Arts Now* (2011) at the Richmond Arts Center in Richmond, California. Her articles include "The Inviolate Erotic in the Painting of Liliana Wilson" in *Ofrenda/Offering: Liliana Wilson's Art of Dissidence and Dreams*, edited by Norma Cantú (College Station: Texas A&M University Press, 2014), and "Writing with Crooked Lines" in *Fleshing the Spirit: Spirituality and Activism in Chicana, Latina, and Indigenous Women's Lives*, edited by Linda Facio and Irene Lara (Tucson: University of Arizona Press, 2014). Additionally, Pérez is the author of *Chicana Art: The Politics of Spiritual and Aesthetic Altarities* (Durham, NC: Duke University Press, 2007), and her *Ero-Ideologies: Writings on Art, Spirituality, and the Decolonial* (Durham, NC: Duke University Press) will be published in 2016. She is at work on another research project on women of color and nonviolence, as well as an anthology on the work of multimedia artist Consuelo Jiménez Underwood.

Screenwriter/media artist **Lourdes Portillo** is perhaps best known for her experimentation with the documentary genre. Born in Chihuahua, Mexico, and raised in Los Angeles, Portillo studied at the San Francisco Art Institute. Her projects have won support from the National Endowment for the Arts, the Rockefeller Foundation, the Guggenheim Foundation, and the American Film Institute, and they have been screened widely, at venues ranging from the Sundance Film Festival to the Whitney Biennial. Among the dozens of her films, videos, and video-collage pieces, *Columbus on Trial* (1992), *Corpus: A Home Movie for Selena* (1999), *Las Madres: The Mothers of the Plaza de Mayo* (1986), *La Ofrenda: The Days of the Dead* (1988), and *The Devil Never Sleeps* (1994) stand out. *Señorita Extraviada* (2001), which some critics point to as the apex of her career thus far, consolidates aesthetics of these earlier titles and extends a political agenda on Latina identity and social justice in the Americas. Among her many awards, Portillo earned Academy Award (for Best Documentary) and Emmy (New and Documentary) nominations for *Las Madres*, and for *Señorita Extraviada* she earned an Ariel Award for Best Documentary, an International Documentary Association Distinguished Documentary Achievement Award, the Nestor Almendros Human Rights Prize from Amnesty International, and a Special Jury Prize at Sundance.

Lynn Schuette is a curator, arts administrator, and artist. She studied at the University of Illinois at Urbana-Champaign. In 1980, she founded Sushi Performance and Visual Art, serving as executive director until 1995. Schuette was instrumental in advancing Sushi's multidisciplinary arts program, recognized for introducing nationally acclaimed performance and dance artists to the San Diego community and Southern California regional arts scene. Schuette has served as a panelist and site evaluator for the National Endowment for the Arts and the California Arts Council. Her visual artwork includes paintings, drawings, prints, and mixed-media pieces. In 1992, she was named Woman of the Year in Arts by the *San Diego Women's Times.*

Wood sculptor/artist **Luis Tapia** lives in Santa Fe, New Mexico, with his wife Carmella Padilla. A pioneering artist whose work is rooted in the historic Hispano folk art traditions of New Mexico, Tapia addresses contemporary issues by combining an innovative use of materials with social, political, and religious commentary and humor. His work has been exhibited and collected internationally and is included in the collections of the Smithsonian's American Art Museum, the Museum of American History, and the Latino Center in Washington, DC; the Museum of International Folk Art, the Museum of Spanish Colonial Art, and the New Mexico Museum of Art in Santa Fe, New Mexico; the Albuquerque Museum of Art and History; El Museo del Barrio in New York City; the Rockwell Museum of Art in Corning, New York; the Autry National Center of the American West in Los Angeles; the Denver Art Museum in Colorado; the Heard Museum of Native Cultures and Art in Phoenix, Arizona; and elsewhere. He is the recipient of the 1996 New Mexico Governor's Award for Excellence in the Arts.

Mónica F. Torres earned her doctorate in American studies in 2002 from the University of New Mexico. While she was on the rhetoric faculty at New Mexico State University (2002–13), her research and teaching interests focused on institutional discourses, particularly those that shape conventional or "commonsense" knowledge about race, class, gender, and sexuality. She has published articles on Lourdes Portillo's films in *The Velvet Light Trap* and *Revista Casa de las Américas* and on Chicana cultural expression in *Entre Mundos/Among Worlds: New Perspectives on Gloria Anzaldúa,* edited by Ana Louise Keating (New York: Palgrave, 2005). She is currently serving as vice president for academic affairs at Doña Ana Community College in Las Cruces, New Mexico.

Writer, director, producer, and activist, **Jesús Salvador Treviño** has enjoyed a remarkable career in the film and television industries, working on a range of independent and commercial projects. Treviño was born in El Paso, Texas, spent his formative years in Southern California, and studied on scholarship at Occidental College in Los Angeles. Working in Los Angeles public television in the late 1960s and early 1970s, Treviño created for national broadcast several of the most significant programs and documentaries on Chicano cultural expression and history, including *La Raza Nueva* (1968), *Ahora!* (1970), *Soledad* (1971), *América Tropical* (1971), and *Yo Soy Chicano* (1972). By the mid-1980s, Treviño's career turned to such popular television series as *NYPD Blue* (1994), *Star Trek: Voyager* (1997–98), *Babylon 5* (1995–98), *Dawson's Creek* (1998), *ER* (2002), and *Law & Order: Criminal Intent* (2008). In 1991, he began work with Luis R. Torres and José Luis Ruiz on *Chicano*, the four-part documentary on the Mexican American civil rights movement of the late 1960s. Through many of his projects, Treviño has advocated for Latino representation in the film and television industries, and he promotes Latina/o artists and arts through his Latinopia.com website. He has won prestigious awards from the Directors Guild of America, including a career tribute in 2009; three Daytime Emmy nominations for his television specials; and an ALMA Award for his direction of *Prison Break* (2005). Over its three-season run, *Resurrection Blvd.* (2000–2002), which he cocreated with Dennis Leoni, garnered a total of five ALMA Awards and nine additional nominations, as well as a Nosotros Golden Eagle for Outstanding English-Language Series.

Experimental media artist **Willie Varela** lives and works in El Paso, Texas. He studied at the University of Texas at El Paso, earning his MA with specialization in video production in 1992, and has taught film and media studies at a number of schools, including UTEP. He has produced art in small-gauge film, video, and digital media, as well as photography, and he has exhibited more than one hundred moving-image pieces and almost as many photographs since the mid 1970s. Varela's work has been screened by and received acknowledgment from the Whitney Museum of American Art in New York with a retrospective in 1994 and inclusion in biennials in 1993 and 1995; the Museum of Modern Art in New York; the Los Angeles Film Forum; the Millennium Film Workshop in Brooklyn; Anthology Film Archives in New York; the Pacific Film Archive in Berkeley, California; the San Francisco Cinemateque; and elsewhere. The multicultural resonance of his work has been recognized by the Guadalupe

Cultural Arts Center in San Antonio, Texas; the Mexic-Arte Museum in Austin, Texas; and the National Hispanic Cultural Center in Albuquerque, New Mexico, among others. *Crossing Over: Photographs and New Video Installations* (2002–4) represents Varela's first turn toward video installation work.

Artist/photographer **Kathy Vargas** was born in San Antonio, Texas. Vargas is associate professor and a former chair of the art department at the University of the Incarnate Word in San Antonio, Texas. She earned her MFA from the University of Texas at San Antonio in 1984. Her artwork centers on contemporary themes and social justice issues, and one of her more recent series, *Este Recuerdo*, is an experiment in rephotographing and recontextualizing family photographs. Her work appears in the collections of the Smithsonian American Art Museum in Washington, DC; the National Museum of Mexican Art in Chicago; the Snite Museum of Art at the University of Notre Dame in Indiana; the Toledo Art Museum in Ohio; the Mexican Museum in San Francisco; the National Hispanic Cultural Center in Albuquerque; the Museum of Fine Arts in Houston; and the El Paso Museum of Art. She has had one-person exhibits at the Sala Uno in Rome, the Galería Juan Martín in Mexico City, and the Centro Recoleta in Buenos Aires, as well as a retrospective at the McNay Art Museum in San Antonio, Texas. Her work has been included in such group shows as the landmark *Chicano Art: Resistance and Affirmation* exhibit (1990–93); *Hospice: A Photographic Inquiry* (1996), a national traveling exhibit commissioned by the Corcoran Gallery, Washington, DC; *Cardinal Points/ Puntos Cardinales* (2008–9), a national traveling exhibit sponsored by the Sprint Nextel Corporation Art Collection, Overland Park, Kansas; and the *From the West* exhibit (1995). She was named 2005 Texas Two-Dimensional Artist of the Year by the Texas Commission on the Arts. As an emerging artist in the mid-1970s she was, for a short time, a member of Con Safo. From 1985 to 2000 she was director of the Visual Arts Program at the Guadalupe Cultural Arts Center in San Antonio.

René Yañez is a curator, artist, and producer who lives in and works out of San Francisco. A founder and former artistic director of Galería de la Raza in San Francisco, he currently serves as director of special projects at SOMArts Cultural Center. Yañez was one of the first curators to introduce the contemporary concept of Mexico's Day of the Dead to the United States, through exhibits at the Yerba Buena Center for the Arts in San Francisco. Yañez galvanized a large community of Latino and Chicano artists and

their allies from all communities, notably including Rupert García, Guill-ermo Gómez-Peña, Carmen Lomas Garza, Enrique Chagoya, Amalia Mesa-Bains, Gronk, Ester Hernández, and Yolanda López. Active as both a visual and performance arts curator and artist, Yáñez cofounded the suc-cessful Chicano performance trio Culture Clash. He is widely recognized for innovative art projects that promote awareness of our culturally diverse society. He has curated numerous exhibitions, including *Chicano Visions: American Painters on the Verge,* which toured nationally from 2002 to 2007. Throughout his decades of work in the arts, René has remained a stalwart supporter of grassroots organizations and community artists, col-laborating with such Bay Area organizations as SOMArts, the Oakland Museum of California, Yerba Buena Center for the Arts, Kearny Street Workshop, the Mission Cultural Center for Latino Arts, and the San Fran-cisco Arts Commission. In 1998, he received the Special Trustees Award in Cultural Leadership from the San Francisco Foundation for his long-standing contribution to the cultural life of the Bay Area.

Yvonne Yarbro-Bejarano is professor emerita of Iberian and Latin Ameri-can cultures in the Division of Literatures, Cultures, and Languages at Stanford University, where she also chaired the Chicana/o studies pro-gram in the Center for Comparative Studies in Race and Ethnicity. Yarbro-Bejarano studied German and comparative literature at the Uni-versity of Washington and earned her doctorate in Spanish from Harvard University in 1976. She is author of *Feminism and the Honor Plays of Lope de Vega* (West Lafayette, IN: Purdue University Press, 1994) and *The Wounded Heart: Writing on Cherríe Moraga* (Austin: University of Texas Press, 2001), and she is coeditor of the *Chicano Art: Resistance and Affir-mation* exhibition catalog (Los Angeles: Wight Art Gallery, University of California, Los Angeles, 1991). She has published numerous articles on Chicana/o literature, art, and culture. In 1994, she began development of Chicana Art, a digital archive of images focusing on women artists.

Index

abduction, 56, 254–57, 261, 263, 264, 265, 266, 274–79
absurdity, 71, 103
Acconci, Vito, 243
activism, 8–10; border politics and, 70, 74, 99, 102, 137; civil rights movement and, 39, 47, 127, 281, 291; generations of, 10, 63, 127, 281, 296; grassroots, 60, 102, 258, 264; social commentary as, 113, 130n1, 148, 158, 226, 265, 275, 283, 293, 299, 301
Acuña, Rodolfo, 9, 33n8, 49, 287n2
aesthetics, 53, 58; Chicano, 294, 298; cinematic, 158, 172–74, 179, 235–36, 237; combining traditions, 111, 123, 137, 139, 153–54, 211, 301; conventions and, 7, 211; disrupting conventions in, 79, 240, 245–46, 249, 251; experimental, 61, 79, 236, 246, 256, 301; Latino, 294; postmodern, 44, 95, 241, 242–43, 247; stylistic use of aphorism and, 162; stylistic use of color and, 113, 115, 139, 153, 154, 156, 176, 183, 184, 186, 226, 247, 248; stylistic use of gloss and, 153, 154–55; stylistic use of juxtaposition and, 193, 233–36, 240–41, 245–46, 248–49; stylistic use of subtitles and, 162, 172–74, 179, 235–36, 249
affirmation, 53, 58, 63, 74, 96
Agrippa, Herod I, 119, 124, 128
Agueda Martínez: Our People, Our Country, 283

AIM (American Indian Movement), 37
AKA Pablo, 285
A la Brava: Prison and Beyond, 283
The Alamo (film), 199
Alamo (site), 163, 191–93, 206, 220–21, 226
Alamo, Price of Freedom, 201–2
Albuquerque Museum of Art and History, 146
Aldama, Arturo J., 5
Aldana, Gerardo, 45n4
Alderete, Rosemary, 293
Alianza Federal de Pueblos Libres, 9
Allen, Charles, 281–82
Almeida, Felipe, 79
Alvarez, Cecilia, 54
American Civil Liberties Union (ACLU), 73, 78
American Family, 287
American Regionalists, 154
American Revolution, 39–40
Los Americans, 290
America(s): continental, 9, 10, 12, 13, 37, 39, 40, 43, 59, 219, 225, 283; as cultural model, 13, 168, 176, 209; as democratic model, 13, 81, 212n1, 303; as mythic concept, 61, 104, 139, 153, 191, 208, 303; West as icon and, 218, 220; Western mythology and, 153, 155, 157, 190, 208–11, 215–16
Amor Chicano Es para Siempre/Chicano Love Is Forever, 283
Anderson, Benedict, 64n9, 216, 216n3